CANE SUGAR

The small-scale processing option

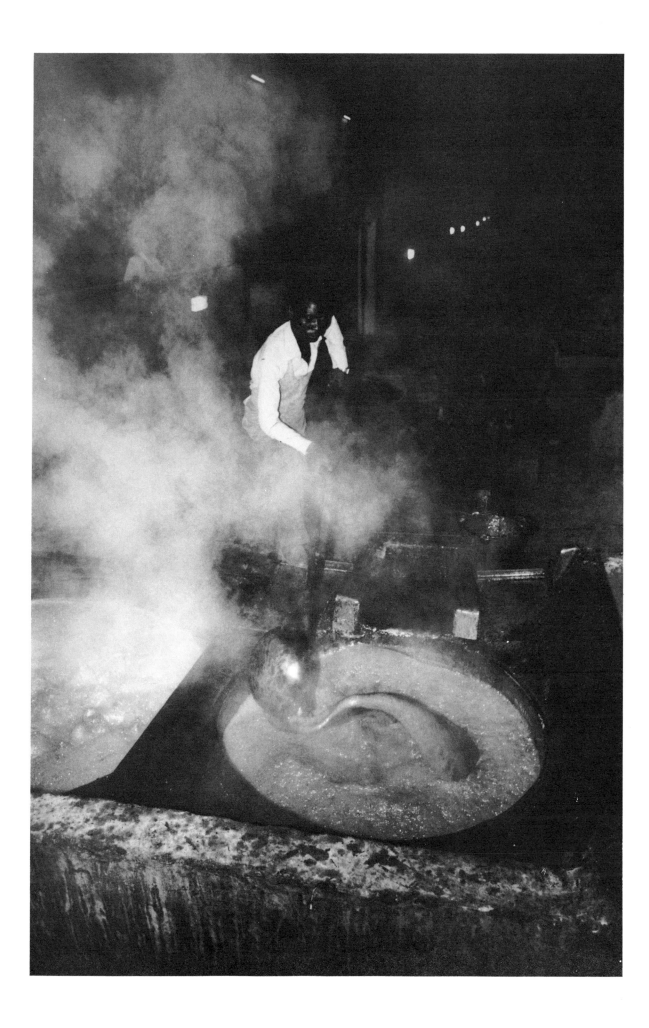

CANE SUGAR
The small-scale processing option

Proceedings of a joint ITDG/IDS conference, 10-11 September 1987

Rapporteur:

Raphael Kaplinsky

Papers presented by:

Maurice Awiti, Alex Bush, Rodney Goodwin, Gerry Hagelberg, Alan James, Mel Jones,
Raphael Kaplinsky, Haleem Lone, David Makanda, Edward Mallorie, J.I. Mbuthia,
Ian McChesney, W.A. Mlaki, George Moody-Stuart, D.P. Nyongesa,
Bhikhu Patel, John Pearson, Michael Tribe

Editors:

Carrie Brooks, Mel Jones, Ian McChesney

Intermediate Technology Publications, London 1989

Frontispiece: Kenyan sugar boiler using the open pan process.

Photos: Jeremy Hartley/ITDG

Intermediate Technology Publications
103/105 Southampton Row
London WC1B 4HH, UK

© Intermediate Technology Publications 1989

ISBN 1 85339 015 1

Printed in the UK by The Russell Press, Nottingham

CONTENTS

PREFACE

ITDG first became involved in small-scale sugar processing in the late 1970s. At that time there was clear interest in the potential for small-scale factories. Equipment suppliers had realized that saturated sugar markets limited the prospects for supplying many new large factories. Only those countries in the developing world with growing domestic markets wanted more capacity, and they were attracted to smaller size factories which were likely to be easier to locate, finance and operate.

The major drawback to small factories was their lack of scale economies. Building large factories smaller invariably meant higher production costs. At a time when world market prices were often at (or below) the cost of production, the incentive to invest was poor. Consequently few small units were built. At this time ITDG became aware of the widespread use in India of a lower cost, small-scale technique for sugar preparation using the open pan sulphitation (OPS) method. Several thousand units of this type had been established.

ITDG reviewed this phenomenon through support to several projects in India and Kenya, and formally embarked on a sugar programme in early 1984. The Programme formed part of ITDG's activities supported by the Appropriate Technology Fund of the Overseas Development Administration (ODA). The basis for the Programme was the pioneering work undertaken by M. K. Garg at the Appropriate Technology Development Association (ATDA) at Lucknow, India (see Garg, 1979). In collaboration with ATDA, the ITDG programme proposed to diffuse these new open pan white sugar technologies outside India.

The stated objective of the programme was to set up demonstration projects in Bangladesh and Peru to show how farm income and jobs could be created in the rural areas. Meanwhile, work was already underway transfering furnace technology from India to Kenya for the same purpose.

In 1985 the untimely death of M. K. Garg robbed the collaboration of its India connection, and, with particular constraints operating in both Bangladesh and Peru, the programme work was focused towards consolidating the initiative at West Kenya Sugar Company (WKS) in Kakamega, Western Kenya. An ODA review of this project had highlighted the jobs and income which the factory had created.

This factory pioneered the successful manufacture of open pan sugar in Kenya. It followed the failure of the two earlier projects at Kabras and Yala. ITDG continued to support the factory with technical assistance on furnaces, and in 1986 a high juice extraction cane expeller was also installed.

A pre-condition for ODA support had been a comprehensive economic analysis of the technology, and this had been done on a comparative basis with conventional large-scale processes. This analysis predicted that West Kenya would fail in its efforts to establish the technology unless broader government support was forthcoming.

Government support to the factory has so far been minimal, yet even without this the enterprise has proved successful. Factors in this success which were not fully

accounted for in the economic analysis included quality of management, versatility of product mix and the attractiveness to farmers of small factories.

ITDG was concerned that these factors might be exclusive. However, further investigation has shown that capable entrepreneurs are interested in investing, that the factories can exert the necessary influence over the local market for cane and sugar products, and that the social impact of cane agriculture is positive.

This last point was an important one to ITDG. Sugar cane has been associated in some way with most forms of labour and land exploitation. However, where cane is grown within the existing agricultural system by independent farmers it does appear to create wider opportunities for participation by the local community. The cash earned is an important source of investment for the families in their children and their homesteads.

ITDG thus remains keen to support the spread of this technology. However, the conclusions of the early analysis remain largely correct — government policy must be supportive of small-scale enterprises. The reasons for this relate to the structure of costs in sugar production. Small factories do not have the processing scale economies to produce cheap sugar. However, they do have lower agricultural costs and lower distribution costs. This means that sugar can be put in the shops for the same price, but only if sector policy recognizes this structural difference and thereby creates an environment which favours small-scale investment.

Having collected over the years a considerable amount of information and evidence on small-scale sugar, ITDG felt it would be useful to turn to a wider forum to consider the future of small-scale sugar processing, and hence organized a conference on the subject, held at the Institute of Development Studies, University of Sussex, Brighton, UK, from 10-11 September 1987.

These proceedings contain the papers presented at the conference together with several commissioned since then. They explore the background and current situation of small-scale sugar processing, and present some options for the future of the industry. The proceedings are presented in two parts. The first contains a summary of each of the papers, and is designed to facilitate a quick reading by those wishing to obtain an overview of the issues under discussion.

The second — and larger — part of these proceedings contains all of the papers in full. This part can broadly be divided into seven major sections. The first comprises a statement of the issues under discussion. This is followed by a description of the various sugar processing technologies, with particular emphasis on OPS. The third section discusses the global context within which each country situates the development of its sugar processing sector. Next there are a series of papers addressing scale economies in sugar processing, both in relation to vacuum and open pan processing. The fifth section comprises a detailed recounting of the experience of OPS technology in Western Kenya. This leads to a section which addresses the policy implications for developing country governments. A final paper draws out the major conclusions, focusing particularly on the policy implications for governments, ITDG and other non-government organizations. It is in the development of appropriate policies that the future of small-scale sugar processing now lies.

Following on from the conference, ITDG has decided to continue the sugar programme for a further year to investigate the potential for dissemination in East Africa. Positive indications have now been received from the Governments of both

Kenya and Tanzania. These will be developed by the programme into a firm basis for establishing a small-scale sugar sector. The conference was an important step on this path towards ITDG's goal of equitable rural development through small-scale enterprises.

Raphael Kaplinsky and Ian McChesney

REFERENCE

Garg, M. K., *Project Report and Feasibility Study of Appropriate Technology on Mini-Sugar (OPS Khandsari)*, ATDA (1979).

PART ONE

SUMMARY OF CONTENTS

SECTION A: INTRODUCTION

Overview

The paper begins by addressing the question of why ITDG should be involved with sugar at all. Justification is provided in terms of the potential benefits to farmers, mill workers, mill owners and the government (often the mill owners anyway) of particular forms of organization of the industry. As a minimum, this should involve supply of cane from smallholdings.

The issue of large- versus small-scale sugar production is examined from a range of perspectives. These include technical performance, economies of scale, financial and economic viability, social impact and the impact of government policy. Discussion is referenced to the papers which follow in the main body of the book. Small-scale open pan methods are capable of producing a product mix of either sugar and liquid molasses, or sugar and solid molasses. Large-scale vacuum pan technology is considerably more efficient at processing cane to sugar, owing to technical economies of scale. However, managerial and distributional diseconomies, associated with the problem of ensuring sufficient cane supplies for crushing, can offset the technical economies.

Given current cane and sugar prices in Kenya, both vacuum pan and open pan processes are only marginally financially viable, though vacuum pan may be rather more profitable than open pan where both technologies operate at full capacity. In economic terms, vacuum pan technology makes more efficient use of cane supplies while open pan is more sparing in its use of capital. Economic analysis somewhat improves the performance of open pan relative to vacuum pan but, given the low world market price for sugar, again viability is no more than marginal.

Evidence regarding social impact in terms of the effect on the economic welfare of food security for, and nutritional status of, low income groups is mixed. There are clear signs that farmers supplying an open pan sugar factory are more likely to have smaller land holdings and engage in multiple cropping than are farmers supplying vacuum pan mills. Concentration of land holding and increasing income differentials are also likely to be associated with vacuum pan factory outgrower schemes. On the other hand there is little evidence of a decline in nutritional status among such outgrowers, and differences in social impact between small-scale and large-scale schemes may be due, at least in part, to different periods of operation. Vacuum pan plants have been established much longer than open pan in Kenya; thus the social impact of vacuum pan units may be expected to be more clearly articulated.

Government policy has had, and will continue to have, a significant influence on the choice of technology within the sugar industry. For the present, policies tend to favour the large mills. In Kenya these are mainly government owned, and are therefore more

3

easily able to absorb financial deficits than small private mills. Given the narrow processing margins in Kenya (the consequence of government-set prices for both cane and sugar), there is little incentive for private investment in small- or large-scale sugar. Sugar production is thus less than potential in both large- and small-scale sectors. The removal of excise duty would be sufficient to make small-scale open pan sulphitation (OPS) production profitable.

It may not be enough, however, just to indicate the appropriateness and profitably of OPS sugar to have policy changed. Yet without some change in policy, there is little future for OPS in Kenya.

Mel Jones, Intermediate Technology Development Group

SECTION B: CANE SUGAR TECHNOLOGY

Introduction to processing techniques

This paper sets out the various stages of sugar separation, and the associated derivation of the efficiency terms used subsequently in this book. The distinction between the 'vacuum pan' and 'open pan' methods is explained, as are the reasons for their differing levels of effectiveness. The role of cane quality and capacity utilization in determining these figures is also noted. Open pan systems are particularly sensitive to the skill of the operator, whereas vacuum pan systems respond better to improved management.

The paper also looks at the energy balances of these two sugar processes. While vacuum pan plants tend towards fully integrated energy systems that run entirely on bagasse, open pan plants use a range of energy sources in addition to bagasse to satisfy their heat and power requirements.

In conclusion, the paper sets out in tabular form the range of technologies that might be considered for the 'front' and 'back' ends of the sugar manufacturing process.

Alex Bush, Intermediate Technology Development Group

The history and development of the technology

This paper touches briefly on the early history of cane sugar from its first recorded manufacture through more than three thousand years until the seventeenth century AD. The primitive technology varied slightly from place to place, and was based on herbal and other methods of clarifying the raw juice which were handed down through the generations. It is believed to have originated in the Far East, whence it spread across Asia to Egypt and the islands of the eastern Mediterranean.

When chemistry became an exact science, the process began to be rationalized. By the early 1700s, when European nations were establishing colonies in the Western hemisphere and the East Indies, there was a uniformity of technique and a growing understanding of factors which could affect the purity of the product. It was particularly observed that juice became acid if left standing for long, and that the crystallized mass was made darker in colour by contact with heat. Lime was generally used to neutralize the acid, and the only way to offset colour formation in the open pans was by bleaching with sulphur dioxide.

Most of the product was shipped to the colonial powers, and with increasing prosperity the demand for both greater volume and better quality brought pressure to bear on the industry to become more scientific. The Napoleonic Wars intervened, but in their aftermath at the beginning of the nineteenth century, the newly independent United States of America, enlarged by the purchase of Louisiana from France, saw the

development of the vacuum pan to crystallize sugar with much less formation of colour than before.

The French, meanwhile, had turned to the alternative of beet sugar to counter the maritime blockade of their seaports. Although the technology was similar, the fuel supply was lacking. Intensive research led to the establishment by Rillieux of the principles of multiple effect evaporation, which made the beet industry economically feasible although still not competitive with cane sugar which was largely produced by slave labour.

Victory for the North in the American Civil War led to the outlawing of slavery and the cane industry had to mechanize. In the 1870s it adopted multiple effect evaporation, the centrifugal machine, and steam engines to drive conveyors and lift the juice and create the vacuum for low temperature crystallization. The shape of the modern sugar factory was thus established. Thereafter, any improvement in efficiency was simply achieved by increasing its size and throughput.

The twentieth century has seen the introduction of the diesel engine, electric power and lighting, automation, instruments for measuring and controlling the process, and even computers. But there have been no changes in the fundamental technology.

The paper concludes by suggesting that modern technology should be put to the test of devising a cane sugar factory which provides for the advantages of vacuum pan technology, but at significantly reduced rates of output and with less automated technology.

John Pearson, Independent Sugar Consultant

SECTION C: THE GLOBAL CONTEXT

The world sugar market

World sugar production and consumption are currently running at more than 100 million tonnes, but most of this is consumed in the country of origin. There are also large blocks sold under what are termed 'special arrangements', which are commercial pacts established within a general political understanding. Within these pacts, trading is for the most part at special prices. The balance of sugar which passes from one country to another constitutes the world market, and even including sugar moving in one direction as raws and then in another as refined, the total is still only of the order of 19 million tonnes.

Clearly, world market sugar constitutes only a small percentage of the total. In most years there is a surplus. Consequently, world market prices are low, sometimes falling to less than the cost of production.

Producers look at their sales as an overall package, and can accept low prices from the world market if they can be averaged with better prices received from special arrangements and domestic sales. This tends to perpetuate the existence of surpluses.

Attempts have been made to limit the availability of sugar coming on to the world market through the operation of international sugar agreements (ISAs). Generally these have not been successful. Currently only an administrative ISA operates, and it is in no position to influence the market. There are some hopes that co-operation may develop out of the current General Agreement on Tariffs and Trade (GATT) discussions.

Rodney Goodwin, C. Czarnikow Ltd.

The structure of world production and consumption

Sugar manufacturing is an ancient industry, now carried on over a wide range of physical and economic conditions in more than a hundred countries of every size and population; in some exclusively for internal consumption, in others primarily for export. Sugar can be had in various forms — liquid or solid, impure or refined, granular or in lumps — and there are different methods of making it. The bulk is obtained from sugar beet and sugar cane, the former in temperate climates and mainly in developed countries, the latter in tropical and subtropical regions predominantly belonging to the Third World. Both crops are grown on all kinds of farms, from smallholdings to large agribusinesses.

Processing technology underwent a revolution in the nineteenth century, following the advent of steam which paved the way for the progressive enlargement and centralization of factories. But even today, sugar is still made in tiny rural establishments as well as in very large industrial plants. In several countries, small sugar producers, employing both old and new techniques, constitute an important sector of the industry.

Sugar manufacturing offers a choice between small-scale and large-scale systems and within the former, between open pan and vacuum pan boiling. In addition, there are various levels of sophistication of equipment and processes available in all three options. The diversity of sugar production systems existing in practice reflects the fact that no one way of making sugar is appropriate to all circumstances. Scale economies of larger vacuum pan factories notwithstanding, proximity to the raw material supply and market or exemption from government regulations may give small open pan sugar producers a commercial advantage.

Comparisons of the two basic technologies and of different scales of operation involve a complex set of trade-offs. These arise from differences in capital and labour intensities, lumpiness of investment, time profiles of costs and returns, relative risk, fuel consumption, product yield and product quality — among other factors. Market size and consumer preferences constitute important considerations. The need for careful appraisal of the alternatives is confirmed by the failure of several large sugar projects in recent years, and the delays and cost over-runs experienced in the execution of others. There is considerable scope for the application of small-scale sugar processing techniques, particularly in areas of limited cane supply and in countries with small or fragmented internal markets.

Gerry Hagelberg, Independent Sugar Consultant

SECTION D: THE ISSUE OF SCALE ECONOMIES

Scale considerations in sugar production planning

The paper reviews evidence of detailed research on scale economies in the larger-scale vacuum pan technology-based sector of cane sugar production. It concludes that on the grounds of economizing on scarce capital, scarce foreign exchange and scarce highly skilled labour and of utilizing domestic resources as intensively as possible, as well as of production costs, the minimum economic size for this technology is probably of the order of 3,000-5,000 tonnes of cane input per day. Non-intrinsic scale factors tend to support this conclusion, particularly if low levels of capacity utilization are uniformly experienced at all scales. Other non-intrinsic factors (including, for example, cane transport costs) do not systematically favour larger- or smaller-scales.

There is also some consideration of the impact of differential price and tax structures between the larger-scale (vacuum pan — 1,250 tonnes cane input per day and over) and smaller-scale (generally open pan below 200 tonnes cane input per day) sub-sectors. Differences in operating conditions mean that in many cases (not only in India) the two sub-sector scale/technology types are able to co-exist profitably, with favourable effects on the employment and income generation and rural development objectives of economic policy.

The paper ends with the suggestion that perhaps the ultimate factor determining the degree of success of individual sugar projects (regardless of scale or of technology type) is the effectiveness of management and co-ordination in the planning, implementation and operation phases of the project cycle.

Michael Tribe, Project Planning Centre, Bradford University

New cane extraction technology for small-scale factories

This paper focuses on the application of diffuser technology to high efficiency sugar processing. Work on large-scale units is described, followed by descriptions of performance at the pilot unit installed in Tanzania by De Danske Sukkerfabrikker (DDS).

At the conference, a video of the small-scale DDS diffuser installation in Bangladesh was shown to confirm the conclusion that small plants of this type can be made to work, and made to work efficiently.

Alan James, Sugar Knowledge International Ltd.

Realizing scale economies

For the purposes of this paper, 'large-scale' has been assumed to mean a capacity of at least 1,000 tonnes of cane per day. 'Full production' has been assumed to mean operating at 90 per cent of net available time.

The key to operating a large-scale sugar factory at full production is to have an adequate supply of mature, fresh cane delivered to the factory throughout the harvesting season. The paper examines briefly the main factors which contribute to success or failure in achieving reliable cane availability, including the particular problems of cane supply build-up in a new project. Reference is made to the special circumstances of small farmers.

The factory itself must be appropriately designed, well-maintained and operated by staff who are adequately trained and motivated.

Overall, the view taken is that capacity utilization is achieved by good planning and organisation, with the greatest emphasis on growing and delivering cane.

George Moody-Stuart, Booker Agriculture International Ltd.

SECTION E: IMPROVED OPEN PAN PRODUCTION — A DECADE OF EXPERIENCE

Improvements in open pan sulphitation technology

This paper sets out to review the scope for improving the open pan sulphitation (OPS) technology for white cane sugar manufacture, as observed by ITDG through its involvement in OPS technology development in India and dissemination in Kenya.

The review defines briefly the performance of the technology itself, but necessarily starts with an overview of the prevailing circumstances in agriculture, employment, infrastructure and the investment climate which have encouraged the invention and adoption of the technology. These factors then provide the essential framework within which the improvements have to be designed and incorporated.

The paper concludes that below 200 tonnes per day cane processing there are new, improved OPS technologies—the expeller and shell furnace—with the potential to improve operating performances. This is particularly the case in terms of milling efficiency—up to 85 per cent from 75 per cent—and fuel balances, but further work to supplement current efforts is needed to raise boiling house recoveries above the 75 per cent usually obtained. Rendements therefore lie in the range 7-9 per cent for the old and improved processes respectively, depending on cane quality.

Beyond these levels of operation, there are few obvious economies of scale in open pan processing and therefore little access to lower operating costs—and improved profits—through expansion. This is an important consideration and probably confines the role of the technology to situations where cane supply is either in intermittent surplus (some parts of India), where total cane supply is limited by geographical considerations, or where cane supply is to be built up for other, larger, sugar investments.

Ian McChesney, Intermediate Technology Development Group

Economic viability of small-scale sugar production in Kenya

This paper considers the financial, social and economic viability of sugar production in Kenya. It is based upon data acquired from the West Kenya Sugar Company and estimates of production costs for a range of other types of plant. Five technological options are considered: large-scale vacuum pan (3,600 tcd), medium-scale diffuser technology (450 tcd), small-scale open pans (100 tcd) producing sugar and molasses, small-scale open pans (100 tcd) producing sugar and solid molasses, and small-scale (45 tcd) jaggery production.

Unlike the very small plants producing jaggery, none of the technologies available for sugar production can operate profitably at current prices. However, the vacuum pan (VP) plant should be able to produce sugar at a slightly lower cost than open pan sulphitation (OPS), but VP is more sensitive to sub-optimal capacity utilization. If shadow prices are utilized for both inputs and outputs (measuring these at their foreign exchange opportunity costs), the relative disadvantage of OPS over VP is narrowed. However, even when shadow prices are utilized, none of the three sugar technologies is able to operate profitably at existing prices. A consideration of social parameters probably narrows the gap between OPS and VP.

On this basis, and given the approximate nature of the costings involved, it is difficult to conclude definitively that VP is the optimal choice — especially when economic and social factors are taken into account. It is reasonably clear, however, that diffuser technology is uncompetitive in all major respects.

The paper concludes with a discussion of the policy options open to the expansion of small-scale sugar production in Kenya. It considers a range of incentives and exemptions which might act to tilt the choice of sugar technology in an appropriate direction.

Edward Mallorie, Consultant

Sugar policy in Kenya: A farmer's dilemma

The sugar industry has been established in Western Kenya to generate rural incomes, create rural employment through rural industrialization, and make Kenya self-sufficient in a major foodstuff. In this paper, we evaluate how the industry has managed to achieve these objectvies in the past and what potential exists for the future.

We observe that the location of sugar factories in the Nyanza and Western sugar belts has not been determined by ecological suitability. It evolved from the colonial agricultural policies and was later enhanced by market conditions. The national sugar policy has further enhanced the concentration of sugar cane growing in Western Kenya. Among the major problems facing the sugar industry in Kenya is the determination of a price structure that is both efficient and equitable, particularly in a situation where the government has a majority share of equity contributions in most of the sugar factories.

In terms of returns to farmers sugar cane production is not the most profitable enterprise, even though most farmers are engaged in it because of the absence of other profitable opportunities. The industry has had limited forward and backward linkages, but has generated a lot of unskilled employment. The industry is also seen as a source of food deficiency in an erstwhile food-surplus zone. We therefore conclude that the government should re-evaluate the sugar policy if the industry is to achieve its stated objectives.

David Makanda, Institute of Development Studies, Nairobi

The Kabras experience: An exploratory socio-economic impact analysis of the West Kenya sugar factory

In order to undertake a socio-economic assessment of a small-scale sugar processing technology, a comparison is made between the impacts of two sugar processing industries in the Kakamega district in Western Province, Kenya. The study involves the large-scale vacuum pan factory of Mumias Sugar Company and the small-scale open pan sulphitation factory of West Kenya Sugar Company. The comparison gives valuable information about the impacts of a small-scale sugar processing industry, but definite conclusions are not possible because of the relatively short period since the establishment of the small-scale industry.

The general conclusion for the open pan sulphitation factory has to be that its establishment has induced some developments in the area which, in the long run, could lead to an improvement of the socio-economic status of the rural households in particular and the area in general. The impacts on landless and unemployed are small, since the factory provides mainly casual labour. This labour is, for some farmer households in the area, a very essential addition to the income.

The development is, however, less connected to the factory itself than to the introduction of sugar cane as a cash crop and the subsequent commercialization of agriculture, which is a prerequisite for the emergence of a business class and, later, of an industrial class. The magnitude and the pace of the development are therefore more dependent on what happens in the agricultural sector than in the processing part of the sugar producing technology. The viability and the success of the processing side (the factory) are, however, a primary necessity. This success on the processing side depends on the continuous supply of cane, which in turn depends on the willingness of the farmers to grow cane. This willingness is jeopardized by the discrepancy between farmers' expectations and the existing situation.

A further threat lies in the fact that the way in which sugar cane is now cultivated could, in the near future, lead to diminishing yields. A third threat for cane cultivation

is a possible shortage of food crops as a result of growing sugar cane; a shortage that is not totally absorbed by an increasing buying power through the profits on cane cultivation. Therefore, attention to food crop production, which could be far more efficient, seems to be just as necessary. In spite of all these threats, the farmers will probably stay with sugar cane because they have no other alternative form of cash-yielding production.

For the farmers, this means a dependency on one crop and the threat of being thrown back into subsistence production if, for some reason, the factory decides to close down.

Lex Lemmens, Eindhoven University

West Kenya Sugar Company Ltd.

This paper describes the origins and operations of an open pan factory. The unique cane supply arrangements and the substantial labour requirements are reckoned to benefit the local community.

Difficulties with the technology and the potential for improvement are also described. Concluding recommendations on the policy measures necessary to ensure wider adoption of the technology are made.

Bhikhu Patel, West Kenya Sugar Company Ltd.

SECTION F: POLICY IMPLICATIONS

The sugar industry in developing countries: Import substitution, government policy and scale of production

This paper places the development of the sugar industry in less developed countries (LDCs) in the context of the broader process of import substituting industrialization (ISI). This process of industrialization has tended to focus on the extension of large-scale production, even where technical and social factors suggest that small-scale production would be more appropriate. The primary reason for this commitment to large-scale industrialization is to be found within the political realm, and relates to the weak representation within developing country governments of an indigenous entrepreneurial class.

In the case of sugar, heavy investment in large-scale vacuum pan plants has put a premium on government policies which facilitate high capacity utilization. In the conditions prevailing in LDCs, this requires interventions to ensure continuous access to adequate cane supplies and the development of stable and predictable markets. Thus government intervention is to be found in two main areas — price determination for cane (in the form of both direct and indirect controls) and intervention in sugar marketing.

Two case studies are used to illustrate these trends. In India, the system of government controls is utilized not only to provide access to cane and markets but also to inhibit competition from the small-scale open pan sulphitation sector. Thus the freeing of markets will assist the development of the small-scale sector. In Kenya, the absence of an indigenous entrepreneurial class has resulted in a minor role for small-scale sugar production. Government intervention here is focused on ensuring full capacity production although, with a few striking exceptions, the experience is very poor.

The conclusions are that the problems specific to the sugar industry are indicative of the wider strategy of ISI via large-scale production hitherto pursued in most LDCs.

Our analysis suggests that an alternative, and perhaps more successful, policy of ISI would have the promotion of small-scale industry as a central component.

Haleem Lone, Institute of Development Studies, University of Sussex

Policy and performance of the sugar industry in Kenya

The Kenya Government's policy in sugar aims at broad self-sufficiency in sugar production, with moderate surplus, in good years, for export. The sugar industry has performed satisfactorily towards the realization of this policy objective. Domestic production has met approximately 95 per cent of local demand for sugar during the last two years. This is after self-sufficiency was achieved temporarily in the years 1979 to 1981.

In order to achieve sustained self-sufficiency in sugar production, the government has set upon implementing a rehabilitation and expansion programme of several sugar factories as top priority. Second priority is given to establishment of new sugar projects, both large- and small-scale.

J. I. Mbuthia, Ministry of Industries, Kenya
D. P. Nyongesa, Kenya Sugar Authority

The future of small-scale sugar processing in Tanzania

The capacity of the Tanzanian sugar industry is laid out in this paper. Utilization of this capacity is limited by a number of factors and national demand for sugar remains unsatisfied.

The paper looks at ways in which domestic availability of sugar may be increased and focuses on three options, all small-scale: mini-plants, jaggery and khandsari. The advantages and drawbacks of these units are described in view of the current sugar industry experience.

W. A. Mlaki, Tanzania Investment Bank

Incentives for increased cane production: Critical policy considerations for Kenya's sugar industry

This paper summarizes a book of the same title that was presented at the conference. The book examines the self-sufficiency objective of the Kenya Government from a number of perspectives: organization, crop financing, foreign exchange, employment, etc. Failure to reach this objective is analyzed in detail.

Strong recommendations to consider the position of the farmer are made in support of the view that cane must be made more profitable if self-sufficiency is actually to be achieved.

Maurice Awiti, University of Nairobi

SECTION G: CONCLUSIONS

Small-scale cane sugar processing: The way forward

This paper reviews the various contributions made to the conference and attempts to draw a series of policy conclusions, both for governments and for non-government organizations such as ITDG.

It begins by considering the four categories identified by Jones in his opening to the conference—the technical, the financial, the economic and the social consequences of

utilizing small-scale sugar technologies. In general, it is widely recognized that a large-scale vacuum pan (VP) plant working at optimal capacity will be more technically efficient, more profitable and more economically optimal than small-scale technologies such as open pan sulphitation (OPS). Yet there are a number of circumstances — some of which are fairly predictable — which suggest that large-scale VP plants cannot always be run at optimal scales. Insofar as the social consequences of sugar production are concerned, there is no discernable negative impact arising from sugar production in Kenya and no major difference between the various scales of output.

The policy conclusions which are drawn from this analysis are as follows. First, despite the fact that sugar can be imported relatively cheaply, its continued production in Kenya is justified by the fact that there is no major alternative form of income-generating agriculture suitable for the western region of the country. Second, there is clearly a case for small-scale sugar plants in Kenya and in some other developing countries. However, the relationship between these small and large plants should not be considered as competitive but rather as a symbotic one. Third, the major obstacles to the wider diffusion of the improved OPS technology are to be found in the political realm; this has clear implications for ITDG's future strategy in this area. Finally, some further technical work remains to be done in improving OPS technology even further, especially at the 'back end' of the process.

Raphael Kaplinsky, Institute of Development Studies, University of Sussex

PART TWO

SECTION A

INTRODUCTION

1

Overview

Mel Jones

This book is about sugar. It is about the production of sugar and the various means by which sugar is produced. It is about the scale of production and the different techniques available within a given scale. It is about the markets for which sugar is produced, the quality of sugar and the location of its final destination. It is about the viability of sugar production. In particular, it is about the viability of small-scale production versus that of large-scale production. Most importantly, it is about the people, organizations and interest groups who produce sugar and share in the rewards of production. It is about the farmers and families who grow cane, the labourers who cut cane or work in the factories, and the investors, private or government, who put their money into sugar factories. Finally, it is about government policy in the sugar industry. Policy which sets cane and sugar prices effectively determines farmer and factory margins, and therefore the incentive to invest in cane and sugar production. Equally, policy which sets final consumer prices determines the effective demand for the finished product.

The specific issues to be addressed in this book, then, are several and varied, not to say complex. Throughout the book, however, runs a consistent theme: that of the examination of the desirability or otherwise of small-scale sugar processing.

Several European manufacturers are now offering small-scale versions of the vacuum pan (VP) process with capacities as low as one hundred tonnes of cane per day (though few are actually in operation). ITDG, on the other hand, has been collaborating with the West Kenya Sugar Company (WKS), in the Kakemega District of Kenya's Western Province, in the development and operation of a prototype improved open pan sulphitation (OPS) sugar processing plant. While the West Kenya Sugar Company itself has been intent on staying in business in an environment featuring government-set cane and sugar prices and competition from the large VP mills, ITDG has been pursuing different but, we trust, complementary objectives. Our main interest has been to test the technical, economic and social viability of the OPS method of sugar processing: does OPS offer benefits to farmers, labourers and investors which might not be attainable either in the case of alternative crops or of alternative sugar processing technologies?

ITDG, then, wanted to know whether farmers could earn a higher return and attain a higher standard of welfare from cultivating cane rather than other crops. We wanted to assess the performance and potential of the OPS sugar production technology in the light of the comparative performance of the VP technology. When the commercial and economic viability of sugar processing was examined, we wanted to know whether the OPS technology could be profitable, whether it could offer a better or worse return on investment than alternative investments in rural industry, and whether, for the country as a whole, investment in OPS plants would represent an efficient allocation of national economic resources. Additionally, and no less importantly, ITDG has been investigating the social viability of sugar processing to find out whether OPS sugar production offers advantages in terms of improved distribution of income and improved welfare for the less favoured sections of the community: the small farmers, under-employed labourers, women and children.

The immediate interest — as the weight of papers based on experience in that country suggests — is with Kenya. However, the publication of the proceedings of a Conference on small-scale sugar production will, we hope, be viewed with interest by a much wider audience — particularly in Africa. The contribution from Tanzania is evidence of such a broader geographical interest.

WHY SUGAR?

For a group such as ITDG, with a commitment to gaining an understanding of the ways in which (appropriate) technology may be applied to help relieve poverty, one might ask 'why get involved with

sugar?'. After all, the history of sugar is associated with first slavery and then low paid plantation labour. Sugar is not only inextricably linked to, but may be seen as being a primary cause of, poverty (see, for example, Albert and Graves, 1986; Mintz, 1986; Coote, 1987). Indeed, sugar cane is not even an essential food crop, and cash cropping in general has been heavily criticized for causing shortages of food in areas where pressure on land means that cash crops must be grown mainly at the expense of food crops. So why is ITDG interested in sugar at all?

In countries such as India, Kenya and other parts of the developing world, policies exist to promote a variety of development objectives. These might be to generate or save foreign exchange, to promote self-sufficiency in food production (and therefore enhance security of food availability), to encourage rural development through rural industrial investment and employment creation, to provide access to income earning opportunities in the countryside, and to improve the welfare of the poorest groups in the society.

Under certain conditions, the sugar industry can contribute to the attainment of these goals. More specifically, small-scale OPS sugar production in particular might have an important role to play. OPS is labour- rather than capital-intensive, and therefore has a smaller foreign exchange requirement per tonne of sugar produced than capital intensive VP skills. The absolute capital cost of a small OPS plant is low compared to that of a VP plant, and therefore brings the possibility of investment much closer to indigenous businessmen. As the sugar factory has to be central to the cane supply, it has to be established where the cane can be grown — in the fields. Paid employment generated in harvesting cane, and in its processing in the mills, creates more employment per tonne of sugar produced in small OPS factories than in the large VP mills. Wage earning opportunities are thus provided for the landless and marginal farmers. Further, given the level of support governments tend to give to cane prices, its cultivation offers returns to family labour higher than for most alternative crops. Where smallholders are relied upon for supplies of cane, it has been found in Kenya that even farmers with less than two hectares of land can share in the benefits of cane cultivation. The income earned is often spent on improvements in housing and children's schooling.

These, then, are some of the potential benefits which might flow both directly and indirectly from small-scale sugar processing.

The purpose of the conference, then, was to examine the current state of knowledge concerning the actual performance of small-scale sugar production — and OPS sugar production in particular — in achieving this potential.

The structure of this part of the book follows that of the conference. It begins with the world sugar market and an examination of the pattern of world production and consumption. The issue of potential and reliable economies of scale with vacuum pan production techniques follows. This is, in turn, followed by discussion of the technical, financial, economic and social viability of open pan production. The penultimate set of papers examines the policy environment within which sugar production takes place. Finally, a concluding paper attempts to draw together the most important issues arising from the proceedings, and to indicate policy directions for the further development and dissemination of small-scale sugar processing technology.

SUGAR CANE TECHNOLOGY

The first set of papers contains a brief description by Bush of the technologies used to produce sugar, and a short review of the history of the development of sugar technology by Pearson. Bush outlines the stages of sugar production and the technology used at each stage. In particular, he distinguishes between crushing, the 'front end' of the process, and crystallization, the 'back end'. The trade-off between sugar recovery and labour intensity is also addressed: small-scale, labour intensive plants are technically less efficient at recovering sugar from cane than are large-scale, capital intensive mills. Pearson traces the history of sugar production from the days prior to the eighteenth century, when it was regarded as a luxury spice, to the establishment of volume production, based on slave labour, in the Colonies. He identifies the key role of Norbert Rillieux in the development of the multiple effect evaporator, which was to revolutionize sugar production by making sugar boiling self-sufficient in energy. The burning of bagasse (crushed cane) subsequently became more than adequate to produce the energy to crush cane to extract juice and to crystallize the juice into white sugar.

THE GLOBAL CONTEXT FOR SUGAR PRODUCTION

In the following section, Goodwin summarizes the current situation and outlook for the world sugar market. He draws attention to the fact that the free world market is, in fact, a residual market accounting for only twenty per cent of current world production of one hundred million tonnes. In a residual market, price is particularly subject to fluctuations in supply; an instability which the international sugar agreements have failed to eliminate.

Goodwin makes the important point that with domestic consumption accounting for seventy per cent of world sugar production and special arrangements for another ten per cent, the incentive to produce sugar is determined by the total package of sales in the three markets: domestic, special arrangements and free world. As prices in the domestic and special arrangements markets tend to be higher than those in the free world market, profits can still be made from sugar production. However, a cautionary note is sounded regarding the future price of sugar. Although the price may be anticipated to rise within the next two or three years, benefits to tropical producers will only be short-term. The long-term effect of an increase in the price of sugar is likely to be a further increase in the supply of both beet sugar and alternative sweeteners such as aspartame and high fructose corn syrup.

Hagelberg builds on Pearson's earlier paper to discuss how historical developments have led to the current distribution of large and small sugar plants throughout the world. He notes the clear technical economies of scale which accrue to large vacuum plants, but explains the survival of smaller units in terms of the failure of many large mills to achieve the promised level of performance. He further sees potential for small-scale production firstly in countries with markets insufficient to support a large VP mill, and secondly in sugar importing countries with a tradition of non-centrifugal sugar production. In his conclusions, Hagelberg notes that the choice of scale and technology in sugar production is 'more often influenced by political than by technical considerations'. It is an observation pursued by several papers.

Most discussions of the world market for sugar focus on the plight of the traditional sugar exporters. For those countries the prospects do appear bleak, and contraction of their sugar industries is seemingly inevitable. On the other hand a focus on countries producing for their own domestic market, with a view to attaining self-sufficiency, may yet provide opportunities for a viable sugar industry. As is discussed in Lone's paper, production for the domestic market inevitably raises questions of 'fair' — or economically efficient — prices for cane and sugar, given low and subsidized world market prices. Should a country price its cane and sugar according to their costs of production (in which case some protection in the form of import tariffs or quotas would be necessary), or should it set prices in line with world market prices (in which case the domestic industry would have to be subsidized or allowed to wither away)? This is an essential issue to address, and one to which we will return later. For the moment, we will assume that the primary objective is domestic self-sufficiency and consider some issues relating to the technology which might be used to achieve that target.

ECONOMIES OF SCALE IN SUGAR PRODUCTION

The conventional method of processing cane is vacuum pan technology. Plants normally have minimum capacities in excess of 1,000 tonnes of cane per day (tcd) and may be as large as 20,000 tcd. Tribe's contribution examines scale considerations in sugar production planning. He is primarily concerned with VP technology, but examines a range of other issues associated with choice of technology. He also investigates the relationship between scale economies and capacity utilization, an issue which Kaplinsky considers critical in the debate on the economic viability of large-scale vacuum pan production.

Tribe begins by taking the view that choice of technology is not simply a case of selecting technologies which save capital and use labour. He argues that there are a number of complications which override a crude emphasis on these two factors of production. They include cases in which foreign exchange or technical and managerial skills are scarce or where there are hidden overhead costs in the form of worker housing and transport, where the structure of an economy permits the co-existence of different pricing regimes for different technologies, or where the product characteristics permit separate markets to be supplied. Indeed, in an unpublished paper on differential pricing and technology selection in India, Tribe (1987) describes how VP and OPS technologies co-exist within the sugar industry as a result of a pricing and taxation structure which reduces OPS costs by 30 per cent compared to VP. Lone's case study of the Indian sugar industry endorses the view that it is the freedom from government regulations which permits OPS units to flourish. Lone's conclusions, however, differ from those of Tribe in that he believes that in a market free of restrictions and interventions, OPS technology would be even more

widespread in India as government intervention provides a degree of security for the larger mills which is not available to the smaller OPS plants. Although VP remains more economically efficient as a sugar producer, the survival of the OPS technology is said, among other things, to provide a wider regional distribution of sugar production and employment (which limits distribution costs and labour migration), and to help maintain a more equitable distribution of income by protecting the jobs of low paid employees with little chance of alternative employment.

Tribe distinguishes between 'intrinsic' (ie. technically derived) and 'non-intrinsic' (ie. not technically derived) economies of scale. He finds that unit production costs for 1,250 tcd VP mills are 33 per cent higher than for 10,000 tcd VP mills; that small VP cannot compete with larger VP or small OPS. In terms of economizing on scarce capital and foreign exchange, making efficient use of scarce managerial and technical staff and making the most intensive use of domestic resources (where cane is the major domestic resource), the largest scale of production is best.

Non-intrinsic factors, such as the problem of co-ordinating large numbers of outgrowers, may limit capacity utilization. But, somewhat surprisingly, Tribe concludes that the differences between large and small VP are accentuated by sub-capacity operation, since the unit capital costs of the smaller VP mills are higher than those of their larger counterparts. Of course, it may well be that the bigger plants have larger problems of co-ordination and management and are thus more likely to operate sub-optimally. This issue is addressed in George Moody-Stuart's paper which describes considerations in achieving full-scale production from large plants. The evidence from Kenya and elsewhere in Africa is far from uniform. While one or two of the large factories achieve satisfactorily high rates of capacity utilization, most of the rest have struggled to secure sufficient supplies of cane to enable production to approach capacity. There may well be, as Lone suggests, an essential incompatibility between large-scale VP milling and smallholder cane production as part of a mixed farming system. Clearly, special and scarce skills are required to operate large VP plants efficiently. Indeed, the scarcity of managerial skills may equally militate against the establishment of a larger number of smaller VP plants.

It is possible that VP plants can operate at a scale well below that so far considered. Questions of scale of VP sugar production have so far considered the range 1,250-10,000 tcd. Yet diffuser juice extraction technology, when combined with processing, provides for a technically feasible scale of operation of 600 tcd or less. On the basis of recent experience in Bangladesh (where a 360 tcd diffuser plant was installed at a cost of over $6mill.), this type of technology does not seem cost-competitive. Further, the scale of operation is still several times the capacity of OPS plants described in McChesney's paper. The typical size of an OPS sugar factory is 100 tcd, with a maximum feasible scale of 200 tcd. Recent tests of a cane expeller to extract juice raise the prospect of reducing the minimum scale of technical viability to 40-50 tcd, approaching the scale at which many jaggeries now operate in Kenya.

In terms of technical efficiency, both large- and small-scale VP plants perform to a higher standard than OPS. VP technology can extract 10-11 per cent sugar from cane, whereas OPS achieves 7-9 per cent depending on the extent to which recent improvements in the process have been incorporated into factory design. McChesney traces the development of OPS sugar processing technology from its emergence in India in the 1950s. He records how improvements in cane crushing, juice clarification and boiling and sugar recovery — by crystallization and centrifugal separation — raised the rendement (overall recovery of sugar from cane) to 7 per cent in the 1960s. Develoments since then, originating with M. K. Garg at the Appropriate Technology Development Association (ATDA), Lucknow, are discussed and the potential for further improving OPS performance is considered.

A cane expeller to improve milling efficiency is at an advanced stage of testing. The introduction of shell furnaces has already improved boiling house performance by enabling the efficient combustion of wet bagasse. The possibility of improving the recovery of sugar by re-processing molasses to produce liquid sugars has also been considered, but little development work has been carried out. However, high boiling house recoveries have until now been less important in Kenya than in India, as there has been a ready market for solidified molasses. This may change, though, if the establishment of a number of new OPS factories results in a significant increase in the supply of solidified molasses.

No substantial economies of scale can be derived from OPS capacity in excess of 200 tcd. Expansion is therefore likely to take place by duplication and replication. Three conditions relating to cane supply indicate the possible future role of OPS sugar production. They are where cane surplus to the requirements of the VP mills may be absorbed by OPS units operating on the fringe of the VP cane zones, where land available for cane cultivation is insufficient to supply a large mill, and where a low cost approach to developing cane supplies is required with a view eventually to support a large mill.

However, as accountants, economists and politicians might be quick to note, technical efficiency alone is not the 'bottom line' when it comes to making decisions about investment or the allocation of national resources. Also to be considered are the cost of capital (especially that utilizing foreign exchange), profitability, the wider economic implications for the nation as a whole and the social impact in terms of the effects on different social groups. It is to these non-technical aspects of viability that we now turn.

THE VIABILITY OF IMPROVED OPEN PAN PRODUCTION

Mallorie assesses the economic viability of small-scale producton in Kenya by comparing the performance of five models of sugar production: large-scale VP (3,500 tcd), small or medium-scale VP (450 tcd), two versions of small-scale OPS (100 tcd producing sugar and liquid molasses, and the same scale producing sugar and solid molasses) and a jaggery (45 tcd).

Mallorie finds that if no account is taken of the possibility that VP might be more likely to operate below capacity than OPS, total unit costs for OPS are somewhat higher than for large-scale VP but are lower than for small-scale VP. As OPS production in Kenya receives a higher price by wholesaling sugar direct (whereas VP sells through the state trading company), the net result is that both large-scale VP and small-scale OPS are able to operate simultaneously. However, sugar processing margins in Kenya are narrow and have been declining over time. Since 1980, the official cane price has risen faster than the price of sugar. So truly profitable production (that is, taking account of real capital costs) is barely attainable whatever the technology employed.

When OPS produces a combination of sugar and solid molasses, OPS margins rise and come into line with large-scale VP. Interestingly, however, jaggery production is shown to be the most profitable of all, owing to its low capital cost and the fact that jaggeries only pay roughly half the official price for cane.

Using shadow prices to examine the wider economics of sugar production, Mallorie finds that OPS plants do not make substantially better use of national resources than VP plants; however, they do appear to make more efficient use of cane supplies than jaggeries. This is an interesting conclusion which is at variance with Kaplinsky's finding (Kaplinsky, 1983) that if private investors had to pay the full costs of VP, then OPS would be financially viable. Kaplinsky is here implying that the capital costs of establishing a VP plant are not fully accounted for, as the government both provides supporting infrastructure and subsidizes private investment in the industry. But Mallorie's conclusions are also partly accounted for by his assumption of full capacity operation.

There are, however, benefits of small-scale sugar production not shared by large-scale production. Both Mallorie and Kaplinsky point to the labour intensity of OPS compared to VP, and the lower investment cost per job. OPS also appears less likely to encourage monoculture, as only 10 per cent of the total land area within a 10 km radius of the factory would be required to supply 100 tcd. OPS may further stimulate the development of a local sugar engineering industry, as its lower technical complexity makes local fabrication feasible.

In addition to these economic considerations, it is also important to question whether cultivating cane and producing sugar are desirable activities in terms of the options available to the nation as a whole and to farmers in particular. It is to these wider economic and social issues that we now turn — and we find that there is considerable controversy caused by differing views of the social impact of sugar production.

SOCIAL IMPACT OF SUGAR PRODUCTION

A measure of the differences of opinion can be gleaned from the results of investigations into the profitability of cane cultivation compared with that of alternative crops. Mallorie estimates that the gross margin for cane is approximately twice that for maize. Makanda's paper, on the other hand, finds that the net return to maize and beans intercropped is greater than that for cane. Odada et al (1985), in a book which is summarized here by Awiti, find that the returns to cane cultivation in outgrower schemes associated with large VP factories vary according to deductions for transport. Thus, those closest to the factory in Zones A and B (within 10 and 15 km radii respectively) earn relatively good returns which are higher than those for maize. Farmers in the more distant C and D zones might find little advantage in planting cane rather than maize (and beans). Kennedy and Cogill (1987), in a report prepared for the International Food Policy Research Institute (IFPRI), investigate the effects of cane cultivation in South Nyanza in South West Kenya, and argue that although maize appears to offer a higher return to land, cane provides a higher return to labour which is also three times more profitable per day of household labour than the daily agricultural wage rate. They also find that incomes for sugar cane farmers are higher, generally, than for non-cane farmers. Lone provides data for many countries to suggest that few crops can compete with sugar. He also observes that in some cases, there have been shifts from the cultivation of cane to that of maize. While this may reflect higher actual returns to maize than cane, it is unlikely to be due to the official price of cane being too low. Where mills encounter cash flow problems which prevent payments to farmers for their cane, farmers may opt for the lower nominal returns, but the greater certainty, of payment associated with maize. Further, Makanda argues that the high-input

husbandry techniques of the large sugar schemes do not necessarily increase farmers' incomes, and that the low husbandry techniques associated with small-scale sugar factories may in fact provide higher net incomes to farmers. This is supported by Odada's finding that farmers on the fringe of cane collection zones may find cane to be an unprofitable crop.

Lemmens' paper on the socio-economic impact of an OPS factory in Western Kenya also relates some evidence of farmer dissatisfaction with the rewards for cane cultivation. He nevertheless still finds that the gross margin for cane is greater than that for any other crop, given the present lack of infrastructure to promote the cultivation of alternatives. From their data on South Nyanza, Kennedy and Cogill conclude that the incomes of sugar cane farmers are significantly higher than those of non-cane farmers, and that much of the incremental income received from the sale of cane is spent on housing and education.

Though the evidence is far from uniform, it is clear that cane cultivation can have a significant, positive, impact on farm incomes. Is there, then, any clearer evidence of a trade-off between cash and food crops? One might expect to find that the planting of cane occurs only at the expense of the cultivation of food crops.

Most evidence seems to suggest that cane supplants food crops and fallow land. Both Lemmens and Kennedy and Cogill agree on this. However, there is little evidence as yet to suggest that this has had a negative impact on nutritional status. Makanda, Odada et al and Lemmens all admit to having to hypothesise in the absence of hard data. Kennedy and Cogill present data which suggests that increased income from cash cropping has had some small positive impact on the calorie intake of households. Where households are headed by women, the effect is slightly greater. However, improvements in nutritional status are largely dependent on improvements in sanitation: commercial agriculture schemes linked to low cost, low technology preventive health measures can significantly improve children's health. There is thus an implication here that perhaps a large and well-managed commercial agricultural development project (which may be linked to the establishment of a large VP mill) might be more likely to bring with it the desired health and sanitation services than the establishment of small, independent OPS factories. For the future, too, as pressure increases to produce both food and cash from a finite area of land, the lower yields of cane and less efficient extraction of sugar under OPS have to be weighed against the higher cane yields and greater extractive efficiency of VP methods.

On the other hand, there are certain social benefits which are more likely to result from small-scale schemes than from large ones. The construction of new large-scale plants, with a requirement for a nucleus estate, may result in eviction of landholders, as Odada *et al* note. Thus the poor nutritional impact (and other social costs) is more likely to be identified by researching the conditions of those displaced from their land than of those cultivating cane. The average size of holding of cane farmers around WKS is smaller than that around Mumias and other large mills, which suggests that small farmers are more likely to participate in small schemes than large ones. Small-scale OPS creates employment directly and indirectly in greater proportion than large-scale VP, as the labour/output ratio for small-scale factories and outgrowers is greater both within the factory and on the land.

So once again the evidence is mixed. It might be emerging, however, that there may indeed be no significant advantage in one or the other technology. Each has advantages and disadvantages. It may even be found that the two main options for sugar processing could coexist and even complement one another. OPS would be most effective, McChesney and Hagelberg both note, where VP cannot operate — for example, in servicing small pockets of cane, in handling periodic surpluses, and in establishing cane in an area in which it has never been grown before or where the domestic market is limited and insufficient to support a large VP unit.

We should not pretend that OPS will be able to solve the problem of sugar production in Kenya or elsewhere in the Third World. The bulk of Kenya's sugar requirements will continue to be met by large VP mills. The deficit between VP production and potential consumption, however, does present an opportunity for the encouragement of rural investment, the generation of income and employment in rural areas, and the prospect of a reasonably equitable distribution of those benefits.

We are now entering the political arena, for it is the government which sets cane and sugar prices, and decides on the policies to encourage rural investment and income and employment generation. As Mallorie observes, the financial returns to sugar production in Kenya are poor. If OPS is to disseminate in Kenya via the private sector, and in so doing provide an important vehicle for rural investment and its associated benefits, then financial incentives for investors are required.

GOVERNMENT POLICY IN THE SUGAR INDUSTRY

Mallorie, Lone, Nyongesa and Mbuthia all address the issue of government policy and incentives in the sugar industry. Lone provides a review of the effect of sugar policy on the relationship between farmers

and millers. He also examines the consequences of such policies for different types and sizes of milling technology. These policies developed in the context of import substituting industrialization strategies which favoured mass production industries. However, in many of the industrialized countries there is now fairly widespread recognition that the theoretical benefits of large-scale production are often belied by the reality of low capacity utilization rates. Thus sugar is not the only sector where large plants are under scrutiny. Yet he finds that OPS sugar production is widespread in only one country (India), where it survives largely because it is allowed to operate outside the regulatory system for large VP mills.

Nyongesa and Mbuthia discuss the relationship between sugar sector policy and industry performance in Kenya in particular. Historically in Kenya, this policy has focused exclusively on VP mills and their associated estates and outgrowers. Incentive schemes have been designed only with these parties in mind. Now the emergence of OPS presents both a challenge and an opportunity to policy makers. The challenge is to re-design policy in the sugar sector to ensure that OPS is not discriminated against. To leave policy as it stands effectively discriminates against OPS, because unprofitable VP mills are subsidized by their owners — the government — either by deferring payment of excise duty or by absorbing losses. Most VP mills in Kenya at present do not make a profit — partly because many do not operate efficiently (in particular, cane supplies rarely match factory capacity), and partly because financial margins have been eroded by the narrowing of the differential between cane and sugar prices.

The net effect of government policy in the Kenya sugar industry has been, as Lone observes, to both constrain the growth of OPS units through its close regulation and yet simultaneously fail to provide consistently for the cane requirements of the VP mills. Sugar production is thus less than potential in both large- and small-scale sectors.

Any policy to increase the margins to sugar processing in general would automatically benefit OPS as well as VP factories, though this might well prove to be politically unpopular. Specific measures designed to provide incentives to small-scale sugar production in particular are identified by Mallorie. Exemptions from import duty on equipment (already enacted for rural industries importing equipment worth up to KSh 5 million) would reduce capital cost by an estimated 11 per cent. Exemption from the KSh 1,000/tonne excise duty on sugar would increase returns by the same amount and compensate OPS for the lack of government investment in the kind of supporting infrastructure provided for VP plants.

The availability of low interest credit for rural investment would reduce the cost of capital, and decontrol of cane prices would tend to reduce cane costs (but could adversely affect the supply of cane). Mallorie argues that 'although import duty exemption and cheaper capital improve returns, only the removal of excise tax will increase returns sufficiently to make OPS sugar competitive with jaggery production'.

To conclude this section on policy and to wind up this overview paper as a whole, we return to Kaplinsky's (op. cit.) observations. He notes that technical choice does not take place in a political vacuum.

The interests backing the large-scale VP technology are powerful. They generally consist of an alliance between foreign machinery suppliers, foreign investors, foreign managers, international aid agencies and those in the state anxious (for whatever reason) to establish large, modern plants. The pressures which this coalition can exert on industrial and foreign exchange licensing and on the price structure of sugar are very considerable. Merely to point out the appropriateness and profitability of OPS technology may be useless, since the private and social benefits it provides cannot be appropriated by those influencing and making policy decisions (p. 126).

So we should not expect change in policy to come easily. One thing, though, seems clear — without some change in policy there can be little future for OPS in Kenya. For without the financial incentive of anticipated profit, no private investment can be expected.

REFERENCES

Albert, B., and Graves, A. (eds.), *Crisis and Change in the International Sugar Economy*, proceedings of a conference held in Edinburgh in September 1982 (1984).
Coote, Belinda, *The Hunger Crop*, OXFAM (1987).
Kaplinsky, R., *Sugar Processing, The Development of a Third World Technology*, Intermediate Technology Publications, London (1983).
Kennedy, Eileen T., and Cogill, Bruce, *Income and Nutritional Effects of the Commercialization of Agriculture in South Western Kenya*, IFPRI (April, 1987).
Mintz, Sydney W., *Sweetness and Power*, Penguin (1986).
Odada et al, *Incentives for Increased Agricultural Production; a Case Study of Kenya's Sugar Industry*, Friedrich Ebert Foundation, Nairobi (1985).
Tribe, M. A, *Differential Pricing and Technology Selection in Indian Sugar Manufacturing*, unpublished (1987).

SECTION B

CANE SUGAR TECHNOLOGY

2

Introduction to processing techniques

Alex Bush

The process of converting sugar cane into white sugar can be conveniently divided into six stages and into a 'front end' and a 'back end', as shown below.

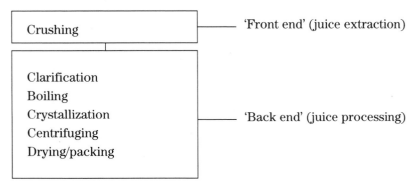

The overall recovery of the factory is the percentage of sugar in the cane that ends up in the bag. Any sugar factory will seek to maximize this figure within its operational and financial constraints. This figure is the product of two other 'recoveries' or efficiencies which correspond to the front and back ends:

| Overall recovery | = | Sucrose extraction | x | Boiling house recovery |

or:

$$\frac{Sugar\ in\ bag}{Sugar\ in\ cane} = \frac{Sugar\ in\ juice}{Sugar\ in\ cane} \times \frac{Sugar\ in\ bag}{Sugar\ in\ juice}$$

The vacuum pan (VP) factory has a greater efficiency in both front and back ends than the open pan sulphitation (OPS) plant. A very rough idea of the differences can be gained from Table 1.

Table 1: Process efficiencies

Process	Extraction efficiency	Boiling house recovery	Overall efficiency
VP (high)	0.95	0.90	0.85
VP (low)	0.90	0.85	0.77
OPS (high)	0.75	0.80	0.60
OPS (low)	0.75	0.50	0.38

The high and low figures for the VP plant correspond approximately to good and bad operating practice. The high figure for OPS refers to standard technology using crushers rather than expellers and taking three sugars; the low figure corresponds to a condition where only one crystallization is being performed (first sugar only). Under this condition it is just about possible for the plant to operate without bringing

in extra fuel for white sugar manufacture. The molasses from the centrifuges would then be re-boiled and solidified to 'solid molasses'.

An often-quoted figure is the **yield of sugar on cane**. Typically this will be about 11 per cent for a vacuum pan factory and 8-9 per cent for an OPS plant with three crystallization stages.

All of the figures quoted above are indicative and depend on the quality of the cane coming into the factory — its maturity, sugar content and fibre content. This will vary with, among other things, the cane type, the climate and the standard of agricultural practice.

Each process also imposes a different technical constraint on the overall recovery. The VP process takes advantage of many economies of scale, and much of the equipment is designed to take the full throughput of the factory (single train operation). If this equipment is not operated at a point close to its design capacity, its efficiency and hence the overall recovery of the factory will fall off. Thus **capacity utilization** is extremely important to the VP plant.

Good recoveries in the OPS plant are much less dependent upon utilizing full capacity (although profitability is obviously affected by low utilization in both processes). The back end of the process is effectively a series of interlinked trains, allowing for a much greater flexibility of operation. **Operator skill** is the variable that most affects the recovery here. Largely unsupported by instrumentation, the workers judge the progress of the operation by sight and feel. The determination of the point at which to 'strike' the juice from the boiling pans, for example, calls for fine judgement.

The higher overall recovery of the VP process can be largely ascribed to three factors:

Imbibition: Water is added to the cane during crushing and expelled in the later sets of rollers. This water carries with it some of the residual sugar in the cane.

Inversion: High temperatures and acid conditions lead to the chemical decomposition of sucrose into simpler sugars. By boiling under carefully controlled conditions, the VP process reduces inversion of sucrose.

Crystallization: In a VP plant the crystallization process is very carefully controlled. This ensures maximum yield of sucrose from the massecuite.

In addition to having a higher sugar recovery, the VP process is more energy efficient than the OPS process. The heat and power required in the VP factory is usually drawn from a central steam raising plant. Here bagasse is burnt under a boiler to produce high-pressure steam which passes to turbines to generate power and thence to the plant to perform the various heating duties. This centralization results in an efficient utilization of the energy in the bagasse.

In contrast, the OPS process draws its power from the electric grid or from on-site generators — in other words it buys in power. Heat is provided by the direct consumption of bagasse in different furnaces, each serving a particular duty. The relatively small size of these furnaces and their simple construction imply lower efficiencies.

The biggest single heat demand in the factory is for juice boiling. The use made by the VP process of the multiple-effect evaporator considerably reduces the amount of heat that needs to be supplied to the juice. Effectively, this device simply recovers the heat from the steam leaving the boiling juice and re-uses it. Thus the VP plant can support the higher boiling-duty introduced by the imbibition process.

The use of open pan furnaces with no heat recovery from the steam limits the amount of boiling that can be performed using only the bagasse generated by the crushers. Thus the OPS plant cannot support imbibition. This, coupled with the fact that the overall efficiency of the furnaces is 10-20 per cent less than that in the VP factory, means that the OPS process can just about achieve a fuel balance on first sugar only. Any further processing of the molasses must be done with supplementary fuel.

Table 2: White sugar manufacture — VP and OPS processes compared

Process stage	Crushing	Clarification	Boiling	Crystallization	Centrifuging	Drying and packing
PURPOSE	Removal of juice from cane	Removal of impurities from juice	Concentration of juice	Formation of solid sucrose	Separation of solid sucrose from molasses	Preservation of sugar for distribution
SOURCE OF SUCROSE LOSSES	Residual juice in bagasse	Residual juice in filter muds. Inversion of sugar in hot juice	Sucrose inversion in hot juice	Inhibition of crystal formation by impurities	Uncrystallized sucrose in molasses	Minor losses in dust, etc.
TECHNIQUES						
VP	Multi-roll crushers with imbibition	Liming and sulphitation or carbonation. Continuous clarifiers	Multiple effect evaporators and vacuum pans	Evaporative vacuum pan crystallizers with seeding	High speed centrifuges with steam or water washing	Continuous driers. Automatic baggers/ bulk storage
OPS	6 or 9 roll crushers **without imbibition**	Liming and sulphitation. Batch settling tanks	Open pan furnaces	**Crystallization by cooling in open tanks**	High speed centrifuges with water washing	Rotary driers or sun drying. Manual or automatic bagging
ENERGY SOURCES						
VP	Turbines or motors driven from main steam boilers	Steam heating of juice in closed vessels	Exhaust steam from power turbines or live steam from boilers	Exhaust or live steam to vacuum pans	Electricity from central steam power plant	Power from central steam plant
OPS	**Motors driven from grid or diesel generator sets**	Direct bagasse firing of open pan furnaces	Direct bagasse fired boiling furnaces	**Stirrers powered from grid or gensets**	**Electricity from grid or gensets**	**Heat from wood-fired furnaces. Power from grid or gensets**

NOTE: Sections of OPS description in bold denote technical choices dictated by the use of open pan furnaces and the rejection of a central steam plant for heat and power.

3

History and development of the technology

John Pearson

The word 'shakar' was used by the Persians in ancient times to describe a sweet spice which passed through their markets on the caravan route from East to West. Hindu literature would have us believe that it originated in north-eastern India around 1,000 BC., while others maintain that the Chinese knew of it many centuries earlier.

It was made from a cane with grass-like leaves which grew twice as tall as a man and, unlike the bamboo, could be chewed in the mouth and yielded a pleasant, sweet taste. But if it were allowed to grow for too long and become hard or to lie uneaten after being cut, it would soon lose much of its flavour and turn black.

Most societies had acquired the art of cooking food over a fire to preserve it, and the Chinese used boiling water to infuse the aromas of herbs such as tea. So it is likely that one day they would have boiled some of the cane juice, perhaps by accident, and discovered an interesting residue in the pot. It would have tasted good and been fairly stable. It could be carried conveniently over long distances and if pieces were dropped into warm water, the flavour and sweetness of the original cane juice could be recaptured — days, weeks or even months later.

People in colder places who had never seen sugar cane came to know this rare spice as a delicacy, not unlike honey but purer in taste and much easier to carry about. It was a bit sticky, but if wrapped in a cloth and kept dry it would come to no harm at all. This was worth money — perhaps gold — to the traders along the way, and so a demand was created and a manufacturing industry was born.

The cane would thrive only in certain climatic conditions. We know now that it needed two thousand or so hours of sunshine in a year, that it would not survive frost and that it had to have quite a lot of rain. But the pioneers did not have to worry about such things. Their first concern was to achieve a consistent product. It was made in batches, and sometimes it would turn out black and evil-smelling while at others it would be a reasonably light brown. Then just occasionally, one batch might appear almost golden and very attractive indeed. Possibly someone found out that one of the workers who cleared away ashes from the fireplace had let some drop in the tray of fresh juice standing ready to be boiled the next day. The addition of a little wood ash to slightly warm juice — allowing it to stand for some hours — had a clarifying effect. This became one of the many techniques of purification that were to make sugar-boiling into an art. As time went by, those who knew kept this knowledge as secrets and passed them guardedly.

The product found favour in regions far away to the west and, as more was sought by the merchants, cane was transplanted and multiplied. Each new attempt to boil sugar in a different place would be met with fresh difficulties in controlling the appearance of the final material. Various treatments would be tried out on the juice before the best one was found. Among the substances used were plant extracts, animals' blood and sour milk. But two operations remained essentially unchanged — the crushing of the cane and the boiling in a wide metal pan over an open fire.

For more than two thousand years these procedures continued in South Asia. We next hear of cane being grown in small quantities in Cyprus and Egypt. The crushing mill still consisted of two wooden rollers on vertical shafts, one being rotated by an ox or a camel walking round in a circle. A boy would feed sticks of cane in between the rollers and pull away the crushed pieces while the juice drained along an earthenware channel into a collecting jar. The rejected cane would be laid aside in the sun to dry. Outside the circular path would be one or two more jars of juice undergoing purification by settlement and the pan boiler seated beside the hearth on which rested the pan itself. This could be anything up to six feet wide, round, shallow and beaten out of thin iron with two handles on opposite sides. The panworker would use a long-handled ladle to stir the juice in the pan while the fire was stoked and blown to keep it on the boil. Exactly the same technology is still in use today in the hundreds of country crushers where jaggery is made in Colombia, India, Pakistan, Bangladesh and Sri Lanka.

From the Eastern Mediterranean in the thirteenth century AD., raw sugar was being shipped to Venice where it was refined. Attempts were also being made to grow cane in Madeira and Southern Spain. However, sugar was still rare and expensive, and it was not until the great ocean voyagers of the maritime nations of Europe opened up trade routes to other continents that many of their poorer compatriots even heard of it. Among the first of these venturers were the Portugese, founding settlements in Brazil, and the French and the Spanish, both setting up outposts on the island of Santo Domingo. The Dutch headed eastward round the Cape to Java, and the French progressed on to Louisiana on the mainland of America. In all of these areas it is noted that one of the earliest developments was to introduce sugar cane if it was not to be found growing already and to send a supply of this, quite rare, commodity back home.

As wealth and prosperity grew among the commercial entrepreneurs on both sides of the oceans so did the demand for sugar. Crushers could be built in less time than it took to propagate the cane, but finding the expertise to operate them was becoming more difficult. The traditionally secret arts of the sugar boilers had to be rationalized so that more people could be trained to boil a good sugar. Even though it was a sellers' market, the better the appearance of the product the higher the price it would fetch. Among many who sought to make their fortunes, the more astute could foresee that a certain quality standard would sooner or later become crucial to their continuing in business.

Fortunately for them, the preceeding century had seen the foundation of the science of inorganic chemistry. The concept of acid and alkaline solutions and what could be expected to take place in certain conditions when known substances were brought together in water had been tried and tested and the results published. This could provide the key to controlling the process of purification and securing good and consistent product appearance. Experiments were carried out in Louisiana, Brazil, Egypt and Java and a remarkable consensus of results must have been found because a new technique emerged which was to supersede, almost universally, the traditional methods of juice purification. It involved the burning of sulphur and passing the fumes through the juice while adding lime in a sufficient quantity to counteract the resulting acidity. This caused a large proportion of the mineral impurities to precipitate and to sink to the bottom of the tank.

Different names were given to the vessels in which the settlement took place: some were known as. subsiders, some as clarifiers; but the process was technically described as 'sulphitation'. The complete sequence of operations for the production of sugar in this way is now called the open pan sulphitation (OPS) technology.

A new group of people began to emerge towards the end of the eighteenth century as this rationalization of the industry was taking place, and they were to render this method obsolete in the space of three generations. Their first major innovation was to define the two distinct operations which go on in a factory where sugar is made from cane. One operation, they decided, was devoted to removing from the cane as much as possible of the sucrose it contains at the moment when it reaches the factory gate. The other was to ensure that the maximum amount of juice was transformed into sugar of the right quality for sale. The engineers generally exerted more influence on the former while the chemists gave most of their attention to the latter, so they invented a simple and practically 'unfiddleable' device called the juice scale to make sure that the other side did not cheat. By common definition, the name 'extraction' was given to the process of removing sucrose from the cane while the rest came to be called 'boiling house recovery'. The product of the two is the 'overall recovery' of the factory.

The industrial revolution, which was well under way in Europe, provided the engineers with the means to improve immediately the extraction capability of the crusher. Iron rollers were substituted for wood and much greater pressure was exerted on the cane. Wind-power, water-wheels and the newly-patented steam engine were all tried in order to put more power into the shafts which by this time had been set horizontally instead of vertically. The steam engine rapidly showed the most promise. If the bagasse was laid out to dry before being burned, it produced more heat and there was enough of it to make steam for the mill engine as well as heating the crystallizing pans. Then a great improvement in extraction was found when three rollers were used instead of two and the top one applied two successive pressures to the cane before releasing it.

But political events on both sides of the Atlantic between 1795 and 1815 caused a temporary slowing down of physical progress, though not of creative ideas. Europe was in a state of war. Britain, the fastest-developing industrial nation, was setting out to become the engineering workshop of the world, to export manufactured goods and in return to import commodities like cotton, tobacco and sugar. France on the other hand had an agricultural economy and imported sugar, not only for its own needs but to earn a large revenue from refining it and re-exporting it to other countries. The sale of Louisiana to the United States of America in 1803, and the British naval blockade, led the Emperor Napoleon to direct the best of his 'polytechniciens' to research into the production of sugar from home-grown beet. This decision was to have interesting repercussions on the cane industry fifty years later.

British and American technologists and, no doubt, the Dutch in Java were meanwhile trying to improve the quality of the plantation sugar which was being criticized because of its colour. No matter how clear the liquor was when it entered the crystallizing pan, the product still turned brown. The combination of high temperature at the base of the pan and the length of time during which the boiling liquor was in contact with it was clearly the cause, even if the reaction was not understood. E. C. Howard invented the vacuum pan in 1812 in an effort to solve two problems at once, and it was an immediate success. At no time was the juice in contact with surfaces much above one hundred degrees centigrade, the body was deeper and promoted much more rapid circulation away from the heating element, and evaporation actually took place at temperatures well below a hundred degrees on the surface. It underwent many improvements in detail, but the principle was established and formed the basis of vacuum pan (VP) technology.

Between 1820 and 1850 more important advances were made at the front and back ends of the factory. Owners were beginning to exploit the economies of scale, and a three-roller mill had proved so effective in improving the extraction that a second unit was tried in tandem with it. The result was even better. Up to three mills are known to have been used at this time but it is doubtful whether the last one did much more than squeeze the bagasse a fraction drier.

At the output end of the plant much attention was being given to the removal of mother-syrup from the vacuum-boiled crystals. If they could be separated and dried they had a pure sparkle which was very attractive. In those days it was usual to empty the pan into large barrels, or hogsheads, in which the staves were not tight and the syrup could drain out through the gaps between them before it became quite cold. When no more would appear the hoops were driven home and the barrel was ready for delivery; but there would always be a quantity of brown, slightly syrupy sugar at the bottom.

The refining industry, which was growing quite large in European and American Atlantic coast seaports, could charge a high premium for speciality sugars and they were experimenting with loaf sugar. This was made by pouring the massecuite into inverted cone-shaped moulds, and when it had set they would pour some of the original clear liquor over the cones to wash away the coating of yellow syrup from the crystals. It was far too costly a process to be applicable to the thousands of tons of unrefined sugar that were being produced for shipment as general cargo across the sea. Ideally it should be sufficiently dry and free-flowing to allow it to be packed in jute or cotton sacks and handled like any other commodity in bulk. Some kind of spin-drier was needed.

A gentleman named Weston is credited with finally producing a centrifugal machine that would work on sugar without wrecking itself. In 1867 the vertically suspended machine, driven by a variable-speed belt or hydraulic motor, had arrived, and it was possible to turn out all but the most inferior grades of sugar in granular form. Coincidentally, however, a serious obstacle had arisen as the factories were suffering a chronic shortage of fuel. In the cane-growing regions, there were no deposits of coal. Oil was yet to be exploited and bagasse was no longer able to meet all a factory's energy needs.

The mills had brought this situation upon themselves in two ways. Firstly by exploiting economies of size, and then simply by becoming too efficient. As it was difficult to recruit experienced people like mill engineers and chemists to run all the new factories, instead of building them to crush ten tons per hour the machinery was made larger so that it could handle twenty, or even more, tons of cane. The only difference was in the size of each piece of equipment. However, it was no longer possible to feed the mill directly by hand and an extended cane carrier was needed to give the labour force enough space to work in. The same thing applied to bagasse handling and the removal of juice from the mill to the boiling house; in fact steam-driven appliances were being added to the plant for another reason as well — to replace labour which was no longer an insignificant cost since slavery had become unlawful. Even though the engines provided the exhaust steam for evaporation of the juice, they absorbed energy from it and the total demand was exceeding the amount of heat that could be obtained from the bagasse.

Improvements in efficiency had also contributed to the dilemma, since more juice was now being extracted from each ton of cane put through the crusher. It is well known that about seventy per cent of the weight of fresh-cut cane is water. With the nine-roller mills which were coming into use, nearly sixty tons of water were being squeezed out in the juice from one hundred tons of cane, the remainder being held in the bagasse. Unless the fibre content of the cane was at least fifteen per cent, there would not be sufficient heat energy to run the factory. It was often less.

Fortunately the solution had been found some twenty years earlier but ignored by the industry at the time. As already mentioned, France had faced severe economic problems after many years of war and the loss of Louisiana in 1803 and had been successful in setting up a beet sugar industry. The major technical problem had been to find an efficient system for evaporating juice, because a beet factory has no energy source of its own. Among the team who eventually solved it, and indeed the man who is acknowledged to have worked out the principles involved, was Norbert Rillieux from New Orleans who was working in Paris at the time. By 1843 he and his colleagues had devised and tested a multiple-effect evaporator which could boil off three, four, or even five times as much water with the same amount of

fuel as a single boiling pan, and these evaporators were already working in several beet factories in France. He went back to Louisiana to demonstrate his principles. But in the 1840s the cane sugar industry was in no need of them, so he returned to Paris where he pursued an interesting and, apparently, successful career.

He was more than sixty years old when the fuel crisis on the cane plantations caused someone to remember his name. He came back once again to the land where his grandfather had been a soldier under General Lafayette. This time they listened to what he had to say. Of all the characters — and there are many — associated with the development of sugar technology, Rillieux's contribution is quite unique. He helped to make possible the manufacture of sugar from beet, which accounts for half the world's present output, and produced the last great innovation upon which the other half of our supplies depends. The process flowsheet of a cane factory built in the closing years of the nineteenth century is applicable to the vast majority of those in operation today. Indeed if an experienced factory manager in the year 1887 and the mill engineer and chief chemist could be reincarnated in 1987, they would probably be able to manage a new plant within a couple of days of seeing it for the first time.

So what have we gained in the last hundred years? The answer, of course, is too long a list to catalogue in full. It begins with the electric light and electrical power, which were only just coming into use in Rillieux's day. The internal combustion engine and the steam turbine followed and revolutionized transport on land and at sea. The telephone, the aeroplane and wireless communication spread rapidly after World War I and automation, instrumentation, and solid state electronics after World War II. Now we have data processing and programmable computers which will be able, in the foreseeable future, to operate a factory with only limited human assistance. All these devices are now essential for the control of quality and for the maintenance of the levels of efficiency that are required in a highly competitive world. They all require special skills to look after them, but in effect they add nothing to the technology with which this book is concerned. We are at liberty to use them or discard them as we wish.

So what are the prospects for the future of sugar processing? Is it inevitable that the industry will be increasingly dominated by larger and larger plants? Indications are that with sufficient energy available to support mechanization the scale at which cane sugar production takes place continues to grow. As smaller mills become obsolete they tend to be replaced by larger, centralized units. New projects are seldom now planned for an eventual capacity of less than forty thousand tons of sugar per crushing season, ie. three thousand tons of cane per day. Yet this need not be a trend which replicates itself in all circumstances. In certain areas, particularly on the African Continent, opportunities may exist for a diversity of scales of production. Some communities, although possessing the climate and soils in which to grow cane, may not be able to finance the considerable investment cost of large plants. In other areas the market for sugar may be restricted by the small size, remoteness and poverty of a community. Or the amount of land capable of growing good quality cane may be insufficient to support large-scale sugar production. Under all these circumstances VP technology is not an option. Choice would be restricted to either importing the sugar or producing it on a small scale. Opportunities may, then, still exist for OPS technology.

Such situations, however, are likely to change over time. Where lack of finance or limited market size are the initial constraints, a rise in the general affluence of a country may increase both the market size and the availability of finance and thus pave the way for investment in larger scale VP technology at a later date.

To conclude, if cane sugar technologists are seeking a new challenge, they might apply themselves to the concept of a factory that will start up as an OPS operation, crushing between one and two hundred tons of cane per day, yet be capable of expanding as and when required.

It may take five years, it may take ten, but at some time a transition is likely to be needed from OPS to VP technology. This process will be accelerated if labour costs rise as the prosperity of the area grows. The technological progression of the last three hundred years could be re-enacted during the planned life of such a project. Indeed, the advantage of hindsight is clear knowledge of the stages through which technology development can pass. This gives rise to the prospect of a hybrid OPS/VP factory as a possible bridge between the extremes of the process of sugar technology development.

At any given point in time, then, it is entirely conceivable that small OPS units should exist and co-exist in an industry dominated by large VP plants. Some units may grow into VP operations where conditions permit and management is capable of seizing the opportunity. Others may simply continue to fill a niche in the industry, with expansion occuring via a multiplication in the number of units rather than by concentration in larger-scale plants.

SECTION C

THE GLOBAL CONTEXT

4

The world sugar market

Rodney Goodwin

The relative scale of free trade in sugar compared with overall annual production has an important bearing on the basic character of the market and its price patterns. First of all, therefore, it is necessary to provide an indication of the size of the world market for sugar.

Nowadays, world sugar production and consumption are both a little in excess of 100 million tonnes. Some countries, a very few, do not produce sugar, while others do not produce enough for their needs. These countries have to import to fill their requirements; in recent years, world net imports of sugar have amounted to about 23 million tonnes. In addition, some countries both import and export sugar, and this helps to expand the tonnage traded, bringing the total up to about 27 million tonnes.

Now of this overall total, a significant proportion moves under special arrangements. The tonnages and prices are fixed in advance, which removes any question of the interplay of market forces. Therefore such transactions cannot be considered part of the world market. Into this category come shipments from Cuba to members of the socialist bloc in Europe and Asia, and from members of the African, Caribbean and Pacific (ACP) group to the European Community (EEC). Together these deliveries amount to about 6.8 million tonnes each year, while the USA imports another million tonnes within its quota arrangements and at prices which are normally well in excess of the world market.

If this is taken from our total of 27 million tonnes, we are left with a real world market, with prices reacting to the law of supply and demand, of about 19 million tonnes. The proportion of total sugar requirements represented by the world market is thus less than 20 per cent.

In almost all cases, the domestic and special arrangements markets pay higher prices than the world market. They are therefore the markets which are of most interest to producers. Consequently, in times of shortage, it is the world market that goes short. On the other hand, when there are surpluses their full weight is felt on the world market.

Representing so small a percentage of total production, but also having to reflect the full weight of world surplus or shortage, the world market price is greatly affected by the supply situation; in times of surplus the price becomes depressed with sugar often selling for long periods below the cost of production, while in times of shortage it can soar as buyers compete for supplies, so that sometimes it reaches many times the cost of production.

Being effectively a residual market, the world free market has shown a tendency to be cyclical. At a time of shortage, when prices reach high levels, the pattern is for consumption to be checked and investment to be funnelled into production. Within a short period of time this investment leads to an upward leap in production, and for a few years production on a global basis exceeds consumption each year and a surplus is established which hangs over the market. This is carried forward from year to year and depresses prices. Eventually these price pressures lead to production being held in check. Meanwhile consumption continues to grow, if for no other reason than because of the increase in the world's population of some 1.7 per cent per year. Eventually the surplus is eroded and the cycle commences once more. The problem for the exporting countries, however, is that the period of shortage and high prices normally lasts for one or two years while the period in between runs for seven or eight years. The reason for this is quite simple, of course. You can carry a surplus forward from year to year, but a shortage which causes reduced consumption cannot be carried forward.

It might be thought that one way of avoiding this surplus and shortage cycle would be by having some sort of international arrangement which permits only enough sugar to come onto the market to meet requirements. In fact there have been many attempts over more than a century to control the flow of sugar through international sugar agreements, but none of these have been really successful.

The problem so far as the most recent agreements are concerned is that to encourage them to join, it has up to now been found necessary to offer individual exporters quotas or export entitlements which collectively are greater than the market can absorb. Obviously this tends to defeat the object of the

agreement. In addition, however, there is also an unfortunate tendency for some countries not to abide by their obligations and this also undermines the agreement.

The example of the 1977 new International Sugar Agreement illustrates this clearly. This agreement was negotiated to come into operation from the beginning of the following year. Its primary aim was to achieve a relatively stable world market with prices within a specified range. In fact it was only within that range for relatively few days and above it for a few weeks. For the balance of the seven years' life of the agreement it was below the range. To put it bluntly, the agreement, like so many of its predecessors, was a failure.

Not only did the agreement have the usual fault of a mechanism which led to inflated export quotas, but in addition the EEC, which has in recent years become a major exporter, was not a member and did not see why its exports should be constrained by agreement considerations. However, another very important reason for the failure of the agreement was that Thailand, which was a member, regularly exported far more than its quota entitlement.

Of course there is always the chance that at some date in the future it might be possible to negotiate an agreement which would be so watertight that the supply of sugar could be made to match requirements much more closely than has been the case in the past. The history of agreements to date, however, has not been such as to encourage me to be enthusiastic about this, though I will return to this possibility in the conclusions.

At the moment we have only an administrative agreement. That is to say it collects statistics and provides a forum for delegates to meet, but it has no economic provisions and therefore cannot exert any influence on the sugar market.

Even this agreement almost broke down in 1987 over the question of finance. Although the cost of the International Sugar Organization with its staff, facilities and opportunities for meetings is less than £1 million a year (which spread over all its 56 members is hardly an enormous sum of money by international standards), some members, most importantly the USSR and the USA, objected to the amounts they had to pay. It was only after extensive negotiations and concessions from other members that they could be enticed to continue with their membership. However, the Agreement has finally been negotiated and was due to receive formal acceptance by delegates on 10 September 1987, though governmental ratification will be spread over the following few months.

If world market prices remain low in most years and if the chance of international co-operation appears forlorn, why do farmers continue to grow and producers continue to make sugar?

The answer, I believe, is in the overall package of sales. As I mentioned earlier, most producers dispose of sugar in three different markets. It is customary for the return from the domestic and special arrangements markets to be high enough to compensate for the low prices received from the world market, and producers and farmers tend to look at their return from sugar sales as an overall package. Their fixed costs are mostly covered by sales to the domestic market and special arrangements outlets, so they can afford to accept a low return, closer to their marginal costs, from the sugar sold to world market outlets. It is only when the return from the world market gets so low or their percentage of sales to the world market grows so large that the overall package is insufficient for them to recover their costs that they will normally consider reducing production. Even then there is a tendency among producers to hold off in the hope that another country will reduce its output first. Currently some producers are in fact now cutting back so as to limit the tonnage they have to sell on the world market, but others are still going ahead with expansion projects.

It is helpful here to expand the discussion of the special arrangements, first of all because they are an important part of the overall market, and secondly because of the effect they have on the world market itself. To understand them, with all their benefits and disabilities, it is necessary to delve briefly into their history.

For much of its history, sugar has been a commodity with a high political profile, and there are now several important instances where close political ties between countries have been translated into special trading arrangements for sugar. While intended to cement these political affiliations, such arrangements usually aim to give a long term assurance of outlet at a stable and usually enhanced price to the suppliers, as a counterpart to ensuring a continuity of supply for the recipients.

Cuba's experience is a useful starting point. Before the revolution in 1959, Cuba used to have a special arrangement under which it supplied about 2.7 million short tons to the USA. Shortly after the revolution this was taken away. Left with a surplus of sugar, Cuba had to find a new outlet and did so in the socialist countries. The first transactions were made for political reasons and originally the socialist group bought sugar they did not want. Consequently they themselves had to re-export the sugar surplus they had acquired. However, with the passage of years, they have trimmed their own production and increased the size of the market which could be offered to Cuba. Currently Cuba has contracts to supply nearly 7 million tonnes annually to her socialist partners under bilateral trading arrangements, although in fact

she is never able to provide all of this. The fact is that Cuba likes to hold back some sugar for sale to the free market in order to obtain hard currency.

The EEC's experience is also interesting. The Common Agricultural Policy nowadays receives a lot of criticism, but it was inaugurated by policy-makers who had experience of food shortages during and immediately after the last war. They decided that, where possible, Europe should become self-supporting in food. A guarantee of self-sufficiency by its nature implies a surplus, but what was not, indeed what could not, be taken into consideration was the massive increase in efficiency in farm and factory which would take place (given guaranteed incomes) and which has resulted in surpluses which have to be sold outside the Community.

When the United Kingdom joined the Community, the existing members claimed, as they had a right to under the Treaty of Rome, that the portion of the UK market not filled by domestic UK production should be filled by beet sugar produced by other Community members. But the UK had an arrangement, the Commonwealth Sugar Agreement, under which it imported raw sugar from Commonwealth countries for refining and consumption in this country. Consequently a compromise had to be worked out. It was agreed that with the exception of Australia, the Commonwealth Agreement countries, together with a few other developing countries which were added to the list (which became known as the ACP countries), could continue to supply just over 1.3 million tonnes of sugar in terms of white equivalent to the European Community at a price which shows them a very good return. As almost all these countries supply raw sugar, the actual quantity they may deliver works out at rather more than 1.4 million tonnes a year.

As stated above, a compromise was worked out. It was accepted that the EEC member countries also had a right to this market which was being filled by sugar from overseas. Consequently, out of their total exports for which they receive only the world market price, financial restitutions are received which restore to the producer the full internal guaranteed price for a quantity equal to the amount imported from the ACP countries. There are production quotas for producers in the EEC countries which far exceed domestic needs. For all other sugar produced within quotas and exported, a financial restitution is granted to bridge the gap between the prices on the internal and external markets, but this has later to be repaid in the form of a financial levy on production. Meanwhile any sugar produced in the Community in excess of quota has to be exported and the producer gets only the world price without any form of assistance for it.

The other high price market is in the USA. What has happened to that market is a sad example of how the economies of poor countries can be damaged by fiscal policies of rich countries.

As we have seen, Cuban sugar shipments were transferred from the US to the socialist group of countries in the late 1950s and early 1960s. The counterpart to this switch was the opening of the US market to a large number of smaller-scale suppliers. While many of these beneficiaries were in Central and South America, there were others in Asia and the Pacific, so that the suppliers to the US became much more numerous and fragmented. There then followed a decade or so of import growth — ten years ago the USA imported more than 5 million tonnes of sugar. But this year it is doubtful whether it will take more than one million tonnes. What has happened is that domestic producers have been effectively granted price guarantees which are so high as to encourage them to expand their production. This, of course, leaves less room for imported sugar. Even worse, the high price has provided an umbrella beneath which an alternative sweetener, known as isosyrups in this country and high fructose corn syrup (HFCS) in the USA, has been allowed to develop and expand until it is estimated that this year its market share, in terms of raw sugar equivalent, will not be much short of 5 million tonnes. All of this has come off US sugar consumption, and the loss of outlet has been largely felt by those exporters which ship to the USA. Not only have they lost an outlet for their sugar, but it was a highly remunerative one into the bargain. It is possible that alternative outlets will eventually be found, but they are unlikely to offer such an attractive price as could formerly be secured in the USA.

Isosyrups have not been able to make much headway in the EEC as they have been incorporated into the sugar regime and given small production quotas in each member country. On the other hand, the high internal prices for sugar in the Community have allowed glucose consumption to expand.

So far the discussion has been confined to caloric sweeteners. But there are also artificial products which are very sweet and have no calories. To digress, it seems ironic that at a time when so many people in the world are starving, people in the developed areas are searching for ways to cut down on their calorie intake. However, that is what is happening and this is another factor that is damaging the sugar market. New non-caloric sweeteners are being developed, and it can be expected that the upward trend in their consumption will continue.

For all these reasons, there is little cause to be enthusiastic about the state of the world sugar market. However, there are two aspects to be considered: the short and the long term situations.

The last time prices rose to very high levels was in 1980. If the cyclical factor holds good, another price rise should be seen soon. According to the latest statistics (see Appendix I), the worst of the world

surplus for this cycle is now over and we are witnessing a gradual fall in world sugar stocks. How long it will be before the surplus is sufficiently eroded for a substantial price rise to occur will depend partly on commercial and governmental decisions, but most of all on climatic conditions which can easily change total production of sugar by a few million tonnes one way or the other. However, at some stage during the next two or three years, probably sooner rather than later, there is likely to be a sharp price rise.

The response we have usually witnessed in the past has been some reduction in consumption. At the time of the last price rise, we also noted an encouragement to the producers of alternative sweeteners. What many fear is going to happen next time round is that there will be a much greater shift to the production and consumption of other sweeteners. We have already seen what has happened in recent years in areas of high consumption where sugar prices have been kept high. In the USA there has been a massive increase in the use of isosyrups, glucose usage has continued to grow and the non-caloric sweeteners have secured a large market both as pills and as additives in pre-prepared foods such as diet drinks. Here in the European Community isosyrups have been held at bay by using political measures, but other sweeteners have increased their hold and this has also been the pattern in other countries where the sugar price is high. The technology is now available for many new sweeteners to expand their production rapidly as soon as the next sugar price boom gets under way and encourages them to seek out new markets.

A price boom would therefore bring very short-term benefits to sugar producers. But what should they do about all this if they want to keep a viable and growing long-term market? Two possibilities arise.

We have briefly reviewed the history of past international sugar agreements and the problems currently being faced. Nevertheless, despite all the problems of the past, the exporting countries could re-examine the situation in the light of the present outlook to see whether it would be possible to establish some sort of working arrangement. This would restrict the quantity of sugar coming onto the market at times of surplus and low prices, while at the same time setting aside stocks which could be used to restrain prices if a tight supply situation should develop. Recent developments at the United Nations Conference for Trade and Development, where it appears the Common Fund after all these years of apparently fruitless talk might eventually come into operation, suggest that governments might be prepared to fund some sort of buffer stock arrangement. However, if it is to become an effective mechanism, it will be fundamentally important that producers do not come to regard a buffer stock as just another outlet to be filled. If they were to do that, they would soon find themselves with a surplus in the market, and a buffer stock in the background with little hope that it could ever be drawn upon.

The other approach seems to be even more important. The exporters should endeavour to expand their regular and guaranteed outlets for sugar, either through long term contracts or, better still, through agreements such as Cuba has with her socialist partners (although they have reduced their sugar outputs) or the ACP countries have with the EEC. At their worst these give access to markets, and at their best they also give a guaranteed and highly remunerative price.

My brief has been to discuss the world market, and this I have endeavoured to do. But I started by indicating that sugar is mostly produced for consumption at home and I should like to end on that topic. It has long been argued that the technical search for ever whiter sugar is wasteful of time and resources. It is interesting in this context to examine a recent development in the UK market.

In this country we used to eat and enjoy raw sugar from the West Indies. Gradually this went out of fashion and in its place the refiners, having made white sugar, added back molasses and sold the resultant product at a premium.

Now we find Mauritius is stepping into this market. For a long time their raw sugar has been of a very high quality; now they have taken to selling a very high quality raw sugar (which is effectively a plantation white sugar) in our supermarkets. They receive for this unrefined product a premium over the price of refined sugar. Consumers like it and it shows obvious benefits to the producer. One therefore has to ask the question: if high quality raws sell easily in the market place of a developed country, why should a developing country waste its resources producing a highly refined product for domestic consumption? For the canning and other similar industries, a very high quality product is needed but, in developing countries aiming to become self-supporting, the accent, for everyday table-top use, should be on increasing output rather than on increasing quality.

5

The structure of world production and consumption

Gerry Hagelberg

Sugar has been made for fifteen hundred years and perhaps for much longer. The earliest unequivocal evidence of sugar in solid form dates from Persia about 500 AD., but sugar manufacturing probably originated in India where sugar cane is thought to have been in cultivation by 400 BC.

Ordinary white sugar is almost pure sucrose, an organic chemical of the carbohydrate family which also includes glucose (commonly called grape or corn sugar), fructose (fruit sugar), lactose (milk sugar) and maltose (malt sugar). Sucrose is the only chemical substance consumed in practically pure form as a staple food. A product of photosynthesis, sucrose is found in the sap of all green plants. Commercially the main sources of sucrose are sugar cane and sugar beet, but it is also won from the maple tree, certain species of palms and sweet sorghum.

Although we speak of sugar factories, what actually happens there is not a manufacturing process in the sense of a transformation such as takes place in a shoe factory, but rather a series of liquid-solid separations to isolate the sucrose made by nature in the plant. To produce free-running granulated sugar from sugar cane, juice is extracted from the stalks, in most cases by crushing and pressing, leaving a fibrous residue known as bagasse; impurities are then removed from the juice; water is boiled off to reduce the juice to a syrup in which the dissolved sucrose crystallizes and the sugar crystals are separated from the surrounding syrup by centrifuging, leaving uncrystallizable sugar and remaining impurities in the final molasses — a by-product mainly used for livestock feed or fermentation into alcohol. Depending on the degree of purification, the main product is a white or off-white sugar, or a raw sugar that is usually reprocessed in a separate refinery before reaching the consumer. Other end products can be obtained by varying the procedures at a particular stage or stopping the process short of the last step of centrifugation.

PATTERNS OF WORLD SUGAR PRODUCTION AND CONSUMPTION

Globally, about 15.7 million hectares of sugar cane and 8.7 million hectares of sugar beet—together roughly equivalent to the total area of the United Kingdom—were harvested in 1985 (Food and Agriculture Organization, 1981-), the greater part for the production of sugar and in some countries also for the manufacture of alcohol. Whereas sugar beet needs a temperate climate and is mainly grown in developed countries, over 90 per cent of sugar cane, a crop of tropical and subtropical regions, belongs to the Third World and it is this sector on which we shall focus in this paper. Table 1 lists the major producers. The 13 countries named accounted for close to 80 per cent of world sugar cane production in 1985. The rest came from 84 other countries and territories, all but 6 in the Third World.

The physical characteristics of sugar cane partially determine how it is grown and processed. A perennial giant grass belonging to the same botanical tribe as sorghum, sugar cane is produced from cuttings; never from seed except in breeding stations. Depending on cropping system and location, the length of the growing period ranges from less than ten months to over two years. The sucrose content rises as the plant reaches maturity and then gradually declines. Once harvested, however, sugar cane deteriorates rapidly and, unlike sugar beet, cannot be stored for more than a few days without serious loss of sugar; thus the harvesting and processing seasons have to be concurrent. After the cane is cut to the ground at harvest time, new stalks called ratoons spring from the stubble so that several crops can be obtained from the same planting.

Sugar cane is a bulky raw material of relatively low unit value. Roughly three-quarters of the weight of clean mature stalks is water; the rest is composed of fibre and soluble solids. About four-fifths of the solids dissolved in the juice is sucrose which is accompanied by small amounts of glucose and fructose,

Table 1: Major sugar cane producers in the Third World, 1985[a]

Country	Area harvested ('000 hectares)	Production ('000 tonnes)	Yield (tonnes/hectare)
Brazil	3,852	245,904	63.8
India	2,900	173,569	59.8
Cuba	1,400	73,000	52.1
Pakistan	904	32,140	35.6
China	838	58,665	70.0
Thailand	551	25,690	46.6
Mexico	550	37,800	68.7
Philippines	469	16,000	34.1
Indonesia	295	24,901	84.4
Colombia	290	25,000	86.2
Argentina	200	11,000	55.0
Dominican Republic	185	10,200	55.1
Bangladesh	163	6,880	42.2
Other developing	2,163	126,678	58.6
Total developing	14,760	867,427	58.8
Total developed	908	73,484	81.0
Total world	15,667	940,911	60.1

a. Some of the figures are marked as estimates in the source. Figures may not add up to totals due to rounding.

Source: Food and Agriculture Organization, 1981- .

soluble polysaccharides, minerals, organic acids and colourants. Sugar cane is unique among crops in the extent to which it furnishes its own processing energy. By rule of thumb one tonne of wet bagasse, the residue from juice extraction, is equivalent to a barrel of fuel oil. Under normal conditions, modern raw cane sugar factories employing vacuum boiling methods are self-sufficient in energy and even produce a surplus. Steam and electricity produced from excess bagasse are often fed to attached refineries and distilleries, and some cane sugar factories deliver power to irrigation systems or to the public grid. Bagasse fibre has further uses as chicken litter and as the base for board, paper and chemical industries.

Sugar cane has been seen as the plantation crop par excellence. But the production organizations growing and processing sugar cane vary greatly in both size and type. Even in such a classical plantation region as the Caribbean, small farmers accounted for a considerable part of the total crop in recent years (Hagelberg, 1974, p. 6). A world-wide survey of the cane sugar industry would lead to a typology of enterprises and organizational patterns such as the one shown in Tables 2 and 3.

Until the nineteenth century, all sugar was made in small establishments by boiling the juice in open kettles and separating the crystallized sugar from the syrup by simple drainage. The average Cuban sugar mill of the early 1800s, for instance, could only produce about 135 tonnes of sugar in a 150-day crop (Moreno Fraginals, 1964, p. 83). The introduction of the steam engine and the invention of the vacuum pan, the multiple-effect evaporator, the filter press and the centrifugal machine—to mention only some of the major innovations—revolutionized sugar technology and paved the way for the progressive enlargement and centralization of factories from the latter part of the last century. Even today, however, a substantial portion of the world's sugar is still made in small plants employing both ancient and modern techniques.

Partly as a result of these technical developments, it has become a convention of international sugar statistics to distinguish between centrifugal and non-centrifugal sugar. But there are differences in how these terms are applied, an important one concerning the treatment of khandsari — a type of sugar produced in small factories, mainly in India. Following the definition of sugar in successive international sugar agreements, the statistics of the International Sugar Organization (ISO) ought to encompass under the heading of centrifugal sugar any of the recognized commercial forms of sugar derived from sugar cane or sugar beet, including edible and fancy molasses, syrups and any other form of liquid sugar used for human consumption. Excluded are final molasses, 'low-grade types of non-centrifugal sugar produced by primitive methods', and sugar destined for uses other than human consumption as food (and therefore also high-test molasses from which no sucrose has been extracted but which is not used for human food

Table 2: Types of enterprise in cane sugar production as classified by Blume, 1985

1. Agricultural enterprises growing but not processing sugar cane (planters)
 - (a) Large planters (more than 100 ha)
 - (b) Medium planters (20-99 ha)
 - (c) Small planters (10-19 ha)
 - (d) Peasants (2-9 ha)
 - (e) Smallholders (less than 2 ha)

2. Agro-industrial enterprises growing and processing sugar cane (miller-planters)
 - (a) Private (individual or corporate)
 - (b) Co-operative
 - (c) State-controlled
 - (d) State-owned

3. Industrial enterprises processing but not growing sugar cane (central sugar mills)
 - (a) Private (individual or corporate)
 - (b) Co-operative
 - (c) State-controlled
 - (d) State-owned

Table 3: Organizational forms of national cane sugar industry according to Blume, 1985

Organizational form[a]	Examples
1. Monostructural systems	
(a) Miller-planters	Ethiopia, Ivory Coast, Malawi, Sudan, Swaziland, Zambia
(b) Planters linked to central sugar mills	China, Fiji, India, Indonesia, Mexico, Philippines, Thailand
2. Polystructural systems	
(a) Predominance of miller-planters	Dominican Republic, Mauritius, Tanzania, Trinidad
(b) Predominance of planters	Colombia, Jamaica, Taiwan

a. In monostructural systems, miller-planters own or operate more than 85 per cent of the total cane area or independent planters supply more than 85 per cent of the cane processed; in polystructural systems, the shares of the respective categories are 51-85 per cent.

consumption). At variance with this definition, however, ISO statistics do not cover Indian khandsari, although it is relatively high-grade and centrifuged.

Unlike the ISO, the Food and Agriculture Organization (FAO) of the United Nations collects and publishes production figures for non-centrifugal as well as centrifugal sugar but includes khandsari in the former category, although this is defined as any sugar produced from sugar cane which has not undergone centrifugation. Only the US Department of Agriculture (USDA), among the leading compilers of international sugar statistics, correctly identifies khandsari as a 'native-type, semi-white centrifugal sugar' and treats it as part of Indian centrifugal sugar production. Khandsari is made in small plants, and while the total volume can only be estimated it is clear that a considerable amount of sugar is involved in this terminological confusion: India produced 1.0-1.2 million tonnes of khandsari annually in the mid-1970s and is currently producing at the rate of 530,000 tonnes according to USDA figures (Hagelberg, 1978; US Department of Agriculture, 1980-).

Without khandsari, developing countries produced some 57 per cent of the world's centrifugal sugar, both beet and cane, in 1986 and consumed 53 per cent (Table 4). Globally, production and consumption of centrifugal sugar have roughly doubled since 1960 from 52.3 million tonnes and 49.2 million tonnes respectively. This overall growth has been accompanied by a major structural change: in 1960, developing countries produced about 52 per cent of the world's centrifugal sugar but consumed only around one third. The balance will continue to shift toward the developing countries, which in 1990 are expected to account for close to 63 per cent of world centrifugal sugar production and for 57-58 per cent of world consumption (Food and Agriculture Organization, 1985). These projections take into account the

expected growth in the production and consumption of alternative sweeteners, principally high fructose corn syrup and aspartame.

Sugar consumption has increased faster than the population. In the developing countries as a group, annual centrifugal sugar consumption now averages about 14 kilogrammes per head against 8 kilogrammes in 1960. But there are wide differences between regions: overall in Central and South America per capita consumption exceeds 40 kilogrammes, while in Africa it is of the order of 15 kilogrammes and in Asia even less.

In a number of developing countries, particularly in Asia and Central and South America, actual sugar consumption is much greater than these figures indicate because of the continued availability of various kinds of non-centrifugal sugar. These are sugars made in thousands of small rural establishments from cane and to a lesser extent from palm species. They are consumed mostly within the areas where they are produced and are known under their indigenous names as gur, jaggery, panela, piloncillo, chancaca, papelon, rapadura, muscovado or panocha.

In the manufacture of such sugars from cane, the juice is extracted by small crushers operated manually or by animal or mechanical power. No water is added to increase extraction (ie. there is no imbibition as practised in factories with vacuum evaporation). The juice thus obtained is partially purified by the addition of chemical or vegetable clarificants and manual skimming. Evaporation takes place under atmospheric pressure in open pans heated directly by a bagasse or wood fire. When concentrated to about 95 per cent dry matter, the mixture of syrup and fine crystals is finished by manual stirring and moulding or rubbing. The final product in lump or powder form is dark to light brown in colour and can be defined as a practically dehydrated raw cane juice. Because of poorer extraction and prolonged

Table 4: Centrifugal sugar production and consumption of developing countries, 1986 ('000 tonnes, raw value)[a]

Country	Production	Consumption
Brazil	7,999	6,589
India[b]	7.594	8,694
Cuba	7,467	762
China[c]	5,670	6,700
Mexico	4,068	3,451
Thailand	2,718	744
Indonesia	2,150	2,123
Philippines	1,514	1,180
Turkey[d]	1,414	1,483
Colombia	1,272	1,101
Pakistan[e]	1,151	1,750
Argentina	1,100	950
Egypt[f]	950	1,650
Dominican Republic	895	294
Mauritius	748	40
Guatemala	651	300
Venezuela	650	1,300
Iran[g]	600	1,300
All developing countries[h]	57,471	53,652
World[i]	100,222	100,854

a. Developing countries comprise Africa, except South Africa; Central and South America; Asia, except Israel and Japan; Oceania, except Australia and New Zealand. Time reference is the calendar year. As far as possible, all sugars are expressed in terms of raw sugar testing 96 sugar degrees by the polariscope, which for practical purposes can be taken to mean a sucrose content of 96 per cent on a dry-weight basis.
b. Excluding khandsari.
c. Production: beet sugar, 970,000 tonnes; cane sugar, 4,700,000 tonnes, not including Taiwan province.
d. Beet sugar producer.
e. Production: beet sugar, 22,000 tonnes; cane sugar, 1,129,000 tonnes.
f. Production: beet sugar, 100,000 tonnes; cane sugar, 850,000 tonnes.
g. Production: beet sugar, 400,000 tonnes; cane sugar, 200,000 tonnes.
h. Production: beet sugar, 3,850,000 tonnes; cane sugar, 53,621,000 tonnes.
i. Production: beet sugar, 37,498,000 tonnes; cane sugar, 62,724,000 tonnes.

Source: International Sugar Organization, 1986.

processing at high temperatures, technical efficiency is far lower than in vacuum pan factories. However, the yield on cane is of a similar order because with little or no separation of molasses the product has a relatively high moisture content and retains many impurities.

Similar methods were traditionally employed on the Indian sub-continent to produce a fine-grained, yellowish-brown crystal sugar of better quality known as khandsari. Within the last thirty years, with the general adoption by the khandsari industry of centrifugals and of lime sulphitation for juice purification, top-grade khandsari approaches the standards of colour, size and dryness of crystal of direct-consumption white sugars made in vacuum pan factories, although generally it is not quite up to that quality.

Table 5: Non-centrifugal sugar production estimates
('000 tonnes, product weight)[a]

Country	Food & Agriculture Organization			US Department of Agriculture		
	Average 1969-71	Average 1979-81	1985	Average 1971-75	Average 1976-80	1986
India[b]	7,395	8,107	9,660	6,295	6,320	8,000
Pakistan	1,423	1,766	1,400	1,313	1,449	1,300
Thailand	210	733	950	312	614	
Colombia	457	925	850	672	818	900
Bangladesh	526	427	496			700
China[c]	208	351	443	790	863	
Indonesia	207	301	243	191	210	
Brazil	217	200	200	271	200	
Burma	145	139	141	140	139	
Haiti	68	80	84			
Mexico	155	68	73	105	61	
Ecuador	40	53	60	40	46	
Africa	49	77	85			
Other C. America	130	106	112	117	111	
Other S. America	36	29	29	42	54	
Other Asia	85	58	65	84	83	
World	11,350	13,419	14,889	10,372	10,968	

a. The time reference of FAO data is the year in which the entire harvest or the bulk of it took place. USDA data relate to crop years which ended in the year shown. Figures may not add up to totals due to rounding.
b. FAO figures include khandsari; USDA figures do not.
c. Including Taiwan province.

Sources: Food and Agriculture Organization, 1981- ; US Department of Agriculture, 1980- .

Table 5 summarizes the available information on the volume of open pan sugar production in recent years. Only FAO now publishes virtually comprehensive world-wide estimates for this sector, data of the USDA Foreign Agricultural Service being limited latterly to selected major producers. Even for earlier years the two sources are not directly comparable, not only because of the different handling of Indian khandsari but also because of differences in time references and geographical coverage. In any case, the figures should only be taken as approximations. Observers also differ on how non-centrifugal sugars compare with centrifugal sugar in terms of their use value (Hagelberg, 1978).

Nevertheless, three things are evident. First, at the global level production of open pan sugars is still tending to increase, albeit at a slower pace than centrifugal sugar, so that its share of the total world sugar supply is declining. Second, open pan sugar production and trade continue to be important economic activities in particular regions. Third, whether deemed to have the same utility weight-for-weight as centrifugal sugar or not, open pan sugars remain an important item of the diet of very many people and in some countries are the principal home-grown sweetener. Notably for Bangladesh, Burma, Colombia, Haiti, India and Pakistan, per capita consumption figures of centrifugal sugar alone are highly misleading.

There are several reasons for the persistence of small-scale open pan sugar production. Even more than large-scale sugar manufacturing, it is a rural industry, often located in the remoter and more inaccessible regions. Whereas in India large mills and small crushers operate in close proximity, in

Colombia panela production is widely dispersed, and particularly associated with coffee growing, while the big factories are concentrated in the Cauca river valley (Junguito, 1976). The main outlets for open pan sugar also lie in the rural regions, although commercialization may involve, as it does in India, large urban wholesale markets and a considerable volume of interstate trade. Local small-scale sugar production thus makes for greater equality of distribution between town and country. Even where centrifugal sugar is available at competitive prices consumers may prefer good quality gur or panela for certain purposes because of its flavour, just as there is considerable use of various types of yellow and brown sugars in Great Britain.

Small open pan sugar processors frequently also enjoy commercial advantages over the bigger vacuum pan factories. Closeness to the raw material supply on the one hand, and to the market for the product on the other, may mean lower transport costs. Smallness and large numbers afford protection against direct government regulation, and open pan establishments tend to be partially or wholly exempt from price controls on cane and sugar, excise duties and taxes.

Not to be overlooked, finally, as a factor in the survival of small-scale village sugar manufacturing is that, though far from the mainstream of Western-style technological development, it has advanced technically. The last hundred years have seen stone and wooden crushers being supplanted by iron mills, motor driven horizontal mills gradually replacing bullock powered vertical rollers, the adoption of larger multi-pan furnaces, the introduction of centrifugals and the advent of a radically different type of plant for the production of khandsari (Ghani, 1979; Kaplinsky, 1984).

CONCENTRATIONS OF SMALL-SCALE SYSTEMS

The list of major non-centrifugal sugar producers (Table 5) by itself offers a clue to where concentrations of small-scale production systems are located. However, small-scale sugar making is not confined to open pan operations.

The consolidation of processing facilities into fewer and larger units has been a continuous trend in the world sugar industry — both beet and cane — since the last century, and the notion of what constitutes small-scale has shifted over time. Yet this has not made for greater uniformity, and plant size continues to vary widely from one country to another and even in the same country. Less than forty years ago — relatively recently in the time-scale of such an old industry as sugar manufacturing — there were still many vacuum pan factories with a daily grinding capacity of under 1,000 tonnes of cane. Around 1950, when the 2 largest cane mills in Cuba were already handling over 10,000 tonnes of cane per day, 6 Cuban factories did not reach 1,000 tonnes. Elsewhere, 104 of the 144 vacuum pan factories in India, half of the 28 in Mauritius, and 8 out of 54 in Louisiana ground less than 1,000 tonnes of cane per day, and of these 32 had a capacity of under 500 tonnes. Measured by annual sugar production capacity, there were similar disparities: in 1951, 5 Cuban factories had capacities of less than 10,000 tonnes of sugar per crop while the largest could already produce over 200,000 tonnes (Timoshenko and Swerling, 1957, pp. 68-69).

Table 6 shows the geographical distribution of 100 small cane sugar factories still active in what may be called the 'formal' sector of the world industry, ie. factories individually listed in international directories or reported in the technical press. Virtually all are believed to be equipped with vacuum pans and to produce centrifugal sugar. Table 6 does not include Indian open pan sulphitation khandsari units; it is not known how many of the 1,200 plants said to have existed in the first half of the 1970s (Krause and Hagelberg, 1978) are operating at present. Nor does the table include the Chinese industry. Apart from about 2,000 motor-driven mills producing non-centrifugal sugar, China was reported in 1983 to have 148 factories for the production of centrifugal cane sugar in the range of 500-1,000 tonnes of cane per day and 169 with capacities of less than 500 tonnes, only 42 out of a total of 359 cane sugar factories being able to handle more than 1,000 tonnes of cane per day (Blume, 1983). On the other hand, Table 6 includes factories in Japan and Spain — two developed countries — to demonstrate that small-scale processing is not exclusively a Third World phenomenon.

Looking at the size distribution of sugar factories thirty years ago, Timoshenko and Swerling (1957, p. 67) thought that the relative scarcity of capital in India and the exceptionally short harvest season in Louisiana appeared to be important factors contributing to small mill size in those areas, and that regions with a long history of cane production also tended to carry over a legacy of small-scale processing enterprises. However, not all small factories are relics of a former era. Piecing together information from technical publications on the establishments enumerated in Table 6, it is possible to identify some of recent vintage. All the Japanese factories were built after 1950. The Dougabougou factory in Mali commenced operations in 1966. The Rwanda plant was built with Chinese assistance in the 1970s. The Sierra Leone mill started production in 1981. Two factories with grinding capacities of 350 tonnes of

cane per day, built by the Dutch firm Stork-Werkspoor in Burma, started in 1984. A new 300-tonne-day plant erected by the Danish company De Danske Sukkerfabrikker (DDS) in place of an old factory at Deshbandhu, Bangladesh, began operations in 1986/87. And scheduled to open at the end of 1987 is the first sugar factory in the Central African Republic with an initial capacity of 600 tonnes of cane per day.

Table 6: Cane sugar factories in the 'formal sector' with capacities of less than 1,000 tonnes of cane per day, excluding China

Country	Number of factories	Range of capacities
Angola	1	700
Argentina	1	700
Bangladesh	1	300
Burma	4	50-600
Colombia	1	400
Costa Rica	12	300-800
Dominican Republic	1	500
Ecuador	3	150-900
Grenada	1	500
Guatemala	3	50-450
Guinea	1	400
India	35	500-982
Indonesia	1	900
Japan	13	360-950
Mali	1	400
Mexico	4	600-950
Nepal	1	500
Nicaragua	1	600
Pakistan	1	550
Paraguay	4	200-800
Peru	2	300-450
Philippines	1	478
Rwanda	1	150
Sierra Leone	1	400
Spain	3	300-600
Thailand	2	800-850
25 countries	100	50-982

Sources: Lichts, 1981; Lichts, 1986, 113, p.427; International Sugar Organization, 1982, p.31; *Zuckerindustrie*, 1984, 109, p.862; *Zuckerindustrie*, 1987, 112, p.173.

TRADE-OFFS IN SMALL-SCALE PROCESSING

Although it is generally cheaper to enlarge an existing sugar factory than to build a new one from the ground up, shortages of capital and particularly of foreign exchange might explain the survival of a few fully-depreciated small vacuum pan installations, given the longevity of most sugar mill equipment and the high cost of modern apparatus. But in view of the economies of scale in sugar manufacturing, it is puzzling on the face of it that small plants should still be built. Much of the equipment used in sugar processing consists of vessels rather than complex, intricately constructed machinery. Other things being equal, their cost tends to increase in proportion to the surface area of the materials used, whereas capacity rises in proportion to volume. For many years now sugar technologists have been guided by the engineering rule of thumb that the cost of machinery varied as the cube root of the square of its capacity, or, alternatively, that the capital cost of a large factory compared to a smaller one varied as the square roots of the respective capacities. Greater size also brings savings in labour costs since the number of workers required does not increase in proportion to capacity.

It has been found in India and elsewhere that small open pan plants tend to have significantly lower capital costs per unit of output than larger vacuum pan factories. This indicates that capital economies of scale do not extend continuously across technologies in the sugar industry. But small sugar factories, open or vacuum pan, do employ more labour per unit of output than larger ones. Altogether, vacuum pan technology offers greater scope for scale economies than open pan technology. Moreover, in the

47

present state of the art the latter appears to be practically limited to plants of up to 200 tonnes of cane per day, although there may be a few bigger installations.

Comparisons of the two technologies and of different scales of operation have to deal with a complex set of trade-offs. In addition, the weights of the various factors involved are very much determined by local conditions, so that a balance struck for one place is unlikely to be wholly valid for another. Conclusions derived from exercises in number-crunching in this field are not only subject to the usual caveats concerning the reliability and representativeness of the data used and the underlying assumptions, but are also bound to a particular combination of circumstances.

As we have seen, the basic choices in sugar processing are between small-scale and large-scale systems, and, within the former, between open pan and vacuum pan boiling (leaving aside the graduations of sophistication in the conduct of operations existing in both technologies). The major trade-offs arise out of differences in the intensities of capital and labour, lumpiness of investment, time profiles of costs and returns, relative risk, fuel consumption, product yield and product quality. Among the factors to be considered — apart from the obvious ones of the cost and relative abundance of capital, land and labour — are cane quality, length of harvesting season and capacity utilization within that period, transport costs, skill and management requirements, maintenance needs and capabilities, and linkages with local construction and equipment building and repair capacities. Market size and consumer preferences may constitute overriding constraints.

Inherent in the mode of operation of open pan plants — dry extraction (ie. no imbibition), prolonged boiling under high temperatures and the need, in the absence of a steam plant, to supply energy separately for the extraction and processing of the juice — are a far higher fuel consumption and a lower sugar recovery compared with vacuum pan factories. The gap is narrowed, but not nearly closed, by the substitution of screw presses for conventional mills and improvements in furnace design (Kaplinsky, 1984).

Because of its lower sugar recovery, open pan khandsari manufacturing in particular has often been charged with wasting cane. But it can be argued with equal force that for all their superior recovery, larger vacuum pan factories working at less than capacity because of lack of cane represent a waste of capital. The point was forcefully stated thirty years ago by the eminent sugar technologist Emile C. Freeland, who surveyed the sugar industry of Pakistan for the National Planning Board under a contract sponsored by the US International Co-operation Administration. Only when established in proven cane growing areas or where there were prospects of a large cane supply being developed in a short time, Freeland emphasized, was the establishment of a large factory more economical than the manufacture of sugar on a small scale. In areas where the development of sufficient supplies would take a number of years, it was better to install small factories with very much lower investment costs and overheads (Government of Pakistan, 1958, pp. 36-37).

Along with the cases of punctual completion of construction programmes and fulfilment of output targets, enough large sugar projects have turned out costly failures in recent years to induce a greater awareness of the possible pitfalls.

President Felix Houphouet-Boigny of the Cote d'Ivoire has described the huge investment in sugar factories made by that country in the 1970s, with a view to becoming a net exporter, as a fundamental error which included acceptance of too early repayment terms of foreign credits, overcharging by the contractors, planning mistakes, shortages of spare parts and the appointment of unsuitable managers. The 6 mill-plantation complexes built in the 1970s (4 further projects originally planned having been shelved) were to have produced 240,000 tonnes of sugar by 1984/85, but peaked at 187,000 tonnes in 1982/83 and 2 have since been converted to paddy rice and seed production. More foreign loans were recently negotiated to finance the restructuring of Sodesucre, the state sugar company, after the Cote d'Ivoire again became a net importer.

The 2 sugar factories in Ghana which started producing in the second half of the 1960s and were to have to have attained their full projected output of 36,000-39,000 tonnes in the third year of operation, but at best reached only about half of the original goal, finally collapsed altogether, victims of a shortage of foreign exchange to buy spare parts, and no production at all is reported since 1983. The numerous inquiries and consultancy reports occasioned by the problems of the 2 factories made the failure of the Ghana sugar industry to perform according to expectations a matter of some notoriety, and it became the subject of a case study of what can go wrong, and why, in a project to establish an agricultural processing industry (van der Wel, 1973).

The COT Girek sugar mill in Aceh, North Sumatra, which opened in 1970 with a capacity of 2,000 tonnes of cane per day, closed in 1986 because it could not obtain enough cane to operate efficiently, and the site is to be used for palm oil production.

Short of such outright waste of resources, there are the projects which far exceeded their planned gestation period.

The sole sugar factory in Benin — a mill-plantation complex worth over US $100 million designed to produce 47,000 tonnes of sugar per year from 5,200 hectares of cane, jointly owned by Benin, Nigeria and Lonrho — was originally expected to come on stream at the end of 1981, the turn key construction contract having been signed in 1977 and financing arrangements made in 1980. According to International Sugar Organization estimates, the first 3,000 tonnes of sugar were produced in 1984 followed by 5,000 tonnes in each of the next two years.

Plans for the establishment of the first sugar complex in Burundi were announced in 1981. Subsequent reports spoke of a project costing some US $70mill., comprising 1,925 hectares of irrigated cane, a factory to grind 1,000 tonnes of cane per day and produce 16,000 tonnes of sugar per year and a settlement for 4,000-5,000 persons. A West German company was eventually contracted to build the plant which is scheduled to be completed at the end of 1987.

Efforts to reduce Nigeria's dependence on sugar imports by large schemes conceived in the 1970s have had disappointing results. The Numan project operated by the Savannah Sugar Company, in particular, has been dogged by problems, a major one being delays in the completion of the Kiri dam on the Gongola river. Late in starting up, the factory came on stream toward the end of 1979 and was to have built up to 120,000 tonnes of sugar by 1983/84. As it happened, the company, struggling against the competition of cheap imports on the local market, entered the 1986/87 season with a target of 25,000 tonnes and the aim of gradually increasing production to 65,000 tonnes in 1989/90. The total sugar production of Nigeria is estimated by the International Sugar Organization to have amounted to 45,000 tonnes in 1986.

In Somalia, the Juba sugar project, a US $200 million development financed by Arab aid agencies which started operations in 1980, was expected to reach its 1984 target of 70,000 tonnes in 1986, despite delays in land development due to hold-ups in external financing and a shortage of spare parts for cane transport due to the scarcity of foreign exchange. However, total Somalian production fell to 30,000 tonnes in 1986, the lowest level since 1979 according to ISO figures.

SMALL FACTORIES FOR SMALL MARKETS

Most of the projects to expand sugar production launched by developing countries in recent years were motivated by the desire to save scarce foreign exchange, promote rural development, create employment and increase the level of self-sufficiency in a staple food. Only a few countries not previously net exporters of sugar, like the Cote d'Ivoire, aimed to achieve a surplus to sell abroad; and even here import substitution and regional development were strong additional considerations.

The volatility of the free world market as well as the difficulty of gaining access to remunerative preferential outlets having been amply demonstrated, the temptation to create new export sugar industries is far smaller today than it was in the 1970s. Programmes to expand production, particularly by late-comers to the sugar scene, must be geared primarily to meeting domestic requirements. Yet sugar cane may be the arable crop most suitable for certain environments, and as an agro-industry sugar manufacturing recommends itself for rural development.

This poses a dilemma for countries with internal markets that are either small in their entirety or fragmented because the population is scattered and transport expensive. It is in such situations — apart from cases of limited cane supply — that small factories clearly have a role. The following 26 countries consumed less than 150,000 tonnes of centrifugal sugar and were net importers in 1986; all grow sugar cane already to some extent and therefore can be assumed to possess areas with the necessary ecological conditions for sugar production:

Angola	Benin	Burkina Faso
Burundi	Cape Verde Islands	Central African Republic
Chad	Cote d'Ivoire	Ghana
Guinea	Haiti	Kampuchea
Laos	Liberia	Mali
Mozambique	Niger	Papua New Guinea
Senegal	Sierra Leone	Somalia
Suriname	Tanzania	Togo
Uganda	Zaire	

Implicit in the current size of the domestic markets of these countries are only modest annual increments in consumption requirements, in line with population growth and economic development. They are too small to absorb, except gradually, the output of an additional large factory running at full capacity, even where increased availabilities uncover a latent demand. Some of the countries named could become

self-sufficient in sugar and perhaps also, for a time, satisfy future consumption growth by better utilizing or expanding existing large installations. But the list indicates the considerable scope for the application of small-scale sugar processing techniques. In addition, there are net importer countries with an annual consumption of over 150,000 tonnes of centrifugal sugar which have a tradition of small-scale non-centrifugal sugar production. Bangladesh, Ecuador, Indonesia, Kenya, Malaysia, Nigeria, Pakistan, Sri Lanka and Vietnam are examples of this category. Beyond this, there is the need to improve the equipment of the great number of small sugar manufacturers in exporter countries such as Colombia and Thailand; and in India, exporter in some years, importer in others.

The specific nature of the technological requirements obviously depends on local conditions. Open pan khandsari and non-centrifugal sugar units demand the least capital per tonne of sugar as well as per workplace. But their inferior recovery rate and product quality and high fuel consumption may make them unacceptable. Vacuum pan factories do not have these drawbacks, but the scaled down versions of conventional plants available from Western equipment manufacturers are expensive unless at least partially financed by grants from aid agencies. Third World suppliers may offer cheaper models, but buyers will also want to compare credit facilities, warranties and servicing. One thing is certain: the present and potential volume of small-scale sugar manufacturing in the world justifies more intensive high quality research and development in both its technical and commercial aspects than it has had thus far.

Like many development issues and investment decisions, the choice of scale and technology of sugar processing is often more influenced by political than by technical considerations. Small-scale sugar manufacturing is inherently a private sector activity. But even an open pan sulphitation plant capable of producing only 10 tonnes of sugar per day may fall between two stools: too big in capital and complicated in management requirements for small farmers, too risky and unattractive for urban entrepreneurs. Positive action may be needed to elicit the desirable private sector involvement in the expansion of sugar production, particularly where it is not already a major industry. Even where sugar manufacturing is long established, the role of tax concessions and financial incentives as a factor supporting the viability of small-scale systems (though perhaps no greater than the sometimes less apparent favours extended to large-scale systems) illustrates the extent to which technological choices hinge on the fiscal and monetary environment.

In the end, whether or not the most appropriate system is selected depends on the willingness of governments, aid agencies, investment banks and other institutions to think either small- or large-scale.

REFERENCES

Blume, Helmut, *Die Rohrzuckerwirtschaft der Volksrepublik China, Zuckerindustrie,* 108, pp.1059-1064 (1983).

Blume, Helmut, *Geography of Sugar Cane,* Dr. Albert Bartens (publisher), West Berlin (1985).

Food and Agriculture Organization, *Production Yearbook,* FAO, Rome (1981-).

Food and Agriculture Organization, *Sugar: Major Trade and Stabilization Issues in the Eighties,* in *Economic and Social Development Paper 50,* FAO, Rome (1985).

Ghani, A. R., *Gur and Indigenous Sugar Industry of South Asia: An Annotated Bibliography,* Gujrat and Islamabad, Shahtaj Sugar Mills Ltd. and Appropriate Technology Development Organization (1979). Government of Pakistan, National Planning Board Report: *Sugar Industry of Pakistan,* Manager of Publications, Karachi (1958).

Hagelberg, G. B., *The Caribbean Sugar Industries: Constraints and Opportunities,* Antilles Research Program, Yale University, New Haven (1974).

Hagelberg, G. B., *The Statistical Treatment of Artisan Sugars, Zuckerindustrie,* 103, pp.140-43 (1978).

International Sugar Organization, *The World Sugar Economy: Structure and Policies,* in Vol. 1: *National Sugar Economies and Policies, Central America/South America,* ISO, London (1982).

International Sugar Organization, *Sugar Yearbook,* ISO, London (1986).

Junguito, R., et al, *Las Industrias Azucarera y Panelera en Colombia,* Fundacion para la Educacion Superior y el Desarrollo, Bogota (1976).

Kaplinsky, Raphael, *Sugar Processing: The Development of a Third-World Technology,* Intermediate Technology Publications, London (1984).

Krause, Elmar W., and G. B. Hagelberg, *A New Technology for Small-Scale Sugar Processing,* in *Zuckerindustrie,* 103, pp.757-761 (1978).

Lichts, F. O., *International Sugar Report,* 113, p.427 (1981).

Lichts, F. O., *International Sugar Economic Yearbook and Directory,* Ratzeburg (1986).

Moreno Fraginals, Manuel, *El Ingenio: El Complejo Economico Social Cubano del Azucar, Tomo I: 1760-1860,* Comision Nacional Cubana de la UNESCO, La Habana (1964).

Timoshenko, Vladimir P., and Boris C. Swerling, *The World's Sugar: Progress and Policy,* Stanford University Press, Stanford (1957).

US Department of Agriculture, *Sugar, Sugar, Molasses and Honey, and World Sugar and Molasses Situation and Outlook,* Foreign Agricultural Service Circular Series (1980-).

van der Wel, P. P., *The Development of the Ghana Sugar Industry 1960-70: An Exercise in Ex-Post Evaluation,* Institute of Social Studies, Occasional Paper No. 26, The Hague (1973).

SECTION D

THE ISSUE OF SCALE ECONOMIES

6

Scale considerations in sugar production planning[1]

Michael Tribe

Traditional economic theory tends to view scale selection, in the context of minimizing unit costs of production, in a world where there is essentially no uncertainty and where there is full capacity utilization. Some of the crucial constraints and shortages that exist throughout the Third World, and in African countries in particular, restrict the relevance of the traditional approach.

This paper will start with a discussion of a range of issues that are associated with the choice of technology, linking the discussion to the issue of scale. It will then consider scale selection within particular technology types, including the distinction between intrinsic and non-intrinsic scale economies (Tribe and Alpine, 1987, p. 216). Of particular interest is the link between scale economies and capacity utilization. The paper will close with discussions of recent technological change in the large-scale sector, and of the comparability of Kenyan experience with that of other African countries.

CHOICE OF TECHNOLOGY

Conventional economic theory views the question of technology choice as being predominantly a matter of selection of an appropriate factor proportion (specifically of a particular capital-labour ratio) in a two-dimensional world. The generalization, unexceptional in itself, is that capital scarce countries should economize in the use of capital, and labour scarce economies should economize in the use of labour. This heuristic approach certainly casts some light on the issue of substitution possibilities between a range of inputs to the production process, so that different socio-economic environments would logically then be associated with the selection of different technologies most appropriate to different sets of circumstances judged on the criterion of 'least-cost'.

However, discussion of technology selection tends to cover issues of considerable economic significance somewhat unevenly. That is to say that some contributions discuss some of the points which follow but few, if any, cover all.

Foreign exchange

Most less developed countries (LDCs), not least those on the African continent, are experiencing increasing foreign exchange problems. This occurs in a context in which international sugar prices have stagnated or fallen in real terms, with little or no prospect of revival, given over-production (for example, in Europe) and the increasing foothold of alternative sweeteners (both natural and artificial).

Under the influence of pressure from the International Monetary Fund (IMF) and the World Bank, devaluation programmes have been followed in a range of countries, implying that projects with high foreign exchange dependence are likely to become increasingly unattractive when economically appraised at market prices (as well as with shadow prices which reflect the social opportunity cost of foreign exchange more systematically). Increasingly, the concern is not so much with the foreign exchange costs associated with the investment element (where preferential credit terms, tax concessions, etc., may make capital artificially cheap) but more with the continuing foreign exchange demands presented by the need for imported spare parts and materials to keep plants operating efficiently.

The rate of exchange (ie. cost) at which foreign currency is available may be less of a problem than bureaucratic or administrative rationing and/or delays — either intended or not — which have random, disruptive effects on seasonal processing industries such as sugar production. To an increasing extent,

the likelihood is that technologies will be selected on the grounds of saving primarily on foreign exchange requirements rather than simply of saving capital.

Technical/managerial skills

Large-scale projects often incorporate sophisticated technology, not least in the sugar industry. They demand highly skilled, experienced and effective management and technical personnel. The implications of this for scale selection within a particular technology type will be considered in the following section. However, in the more sophisticated large-scale plants, the continued employment of expensive expatriate labour may be more than justified for a period by higher levels of technical and economic efficiency than those which might arise from attempts to localize high level posts quickly. The use of foreign expertise through regular consultancy assignments, as opposed to expensive recruiting of resident expatriate managers, is an intermediate step towards full localization of staffing.

The logic of the development of the African sugar industry is entirely different to that of, for example, the Indian industry. In India, there has been an organic development of the industry over a matter of centuries (Garg, 1979, Chapter 1) from technologically rudimentary extraction and processing methods. The adoption of vacuum pans, centrifuges and modern clarification techniques on the way to steadily bigger plants in the large-scale sector has a certain logic.

Meanwhile, the small-scale sector has equally seen steady development and adoption of newer technologies (Garg, 1979, Chapter 2; Kaplinsky, 1984, Chapter 3), but remains firmly wedded to the use of open pan boiling technology. The implications of this are that any attempt to transfer the small-scale Indian technology to the African continent involves implantation of an alien technology just as much as does the transfer of the larger-scale technologies. The demand for sophisticated 'karigars' to supervise boiling in thousands of open pans (Baron, 1975, Appendix II, p. 199) represents just as much of a challenge as the demand for skilled labour to operate the complex equipment incorporated in tens of large-scale factories. The technological environment is as important a dimension as the economic environment (Stewart, 1977, Chapter 1; and see below this section). Equally, the difference between the characteristics of the capital goods/engineering sectors in India and in most African countries means that while in India all equipment for all types of sugar production technologies can be locally manufactured and maintained, in African countries the local element is generally limited to fabrication of storage and processing vessels and stagings and to some of the more straightforward maintenance requirements (in this respect Kenya is quite advanced as compared with most other African countries).

Overhead capital costs

Large-scale vacuum pan (VP) sugar factories are extensive users of capital investment funds as compared with the smaller-scale open pan sulphitation (OPS) plants which are the usual alternative (Baron, 1975, p. 186; Alpine and Pickett, 1980, p. 167; Bhat and Duguid, 1980, p. 26; Tribe, 1987). The fact of this high capital intensity (reflected in higher capital-labour and capital-output ratios) generates a dynamic which demands the utmost intensity of capital utilization in the large-scale plants, implying in turn three shift, twenty-four hour operation for as long a crushing season as possible (see below, next section on capacity utilization). Although, to this writer's knowledge, no systematic attempt has been made to undertake any research on the shift-working patterns (or even downtime characteristics) of small-scale plants as opposed to large-scale plants, the same pressure does not exist for the smaller, open pan plants to operate twenty-four hours a day.[2]

The implication of twenty-four hour operation for large-scale plants with upwards of 700-1,000 employees is that in order to ensure efficient working with shift changes in the middle of the night, it is necessary to provide a considerable amount of workers' housing and transport as an integral part of the investment package. This, of course, makes the capital-output and capital-labour ratios of such plants even higher than they would be in the absence of such overhead investment. It should be emphasized that housing and transport facilities are not usually provided by employers as a social service, but rather as an operational necessity.

Socio-economic environment

Much of the discussion of choice of technology emphasizes the differences in economic conditions (especially of relative factor prices) between countries, and particularly between developed industrial countries and LDCs. Little attention has been directed to the differences in economic conditions between regions and between sub-sectors within LDCs, and the implications of forces determining market prices (eg. the impact of taxation) for technology choice. Parts of the logic are implicit in the literature on the so-called 'informal sector', but this logic tends to be dismissed by economists in the mould of I. M. D.

Little (1987, p. 205) without consideration of the fundamental issues involved. Basically, the argument is that the dynamics of the economic structures of many LDCs perpetuates a perfectly rational co-existence of 'low-tech' small-scale and 'high-tech' large-scale plants within the same industry/product groups.[3]

The analysis of Tribe, 1987, suggests that the large-scale sugar plants in India are lower cost producers than the small-scale plants but that due to the market prices faced by the respective sub-sectors, the small-scale sector is more likely to be profitable for the investors concerned (but refer to note (b), Table 4). The fact that the large- scale factories are predominantly owned by growers' co-operatives and that the higher sugar cane prices paid by co-operative factories go to, inter alia, the owners is but one of the complicating factors involved in interpretation of the economic aspects of the industry.

An associated but not insignificant question is that in many LDCs, notably in Africa, the absence of any substantial capital market implies that most large-scale sugar factories are in the public sector, largely due to the very large volume of investment required. (Another factor is the political sensitivity of the interaction between factory and smallholder farmer, which tends to favour public sector operation of the processing).

The issue of the relative degrees of encouragement to be given to small-scale and large-scale manufacturing plants in an economic strategy which attempts to develop the entire economy, not least by generating economic surplus in a way which facilitates effective re-investment, is also important in relation to the choice of technology; but this cannot be pursued in this context (Galenson and Leibenstein, 1955, pp. 369-370).

Product characteristics

Finally in this section, the issue of product quality/characteristics should be mentioned (Stewart and James, 1982, Chapter 11; Lancaster, 1966). Different technologies are associated with different product qualities/characteristics in a chain or spectrum of substitutes. The smaller-scale plants often tend to produce a lower quality product with a shorter shelf-life, which is perhaps unsuitable for export. These smaller-scale technologies tend to be less extensive users of foreign exchange, more labour intensive and less capital-using. In the sugar industry as in others, eg. maize-milling (Bhat and Uhlig, 1979, pp. 15-21), there is no contradiction between a large-scale sub-sector producing a product which is an import substitute in every sense, and a small-scale sub-sector producing for restricted local markets. The spectrum of product characteristics is in no way logically inconsistent with the market structure.

CHOICE OF SCALE

As with technology choice, the basic objective of scale selection would be related to the minimization of production costs. However, a distinction can be made between intrinsic scale economies (mechanistically based on calculations of the relationship between differing proportions of various production inputs, determined technically) and non-intrinsic scale economies (relating to a variety of influences which affect production efficiency at different scales).[4] This section will concentrate on intrinsic scale economies.

Table 1: Breakdown of production costs — 1,250 and 10,000 tcd VP mills

Cost category	Percentage breakdown	
	1,250 tcd	10,000 tcd
Fixed investment cost	29.7	17.4
Working capital	0.8	0.8
Cane cost	36.8	49.1
Cane transport cost	3.6	9.8
Factory labour	5.9	2.4
Non-factory labour	1.9	0.8
Material inputs	5.4	7.2
Spare and replacement parts	5.9	4.0
Overheads	10.0	8.4

Source: Tribe and Alpine, 1985, p.7, Table 3.

In a paper published in mid-1987, Tribe and Alpine discuss the sources of scale economies in the cane sugar industry in a number of LDCs. Another paper delves in more detail into the nature of the relationship between scale economies and investment costs (Tribe and Alpine, 1986). The basic conclusion of the research reported in these papers is that unit production costs at a 1,250 tcd scale of production (using VP technology) are about one-third higher than at a scale of 10,000 tcd, independently of the range of technical and economic conditions applying in the LDCs considered. The principal source of these scale economies is the reduction in the investment cost per unit of output as scale increases.

Table 1 shows that at 1,250 tcd fixed investment costs account for about 30 per cent of the total production costs, and at 10,000 tcd they account for only about 17 per cent. Labour costs account for 7.8 per cent of the total at 1,250 tcd and 3.2 per cent at 10,000 tcd, while cane costs account for 36.8 and 49.1 per cent respectively. Essentially, this merely indicates that fixed costs tend to fall as a proportion of the total as scale increases, and variable costs increase. Table 1 shows that cane transport costs nearly treble as a percentage of total costs from 1,250 to 10,000 tcd, but starting from only 3.6 per cent of the total do not lead to overall diseconomies of scale. It should be noted that in the model on which the data in Table 1 is based, cane transport costs have been charged to the factory; if the transport costs were charged to the farmers, then a range of other considerations (too diverse to discuss here) would come into play. This is illustrative of the difficulty with which binding generalizations are made in this context.

There are four significant conclusions from this analysis:

○ if we wish to economize in the use of scarce capital per unit, selection would tend to favour the larger scales of production

○ if a significant amount of investment expenditure is in foreign exchange, the larger scales of production will economize on this scarce resource

○ if we wish to utilize expensive expatriate labour and/or scarce highly skilled local labour effectively, the larger scales of production would still be favoured

○ if we wish to utilize domestic resources as intensively as possible, cane costs (the major domestic resource) are the highest proportion of total cost at the largest scale of production

Thus selection should be biased towards the larger capacities on criteria other than production costs alone, as outlined in the previous section. The question of appropriate factor proportions is essentially irrelevant. Table 2 shows that the capital-labour ratio increases across scales, indicating, in this industry, that labour requirements drop more quickly than capital requirements as scale increases.

Table 2: Factor proportions and capital-output ratios — VP mills

Scale: crushing capacity (tcd)	Capital-labour ratio (10,000 tcd = 100)	Capital-output ratio (10,000 tcd = 100)
1,250	75.1	224.7
2,500	77.1	153.0
5,000	88.9	115.7
7,500	93.6	107.4
10,000	100.0	100.0

Source: Tribe and Alpine, 1985, page 9, Table 4.

More pertinently and logically following from the data in Table 1, the capital-output ratio drops by more than half as scale increases from 1,250 to 10,000 tcd, indicating more effective utilization of investment funds and of foreign exchange.

In an industry (ie. the vacuum pan sub-sector) which uses such large amounts of investment, it is only to be expected that the key to basically rational decision-making is to favour the larger scales of production. However, this discussion can be taken further. Table 3 summarizes the technological alternatives which are available and characterizes them in terms of scale, labour/capital intensity and technology type.

Since the small-scale plants tend to employ 100-150 people, they would be considered as medium-scale industries in many LDCs. The problem for group B is simply that with a comparatively high capital-output ratio (considerably higher than any of those in Table 2), it is impossible to reduce unit production costs to levels comparable with groups A or C.

Table 4 presents some estimates of unit production costs for OPS and VP technologies in India (as at 1977-78) at various scales.

56

Table 3: Scale and alternative technologies

Scale: crushing capacity per day (tonnes)		Technology type	Techology characteristic	Scale category
A	50-200	Open pan sulphitation	Labour intensive	Small-scale
B	300-600	Vacuum pan	Capital intensive	Medium-scale
C	1,250-20,000	Vacuum pan	Capital intensive	Large-scale

The reason for the reduced extent of scale economies over the range 1,250-4,000 tcd (as compared with the Tribe/Alpine estimates presented in Table 5) is that investment costs in India reflect the availability of domestically manufactured equipment at a cost significantly below that of equivalent European equipment. Table 4, then, shows that unit production costs are markedly higher for the 300-800 tcd range than for the 1,250-4,000 tcd and 100-200 tcd ranges. The supposition must be that in the context of the Tribe/Alpine results, the medium-scale plants would fall between two stools, having comparatively high unit capital costs but not being able to benefit from the different price structure which, in reality, allows the OPS sub-sector to compete effectively in the Indian context (Tribe, 1987). Thus, discussion on alternative scales in the sugar industry tends towards comparison of the OPS technology for 50-200 tcd and the VP technology for 1,250-20,000 tcd.

Table 4: Indian sugar production cost estimates (market prices of 1977-78)

Scale: crushing capacity per day (tonnes)	Technology type	Unit production costs (2,500 tcd = 100)
100	OPS	118.8
200	OPS	109.4
300	VP	135.3
500	VP	117.5
800	VP	112.4
1,250	VP	105.6
2,500	VP	100.0
4,000	VP	101.2

Source: Based on unpublished research undertaken by the author in the David Livingstone Institute, University of Strathclyde, 1978-85.

a. Production costs at 4,000 tcd are probably higher because this scale of plant would be available only to special export order given to standard technical specifications and scales adopted in India.

b. Note that there are two limitations with the data in Table 4. First, the OPS technology is of the 'unimproved variety' with specifications as described in Garg (1979) rather than incorporating the changes described in Kaplinsky (1984). Second, the technical data on which the OPS calculations are based relates to Uttar Pradesh while the VP calculations are based largely on technical and economic data from Maharashtra. (For climatic reasons, sugar recovery rates are generally 10-20 per cent higher in Maharashtra than in Uttar Pradesh). While this limits comparability, the general orders of magnitude are basically sound for the time period involved (1977-78).

NON-INTRINSIC SCALE ECONOMIES

The calculations reported in the previous section assumed full capacity production for all technology and scale variants, identical technical coefficients (conversion of cane inputs into sugar output) for different scales of the same technology, and other elements of the operational factors being in a state of *ceteris paribus*. Let us lift some of these restrictive assumptions.

As we move to larger scales of operation, the complexity of the co-ordination of thousands of smallholder farmers increases (we are assuming that outgrower models have been favoured over plantation models, ie. the Kenyan situation). However, it may be difficult to maintain capacity utilization at a consistently high level, and, if deliveries are delayed, cane deterioration will lead to reduced recovery rates and reduced technical and economic efficiency. This presents the possibility that operating efficiency may drop as scale increases and managerial co-ordination of cane supply becomes more complex.

On the other hand, if the decision were to be made to go for smaller VP plants (say of about 2,000 tcd, as at Nzoia in Western Kenya), then the available skilled labour would be spread more thinly between factories — possibly implying a lower degree of managerial and technical efficiency as compared with the larger-scale VP alternatives which concentrate the use of skilled labour. Thus, compared with the labour requirements of one 10,000 tcd plant, four 2,500 tcd plants would need 3.4 times the number of managerial staff, 2.8 times the number of supervisory staff and 2.2 times the skilled labour (Tribe and Alpine, 1987, p. 221). These are precisely the types of labour which are scarcest in LDCs or are hired from abroad at considerable expense.

For the sake of making some illustrative calculations, let us subsume all elements of operating deficiencies into low levels of capacity utilization. Table 5 takes the five scales of production presented in Table 2 and presents, in three ways, relative unit production costs at 50-100 per cent capacity utilization by 10 per cent intervals.

Table 5: Unit production costs with various levels of capacity utilization for a range of scales in VP plants

Scale (tcd)	Capacity utilization					
	100%	90%	80%	70%	60%	50%
Basis: 10,000 tcd @ 100% capacity utilization = 100.00						
1,250	138.1	146.6	157.1	170.7	188.8	214.1
2,500	114.6	120.3	127.4	136.6	148.7	165.7
5,000	102.8	106.9	112.6	118.8	127.8	140.4
7,500	101.2	105.0	109.9	116.1	124.4	136.0
10,000	100.0	103.7	108.2	114.1	121.8	132.7
Basis: 10,000 tcd = 100.00						
1,250	138.1	141.4	145.2	149.6	155.0	161.3
2,500	114.6	116.0	117.7	119.7	122.1	124.9
5,000	102.8	103.1	104.1	104.1	104.9	105.8
7,500	101.2	101.3	101.6	101.8	102.1	102.5
10,000	100.0	100.0	100.0	100.0	100.0	100.0
Basis: 100% capacity utilization = 100.00						
1,250	100.0	106.2	113.8	123.6	136.7	155.0
2,500	100.0	105.0	111.2	119.2	129.8	144.6
5,000	100.0	104.0	109.5	115.6	124.3	136.6
7,500	100.0	103.8	108.6	114.7	122.9	134.4
10,000	100.0	103.7	109.5	114.1	121.8	132.7

Source: Derived from the same data base as that used for Kenya in Tribe and Alpine, 1985.

Table 5 shows that with comparatively low levels of capacity utilization the disadvantages of the lower scales of production become even more conspicuous. With 100 per cent capacity utilization costs at 1,250 tcd are 38 per cent higher than at 10,000 tcd, while at 50 per cent capacity utilization the disadvantage increases to 61 per cent.

Alternatively, at 50 per cent capacity utilization the 1,250 tcd variant has production costs 55 per cent higher than at 100 per cent capacity utilization, while for 10,000 tcd the difference is only about 33 per cent. This is only to be expected since fixed costs are a higher percentage of total costs for the smaller scales of production within the VP technology.

The conclusion of this discussion must be that the non-intrinsic scale economies are likely to favour the larger-scale variants (ie. up to 10,000 tcd). This discussion therefore reinforces the earlier conclusion (Tribe and Alpine, 1987, p. 223) that the optimum scale is probably in the order of 5,000 tcd at this time.

Within the area of non-intrinsic scale economies, comparative distribution costs for a few large-scale plants and for many small- scale plants should also be considered. In Kenya, the difference between the factory gate price (which includes the excise duty) and the retail price of sugar is in the order of 50 per cent of the ex-factory price. If this difference were to be significantly lower for a large number of very small-scale processing plants, then a considerable amount of the production cost advantage of the large scale VP plants could be eroded. This issue clearly requires more careful consideration than is possible in this paper.

TECHNOLOGY CHANGES: LARGE-SCALE SECTOR

Sugar production costs may be steadily reduced by a range of changes:

○ higher yields of cane per hectare through changes in cultivation techniques and adoption of improved cane varieties, with concomitant reductions in cane production costs and prices
○ higher ratios of sucrose in cane, giving more sugar for any given amount of cane

(combining the above changes increases field sugar per hectare, of course)

○ improved cane transport, delivering fresher cane to the factory and permitting improved recovery rates
○ improved processing techniques, giving a higher recovery rate (higher ratio of sugar output to cane input)
○ improved management of existing technologies, giving lower production costs

For the future, an important question is whether there is greater scope for increased **economic** efficiency with the large-scale or with the small-scale technology, and whether any changes in relative efficiency are likely to change the kind of 'rank-ordering' reported in the earlier sections of this paper.

Perhaps the chances of improved varieties and improved cultivation techniques (including the adoption of irrigation) are greatest in association with the large-scale processing technology. Fairly significant reductions in production costs could be quite widely achieved by extensions to existing VP production capacity within the range of scales which are suggested as prudent in this paper. On the other hand, the adoption of radically different processing techniques is less likely than the steady improvement of existing techniques. For example, improved milling extraction is more likely than the widespread adoption of cane diffusion, and the wider use of continuous centrifugals is likely to reduce capital and labour costs to a certain extent. The scope for improvements in efficiency perhaps suggests that the large- scale VP technology is secure in its market position and is not threatened by the prospective limited adoption of small-scale technology, based on open pan boiling, in Kenya.

THE SCOPE FOR GENERALIZATION BASED ON KENYAN EXPERIENCE

Kenya has had comparatively good experience with its cane sugar industry in the last fifteen to twenty years. In part this has been owing to careful attention to planning and management, including selection of foreign management consultants (although all Kenyan VP plants do not have universally good experience by any means). In general, it has been possible to maintain a high level of self-sufficiency in sugar production, and to generate a large amount of employment and income to farmers, plantation and factory workers and a significant amount of tax revenues to the Government.

Part of this success has been due to the very long crushing season which is feasible in Kenya, with a consistently high level of sucrose in cane and of cane yields per hectare. The ten months' crushing in Kenya's large-scale sector compares with eight to nine months in her East African neighbours Tanzania and Ethiopia and the five to six months in West Africa. The higher level of capital utilization (note the distinction between 'capital' and 'capacity' utilization) which this long season permits gives a cost advantage over and above that based on the relatively high levels of sucrose in cane and of cane yields per hectare.

Experience with the 7,000 tcd processing plant at Mumias in Western Kenya suggests that it is possible to run a very successful large-scale sugar complex and to reap most of the available economies of scale with good planning, competent management and continuity of planning, implementation and management. The good experience with this 7,000 tcd plant is not replicated with the smaller 2,000-3,000 tcd plants which have been set up in Western Kenya. These have exhibited a range of problems in

planning, implementation and operation phases. Perhaps these issues are ultimately of greater significance than that of scale per se?

Notes

1. This paper, appropriately, was drafted in Kenya. It is an attempt to present an overview of the issues involved in selecting scales of cane sugar factories in less developed countries (LDCs). As such, it draws substantially on writing done jointly by myself and Robin Alpine (of the Department of Economics, University of Strathclyde — see references) and on discussions with Eric Rahim (also of the University of Strathclyde). The outline of this paper resulted from an extended conversation with Ian McChesney (of ITDG) for which I am very grateful. This paper aims to raise a number of issues relating to the issue of scale in cane sugar manufacturing. In doing so it has tended to act as an advocate of the larger scales of production. However, this should not be taken as a dismissal of the role of the small-scale technology in complementing the larger-scale.
2. The omission of research in this area is simply incredible given the large expanse of printed material on the issue of scale and choice of technology in the sugar industry in LDCs (see Alpine and Pickett, 1980, p. 168; Tribe, 1987).
3. Price formation is but one of the factors explaining this co-existence. Tribe (1987) makes an attempt to press the analysis in this direction. This issue, again, is one where the absence of serious economic analysis in the context of technology choice is little short of incredible.
4. Refer to Tribe and Alpine, 1987, p. 216. This distinction will be enlarged upon in the following section of this paper.

REFERENCES

Alpine, R., and Pickett, J., *More on Appropriate Technology in Sugar Manufacture*, in *World Development*, Vol. 8, No. 2, pp.167-174 (February, 1980).

Baron, C. G., *Sugar processing Techniques in India*, in *Technology and Employment in Industry*, Bhalla, A. (ed.), ILO, Geneva, pp.175-202 (1975).

Bhat, A., and Duguid, F., *Appropriate Technology in Cane Sugar Production*, in *Appropriate Industrial Technology for Sugar*, UNIDO, New York — ID/232/8 (1980).

Bhat, A., and Uhlig, S., *Choice of Technique in Maize Milling*, Scottish Academic Press, Edinburgh (1979).

Garg, M. K., *Mini-Sugar: Project Proposals and Feasibility Report*, Appropriate Technology Development Association, Lucknow (1979).

Garg, M. K., *Mini-Sugar Technology in India*, in *Appropriate Industrial Technology for Sugar*, UNIDO, New York — ID/232/8 (1980).

Kaplinsky, R., *Sugar Processing: The Development of a Third World Technology*, Intermediate Technology Publications, London (1984).

Little, I. M. D., *Small Manufacturing Enterprises in Developing Countries*, in *World Bank Economic Review*, Vol. 1, No. 2, pp.203-235 (January, 1987).

Stewart, F., *Technology and Underdevelopment*, Macmillan, London (1977).

Tribe, M. A., *Differential Pricing and Technology Selection in Indian Sugar Manufacturing*, mimeo, University of Bradford (1987).

Tribe, M. A., and Alpine, R. L. W., *Economies of Scale in Cane Sugar Manufacturing in Less Developed Countries*, in *David Livingstone Institute Discussion Paper No. 2* (revised), University of Strathclyde, Glasgow (1985).

Tribe, M. A., and Alpine, R. L. W., *Scale Economies and the '0.6 Rule'*, in *Engineering Costs and Production Economics*, Vol. 10, pp.271-278 (1986).

Tribe, M. A., and Alpine, R. L. W., *Sources of Scale Economies: Sugar Production in Less Developed Countries*, in *Oxford Bulletin of Economics and Statistics*, Vol. 49, No. 2, pp.209-226 (1987).

UNIDO, *Appropriate Industrial Technology for Sugar*, in *Monograph on Appropriate Industrial Technology (No. 8)*, Proceedings of the International Forum on Appropriate Technology, New Delhi, November 1978, New York (1980).

7

New cane extraction technology for small-scale factories[1]

Alan James

DIFFUSER TECHNOLOGY

The first commercial diffuser installations of the modern era in the cane sugar industry were commissioned in 1962. The De Danske Sukkerfabrikker (DDS) diffuser at the Arusha Chini factory of the Tanganyika Planting Company (TPC) in Tanzania went into operation in that year, and its success over the first ten years was described in International Sugar Journal in 1972 by the factory manager of TPC. Three major advantages were claimed:

○ reduction in lost milling time
○ reduced maintenance costs
○ increased sugar production

The use of diffusion in the cane industry is not, therefore, a new or untried technology; it has been operational for over twenty-five years.

There are many references to this in the literature but, because it refers specifically to a DDS installation, the following extract from the Argentine Sugar Journal in 1982 by Jose L. Carbonell of Ingenio Cruz Alta is quoted:

'The cost in connection with the installation of the diffusion process would be in the order of 60-70 per cent of that of a milling train. The diffuser would demand 4-6 workers less per shift, ie. 12-18 in the 3 shifts. This is due to few accessories, the simple operation principle and the simple automation of the diffuser.

The cost in connection with the maintenance of the diffuser is considerably lower, viz. in the order of 50-80 per cent of that of a milling train.

The power necessary for the primary movements in the diffusion process is much less than that corresponding to mills, viz. 30-40 per cent.

In conclusion it can be said that after more than a decade of industrial experience, diffusers are accepted by the sugar industry in South Africa as the most economical means to obtain a high extraction.'

Comparative figures obtained by Sugar Knowledge International from data provided by DDS and Fletcher & Stewart showed that for the same extraction, a train of 5 mills would have an installed cost 20 per cent higher and a power load 33 per cent higher than an equivalent train of preparation mill, diffuser and de-watering mill.

Some figures from the Argentine end of crop report provide interesting reading, and Table 1 compares the results at Cruz Alta with a diffuser (1) with the average for the rest of the Tucuman area using mills (2):

Table 1

	Rendement %	Imbibition % fibre	Reduced extraction	Molasses	Loss % cane Bagasse	Total	Fuel oil % cane
(1)	10.60	224	94.94	1.46	0.69	2.34	0.12
(2)	10.01	206	92.13	1.42	1.07	2.74	2.26

While some of these figures would be expected, a comment is worthwhile on the small increase in

imbibition and, more particularly, on the reduced consumption of auxilliary fuel. This is logically explained by the smoother process flow which minimizes extraction process stoppages and, therefore, steam blow-offs.

SMALL-SCALE DIFFUSERS

The obvious efficiency of the diffusion system and the dependence of the milling system on multi-stage operation, with one or more mills being omitted for lower throughputs, led DDS to consider the role of their equipment for small-scale units. A series of pilot trials were initiated at Arusha Chini, with the co-operation of the management of Tanganyika Planting Company, to investigate a simpler extraction plant without mills. This involved testing:

○ cane slicer
○ DDS cane diffuser
○ screw press
○ liming systems

By eliminating the first mill and performing diffusion directly on the cane, not just on milled bagasse, and replacing the final mill with a press, the flowsheet was simplified considerably. Cane slicing was found to combine fineness of preparation with good permeability, due to a uniformity which is retained even though the press water is not screened or clarified. The slices are some 2-3 mm thick at an angle of 60-90 degrees to the axis of the cane stick, although most of them break into pieces before entering the diffuser.

The diffuser itself showed no tendency to channel or flood, and pol extraction appeared rather insensitive to draft over the range of 90-100 per cent.

Figure 1: Analyses of diffuser juice at various points along the DDS diffuser

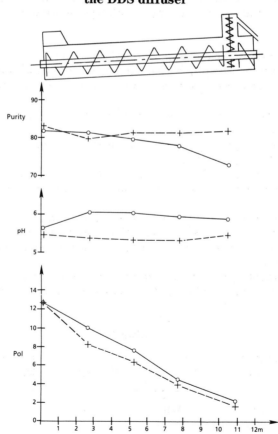

Juice quality was compared with that from the bagasse diffusion factory to which the pilot plant was attached, and the purity of mixed juice was significantly higher and, indeed, was only slightly lower than first expressed juice. This may be explained by the preservation of the natural structure in the cane slices, with the broken slices fracturing along the soft-walled storage cells, leaving the vascular bundles containing the lower purity juice intact.

The screw press yielded bagasse with moisture of 45 per cent. It was noted that compared with trial runs pressing bagasse from a milling-diffusion system, power consumption was much lower. This has been attributed to the practice of recycling the clarifier mud into the diffuser resulting in a lower pH in the press water, which has been shown to make the bagasse more slippery and therefore easier to process in a press than a mill.

Recycling of the mud has a marked effect on conditions along the diffuser but little, if any, on the output juice (see Figure 1). It certainly has the desirable effect of eliminating the filter station.

Based on these satisfactory results DDS has marketed compact sugar factories, and the audio-visual gives an impression of the application of this technology in Bangladesh in an environment where 'small is beautiful'.

Compact factories as 'human-scale' developments come into their own where smaller areas of excellent soil exist, and limited agricultural and industrial progress is required which does not cause undue disruption of the local pattern of life.

Note

1. Editors' note: This paper was actually presented in the form of a video on the newly installed 300 tcd compact diffusion process at the old Deshbandu factory in Bangladesh. The text argues the case for consideration of modern diffuser technology in small-scale cane sugar processes, a technology more normally associated with beet sugar processing.

8

Realizing scale economies

George Moody-Stuart

Achieving full production from large-scale sugar factories is not, specifically, a technical problem. It is all about good planning, good organization and good management. Inputs of high quality are needed from a wide range of specialists — agronomists, agricultural engineers, sometimes civil engineers, mechanical, electrical and instrument engineers, chemists and even, occasionally, accountants — but the best of these inputs are worthless without proper co-ordination.

DEFINITIONS

It is necessary to define two expressions. The first is '**large-scale**'. **Lay people** think of sugar projects in terms of tonnes of sugar per annum because that is what they are interested in. A **factory worker** talks in terms of tonnes of cane per hour or per day, or tonnes of fibre per hour or per day; but even these terms are fairly meaningless without further qualification, because it is possible to push a lot of cane through a mill without making much sugar.

The other fundamental factor in turning the factory worker's daily throughput into the lay person's annual output is the number of operating days, which may vary from as few as ninety to something over three hundred. However, for present purposes and for simplicity, let us say that 'large-scale' means a capacity of at least 1,000 tcd. In some very large plants, crushing capacity may be as high as 20,000 tcd.

The definition of '**full production**' causes a few more difficulties. Achieving rated capacity, or something close to it, on a daily basis is not very clever if it is only done following a thirty-six hour weekly shutdown. Equally, it may be very profitable to add a week or two at the beginning or end of the crop, even in difficult conditions, if there is cane of reasonable quality available. I therefore tentatively offer the following imprecise definition of 'full production':

> operating at rated milling capacity for not less than ninety per cent of net available time (after scheduled maintenance stoppages), with an overall recovery of not less than eighty-five per cent throughout those periods of the year when cane of reasonable quality can be harvested.

THE ESSENTIAL ELEMENTS OF SUGAR PRODUCTION

There are basically three elements in sugar production:

○ growing the cane
○ harvesting and delivering the cane
○ operating the factory

These elements are interdependent, but the key to the whole exercise is the availability of an adequate (but not excessive) supply of mature cane at the right time.

GROWING THE CANE

If you want a good supply of cane, the most important thing is to put your factory in the right place having regard to:

○ soils
○ adequacy of rainfall or availability of irrigation water
○ sunshine hours
○ temperature variations
○ opportunity days for cultivation, planting and harvesting
○ existing infrastructure

These are in addition to the less demanding requirements of the factory itself — reasonable foundation material, a water supply, ease of effluent disposal and accessibility to the market.

The best management cannot create a good project on a site which does not have the basic physical properties. Conversely, bad management may abuse a good site; but that situation is never beyond redemption.

Assuming that a good site has been chosen, what else has to be done to ensure that there is enough cane, both in terms of quantity and quality, to enable full production to be achieved? The following are all important:

○ selection of appropriate cane varieties
○ use of good quality seed material
○ use of the right cultivation techniques
○ adequate fertilizing
○ close attention to weed and pest control

Without diverting into the small farmers versus plantations debate, it is worth emphasizing that if small farmers are to succeed, as they certainly can do, then they must be encouraged to pay as much attention to these things as a well-run plantation does. To maintain the small farmer's interest, he must also be able to make at least as good a living from cane as from any competing crop and preferably be able to combine it with subsistence food crops. Cane, as a cash crop which needs little attention after the first three or four months of growth, combines very well with more labour intensive subsistence crops. The small farmer is likely to need credit for seed cane, fertilizer and possibly for other inputs and, essentially, to be paid promptly when his cane is delivered.

To ensure cane availability, much care must be given to the planting programme. Normally, particularly in rainfed areas, the opportunity days for planting will be far fewer than the opportunity days for harvesting. Therefore, even with the best variety selection, the agricultural manager has to compromise to some extent between the optimum time of planting and optimum maturity at harvest.

A particular problem faces the manager who is seeking full capacity utilization in a new project. In a steady state, it is desirable to replant about the same area of cane each year. Assuming a typical cycle of plant cane and two ratoons over a three year period, and also assuming a yield decline from plant to first ratoon and a further decline to second ratoon, a reasonable target is fifty per cent production in year one, seventy-five per cent in year two and a hundred per cent in year three. It is probably fair to say, however, that this rate of build-up is not very often achieved. Factors making it easier to reach full capacity quickly include:

○ the availability of contractors' equipment for land clearing and primary cultivation
○ a good supply of seed cane, perhaps from a neighbouring estate
○ a relatively short harvesting season, say five or six months rather than nine or ten

Factors working in the other direction include:

○ the need to install an irrigation system
○ heavy land requiring the use of crawler tractors for cultivation
○ small farmers rather than plantation organization, particularly if the farmers are unfamiliar with sugar cane

In any event, this is a common area of failure with potentially serious effects on cash flow at the most vulnerable time.

The question may be asked whether the best way of ensuring cane availability isn't simply to grow a modest surplus. Unfortunately, if one always has a buffer one is always handling over-mature cane — and unhappy farmers or estate managers.

On an irrigated plantation, good agricultural management should be able to produce the required tonnage fairly accurately. On a rainfed estate, particularly if small farmers are involved, the calculations

are more difficult. To ensure full factory production, one has little alternative but to risk some over-production of cane in a very favourable year in order not to be too short in a bad year.

One can deal with small surpluses, according to circumstances, either:

○ by lengthening the harvesting season
○ by allowing the average age of cane at harvest to increase
○ by standing-over cane to the next season
○ by occasional extensions of the crushing season, although if this is repeated too often essential long-term maintenance may suffer

There are some penalties attaching to any of these 'solutions' but they are likely to be less onerous than allowing the factory to be frequently under-utilized.

HARVESTING AND DELIVERING THE CANE

This is the area in which many large-scale operations fall down badly. The bigger the operation, the greater the logistical problem. If, like me, you have difficulty thinking what, say, 20,000 tonnes of cane looks like — the sort of quantity required daily to feed several of the world's largest mills — then think in terms of a ten-tonne truck rolling up every forty-five seconds throughout the day and night.

I am dealing briefly with four areas:

○ harvesting
○ transport
○ the field workshop
○ the cane yard

All must work efficiently if the large-scale factory is to be smoothly fed.

Despite improvements in the efficiency of mechanical **harvesters**, manual cutting is still far more common world-wide. In any case, given an adequate labour force, mechanical cutting does not, as such, contribute to full factory utilization. Mechanical **loading** is much more important.

Under most systems there is no problem about a cutter working, within reasonable limits, at his own speed. Great problems used to arise, however, before the days of mechanical loaders when the transport was delayed because the cutters were naturally reluctant to sit around, perhaps for hours, waiting to load another trip. Thus quite a short factory breakdown — say a couple of hours in the morning — could have bad knock-on effects: inability to turn round transport, late return to the fields, no loaders, therefore leaving the factory without cane the next morning. Mechanical loading largely avoids that vicious circle.

Good planning of the harvest is also essential to full factory utilization. For example:

○ mixing long and short hauls so that the transport fleet is not over-extended on any day
○ the harvesting of low-lying areas and clay soils in dry weather, leaving the free-draining soils for wetter periods
○ the timely harvesting of final ratoon fields to enable them to be recultivated and replanted at the right time of year

These priorities often conflict. If the agricultural manager fails to sort them out correctly, the factory will sooner or later — maybe tomorrow, maybe next year — run out of cane.

There are many ways to **transport cane** — by rail, by lorry, by tractor and trailer (large or small) and by bullock cart. All that matter from the capacity utilization point of view are reliability and ability to operate under all conditions which are likely to be met.

Most large-scale factories rely on cane delivered by lorries or tractors and trailers, which may be owned by the factory or by contractors. A system which can work well is to have enough owned capacity to handle, say, half of the cane requirements, and to rely on contractors for the balance. It is attractive from the factory's viewpoint to have some surplus contractors' capacity available; but reliability remains important. Broken-down cane transport disrupts the supply, leads to stale and lost cane and can be a hazard on the roads.

The **field workshop** is a vital part of maintaining a reliable transport fleet — not to mention the maintenance of cultivation tractors and staff vehicles. It is one of the most difficult areas in which to achieve satisfactory standards of efficiency. At Mumias in Western Kenya, which is now making more than 200,000 tonnes of sugar pa., one of the two remaining expatriates is the field workshop manager.

The workshop sometimes also has a responsibility for road maintenance. Wherever this responsibility lies, it is an important one. If all necessary roads are not kept in passable condition, the best transport will not be able to keep the factory fed.

66

Finally to the **cane yard**, which is the physical interface between field and factory. Again numerous systems are in use, but they should all have the same objectives — quick turn-round of transport and a smooth feed to the cane carrier, which must be as nearly as possible on a first-in first-out basis. One problem is that the factory operates for twenty-four hours while cane transport usually operates for twelve to sixteen hours.

The ideal situation is that the last of one day's cane should be disappearing on to the carrier as the first of the next day's cane arrives. In practice, one has to plan for some overlap to ensure continuity of supply.

It should be emphazised that a vital objective of the harvesting and transport operation is not only to deliver **enough** cane, but also to deliver **fresh** cane. A factory cannot achieve full production unless the quality of the cane, as well as the quantity, is adequate.

THE FACTORY

I propose to deal very briefly with the following aspects of the large-scale factory:

○ design
○ maintenance
○ training

Some sugar machinery manufacturers would like their customers to believe that you can buy a sugar factory like you would buy, say, a car — a standard **design** with a small number of options. Do you ⌐t the 1,500 tcd, the 2,400 tcd or, perhaps, the 3,000 tcd?

‌ ⌐ customer is going to achieve full production fairly consistently, much consideration must be
⌐ch factors as:

‌ ⌐ of the cane which will normally be received, and the seasonal variations which may be
⌐his way bottlenecks can be reduced and good recoveries can be achieved
○ ⌐ ⌐ campaign (and therefore the length of the maintenance period), which affects the
am⌐ ⌐d or stand-by equipment which is justified
○ the co⌐ ⌐ the availability of skilled labour, which affect the desirability of automation
and soph⌐ factory
○ the need fo⌐ ⌐ or, conversely, the likelihood of surplus bagasse to be disposed of

In fairness to the ⌐ ⌐liers, the buyers of new factories often do not have detailed answers to these questions be⌐ ⌐perating. However, an existing factory can usually be modified to take these items into co⌐ ⌐e search for full production.

Maintenance is basical⌐ ⌐s:

○ short planned maintenance ⌐ during crop — generally at weekly or two weekly intervals and occasionally during unplanned ⌐lant stoppages
○ an annual (or bi-annual) maintenance shutdown

Some operators regard the scheduled short stop as unnecessary; they wait for a breakdown and then clean the evaporator tubes and the furnaces. I am quite confident that the way to achieve full production is to plan your shutdowns, but obviously with a degree of flexibility so that if you have a breakdown within, say, twenty-four hours of a scheduled stop, you stop early.

Unscheduled stoppages are incompatible with efficient operation, leading to inversion losses in the factory, cane becoming stale in the yard and in the field, and cutters sent home when they want to work.

The same arguments, to an even greater extent, apply to annual maintenance. Of course, the longer the campaign (ie. the shorter the shutdown) the more important that the programme should be meticulously planned, that all spares should be on hand and that key staff and tradesmen should not be on leave. Let the work be completed in time for proper steam trials before the campaign is due to start — few things cause more chaos than a major breakdown on the first day of a new crop.

Finally, **training**, which is even more vital in the factory than elsewhere. Agriculture is almost a natural activity for some people. Eight hours in a noisy, sticky environment does not come naturally to anybody, so there is an initial barrier to be overcome. There are skilled and semi-skilled jobs to be learned at many levels, and unless they are consistently and conscientiously performed the factory has no hope of achieving maximum throughput.

CONCLUSION

As this paper has largely been devoted to stating the obvious, I will risk a final repetition.

Capacity utilization in a large-scale sugar factory is all about planning:

Long-term planning: siting the project in the right place, building the right factory, laying out the fields properly, and planting the right hectarages in the right varieties.

Medium-term planning: organizing a thorough maintenance shutdown for the factory and the haulage fleet, arranging a balanced harvesting schedule and replanting programme, and preparing training courses for the workers who will be promoted next year.

Short-term planning: making sure that the right roads are graded this week, that the cane supply is reduced before a holiday weekend, and that every tool and every part needed for a short shutdown is ready to hand.

SECTION E

IMPROVED OPEN PAN PRODUCTION —
A DECADE OF EXPERIENCE

9

Improvements in open pan sulphitation technology

Ian McChesney

The task for any sugar processing technique is to convert sugar cane to saleable sugar; to turn a perishable agricultural product into a stable, tradeable commodity.

As a commercially competitive technique for producing white sugar, open pan sulphitation (OPS) has a unique combination of low capital cost and high labour consumption. Of particular note is the lack of response to normal scale economies, which explains the preference for application in small factories. Sugar recovery is better in quantity and quality than the original open pan systems, but is naturally inferior to more capital-intensive techniques. OPS works because it is a simple, basic approach to the problem of rural sugar production.

In seeking to improve the competitiveness of OPS, it is easy to recommend the adoption of conventional machinery-intensive techniques. This, however, would defeat the purpose of a technology specifically suited to successful rural sugar production.

Yet OPS must evolve to meet changing demands. This is a technical challenge that has engaged ITDG now for a number of years. This paper sets out to look at these changes, and the technical responses they have stimulated. It summarizes the background and origins of OPS and the techniques involved. The emergence of improved techniques is described and potential applications in Kenya are reviewed. The scope for further developments is considered, with particular reference to properly identifying the role of OPS technology in rural development — the primary concern of ITDG.

With the continuing availability of cheap sugar on the world markets, the costs of any increases in domestic capacity are unlikely to be met entirely from factory income measured in terms of world market prices. Incentives are therefore invariably required to stimulate investment in new capacity. Whether these are to be borne by the consumer in the form of higher sugar prices, the farmer in lower cane prices, the government in terms of taxation revenue foregone or, indeed, the investor by way of a low return on capital is a matter for sugar sector policy to address.

The full resolution of these issues lies well beyond the scope of this paper. They do, however, provide the context for the technology, its improvements and the prospects for its future, and present an opportunity to note that in current times final investment decisions are just as likely to be determined by policy considerations as they are to be based on specific factory performance and economics.

THE BACKGROUND TO OPS

Sugar factories do not function in isolation. Certain basic conditions must be satisfied before operation becomes practical. These will include cane supply, labour availability, infrastructure and investment opportunity. To understand how OPS has evolved and where the scope for future development might lie, it is necessary to review these four issues briefly.

Cane supply

Sugar is not produced in the factory; it is simply extracted from cane which the farmers grow. It is therefore fundamental that the factory is geared to the needs of the farmers. Since few countries nowadays have the luxury of planting cane on unallocated land (unless incurring the heavy expense of irrigation), the production of cane usually has to be compatible with existing agricultural practices. For most countries, this means smallholder cane agriculture and mixed cropping.

Since sugar cane prefers conditions of good soil fertility and adequate rainfall, there is immediately a

conflict between the claims of various crops. It is therefore the returns to sugar cane relative to alternative crops that will determine its attractiveness to the farmer.

Setting the price of cane, either by market forces or by government decree, is unlikely to guarantee a satisfactory and predictable balance between the supply of cane and the capacity to process it. Some form of contract between the farmer and the factory becomes necessary. The success of a new sugar project is therefore going to be more closely related to the successful design and administration of this contract than to any other single factor.

Labour availability

Rising population densities force people to seek incomes beyond those available through subsistence farming. If these opportunities are not created within the rural areas, then large-scale migration to urban centres will follow. Sugar cane, with a relatively high input of labour in both harvesting and processing, can assist in this process of rural employment generation. However, if outward migration is heavy, the situation may end up being similar to that in low population density areas with the extra labour necessary for sugar cane processing being unobtainable.

Infrastructure

Before considering an investment in sugar processing, the existence of a reasonable degree of infrastructure will be essential. Roads for cane transport, power for factory operations and the usual administrative and service functions have to be present or must be created at considerable cost.

Investment opportunity

Investment will normally be attracted into sugar factories to generate profit, but the management of public and private investments will differ. Under company rules the main allegiance of the sugar factory will be to its shareholders. Where these are private investors, the drive for profit or the threat of bankruptcy is a considerable spur to activity and efficiency; survival can by no means be guaranteed. Public sector shareholders — whilst perhaps less affected by the danger of enforced liquidation — are especially sensitive to political considerations. These ensure that the liquidation of even an unprofitable factory, to the detriment of the farmers, is a serious and unlikely step.

THE ORIGINS OF OPS

OPS, as a sugar processing technique, emerged in India in the late 1950s as a response to a specific set of conditions prevailing at that time.

Cane supply

Cane had been widely grown by smallholders in India before large-scale processing was introduced, and was then consumed in the manufacture of traditional sweeteners.

With the arrival of the large factories (1930s), it was necessary to intensify cane production from smallholders to produce larger quantities of cane in factory localities. With cane under rainfed conditions and subject to natural yield variations, there was a tendency to overspecify the command area of a factory — with the result that cane would often be in local oversupply. Farmers were left only with the traditional low- value disposal options.

The introduction of large catchment areas also rendered bullock carts, as the sole means of transport, impractical, and mechanization by rail and road from rural collection centres was introduced. This increased the cost of delivered cane, some of which had to be borne by the farmer, making sales of cane to the factory a less attractive proposition especially for peripheral farmers. Farmers were therefore looking for alternative outlets for the crop.

Labour availability

With high population densities, India started moving towards labour surplus farms at quite an early stage. Furthermore, a number of individuals had acquired artisan skills in construction, metalworking and manufacture. There was consequently a rural labour pool which could be tapped.

72

Infrastructure

Widespread investment in rural electrification had created the opportunity for factory installations to operate; also, many administrative mechanisms were well established.

Investment opportunity

The emergence in India of a cheap capital goods industry, and a motivation towards wealth creation by landowners and merchants, generated both the desire to invest in rural industry and the finance to undertake it. This was further encouraged by ideological and fiscal support for small-scale enterprises.

OPS was developed as a process in 1955, based upon an upgrade of khandsari technology with a history exceeding two millenia. It provided small farmers with the means of gaining access to the higher value white sugar market. Initial units were actually farm co-operatives, but private sector interests soon predominated. OPS installations were built in large numbers in the 1960s and 1970s, with estimates running into several thousand functioning units.

Within a short period of time — twenty years — cadres of skilled workers emerged in the OPS industry, and it became practical for managers of OPS units to have virtually no day-to-day involvement in the running of the factory. This eased the constraint of management and facilitated continuing investment.

THE TECHNOLOGY OF OPS

The technology employed was a mix of traditional and modern techniques:

Crushing: A new 4-6 roll hydraulic crusher with 2 sets of cane knives and capacities of 4 tonnes/hour was introduced. Milling efficiencies of 75 per cent were achieved without imbibition. (Small crushers had previously not used knife preparation, although spring loading had been in use).

Clarifying: Chemical clarification in the form of single cold lime sulphitation was introduced. (This copies large-scale practice and replaced the use of vegetable clarificants).

Boiling: Larger, multi-pan furnaces were built to cope with the greater juice flow, and these were operated continuously. (Previously, batch-operated, single pans had been preferred.)

Recovery: New techniques of crystallization by cooling, followed by centrifugal separation, allowed an equivalent boiling house recovery of some 50 per cent on plantation white equivalent and a further 20-25 per cent of lower grade sugars by sequential boiling. Total boiling house recovery being 75 per cent, the overall sugar recovery was 0.75 x 0.75 = 56 per cent, giving a rendement of 7 per cent on cane of 12.5 per cent sugar content. (This was a considerable improvement over the traditional methods of gravity separation to obtain white sugar crystals).

THE OPS PROCESS

Figure 1 sets out the flow sheet for the OPS process. Units of this size were, in practice, able to process approximately 100 tonnes/day of cane. Further capacity could be obtained by duplication of units.

Larger crushers, using 16″x 24″ rollers, were available in place of the standard 13″x 18″ size, giving a nominal crushing rate of 200 tonnes/day, and these offered some limited scale economies. In practice, it is difficult to process more than 150 tonnes/day of juice by the manual open pan process, and few units handling more than 200 tonnes cane/day have been built.

Performance of the OPS process

There are considerable difficulties in assessing the performance of the OPS process, as few factories employ anything but the most rudimentary controls. Rendement — in effect, 'sugar out' divided by 'cane

Figure 1: The OPS process

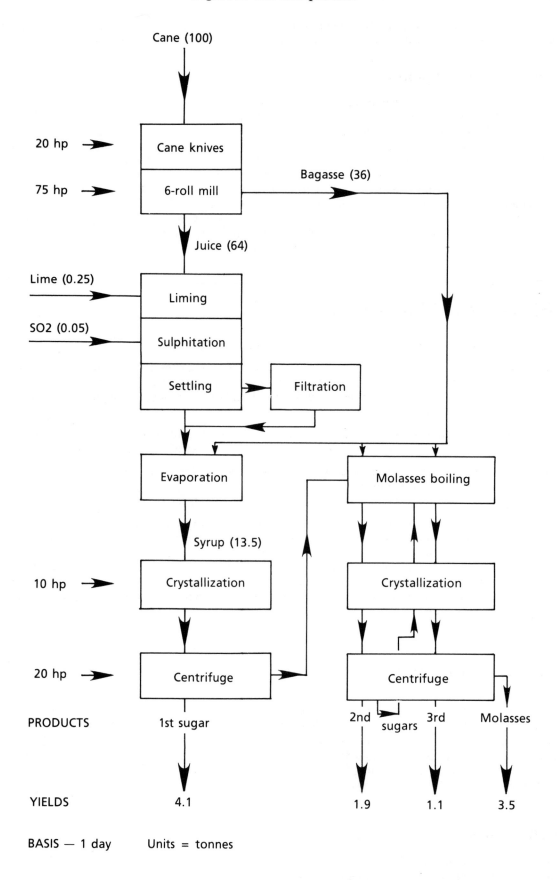

BASIS — 1 day Units = tonnes

in' — is taken from the only two items that are (almost) always weighed. The quality of the sugar is determined not only by the maturity of the incoming cane, but also by the skill of the operators at all stages of the process.

In this paper the following technical terms are used. They are defined here as ratios, but used as percentages:

Milling efficiency $= \dfrac{\text{Sugar in juice}}{\text{Sugar in cane}}$

Boiling house recovery $= \dfrac{\text{Sugar in product}}{\text{Sugar in juice}}$

Overall recovery $= \dfrac{\text{Sugar in product}}{\text{Sugar in cane}}$

$=$ Milling efficiency x Boiling house recovery

Brix $= \dfrac{\text{Weight of soluble solids}}{\text{Weight of solution}}$

(Measured by hydrometer or refractometer; includes sugars and non-sugars)

Pol $= \dfrac{\text{Weight of sugar}}{\text{Weight of solution}}$

(Sugar % as measured by Polarimeter)

Purity $=$ Pol/Brix

Rendement $=$ Pol % x Overall recovery %

Moisture $=$ % on wet weight basis

As a consequence of this lack of data, the usual question of accurately assessing the pol balance in a factory, in order to work towards developing and improving performance, does not normally arise. Broad benchmarks — number of crystallizers filled, etc. — are used in practice for day-to-day control. However, some technical estimate of performance is necessary. This can best be done by making a theoretical assessment of overall recovery and comparing this with actual performance. In some cases, however, detailed measurements have also been made of operating performance.

Also of considerable significance is the fuel balance of the process. Any additional fuel consumed has to be paid for, but, more importantly, may not be locally available in adequate quantities.

Milling efficiency

From Hugot, this is simply defined as $(m\text{-}F)/(m(1\text{-}F))$, where F is the fractional fibre content of the cane and m is a constant factor depending on mill configuration — 0.36 for a 6-roll mill. The limiting value of m in dry crushing is normally taken as $m=0.5$.

In practice, the fibre content of the cane is not generally known. Nor are there any chemical measurements on the quality of the juice, although brix is often known. To get around this a shortcut method, set out in Figure 2, may be used.
The necessary equations are:
1. Mass balance $F + W + w + B + b = 100$
2. Juice extraction % $= B + W$
3. Juice brix $= 100 \dfrac{B}{(B + W)}$

Figure 2: Determination of OPS crushing performance

Where F = fibre, B/b = brix and W/w = water, then crushing may be represented for 100 units of cane as follows:

CANE JUICE BAGASSE

4. Bagasse moisture % $= 100 \dfrac{w}{(F + w + b)}$

5. Residual juice brix $= 100 \dfrac{b}{(b + w)}$

6. Cane fibre % $= F/100$

Direct measurements of juice extraction, juice brix and bagasse moisture are usually available. Since guessing cane fibre may be problematical, it is easier to assume residual juice brix either as equal to juice brix, or more accurately as juice brix minus one.

To permit rough calculation of fibre content, residual juice brix may be estimated in this way and typical figures from an Indian factory are:

Juice extraction: 64% (Weighbridge)
Juice brix: 18 (Direct measurement)
Bagasse moisture: 55% (Laboratory measurement)

From Figure 2, equations (2) and (3):

$$
\begin{aligned}
B + W &= 100 \times 0.64 &&(2)\\
B &= 0.18\,(B+W) &&(3)\\
\text{out of which}\quad B &= 11.52 \\
\text{and}\quad W &= 52.48
\end{aligned}
$$

From Figure 2, equations (1) and (4), eliminating F in (4):

$$\text{Bagasse moisture} = \frac{w}{100 - W - w - B - b + w + b}$$

or $\qquad 0.55 \quad = \dfrac{w}{100 - W - B}$

$$0.55 \quad = \dfrac{w}{36}$$

$$w \quad = 19.80$$

Putting w in equation (5), Figure 2:

$$\dfrac{(Brix - 1)}{100} \quad = \quad \dfrac{b}{b + 19.80}$$

$$0.17 \text{ x } (b + 19.80) \quad = b$$
$$b \quad = \quad 4.06$$

and finally, from equation (1), Figure 2:

$$F \quad = \quad 100 - 11.52 - 52.48 - 19.80 - 4.06$$
$$= \quad 12.14$$

This gives:
$$F \quad = \quad 12.14$$
$$B \quad = \quad 11.52$$
$$b \quad = \quad 4.06$$
$$W \quad = \quad 52.48$$
$$w \quad = \quad 19.80$$

Milling efficiency, as measured, is therefore 100 (11.52/(11.52+4.06)) or 73.94 per cent. From the Hugot formula, a figure of 75.44 per cent would be expected with 12.14 per cent fibre cane (0.36-0.1214)/(0.36(1-0.1214)). In this case, some attention to mill settings may be indicated.

The dry crushing limit on this cane would be reached at a milling efficiency of 86 per cent, corresponding to juice extraction of 76 per cent.

Boiling house recovery

With few, if any, measurements the determination of boiling house efficiency is difficult. Predictive calculation may be based around theoretical estimates of syrup purity:

$$\dfrac{\text{Sugar crystal yield}}{\text{Syrup weight}} = \dfrac{Br}{100} \text{ x } \dfrac{Pr - Pm}{Ps - Pm}$$

where: Pr = purity of syrup
Pm = purity of molasses
Ps = purity of sugar
Br = brix of syrup

Typical purity drops (Pr-Pm) are:

1st Sugar: 10
2nd Sugar: 9
3rd Sugar: 8

In the OPS process, the syrups are crystallized three times in succession and so for a typical syrup purity of 80, the final molasses purity will be (80-27) = 53 if purity drop during boiling is not accounted for. Assuming a 2-point drop in sugar purity — due to a loss of sugar to inversion — and a 2-point rise in syrup brix between each crystallization, the percentage yield of crystal sugar by weight from each crystallization may be calculated after the juice has been boiled to 85 brix from 18 brix to give (18/85x640) = 135 kg of syrup, or 13.5 per cent per tonne of cane.

			Yield		Sugar
1st sugar:	$\dfrac{85}{100}$ x	$\dfrac{80-70}{98-70}$ =	0.30 x 13.5%	=	4.1%
2nd sugar:	$\dfrac{87}{100}$ x	$\dfrac{70-61}{96-61}$ =	0.22 x (13.5 -4.1)[a]	=	1.9%
3rd sugar:	$\dfrac{89}{100}$ x	$\dfrac{61-53}{94-53}$ =	0.17 x (13.5 -4.1 - 1.9)[a]	=	1.0%
					7.0%

a. Adjusted for change of brix and 5 per cent loss in processing.

The value of boiling house efficiency is this 'sugar in product' — 7 per cent — divided by 'sugar in juice'. The sugar content of the juice is based on the weight 13.5 per cent, multiplied by the brix (85) and purity (80), ie. 9.2 per cent. 7/9.2 gives an equivalent boiling house efficiency of 75 per cent.

Using cooling crystallization methods, it is impossible to achieve purity drops of greater than 10 per cent (20 per cent is normally achieved with evaporative crystallization in VP processing) and after three boilings, colour formation and increased viscosity effectively halt the process. In any case, purity drops decrease as boiling progresses, putting an effective limit of 75 per cent on potential sugar per cent yield using this crystallization method. With better quality juices and a syrup purity of 82, this may be improved to approximately 80 per cent with overall quality equivalent to plantation white.

Sugar output of 7 per cent on sugar cane of 12.5 pol represents an overall recovery of 56 per cent (75 per cent milling efficiency x 75 per cent boiling house recovery).

Fuel balance

The potential for achieving this may be figured out by taking the main heat demands of the process. (Power is supplied and accounted for separately). For juice heating, juice boiling and molasses re-processing, these amount to approximately 2.4 GJ per tonne of juice. One tonne of juice will yield 210 kg of syrup and boiling starts at 60°C after sulphitation.

			kJ
Juice heating: (20 °C-90 °C)	Specific heat: 1,000 kg x 70 °C x 3.7	=	259,000
Juice boiling: (From 60 °C)	Specific heat: 1,000 kg x 40 °C x 3.7	=	148,000
	Latent heat: (1,000 kg-210kg) x 2,250	=	1,777,500
Syrup reboiling: (From 30 °C)	Specific heat: 210 kg x 70 °C x 2.5	=	36,750
	Latent heat: (210 kg-130 kg) x 2,250		180,000
			2,401,250

(1.54 GJ/tonne cane @ 64 per cent extraction.)

The fuel kJ/kg value of the bagasse is given by Hugot as approximately (17,765-20,273m), where m is the moisture content. For sun-dried bagasse, this may be taken as 15 per cent. The ratio of juice to bagasse is determined by the crushing performance. High fibre canes tend to give lower extractions—and therefore easier fuel balances—compared to low fibre canes. For the previous crushing calculations, a tonne of cane will yield:

Juice: 640 kg

Bagasse: 360 kg of 55% moisture
or 190 kg of 15% moisture

The overall average efficiency of the furnaces must therefore exceed:

$$\frac{\text{Heat to juice}}{\text{Heat in bagasse}} = \frac{0.64 \times 2.4\ GJ}{190 \times 14{,}725\ kJ} = \frac{1{,}536\ MJ}{2{,}798\ MJ} = 55\%$$

Typical operating efficiencies are less than this at 47 per cent, but over the crushing season in India cane fibre and juice brix both rise significantly. The effect of this is to reduce the required furnace efficiency to the point where a fuel balance can be expected over a season's working.

The main impediment to achieving this balance is the problem of drying the bagasse. Damp bagasse burns slowly and poorly, and furnace efficiency drops off quickly. Under Indian conditions, an excess fuel consumption (as firewood) of 3 per cent on cane is considered usual. This is equivalent, at 15,000 kJ/kg, to an extra 0.7 GJ per tonne of juice. (3 per cent on cane is 46.8 kg per tonne juice x 15,000 kJ/kg = 702,000 kJ.) This would indicate an average provision by bagasse of only 1.7 GJ of the 2.4 GJ required per tonne of juice, and consequently correspond to an average furnace efficiency of only 39 per cent.

One solution is to improve the efficiency of combustion of wet fuel. This would solve the problem, but it also means that furnaces have to be that much more efficient. The fuel value of wet bagasse at 55 per cent moisture is only 6,614 kJ/kg compared to 14,725 kJ/kg for dry bagasse, and the total heat value per tonne of cane is only 2.38 GJ (360 x 6,614) compared to 2.79 GJ — a reduction of 15 per cent. Wet fuel furnaces would therefore need to be more efficient than dry furnaces to obtain an equivalent fuel balance, ie. approximately 54 per cent when compared to the 47 per cent figure of the dry furnaces.

Scope for improvement to OPS

The scope for improvement rests with an increase in sugar yield without a proportionate increase in cost. Furthermore this must be achieved without increasing the complexity of the process or increasing the scale of operation. This means achieving higher milling efficiencies.

If milling efficiencies are increased, however, more pressure is put on the fuel balance. Improvements to the thermal balance of the factory can be sought, for instance, by using vapour from the top of the pans, as in the maple syrup industry in North America, to heat the juice. But these introduce a further level of complication in what is essentially a very simple process.

This effectively rules out increases to milling efficiency by imbibition. This only becomes attractive anyway if there are more than 3 mills in the tandem, and this is not normally the case with OPS. Other means of improving milling efficency must be sought and then matched by improved furnaces if the fuel balance is to be maintained.

After the losses to bagasse owing to low milling efficiency, the other major sugar loss is to molasses brought about by the constraints of cooling crystallization.

Developments with OPS

The following developments to the OPS process were proposed by the Planning Research and Action Division (PRAD) of the UP State Government in the early 1970s to counter some of the deficiencies noted above:

Crushing: Raise milling efficiency to 85 per cent — the dry crushing limit.
Clarifying: Improve methods of control on liming and sulphitation boiling.
Recovery: Introduce faster boiling techniques and furnaces capable of handling wet fuel, giving better efficiencies and reducing inversion losses.
Recovery: Develop a means of re-processing the high grade molasses to yield higher value products, such as liquid sugar.

THE IMPROVED OPS PROCESS

In the programme adopted by PRAD and latterly the Appropriate Technology Development Association (ATDA), under the guidance of M. K. Garg (Garg, 1979), this was translated into the following programme:

Crushing: A single stage screw extrusion device, known as a cane expeller, was developed which gave 85 per cent milling efficiency at capacities of 2-2.5 tonnes cane/hr.
Boiling: Extended surface, rectangular boiling pans replacing the traditional round pans, and wet bagasse combustion chambers were combined in the shell furnace for more efficient boiling. Faster boiling also reduced inversion losses.
Recovery: Investigation and trials of ion-exchange methods of re-processing molasses to produce high quality liquid sugars for industrial use.

It was gauged that these developments would retain the essential character of OPS technology and Figure 3 shows the potential impact of these improvements on factory performance.

	Milling efficiency x	Boiling house recovery =	Overall recovery
'OLD':	75%	75%	56%
'IMPROVED':	85%	75%	64%

Figure 3: Comparative performance of old and improved OPS sugar processes to produce 7 tonnes/day sugar

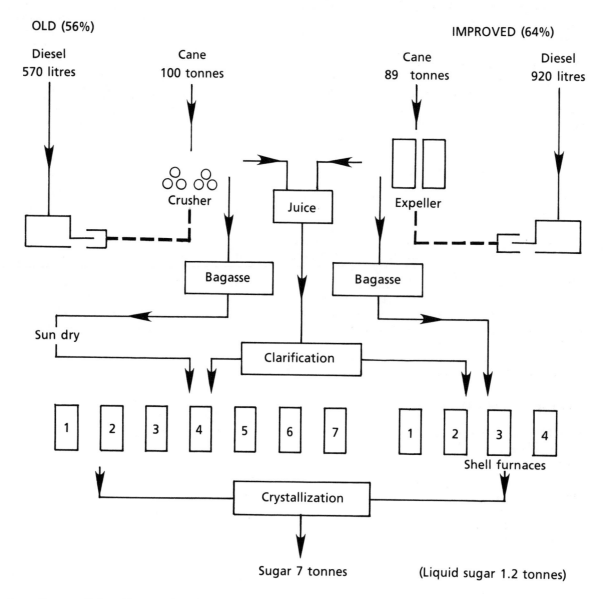

An estimate of the effect of this change in performance can be gained by looking at the impact on the two major cost items — cane purchase and diesel consumption — per tonne of sugar:

KSh		KSh
4,263	(100 t) Cane (89 t)	3,785
398	(570 l) Diesel (920 l)	637
4,661		4,422
	Change	- 239 = £10/tonne

(Assuming no major change in capital or other charges, and using current figures (Mallorie, 1986) for costs).

With the introduction of this more efficient technology, ATDA foresaw a continued expansion in the numbers of small sugar factories. This would include some new units and replacement of old, worn out units. Necessary adjustments to capacity could be achieved by adding or taking away units of equipment, giving a white sugar capability over the 50-200 tonnes cane/day range.

Given the industrialization of the food industry in India, the demand and price for liquid sugar products was expected to be good.

This being the case, ATDA saw scope for introducing the improved technologies as a full package, although there was some potential for introduction of the individual technologies. Replacing a crusher with an expeller would, for instance, increase sugar yield from 7 tonnes (7 per cent recovery) to 8.1 tonnes a day (7.9 per cent recovery), but liquid sugar capability could be added to existing installations and increase sugar yield by the equivalent of an extra 1.3 tonnes.

With a total yield of 9.4 tonnes of sugar from 100 tonnes of cane, the improved technology would then offer similar sugar yields to those of current large-scale practice in Northern India, where 9.5-10 per cent rendement is achieved.

The expeller components of the improved technology have reached the stage of commercial trials in India. So far the liquid sugar technology has not reached this stage of development. However, the new shell furnace has been widely adopted to improve fuel efficiency.

THE DEVELOPMENT OF OPS IN KENYA

ITDG's involvement at this stage turned from facilitating the development of the technology in India to a concern with its spread in other countries. On the basis of the improved technology developed by ATDA, the prospects were found to be potentially encouraging in a number of situations. One such situation involved sugar deficit countries with a tradition of smallholder cane agriculture. A particular example of this came to light in Kenya, where ITDG was to become involved in the small-scale OPS sector.

There are three OPS installations in Kenya, all in Western Province. The first unit was put up by Kenya Industrial Estates at Kabras. The second unit at Yala, the Ulumbi Sugar Factory, was where ITDG started work in 1982, and the third installation of West Kenya Sugar Company at Kakamega is where ITDG has been working since 1983.

There were several major changes from the circumstances in India which were immediately apparent. The longer cropping season (almost a full year), combined with better cane quality and wetter weather, have several implications for the OPS process.

Typical performance figures were:

Juice extraction:	65% (9-roll crusher)
Juice brix:	20
Bagasse moisture:	50%

This gives:	
	$F = 13.4$
	$B = 13.0$
	$b = 4.1$
	$W = 52.0$
	$w = 17.5$

With the higher fibre and higher brix, a fuel balance should be easier to obtain. However, in practice, excess fuel consumption of up to 10 per cent was reported from the Yala OPS factory in Kenya. Both this factory and the original Kenyan OPS unit at Kabras eventually ceased trading.

Although technical reasons are not normally given for the failure of the original Yala plant, underlying difficulties of process performance, particularly fuel efficiency, are likely to have been important.

For climatic reasons, drying of the bagasse is far more problematic in Kenya than in India, In fact, it is virtually impossible to ensure that bagasse can be dried during the rainy months. Without reasonably dry bagasse, it is impossible to run the furnaces and therefore process the cane juice.

Using the shell furnace, wet bagasse technology does overcome this operational difficulty in times of high rainfall, but the fuel balance has not been as good as expected. Firewood consumption has persisted at 3-4 per cent on cane. From trials in India, shell furnace efficiencies of up to 54 per cent were reported, making the performance equivalent to that of dry bagasse furnaces. In Kenya, it has proved difficult to reliably achieve efficiencies of 48 per cent. Part of the reason for this became apparent when it was realized, somewhat belatedly, that the furnaces in Kenya operate at 5,000 feet altitude. This has a dramatic effect on chimney draught. With specific air volumes up by 20 per cent, furnaces designed for sea level use in India require modification. Otherwise outputs and efficiencies tend to suffer at a more or less equivalent rate.

The remaining reasons for this poor efficiency are currently thought to rest with difficulties over regularizing manual fuel feeding over the long operating periods. This is a situation that had not arisen so clearly during trials in India and arises from different labour practices between the two countries —

regular furnace-feeding during the night appears to be more achievable in India. Currently, efforts are being made to change the combustor configuration to improve performance on crusher bagasse.

With expeller bagasse, which is much smaller in size than crusher bagasse, a screw feeder can be used to successfully regulate feed, and higher furnace efficiencies of 55 per cent and above can be achieved. This is important, as the higher crushing efficiency generates a greater volume of juice that is only partly compensated for by the higher heat content of the drier (40 per cent moisture) bagasse.

IMPROVEMENTS TO OPS IN KENYA

While in India it is important to achieve high milling efficiencies and high boiling house recoveries to maximize the yield of crystal sugar, the same is not necessarily true in Kenya. Kenya has a ready market for solidified molasses. With good quality syrups, purity 82 and above, it is possible to take a 35 per cent yield of white sugar (compared to 30% in India) on a slightly larger quantity of syrup (150 kg/tonne instead of 135 kg/tonne, because of higher juice brix) to give at least 5.5 per cent yield of first sugar. The remaining syrup can then be boiled to solid molasses, giving a 6.5 per cent yield of this product which attracts a relatively good price when in short supply. High milling efficiency will improve these figures. However, with the current situation in the sugar products market, it is not always necessary to achieve high boiling house recoveries by going for second/third sugar. This can be expected to change with time if more OPS units are established and the price of solid molasses is driven down by the increase in supply.

For Kenya, then, the key improvements to the OPS technology are improved crushing and fuel efficiency. The value of the expeller and shell furnace in meeting these requirements may be estimated by comparison with use of the existing technology. The calculation in Figure 3 shows the value of this improvement per tonne of cane processed.

The key question now is whether a small-scale white sugar sector will emerge within Kenya. The major impediment to new investment remains the level and uncertainty of the processing margin — the difference between the cane and sugar prices[1]. A pricing structure which allows large-scale mills to earn a reasonable return on capital would also allow profitable operation by OPS units. However, there is no scope for improving OPS technology to the point where it will be unaffected by the level of prices or insulated from uncertainty. On the basis of current estimates, the attractiveness of sugar production to replace jaggery manufacture is not yet proven. Nevertheless, with an incentive price for sugar cane and a domestic deficit in sugar, it is likely that specific investment possibilities will arise, particularly if incentives on duties and taxes continue to be introduced to encourage small industries.

THE SCOPE FOR FURTHER DEVELOPMENTS WITH OPS

The basic drawback to open pan technology is the relatively high consumption of cane for the sugar that it produces. This means that the process is vulnerable to changes in the agricultural environment that limit the volume of cane available, and make it sensitive to the prices that will be charged for it. By incorporating the expeller/shell furnace technology, a significant improvement can be made to this situation. Sugar revenue from molasses could be increased by reprocessing to liquid sugar, but the technology for this is not yet commercially available.

Beyond this, the main technical options for further reducing the quantity of cane required for sugar manufacture by the OPS process are to introduce imbibition to raise milling efficiency, and evaporative crystallization (with closed pans) to improve crystal sugar recovery.

Thinking along these lines soon leads to the adoption of multiple effect evaporation to deal with the extra volume of juice, and steam generation to supply the heat/power needs of this type of plant. All of these are technologies with significant scale economies, and one is no longer immediately talking about a small scale investment.

However, it is important to recognise that the research effort invested in the current generation of OPS technologies has been relatively modest. There may be possibilities for improvements that have not yet been looked at — vapour recompression for instance — which could offer better performance in existing installations, or may require, as with the expeller, the installation of new equipment. At the moment, it is difficult to see technologies which can effectively bridge the gap between the larger 200 tcd OPS plant and the minimum 1,250 tcd of the conventional, large-scale VP processes.

Expansion of OPS units

After any sugar factory has been in succesful operation for some time and the loans have been repaid, it becomes practical to look at further investment opportunities. If there is more capacity on the agricultural front to grow cane, no problems with the workforce, and the infrastructure is capable of sustaining a higher level of activity, then it is simply a question of the incentive to invest.

Attention will turn to the possibility of improving capacity utilization by expanding and rehabilitating the existing processing line. Here it becomes practical, with large-scale processes, to contemplate a significant reduction in operating cost. This would be on the back of major scale economies in procurement and operation of larger pieces of equipment, such as boilers, evaporators, etc., and the rebuilding of milling tandems to provide higher throughput with extra mills and improved cane preparation.

The same situation does not apply to anywhere near the same degree with open pan methods of processing. The reasons for this are clear:

Crushing: Capacity of the 6-roll crusher can be increased from 4 tonnes/hr to 6 tonnes/hr by adding an extra mill, with a slight improvement also in milling efficiency. The extra unit will require more installed power and as a marginal investment, has some attractions where the extra power is cheaply available. Otherwise the extra juice can be more expensive. Beyond this, the scope lies with a bigger, replacement crusher.

Clarifying: Easy to expand, but with no reduction in unit costs as expansion is entirely by duplication.

Boiling: Again, expansion by duplication leads to no reduction in costs; in fact, open pan boiling beyond 200 tonnes/day becomes difficult to manage efficiently.

Recovery: As for clarifiying.

With the expeller, crushing capacity can only be expanded by duplication, so there are virtually no economies of scale to be achieved. In this case, it becomes more practical to think of establishing another completely new unit. However, unless investment prospects are favourable — and in 1987, investments in sugar are unlikely to do as well as earlier investments — the implications are that OPS factories are unlikely to be the subject of major re-investments beyond the initial installation.

The role of OPS technology

With OPS factories barred from major scale economies and restricted by technical constraints to the lower levels of overall recovery, they are unlikely to play a mainstream role in the domestic production of white sugar. OPS technology is, however, indicated in three particular circumstances:

Surplus cane: Where cane is in repeated surplus and existing capacity is unable to cope, then there is a case for allowing OPS units to function.

Restricted cane supply: If it is clear that the land available for cane production is going to be inadequate to supply a large processing unit, but that small quantities of cane may be usefully grown, then there is a case for considering OPS technology.

Cane development: Where cane supply is to be developed, but is currently insufficient to consider establishing a large factory at the outset, then there is a role for OPS. This is particularly the case where the infrastructure of the area is poorly developed and sophisticated technologies are unlikely to prove appropriate. OPS capacity can be extended by duplication and if there proves to be an adequate supply of cane, these units may be replaced or relocated at a later date to make way for a larger processing unit.

Very careful appraisal and determination is required before it can be stated that OPS technology has a role to play in domestic sugar production. This assessment must be firmly based on the performance boundaries of the technology which have been addressed, all too briefly, in this paper.

Note

1. It ought to be noted, however, that the same factor limits the diffusion of new, large-scale mills.

REFERENCES

Garg, M. K., *Project Report and Feasibility Study of Appropriate Technology on Mini Sugar (OPS Khandsari)*, ATDA, 1979.

Hugot, E., *Handbook of Cane Sugar Engineering*, Elsevier, 1972.

Mallorie, E., 'Appraisal of Small-Scale Sugar Production in Kenya', Internal Document, ITDG (1986).

10

Economic viability of small-scale sugar production in Kenya[1]

Edward Mallorie

The purpose of this paper is to evaluate the economic viability of small-scale open pan sulphitation (OPS) sugar production in Kenya relative to conventional large- and medium-scale systems. The wider development benefits of OPS sugar production will be identified, and potential policy measures to realize these benefits through investment in OPS production discussed.

The economic performance of different systems is evaluated using models of five different systems:

○ Large-scale vacuum pan, using conventional technology, with a capacity of 3,600 tonnes of cane per day (tcd). This system is referred to as VP in tables.
○ Medium-scale vacuum pan, using an improved diffusion technology to extract more sugar from a tonne of cane, with a capacity of 450 tcd (MVP in tables). Mills of this type have been installed in a number of countries by A/S De Danske Sukkerfabrikker (DDS), Denmark.
○ Small-scale open pan sulphitation factory, as installed by West Kenya Sugar Company (WKS) but on a slightly smaller scale (100 tcd), manufacturing white sugar and molasses (OPS1 in tables).
○ Small-scale 100 tcd OPS factory (OPS2 in tables), similar to OPS1 but manufacturing white sugar and solid molasses.
○ Jaggery plant with a capacity of 45 tcd (JAG in tables). This is a little larger than the typical jaggery plant and has been included to evaluate the incentives for jaggery producers to upgrade to OPS sugar production.

The physical and price parameters used in the models are in the tables in Appendix II, together with calculations of model performance. The current position of jaggery production following the imposition of sales tax is not entirely clear. For the purposes of this report, it is assumed that jaggery production will continue but, due to the 15 per cent tax, net ex-factory prices will remain the same as last year.

RELATIVE COSTS OF SUGAR PROCESSING SYSTEMS

Cost per tonne of sugar

The financial costs of producing sugar with molasses as a by-product are shown in Table 1 and illustrated in Figure 1.

The following conclusions can be drawn from this analysis:

○ The OPS plant has the lowest capital charge per tonne of sugar produced — about 55 per cent that of the VP plant, which in turn is about half that of the MVP plant. This reflects the less capital intensive, less mechanized technology used by the small-scale system.
○ The OPS plant has substantially higher cane costs per tonne of sugar produced, due to its lower rendement (sugar recovered per tonne of cane). The less efficient milling and boiling technology means less juice is extracted from the cane and less sugar recovered from the juice. In terms of tonnes of cane per tonne of sugar produced, relative efficiencies are:
 VP — 9.09
 MVP — 8.93
 OPS — 12.50

The cost of cane at the mill gate has been assumed to be the same for all three systems at KSh 341 per

Table 1: Costs of sugar production — financial prices (KSh/tonne)

	VP	MVP	OPS1
CAPITAL (depreciation and interest	2,335	3,500	1,293
OPERATING Cane at mill gate	3,100	3,045	4,263
Chemicals and bags	132	131	226
Fuel	8	20	443
Maintenance and misc.	314	588	499
Labour	181	362	798
Management assistance	255	478	0
TOTAL OPERATING	3,991	4,624	6,228
TOTAL COSTS	6,326	8,124	7,520
REVENUE Sugar	5,830	5,830	6,459
Molasses	73	71	352
TOTAL REVENUE	5,903	5,901	6,811
NET MARGIN	-424	-2,222	-710

Figure 1: Costs per tonne sugar, financial prices

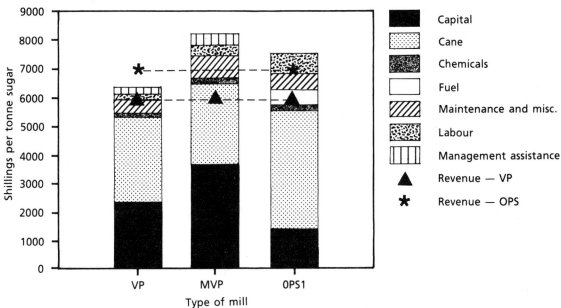

tonne, the current official price. In practice, the actual cost will include transport costs from field to mill in factory trailers less transport allowances deducted from payments made to farmers. Calculations based on transport models in Mallorie (1985) and Mallorie (1986) suggest that although the large mills have to haul cane over longer distances, they are able to do this more efficiently due to a larger daily tonnage and purpose-built access roads. However, interviews with both large- and small-scale mills indicate that official transport allowances broadly cover costs, so transport costs have been excluded from this model.

○ The less efficient OPS technology also results in higher chemical costs (for clarification of juice) and fuel requirements. Vacuum pan mills, if efficiently managed, should generate virtually all their power and heat from steam generated by burning of bagasse.

○ The more labour intensive OPS process results in considerably higher labour costs. However, these

are partly offset by charges for expatriate management and technical assistance for the vacuum pan mills. The requirement for, and cost of, this assistance is difficult to define, and in practice some technicians from India have been involved in the introduction of OPS systems in Kenya. However, the cost of such assistance is likely to be much greater for vacuum pan mills.

O Because of higher cane costs which account for half to two-thirds of total costs, total costs for the OPS model are more than 18 per cent higher than for the VP model but lower than for the MVP model. Higher costs are largely offset by the higher prices received for sugar by the OPS plant, as it is allowed to wholesale its sugar directly rather than via the Kenya National Trading Corporation (KNTC). In addition, the small volume of molasses produced with a high sugar content can be sold for animal feed and other purposes, while most of the molasses produced by large mills has to be exported, incurring substantial transport costs to eventual users overseas.

The net result is a negative margin over total costs of KSh 424 per tonne sugar for the VP model, compared with a loss of KSh 710 per tonne for the OPS model. The MVP model is even less viable; it combines the high capital costs of the VP process without its economies of scale, and within the context of Kenyan prices does not appear to be competitive with the OPS system.

Although large-scale vacuum pan production appears to produce sugar at a lower cost than OPS plants, calculations lack sufficient precision to conclude that OPS is a less profitable system of sugar production. The more capital intensive VP system, with its higher fixed costs, is more sensitive to reductions in cane supplies. It has been calculated that if it is only possible to operate for 215 days per year, the OPS model has a smaller negative margin than the VP mill.

The viability of the OPS system may be declining over time. Cane prices have been rising faster than sugar prices (up over 2.5 times since 1980, compared with a doubling of ex-factory sugar prices), and as OPS factories use more cane per tonne of sugar their margins will have been reduced relative to VP mills.

Cost per tonne of cane processed

Comparison of costs and returns per tonne of cane processed enables the viability of systems making different products to be compared. Systems which convert cane into sugar more efficiently will have a higher revenue per tonne of cane.

Jaggery can be produced by small-scale mills as well as, or instead of, white sugar and molasses. There are numerous small plants producing nothing but jaggery, and an OPS plant can maximize its returns by producing a combination of white sugar and solid molasses (see Table 2). This process involves only a single crystallization, and so avoids the need for equipment for second and third sugars. The residue is all converted into solid molasses which, although selling for less than jaggery made from whole cane juice, gives a much better return than molasses.

Table 2: Value of sugar in different products

Product	Price/tonne[a] (KSh)	Sugar content (%)	Return per tonne of sugar in product (KSh)
Sugar	5,712	100	5,712
Jaggery	4,286	78	4,984
Solid molasses	3,571	64	5,580
Molasses	670	48	1,396

a. Prices are ex-mill, 1986.

The returns per tonne of cane processed are calculated in Table 3 and shown in Figure 2 for 100 tcd plants producing sugar and molasses (model OPS1), sugar and solid molasses (model OPS2), and a medium-scale 45 tcd jaggery plant (model JAG), as well for VP and MVP models.

It can be seen from Table 3 that although the returns from the OPS model are much improved by the production of sugar and solid molasses and are now better than the large-scale VP mill, returns per tonne of cane processed are still lower than for the jaggery mill. The OPS model has higher unit capital and operating costs, which more than offset the better recovery rate and more valuable product combination. In particular, jaggery plants pay well under (about half) the official price of cane. Although these plants

Table 3: Costs and returns per tonne cane (KSh)

	VP	MVP	OPS1	OPS2	JAG
CAPITAL (depreciation and interest)	257	392	103	89	99
OPERATING					
Cane at mill gate	341	341	341	341	170
Chemicals and bags	14	15	18	22	8
Fuel	1	2	35	35	20
Maintenance and misc.	35	66	40	35	21
Labour	20	41	64	66	21
Management assistance	28	54	0	0	0
TOTAL OPERATING	439	518	498	500	239
TOTAL COSTS	696	910	602	589	338
REVENUE					
Sugar	641	653	517	355	0
Molasses	8	8	28	239	0
Jaggery	0	0	0	0	386
TOTAL REVENUE	649	661	545	595	386
NET MARGIN	-47	-249	-57	6	48

Figure 2: Costs per tonne cane, financial prices

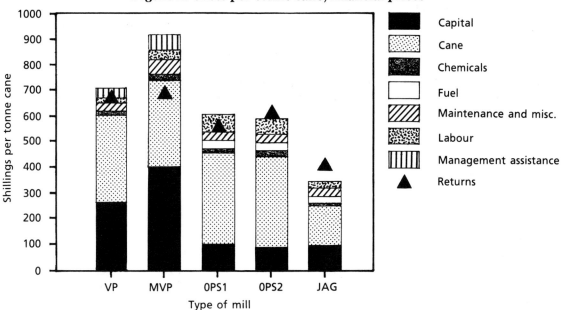

have a less reliable supply of lower quality (often immature) cane, the saving in costs more than offsets the shorter operating season and lower recovery rate.

WIDER ECONOMIC AND SOCIAL BENEFITS

Although the OPS models are only marginally viable in financial terms, there are wider benefits that can be attributed to OPS technology. These benefits can be assessed in terms of broad benefit to the Kenyan economy as a whole, and in terms of linkages which fulfil specific development objectives such as agricultural progress, rural employment and technological self-sufficiency.

Economic cost of production

An economic appraisal has been carried out using shadow prices to reflect the true cost of inputs and value of outputs to the economy as a whole. The following are the principal adjustments to financial prices:

○ Shadow exchange rate (SER) to reflect the scarcity of foreign exchange. This shadow rate amounts to a devaluation of 20 per cent, as used by Phillips (1984). Application of the shadow exchange rate increases the cost of imports and the value of exports.

○ Shadow wage rate (SWR) below formal sector wages to reflect under-employment in the rural economy. For agricultural labour, the SWR has been fixed at KSh 7.50 per day — the current wage for informal casual work on farms — and for unskilled and semi-skilled work in factories, the SWR is 55 per cent of the money wage rate (as used by Aldington, Public Sector Handbook, 1979).

○ Sugar cane has been valued at the cost of production plus a land rental charge equal to the gross margin for a maize crop as the opportunity cost of forgoing this alternative crop. Calculations of cane and maize production costs are in Appendix II.

○ Sugar and maize have been valued at the cost of imports, valuing domestic production as an import substitute. Import costs are calculated as estimated average free market world prices. These estimates, contained in Appendix II, are below some projections for long term prices but about 50 per cent above current levels.

○ Import duties and sales taxes have been excluded from price calculations as internal transfers.

The tables in Appendix II contain calculations of economic returns using shadow prices. The results of these calculations are summarized in Table 4 and include the following changes from the financial analysis:

○ A small reduction in capital costs, as the removal of the 30 per cent import duty more than offsets the 20 per cent reduction in exchange rates.

○ Reduction in cane costs, except for jaggery mills, owing to pricing at production cost excluding the considerable profits made by farmers.

○ Increase in fuel costs for OPS plants, as industrial diesel oil (IDO) is not taxed but is imported — 75 per cent of cost is assumed to be foreign exchange.

○ Decrease in labour cost due to shadow wage rates for unskilled workers.

○ Reduction in sugar prices as import parity prices are below current ex-mill prices. OPS prices include a premium of KSh 629/tonne, the KNTC and Ministry of Commerce (MoC) levies, to take account of lower distribution costs for smaller-scale producers. It is questionable if a premium of this size reflects

Table 4: Costs per tonne cane — economic prices (KSh)

	VP	MVP	OPS1	OPS2	JAG
CAPITAL (depreciation and interest)	247	375	98	84	99
OPERATING					
Cane at mill gate	281	281	294	294	294
Chemicals and bags	14	15	18	22	8
Fuel	1	2	41	41	23
Maintenance and misc.	33	63	37	33	21
Labour	17	34	48	49	20
Management assistance	28	54	0	0	0
TOTAL OPERATING	374	447	438	438	365
TOTAL COSTS	621	823	536	522	464
REVENUE					
Sugar	575	585	468	322	0
Molasses	27	27	28	239	0
Jaggery	0	0	0	0	386
TOTAL REVENUE	602	612	496	561	386
NET MARGIN	-19	-210	-39	39	-78

the real cost difference, but no data has been collected on comparative distribution costs.
○ Increase in value of exported molasses, calculated on the basis of a typical world price less transport costs.

The net result of the economic appraisal is a significant reduction in production costs per tonne of sugar; however, this is partly offset by reduced income. The OPS1 model still has a negative margin over total costs and its performance relative to the VP and MVP models is unchanged, as although the OPS model benefits more from reduced labour and cane costs, this is offset by a relatively large reduction in capital costs for VP models, an increase in the value of VP molasses, and increased fuel costs for the OPS model.

The economic returns per tonne of cane show that the margin per tonne of cane for the OPS2 model have increased, and are now significantly more than for jaggery production where returns have been reduced by an increase in the cost of cane.

It can be concluded from this analysis that although the viability of small-scale systems is better if evaluated using economic prices, they do not appear to make substantially more efficient use of national resources than large-scale mills. However, OPS sugar plants do appear to make a better use of cane supplies than small jaggery mills.

Social benefits

With a rapid rate of population increase, creation of employment is an important objective of government policy. A 100 tcd OPS factory, together with its cane transport, would directly employ about 222 people. As 188 of them would be classed as unskilled, it also meets the objective of creating jobs for disadvantaged people in rural areas. In contrast, the VP plant employs a total of 984 people, or 0.01 persons per tonne of sugar produced compared with 0.116 for the OPS plant. The investment per job is much less for the OPS plant; KSh 59,000 compared with KSh 1.49 million for the VP mill.

The benefits of sugar cultivation are also likely to be more evenly distributed amongst farmers in the area served by an OPS mill. Transport deductions encourage the concentration of production in the area close to the mill. Cane monoculture has tended to develop around the VP mills, resulting in a concentration of land holdings. There is less incentive to develop such a monoculture close to an OPS mill. Owing to loading time, there is little difference in actual transport costs, and none in official allowances, between growers located within 10 km of the mill. If all the cane for a 100 tcd plant were grown in this area, only 1.5 per cent of the land area would be required with cane continuing to be mixed with food crops.

Cane production for VP mills tends to be more commercialized and mechanized, with the mill taking responsibility for most field operations. Production for OPS mills tends to be on a small scale, with an average plot size of 0.6 ha for suppliers to WKS compared with 1.6 ha for Mumias (see Lemmens). These farmers use family labour to grow cane, and as more cane is required per tonne of sugar than in VP mills, additional work is created for farm families.

The development of an OPS sugar sector may have a number of other benefits for the economy. It is more likely to involve local capital and entrepreneurs than the large VP plants, which tend to require some public sector funding and involvement of foreign multinationals in both investment and management. Much steelwork for OPS plants can be fabricated locally, and the development of an OPS sector could result in the emergence of a sugar engineering industry.

Efficiency of land use

Policies for the development and management of the Kenyan sugar industry will have to take account of a growing shortage of arable land. If the degree of self-sufficiency in principal food crops is ultimately limited, then a choice between self-sufficiency in maize or sugar may have to be made. Analysis of net returns per hectare using shadow prices (Table 5) indicates that there is little difference between maize and sugar produced by the OPS2 model, when valued at import parity prices.

There is a better return to land used to produce cane for OPS rather than VP processing. With a higher crop yield and better recovery rate, the VP system produces 6.72 tonnes of sugar per hectare compared with 3.69 tonnes for the OPS1 model. However, this is offset by higher production and processing costs per tonne of cane, so net returns per hectare are higher for the OPS2 model.

Table 5 suggests that export parity prices for both sugar and maize are well below import prices, so it is unlikely to be economic to export one crop while importing the other. Unless above average prices can be obtained (such as by exporting to neighbouring countries), it is unlikely to be economic to produce either maize or sugar for export; better opportunities exist for high value crops such as tea and coffee.

Table 5: Economic returns per hectare (KSh unless other unit shown)

	Maize	OPS cane	VP cane
COSTS			
Cultivation cost per ha	3,519	22,425	39,189
Yield tonnes grain/cane/ha	3.6	215.0	290.0
Cultivation cost per tonne	978	104	135
Processing cost per tonne		228	340
Total cost per tonne	978	333	475
Output tonnes per ha/year	4.8	46.1	60
TOTAL COST PER HA/YEAR	4,693	15,330	28,504
RETURNS — IMPORT PARITY PRICES			
Price per tonne grain/sugar	3,404	5,854	5,225
Value per tonne of:			
cane/grain	3,404	322	575
molasses & jaggery		239	27
Total	3,404	561	602
TOTAL RETURNS PER HA/YEAR	16,340	25,858	36,122
NET RETURNS PER HA/YEAR	11,647	10,528	7,618
RETURNS — EXPORT PARITY PRICES			
Price per tonne grain/sugar	1,932	3,915	3,915
Value per tonne of:			
cane/grain	1,932	215	431
molasses & jaggery		239	27
Total	1,932	455	458
TOTAL RETURNS PER HA/YEAR	9,273	20,943	27,472
NET RETURNS PER HA/YEAR	4,580	5,613	(1,032)

Decisions regarding allocation of resources to different crops should also take employment into account. According to the calculations in Appendix II, one hectare of maize cultivation needs 161 person days per year (at a cropping intensity of 1.5); sugar cane grown for VP mills needs only 63 person days per year and if grown using less machinery for OPS mills, 90 person days. However, if processing is also taken into account, one hectare of sugar cane can create more work—a 100 tcd OPS mill employing 222 people uses 2.22 person days to process one tonne of cane, and 102 person days for the 46 tonnes of cane grown per hectare per year. This gives a total of 192 person days per hectare, compared with 161 for maize (although some additional jobs would also be created in maize milling). VP sugar production is not such a good job creator, only needing a total of 79 person days to grow and process one hectare of cane.

As well as creating more work in rural locations, cane production can result in a major increase in farm incomes. The gross margin per hectare per year for OPS cane is calculated in Appendix II to be double that for maize. Interviews of farmers growing cane indicated that they grew cane for cash and maize for domestic consumption (CSP International Ltd., 1986), and cane production has resulted in a general increase in rural prosperity with linkages creating additional off-farm jobs in trading and services.

Framework for policy for sugar production

Examination of the wider benefits of small-scale sugar production indicate that it has significant advantages relative to large-scale mills as a source of employment in rural areas. Comparison of maize and sugar production suggests that small-scale sugar production is as efficient in utilization of scarce land resources as maize, and can create more jobs per hectare. In addition, the price obtained by farmers selling cane to sugar mills generates considerably more income than sales of maize, contributing further to rural prosperity and employment. These benefits are distributed more widely and equitably in areas supplying small-scale mills.

Policies aimed at developing small-scale sugar production will therefore have the prime objective of creation of rural employment, with additional benefits such as mobilization of private capital and minimal requirements for public sector investment. However, as financial returns to small-scale sugar

production—particularly relative to jaggery production—are poor, it may be necessary to offer investors financial incentives.

INCENTIVES FOR INVESTMENT IN SMALL-SCALE SUGAR PRODUCTION

To encourage development of OPS sugar production, the government could give investors the following concessions and financial incentives:

O Exemption from import duties on equipment. This measure has already been enacted for rural industries importing up to KSh 5 million of equipment, and would result in a significant reduction in capital cost per tonne of sugar for the OPS1 model. As the present potential for development of an indigenous sugar engineering industry is limited, this measure should have little adverse effect on other sectors.

O Exemption from the KSh 1,000 per tonne excise duty on sugar produced by small-scale mills would substantially raise returns. Such exemption could be considered as compensating for the lack of government investment in infrastructure such as power supplies and roads. This can be a substantial additional cost in the establishment of large-scale mills which is paid for directly by the government rather than by the investors, and on which there is no direct return.

O The availability of credit at reduced rates of interest could make capital available at a reduced cost. Such credit from international lending agencies such as the International Finance Corporation (IFC) could be channelled through local banks to the private sector.

O De-control of cane prices could enable small-scale mills to reduce their major item of cost. A high price for cane, while encouraging production, discourages processing, and only benefits those farmers fortunate enough to have access to a mill so may lead to concentration of production on those farms. It is a particular disincentive for jaggery producers (who do not pay controlled prices) to up-grade to sugar production. However, with a substantial investment in capital equipment, sugar processors need a reliable supply of good quality cane to utilize their plant fully. For this reason the potential to reduce cane prices for OPS mills is thought to be limited, but may be a significant advantage for jaggery producers adopting more basic sugar production methods, such as non-sulphur sugar, which are less capital intensive and therefore may tolerate a less reliable supply of cane.

**Table 6: Impact of incentives for investors in OPS sugar mills —
margin over total cost (KSh/tonne cane)**

	VP	OPS1	OPS2	JAG
Baseline	-19	-57	6	48
No import duty		-43	18	
No excise tax		23	61	
No tax or duty		37	73	
Reduced interest rate (5%) and no duty		-24	34	

Table 6 compares the impact on processing margins of exemption on equipment import duty and excise tax for OPS sugar mills, relative to margins for large-scale VP mills and jaggery plants.

These figures suggest that although import duty exemption and cheaper capital improves returns, only removal of excise tax will increase returns sufficiently to make OPS sugar more profitable than jaggery production.

THE FUTURE OF SMALL-SCALE SUGAR PRODUCTION

Constraints to adoption

Apart from low financial returns, a number of management and technical factors may constrain the

development of the small-scale sugar sector. Even if small-scale sugar plants appear to be financially viable, other constraints may prevent development.

A major constraint to the adoption of small-scale sugar is that the scale of a 100-200 tcd OPS plant does not match the resources of rural entrepreneurs. These businessmen, who may also be farmers, typically invest in small industries such as jaggery and posho mills, but lack the capacity to invest millions of Shillings and the management skills to organize a labour force of some hundreds together with cane supplies from a similar number of farmers.

Industrialists and urban entrepreneurs may have better access to management and capital resources, but may see unacceptable risks regarding the volume of cane required for an OPS plant and government control of input and output prices. In a sector dominated by parastatals, government may keep manufacturing margins low in order to maintain politically attractive prices and forego commercial returns on their own investment. To offset these risks, investors may look for rapid returns on investment that would be difficult to achieve in a sugar industry where the substantial capital investment will need to be written off over some time, and where cane supplies may take some time to build up.

One of the major benefits of OPS is that it employs large numbers of workers. However in countries such as Kenya, with a tradition of formal employment and extensive legislation to protect workers, this may discourage potential investors who see a large labour force as an inflexible expense not entirely under their control and a source of legal and management problems.

OPS technology has developed as a craft skill in India. These skills are not readily available in Kenya and may be more difficult to transfer than more formally organized technologies. Shortage of appropriate skills will tend to concentrate OPS production in relatively large units where the best use can be made of a limited number of key workers.

Development path for small-scale technology

Development of the sugar sector should be a dynamic process. Processing enterprises, if they are to survive and thrive, have to adapt to changing circumstances and take advantage of opportunities to improve efficiency. As farmers respond to the market opportunities offered by a processing unit, cane supplies will improve and a processing unit will be able to expand to make better use of its capital and management resources. As profits accumulate, capital may become available to invest in increasing efficiency and generating more income per tonne of cane. This will enable a higher price to be paid to farmers, which in turn will encourage an increased supply of cane.

Individual processing units will therefore tend to grow over time and as they grow, take the opportunity to utilize economies of scale in adopting more advanced processing systems. It may therefore not be unusual for jaggery plants to develop into OPS sugar plants and OPS plants expand to a scale sufficient to utilise vacuum pan technology.

This process of gradual growth and increasing efficiency may be constrained by technologies that are highly scale-specific and so do not operate efficiently outside a narrow range of scales. Enterprises wishing to expand have to make a major investment to leap up a big technological step. The scale and investment required by OPS is a constraint on the introduction of sugar production at jaggery plants. The big difference between controlled cane prices paid by sugar producers and non-controlled prices paid by jaggery mills is an additional disincentive.

Further development of processing systems could therefore aim to produce sugar on a smaller scale (say 50 tcd) which, together with de-control of cane prices for small-scale plants, would encourage the diversion of cane now used to make jaggery into more efficient sugar production. At the same time, technical development of the OPS system would aim to improve the extraction efficiency of larger plants without a disproportionate increase in capital cost.

Continued technical development of small-scale sugar production, combined with de-control of cane prices and concessions on excise duty, would encourage the development and expansion of small-scale sugar production. This would provide a major source of employment and spread equitably the benefits of cane production between a large number of farmers, without displacing food crops.

Notes

1. This paper is, to a large extent, based on some earlier papers (Appraisal of Small-scale Sugar Production in Kenya, ITDG, 1986; Sugar Economics Review, ITDG, 1985) with prices updated to 1987 levels. Reference has also been made to a number of papers written on behalf of ITDG by other authors (see references).

REFERENCES

CSP International Ltd. (now part of Booz, Allen & Hamilton), *Sugar Processing*, ITDG/ODA (1986).
Mallorie, E., 'Appraisal of Small-Scale Sugar Production in Kenya', Internal Document, ITDG (1986).
Mallorie, E., *Sugar Economics Review*, Internal Document, ITDG (1985).

Mallorie, E., *The Economics of Alternative Sugar Production Technologies*, MSc Dissertation, Univerity of Reading (1984).

Phillips, D., 'Choice of Sugar Processing Technology in Kenya, a Social Cost-Benefit Analysis', Internal Document, ITDG (1984).

Sugar Knowledge International Ltd. (SKIL), *Kenya Sugar Study*, Internal Document, ITDG (1984).

Schluter, M., *Constraints on Kenya's Food and Beverage Exports*, International Food Policy Research Institute (1984).

11

Sugar policy in Kenya: A farmer's dilemma[1]

David Makanda

The problems of the sugar industry in Kenya are many and complex. They range from technological choices to management options. At the core is the issue of whether or not the industry has achieved, or is likely to achieve, the desired goals. It is the evaluation of the objectives and the strategies to achieve them that has generated endless debate in Kenya's sugar industry.

The overall objective of the Kenya Government has been the social development of the people of Kenya. This is to be achieved through growth, equity and participation (Government of Kenya, 1965). Rural industrialization has been seen as one strategy of achieving these tripolar objectives; hence the setting up of sugar factories. Apart from generating rural employment, the sugar industry has been seen as a way of making Kenya self-sufficient in a major foodstuff — sugar.

Yet the sugar industry seems to have eluded these goals. Questions are being raised about the industry's ability to make Kenya self-sufficient in sugar production, as well as its impact on the rural economy in which it is located. Thus the problem with the sugar industry in Kenya is defining its future role in achieving the set objectives, given that the performance so far has been unsatisfactory.

The main objective of this paper is to discuss the role of the sugar industry in regional development. This is done by looking at the real options facing farmers in the sugar cane growing area — Western Kenya. Focus is put on two areas in the sugar belt: the Kabras area in Kakamega district and the Miwani/Chemelil/Muhoroni area in Kisumu district. These two areas were chosen because of the insights they provide concerning open pan sulphitation (OPS) production in Kenya. The West Kenya OPS factory lies in the Kabras area, whilst the Miwani/Chemelil/ Muhoroni complex of mills is adjacent to Kabras. It is important to note that neither of the chosen areas is in those regions most ecologically favourable for sugar production in Mumias and Nzoia.

There is one operational OPS plant in the Kabras area, the West Kenya Sugar Company. The Miwani/Chemelil/Muhoroni area contains three vacuum pan (VP) factories, one private and two government-owned. Sugar cane has been grown in the area for the last sixty years. Therefore, the two areas form a representative sample of the diverse conditions in Kenya's sugar industry but exclude the region most ecologically favourable.

The sugar belt

For the purposes of this study, the sugar belt is considered to be that part of Kenya that is administratively covered by Bungoma and Kakamega districts of Western Province, and Kisumu, Siaya and South Nyanza districts of Nyanza Province. Together these districts grow about 98 per cent of the national sugar cane production, the remaining 2 per cent being produced by Ramisi in Coast Province. By virtue of the location of the factories, the sugar belt can be divided into three zones. Zone one constitutes the Nzoia-Mumias axis, producing about 52 per cent of the national sugar production. Zone two is the Miwani-Chemelil-Muhoroni axis, producing another 43 per cent. The third zone is the South Nyanza Sugar Company, which produces about 3 per cent of the national production (see Map 1).

Sugar cane was first grown in the sugar belt for commercial purposes around 1924 with the establishment of Miwani sugar factory. After Independence, the Kenya Government embarked on an aggressive policy of making Kenya self-sufficient in sugar production by investing substantially in the industry. Both climatic and historical circumstances dictated that most of the sugar cane be grown in the sugar belt, particularly in the aforementioned districts. Since 1965, the government has established five sugar factories in the area and sugar cane growing has more than tripled. By the end of 1980, the government had invested more than KSh 2.1 billion (US $290 million, 1980 exchange rate) in the industry. These prices — although converted into 1981 currency — are a compilation of expenditures over the years and are consequently difficult to interpret. Moreover they exclude investments in infrastructure.

Nevertheless, it would appear that more investment has gone into sugar processing than any other industrial sector in Kenya. Government involvement in the industry has invariably been in large-scale sugar companies. The argument, as has been given by the Kenya Sugar Authority (KSA), is that small-scale sugar factories are inefficient both in their use of resources and their financial profitability (KSA, 1981).

The history of small-scale sugar companies in Kenya is short. The first small-scale sugar company, Kabras Investment Ltd., was set up in Kakamega district in 1976. The company operated for only four years and was burned down in 1980. The other small-scale sugar factory, Agro-Investments (East Africa) Ltd., was set up in 1977 and has been in receivership since the beginning of the 1980s. The only operational small-scale factory is the West Kenya Sugar Company Ltd., which was established in 1981 and is situated in the Kabras area of Kakamega district.

Geographically, the West Kenya Sugar Company is situated in an area that lies between 1,250 m and 1,700 m above sea level. The area is dissected by a number of streams running from north-east to south-west, forming a generally slightly undulating peneplain. Most of the soils are developed on granite rocks and they are well drained, deep and sandy-clay to clay. Rainfall is bimodal, with an annual average of 1,600 mm. Temperatures range between 10°C and 30°C, with an annual mean of 20°C. These conditions make the area very suitable for sorghum, sunflower, soya beans, sweet potatoes, chillies, onions and sweet pepper. Maize, pigeon peas and most horticultural crops can also do well. Sugar cane, Robusta coffee and citrus fruits have only a fair yield potential in this area, and cane yields are considerably higher in the Mumias-Nzoia zone (Government of Kenya, 1985).

However, as the Farm Management Handbook (Government of Kenya, 1985) indicates, even though Kakamega district has a high rainfall and high population, the soils are worn out and leached because of their age and poor husbandry. In the north-eastern areas (including Kabras) the generally humid climate is interrupted by droughts, restricting cultivation of important perennial crops like bananas and sugar cane. For this reason the development of the full land-use potential of a mixed farming ecosystem where legumes, other vegetables, fruits and forage can be grown has been recommended. Our argument in this paper is that market conditions are not favourable for the growing of these crops.

The Miwani/Chemelil/Muhoroni sugar factories are located in an area that lies within the Kano plains, at an altitude of 1,200-1,500 m above sea level. The plain is mainly an aluvium peneplain with dark loam soils. It is dissected by meandering rivers, such as the Nyando, which end up in Lake Victoria. The rainfall ranges between 1,100 mm and 1,500 mm. The Farm Management Handbook notes that even though the area is well known for its long established sugar industry, it must be recognized that the area is not the best which is available for sugar cane because of the relatively low rainfall (Government of Kenya, 1985). The most suitable crops for this area are sorghum, sweet potatoes, soya beans, sunflower and sweet pepper. Maize, beans and groundnuts can also do well. Sugar cane and pineapples can only give a fair yield.

On the basis of the climatic conditions prevailing in the sugar belt, one would argue that the crop is unsuitable for this area. It must be, therefore, by historical circumstances that the area has become Kenya's sugar belt. Below, we analyse some of the historical circumstances that may have led to this situation and the dilemma which the farmers now face.

SUGAR POLICY IN KENYA

The policy framework

Agricultural policy formulation and implementation in Kenya is complex. The Ministries of Agriculture and Livestock Development formulate and implement broad policies in collaboration with the Ministries of Planning and National Development, Lands and Settlement, Finance, and Commerce and Industry. However, most of the specific policies are formulated by the parastatal bodies that fall within the two ministries of Agriculture and Livestock Development. Other crops such as tobacco, oilseeds and horticulture are organised by private companies such as British American Tobacco (BAT) and East African Industries Ltd. which are engaged in the processing industry.

We take agricultural policy to mean the government's plan of action within the agricultural sector. It involves the setting of objectives and of the strategies to achieve them. It is not possible to talk about a consistent agricultural policy in Kenya, since both the objectives and the strategies have been changing over time. However, the broad objectives since Independence have been growth, equity and participation. These objectives have been articulated in the Five Year Development Plans and Sessional Papers (Government of Kenya, 1965; 1966; 1970; 1974; 1979; 1981; 1984; 1986). The Government has been applying policy instruments such as direct price determination, taxation and exchange rate adjustments to achieve

Map 1: West Kenya, administrative boundaries

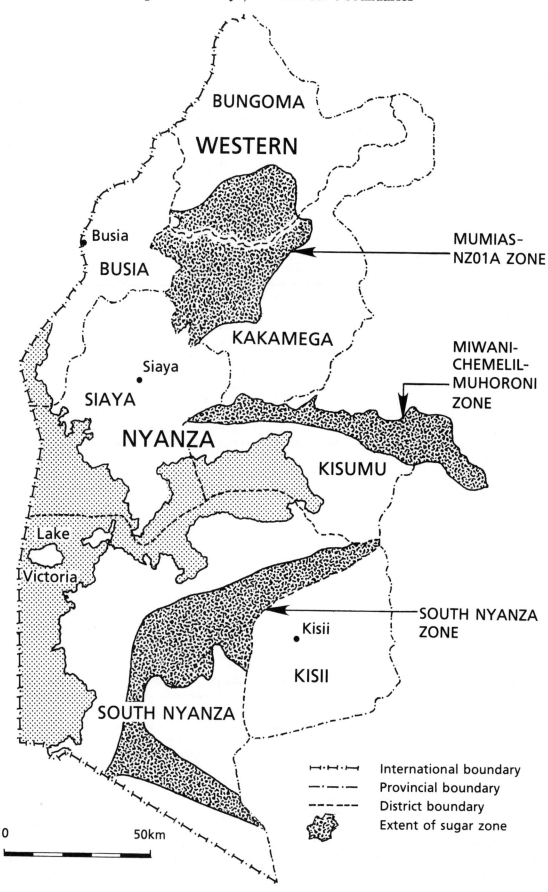

BUNGOMA

WESTERN

Busia

BUSIA

KAKAMEGA

MUMIAS-
NZOIA ZONE

Siaya

SIAYA

NYANZA

KISUMU

MIWANI-
CHEMELIL-
MUHORONI
ZONE

Lake

Victoria

Kisii

KISII

SOUTH NYANZA
ZONE

SOUTH NYANZA

	International boundary
	Provincial boundary
	District boundary
	Extent of sugar zone

0 50km

its stated objectives. However, at times Government policy is quite at variance with Government practice; a situation which is reflected in the problems encountered during policy implementation.

The Government's policy instruments have affected the returns from certain agricultural commodities and their geographical distribution within the country. For instance, most types of food crop (including sugar cane) are grown in Western Kenya while export crops like tea and coffee are mainly grown in Central and Eastern Kenya.

The dual distribution of agricultural activities in Kenya originates from the colonial era. Studies have shown that the Colonial Government deliberately instituted policy instruments that alienated land and labour from Africans and discouraged their participation in commercial agriculture (Swynnerton, 1954; Ruthenburg, 1966; Van Zwanenberg, 1974; Leys, 1975; Smith, 1976). After Independence, the new Government found it difficult to dismantle the dual agricultural economy and aimed at intensifying productivity in the former non-settler areas in line with what had been proposed in the ALDEV (1948) and Swynnerton (1954) plans. The current sugar belt is in the former reserves.

One of the aims of the new Government's development programme was to increase the production of cash crops in the former reserves. Expansion programmes were made for tea and coffee. However, since the supply of these crops was determined on a quota system on the world market, the expansion programme was halted as the national quota had been achieved. For instance, around 1962 many farmers in Kakamega district had applied to grow coffee but they were stopped by the agricultural officers. The 1963 District Annual Agricultural Report noted that sugar cane was becoming increasingly popular with farmers as a cash crop, especially in Mumias and Lurambi Divisions. It recommended the erection of a brown sugar plant. It was on the basis of this argument that Kakamega came to be seen as an area suited for sugar cane, justifying the erection of Mumias, West Kenya and Kabras sugar factories in the area.

In addition to sugar cane, other cash crops such as cotton, tobacco and vegetables were encouraged. The cotton industry has been faced with serious management problems since the early 1970s and its net return to farmers has been relatively low. Tobacco production more or less reached a ceiling once BAT satisfied its demands for the local market. Furthermore, tobacco requires a lot of wood energy for curing that may not be available in densely populated areas. The best options are horticultural crops, but these have no ready market. It is therefore evident that historical circumstances have caused Western Kenya to grow low value food crops for national consumption while high value cash crops are grown in Central and parts of Eastern Kenya. Ranking the crops according to their value per hectare indicates that the first seven high value crops are mainly grown in Central Kenya while the last three low value crops are mainly grown in Western Kenya (Government of Kenya, 1986).

Pricing policy

One of the most important ways in which the Government affects the profitability of sugar cane growing is through setting the producer price of sugar cane during the annual price review. The review of agricultural produce prices is undertaken annually in accordance with the Agricultural Act (Cap. 318) in which, before the fifteenth of December of each year, the Minister of Agriculture reviews the prospects of the agricultural industry. The object is to determine the prices of scheduled crops and produce which include sugar cane, maize, pyrethrum, rice, cotton and milk. The producer prices of tea and coffee are normally determined from the respective prevailing world market prices.

The producer price for sugar cane is determined using a 'cost plus' approach in which the farmers' production costs are estimated through field surveys. A margin is normally added to the production costs to make sugar cane viable. The millers' margin and distribution margins are calculated in the same way.

Once these costs are determined, the Ministry of Agriculture decides on the actual price of sugar cane, taking into consideration conditions of demand and supply in both the domestic and international markets. The price the Ministry arrives at is supposed to reflect economic efficiency and equity. The biggest problem is the determination of realistic prices for each stage in a situation in which the Government itself owns the majority of shares in five sugar factories and is also responsible for pre-wholesaling distribution. Thus the Kenya Government determines the factor price (ie. price of sugar cane), the output price and the consumer price. The Ministry normally argues from the point of view of the opportunity cost of utilizing scarce national resources in producing sugar locally. It therefore applies border import prices to determine the domestic value of sugar.

Problems emerge in using the border prices of sugar to determine the domestic price structure. First is the high fluctuation of the border price of sugar. Since sugar cane takes a minimum of eighteen months to mature, it is difficult to synchronize the fluctuating border prices with a domestic price structure which would ensure the steady flow of sugar cane. Thus there is a need to determine a 'long-term border price'.

97

Secondly, less than 20 per cent of total world sugar production is traded internationally. The rest is consumed domestically by the producing countries themselves. Furthermore, a large proportion of the international trade in sugar is conducted under special agreements which do not reflect the existing market conditions. There is therefore the question of which border price to use.

Finally, sugar traded on the world market (particularly that emanating from the EEC) is highy subsidized (Ziet, 1980). The price offered on the free market is therefore not a true reflection of the efficient utilization of scarce resources at the global level. The irony is that while the EEC can manage to subsidize their small community of farmers to produce sugar inefficiently, the majority of sugar producers from the less developed countries (LDCs), Kenya included, cannot afford to subsidize their large community of farmers so that they can compete with those in the EEC. If this market distortion were to go on for ever, then Kenya would benefit by buying cheap sugar on the world market. But since much of this trade occurs at 'dumping prices', the situation may change depending on the economic performance of the developed countries. Thus the world sugar market is so complex that it does not make economic sense to use border prices to determine the domestic price structure.

The planning objective for encouraging farmers to grow sugar cane is to make Kenya self-sufficient in sugar, as it is in other food crops (Government of Kenya, 1980). Studies have shown that sugar consumption in Kenya is likely to increase significantly due to increasing population and income, increasing food processing and expansion of market inlets into remote areas. Who should then pay for the increased sugar consumption? Those who take sugar to be a necessity argue that the Government should subsidize consumers in case the costs of domestic production make it difficult for the low income groups to buy the sugar. Some argue that in suitable ecological zones sugar cane is one of the cheapest sources of food energy on a per hectare basis (Kaplinsky, 1983). Others are of the view that sugar is not a necessity and it has a very low food content. They argue that even in the developed countries sugar consumption is being discouraged. If that is the case, then sugar consumers should pay the full cost of its production.

In reviewing the domestic sugar price structure, it is illuminating that the factory gate price of cane has increased at a faster rate than either the milling or the retail price — implying that the Government has either been subsidizing sugar consumers or increasing returns to the farmers. (Between 1977 and early 1984, the factory gate price of cane rose by 15 per cent, the ex-factory sugar price rose by 5 per cent and the retail price of sugar fell by 4 per cent).

The determination of the domestic price structure for sugar in Kenya goes beyond opportunity cost analysis, since it involves the allocation of income to groups with divergent interests. The groups involved are: sugar cane growers, workers, transporters and providers of other farm services, sugar cane millers, sugar distributors, sugar consumers and the Government. The Government participates directly in most of these activities, apart from levying excise duty on sugar production. Once the domestic retail price has been set, the next question is how it is to be shared among these groups. The share of cane in the retail value of sugar is 22.50 per cent. Total Government deductions amount to 20.60 per cent which includes 13.89 per cent excise duty (KSA, 1986). Questions have been raised as to the continued heavy taxation of the sugar industry (Ochoro, 1985). More perturbing has been the participation of both the Kenya National Trading Corporation (KNTC), a government parastatal, and the Ministry of Commerce in the distribution of sugar, involving different deductions.

Another aspect of the sugar pricing policy in Kenya is the exclusion of bagasse and molasses when calculating the price of sugar cane. In some countries farmers are paid for sugar cane on the basis of sugar yields, molasses and bagasse. The Kenya Government argues that it is unnecessary to pay farmers a bonus for by-products. Furthermore, some sugar cane millers argue that sugar milling is not profitable if farmers are paid for by-products.

PROFITABILITY ANALYSIS

In this section, we argue that sugar cane farmers are responsive to incentives such as price increases. The constraints to the farmers are connected with market outlets for their produce. We also analyze the gross margins of various crops grown in the area, and conclude that the returns to sugar cane are low in real terms but that the farmers may be suffering from what one can call 'money illusion'. We finally analyze the sugar cane returns in the Kabras and Chemelil areas.

Farmers' response to economic incentives

In a *laissez faire* situation, the supply of sugar cane will depend on factor costs, resource availability, producer price, returns to other agricultural activities and the weather conditions. Farmers will take decisions in response to, and in anticipation of, these factors. Many studies done in Kenya have shown that sugar cane farmers are no exception. If we lag producer prices by two years — the gestation period

of sugar cane — there is a strong correlation between the percentage changes in sugar cane supply and in sugar cane producer prices (Odada et al, 1986).

However, the economic setting of sugar cane farmers, particularly in the large-scale sugar cane scheme, is not *laissez faire*. Farmers sign a contract with the factory, binding them to specific factories for at least five years. The contract is necessitated by the unique nature of sugar cane growing and processing. There is the need for adequate factory capacity to crush the farmers' sugar cane. Secondly, from the factory point of view, there should be a continuous flow of sugar cane to keep the factory working at full capacity in order to justify sugar cane milling. Finally, sugar cane takes two years for the main crop and one and a half years for each ratoon crop to mature. There is therefore a long waiting time, calling for commitment that can only be assured through an agreement.

There is a difference in the organization of sugar cane production in various parts of the sugar belt. In the Chemelil/Muhorooni/Miwani areas, the farmers are organized in co-operatives which handle the contracts with the factory. In the Sony, Mumias and Nzoia zones, outgrower companies have been formed to perform these functions. Most of these organizations are faced with serious management problems (Odada, 1986).

In the Kabras area, the farmers have not formed any organization for the specific function of supplying sugar cane to the small-scale sugar factory. In this area, each farmer grows cane independently and gets a permit from the factory to deliver a specific amount of cane. If the cane the farmer has grown is over and above the requirements of the factory, then the farmer can sell the cane to any of the jaggeries around. Farmers interviewed in the Kabras area about these informal arrangements said they would have liked them to be formalized so that they could be sure that the factory would purchase all the sugar cane contracted. They argued that the sugar company and jaggeries take advantage of the absence of a contract to underpay the farmers. But the mutual informal contracts have been well-established, such that each jaggery has its own set of farmers to supply it with sugar cane. Such arrangements go beyond profitability and involve ethnic and peer group associations.

Sugar cane profitability

Profitability in sugar cane growing depends on yields and factor costs. There is a high variation in both the yields and factor costs throughout the entire sugar cane growing zone. Table 1 shows the actual (1985) and expected yields in the Nyanza and Kabras areas.

Table 1: Sugar cane yields (tonnes/ha)

Area	Main crop Actual/Expected		First ratoon Actual/Expected		Second ratoon Actual/Expected	
Miwani	80	90	60	80	50	60
Chemelil	95	100	82	90	75	80
Muhoroni	100	120	90	100	75	80
Kabras	70	120	40	100	30	80

Sources: Odada et al (op. cit.) and own survey (1987) for Kabras.

In most of the sugar cane growing areas, the actual yields are lower than the expected yields because of declining crop husbandry. The low yield for the Kabras area is due to minimal use of fertilizer. Over 90 per cent of the farmers interviewed in Kabras area indicated that they either did not use fertilizer or used inadequate quantities (fertilizer accounts for 13.6 per cent of the costs of the main crop and 33.3 per cent of the ratoon crop — see Table 2).

While yields are relatively high in areas serving the large sugar factories, the inputs are expensive. Most of the expenses on the farm are determined by the factory. Table 2 shows an example of the sugar cane production costs in the Nyanza area. The pre-harvesting cost per hectare was KSh 16,608. If the yields were, for example, 100 tonnes per hectare, then the pre-harvest cost per tonne would be KSh 166.08. The harvesting and transport costs were estimated at KSh 95. The into-factory price of cane was KSh 270. Therefore, on every tonne of sugar cane the farmer earned only KSh 9 or KSh 900 per hectare. In terms of sugar cane, out of the 100 tonnes per hectare about 95 tonnes went into production costs. At the farm gate level 61 tonnes went into production costs. This implies that a farmer who harvested less than 60 tonnes per hectare in the main crop did not cover production costs.

The costs of sugar cane production in the Kabras area are lower than in the Nyanza area (see Table 3), due to the use of the ox-plough for ploughing and the fact that cane is transported over a shorter

distance. For instance, the farm gate cost per hectare is KSh 9,886 as opposed to KSh 16,608 in the Nyanza area. In terms of sugar cane, about 43 tonnes would go to the cost of production if the price of sugar cane is KSh 270 per tonne. Therefore a farmer who harvests 50 tonnes per hectare in the Kabras area will make a profit. Thus, it is evident that sugar cane production in these large-scale sugar companies seems to be less profitable than for small growers in the Kabras region.

Table 2: Chemilil Sugar Company Ltd., cost of outgrower cane production

Field operation	Input unit per hectare	Cost per hectare (Ksh)	
		Plants	Ratoons
Light bush clearing		400	
Surveying		40	
Ploughing — mouldboard	3.45 hrs	1,302	
First heavy harrowing	2.0 hrs	930	
Second heavy harrowing	1.67 hrs	850	
Light harrowing	2.5 hrs	731	
Opeining and installing drains		400	
Furrowing	1.6 hrs	491	
Inter-row cultivation x 2		983	983
Seedcane supply and transport	7 tonnes	2,218	
Planting	18 m/d	409	
Supplying fertilizer		1,645	1,645
Applying fertilizer		132	132
Gapping		158	158
Weeding — manual		631	631
Weeding — chemical		1,447	1,447
Maintenance fire break/roads		165	165
Controlling disease		94	94
Thrash lining			71
		13,026	5,326
Interest on loan @ 15% pa.		3,582	1,198
Pre-harvest costs per ha		16,608	6,524
Cost per tonne		166.08	98.85
Harvesting and transport costs		95.00	95.00
		261.08	193.85

Table 3: Costs of sugar cane production in Kabras (KSh/ha)

Land preparations (ox-plough)	900
Planting material	1,750
Planting	456
Weeding	2,520
Fertilizer	2,700
Other labour costs	300
Harvesting and loading	1,560
Farm gate costs	9,886
Transport costs	1,860
Factory gate cost	11,746

Source: own survey.

Relative profitability

In the long run sugar cane production competes with other food and cash crops. One can therefore compare the annualized discounted net return of sugar cane to other cash and food crops to determine

its relative profitability. The crops competing with sugar cane in the Nyanza and Kabras zones are cotton, sunflower, maize, beans, sorghum and horticultural crops. Considering the discounted cash flows of sugar cane, maize and beans and cotton and sunflower, maize and beans have the highest net return, followed by sugar cane, then cotton and finally sunflower. Sugar cane has a high gross value of KSh 59,400 over the five year period, with a net return of KSh 8,092. However, when this is discounted it falls to KSh 2,870; less than the discounted net return of maize and beans but better than that for sunflower and cotton. There are two possible reasons why farmers continue to grow cane rather than maize and beans. First, many farmers do not consider the costs involved in waiting for sugar cane payments. They mostly consider the lump sum they are paid, suffering from what can be termed as 'money illusion'. Second, farmers do not always receive the 'official' price for maize and beans at which their output is valued. This is due to imperfections in the market for food crops.

We therefore conclude that whilst sugar cane production is not the most profitable enterprise, most small-scale farmers are engaging in it either through sheer ignorance (which is unlikely), lack of alternative activities or 'money illusion'.

SOCIO-ECONOMIC IMPACT

Sugar cane growing in Western Kenya has often been defended for its wider social benefits such as the promotion of rural industrialization, creation of infrastructure and the generation of rural employment (Government of Kenya, 1970; Odada, 1986). The question is the validity of this assertion and whether sugar cane growing is the best way of achieving these objectives. Historically, the sugar industry has hardly benefited the people who grow the sugar cane — it has mostly benefited the traders and millers. The industry has had a long and shameful history, coated with bitter memories of poverty and squalor on one hand and trade and prosperity on the other (Dinham and Hines, 1983).

While sugar cane growing may indeed generate a lot of employment, it cannot be stated *a priori* that this employment is beneficial to the rural community. In this section we intend to discuss the assertion that sugar cane growing in Western Kenya can bring about socio-economic development.

Employment generation

Sugar cane growing in Western Kenya is a labour intensive activity. It has been estimated that the crop requires a total of 1,746 person hours per hectare, as compared to maize which needs only 325 person hours per hectare (Government of Kenya, 1985). This implies that every hectare of sugar cane requires one unit of labour in permanent employment. If that is the case, then there are at least 85,000 employees working as labourers on sugar farms. It is evident that the industry provides gainful employment opportunities to the burgeoning labour force.

However, sugar cane workers are faced with serious problems. One of these is poor working conditions in terms of poor housing, lack of medical services and lack of protective clothing. In a 1985 report on the sugar industry manpower survey, it was noted that the lack of protective clothing was crucial; in some cases the survey team found the skin of the workers peeling off because of this lack. The workers also complained of low payments for the heavy work they performed, and most of them had been casual for so long that they could rightfully be called 'permanent casuals'.

Household workers on small-scale farms find it more difficult because they do not belong to any trade union. These include the mothers and children who work not for monthly pay, but to wait and share the final returns with the heads of households. It is becoming increasingly evident that many agribusiness firms favour contractual arrangements with smallholder farmers, rather than direct production, in order to avoid the risks of production and the costs of organizing farm labour. The quality of employment provided in the sugar zone should not, therefore, be overestimated.

Nutritional impact

The question of nutrition in cash crop growing areas is becoming a major concern (Government of Kenya, 1974; 1979; 1980). It is becoming increasingly evident that cash crops are replacing food crops, subjecting farmers to regular hunger and starvation. For instance, at the continental level, while cash crop growing has expanded rapidly in Africa it has been accompanied by increasing food imports. Concern is being raised about nutrition in Kenya's sugar belt because this area, which was initially self-sufficient in food production, is becoming food-deficient.

Nutritional problems in the sugar belt can be analysed from the household's food budget by knowing how much of each food nutrient is needed by each member of the household and how much of each food nutrient is obtained from a given foodstuff. On the basis of this data, one can get the land equivalent per household for nutritional self-sufficiency.

The average household size in the sugar belt is eight; that is, father, mother and six children. On the basis of recommended daily intakes (RDI) of nutrients, it is possible to calculate the dietary requirements for a family of eight. They require, per day, about 18,100 calories — representing a combination of carbohydrates and fats — 511 g of protein, 5 g of calcium, 1,209 mg of vitamin A, 11.2 mg of vitamin B2, 115 mg of Niacin (Ni) and 214 mg of vitamin C (figures calculated in consultation with food nutritionists, Ministry of Agriculture and Livestock Development).

The main sources of these food nutrients in the sugar belt are maize, beans, groundnuts, cowpeas, kale, cabbages, paw paws, mangoes, bananas and cassava. Households combine these foods in varying proportions to get the required nutrients. It is not our aim to go into the intricacies of a balanced diet, but to get a working budget for a family of eight. For simplicity we use an index of maize, beans and kale, where maize and beans are consumed in equal proportions. Table 4 shows the maize, beans and kale requirements by weight for the required nutrition to be achieved. The most demanding nutrient in terms of food requirement is the provision of calories which require 10 kg per day. This implies that a family of eight requires about 3,650 kg per annum for subsistence. Using a per hectare yield of 2,500 kg per annum, it implies a requirement for about 2 ha of land under food crops to achieve food self-sufficiency.

The average land holding in the Nyanza sugar belt is 3.15 ha per household. Thus, on average, the area has an extra 1.15 ha per household which can be used for sugar cane growing. The average land holding per household in the Kabras area is 2.19 ha. Therefore, there is an extra 0.19 ha that can be utilized for sugar cane growing per household. Therefore, in terms of average land holding, both the Nyanza and Kabras areas have enough land for farmers to grow both food crops and sugar cane.

Table 4: Nutrients from 210 g of maize, beans and kale in the ratio 10:10:1

Nutrients	Value	kg/Family of 8/day
Calories	365.3	10.00
Proteins	30.9 g	3.46
Calcium	171.0 mg	6.14
Iron	7.4 mg	3.41
Vitamin A	731.7 mg	8.32
Vitamin B$_2$	0.43 mg	5.46
Niacin	3.6 mg	6.71
Vitamin C	20.0 mg	2.42

Source: Odada et al, 1986.

The main trade-off between sugar cane and food production is in the area of household labour allocation. This can be identified by household labour budgeting. The average family labour in the Kabras area is 3.7 persons, consisting of 2.5 family adults, 0.1 permanent hired labour and 1.1 adult equivalent of children below 14 years of age. The working capacity of adults has been estimated at 4.0 person hours per day for 200 days per year (Odada, 1986). This implies that the maximum labour available per household is 2,960 person hours. A hectare of sugar requires 1,746 person hours, leaving only 1,216 person hours to be shared among the other farm activities. Two hectares of sugar cane will thus utilize all the available labour in the household. Secondly, labour shortages are seasonal. For instance, in the months of April and May a household that has planted 1 ha of sugar cane and 1 ha of maize and beans will require about 984 person hours for weeding, spraying and fertilizing. But the maximum available labour for a household of a labour force of 3.7 units is only 474 person hours. This creates a shortage that leads to the allocation of all the available labour to sugar cane. The consequence is poor yields in other food crops.

Thus most sugar cane growing areas experience food shortages. Traders buy maize outside the sugar zone and generally sell it at exorbitant rates to sugar cane farmers. For example, they buy maize in 2 kg tins at KSh 4 per tin and sell it at KSh 7 per tin, implying a 75 per cent price differential.

Another indication of the nutrition problem in the sugar belt is malnutrition. For example, medical records from Matava Health Centre indicate that there are cases of Kwashiokor and Marasmas. In 1985, the health centre recorded 17 cases of Kwashiokor and 2 cases of Marasmas-Kwashiokor. The unreported cases of malnutrition in the region are likely to be high, given the low rate of hospital attendance in the area. The reasons given by the nutrition officers for the malnutrition are poverty, lack of knowledge of what should be grown and broken families.

The movement of food from other areas to a food-deficit area could easily avert the deficiency. But often the people do not have enough income to purchase the food. Moreover, there is a restriction on

102

the movement of maize and beans from one district to another which has often worsened the food deficiency in certain regions, leading to a high regional price differential. This lures traders to 'smuggle' the crops at night. Such restrictions do not make much economic sense, particularly in the sugar belt.

Rural development

A commodity industry like the Kenyan sugar industry, which does not offer sufficient returns to the participating rural household at the farm level, may be defended for its stimulation of other industries and infrastructure. In this section we briefly analyze the forward, backward and horizontal linkages of the sugar industry with the aim of evaluating its 'industrializing' potential.

A major forward linkage of a sugar industry is the utilization of sugar, molasses and bagasse in the production of confectioneries, alcohol and paper respectively. Very few of these industries are located in the sugar belt. Moreover, the ones that are located there, like the alcohol plants in Miwani and Muhoroni, are a mere vertical integration of the existing establishments. Socially undesirable forward linkage is the use of jaggery to make illegal alcohol. The sugar cane industry has therefore not created any desirable forward linkage, as required.

Even though the industry may not have created extensive forward and backward linkages, it can be defended for generating surplus that can be used for infrastructural development and individual investment in other activities. One would expect roads to be well maintained in the sugar belt. However, roads in most parts of the sugar belt are undeveloped and in the Nyanza zone they are a major cause of the high transport costs.

No studies have been done on the impact of the sugar industry in Kenya on household savings and the development of entrepreneurial skills. However, a casual observation indicates that some of the savings are going into buying matatus (minibuses) for local transport purposes. Other savings are going into the construction of semi-permanent houses. Apart from other household expenditures, the rest of the savings are going into leisure. Cases of farmers getting sugar money and becoming 'sugar daddies' have been noted.

Finally, there is the need to assess the environmental impact of sugar cane growing. Studies have shown that the long-term environmental impact of sugar cane growing can be very severe. For example, in Guyana, where sugar cane production was introduced in the seventeenth century, it was found that in the absence of soil renewal mechanisms the soils were rapidly exhausted. In other studies it has been shown that cane harvesting technologies have different impacts on the environment (Pickett, 1977). No major studies have been done in Kenya (particularly in the Nyanza area where sugar cane has been grown for over sixty years) to determine the environmental impact of the industry.

CONCLUSION

The sugar industry in Kenya has therefore only partially met its objectives of raising rural incomes, increasing rural employment and making the country self-sufficient in sugar production. The location of some of the sugar plants in their current situation has largely been determined by historical circumstances and not ecological suitability. Yet the dual development of Kenya's agricultural sector makes it difficult for the farmers in the sugar belt to adjust to more profitable crops, even though they may have a desire to do so.

There is a major contradiction between the Government's policy and practice with respect to the sugar industry. This may explain the contradictory interests that are being articulated within the industry. A call to put the sugar industry in Kenya in its proper perspective may seem far-fetched now, but it will become more real as the 'sugar coated' policies that are now in force necessarily erode over time.

Note

1. Views expressed in this paper are those of the author. They should not be interpreted as reflecting the views of the Institute for Development Studies or of the University of Nairobi. This paper has protection under the Copyright Act, Cap. 130 of the Laws of Kenya.

REFERENCES

Alpine, R., *Economic viability in African conditions of the Small-Scale Open Pan Sugar Technology*, a paper presented at a seminar on *The Implications of Technology Choice in the African Sugar Industry* in Nairobi, April 1977 (1977).

Colony and Protectorate of Kenya, *African Land Development in Kenya 1946-62*, The English Press Ltd., Nairobi (1976).

Duguid, F. et al, *Possibility for the Further Processing of Sugar Industry By-Products*, a paper presented at a seminar

on the *Implications of Technology Choice in the African Sugar Industry* in Nairobi, April 1977 (1977).

Dinham, B. and Hines, B., *Agribusiness in Africa*, Earth Resources Research Ltd., London (1983).

Government of Kenya, *District Annual Reports*, Nairobi (1963-).

Government of Kenya, *Sessional Paper No. 10 of 1965 on African Socialism and its Application to Planning in Kenya*, Government Printer, Nairobi (1965).

Government of Kenya, *Development plans 1965-69, 1970-74, 1974-78, 1979-83, 1984-88*, Government Printer, Nairobi (1965).

Government of Kenya, *Sessional Paper No. 4 of 1980 on Food Policy*, Government Printer, Nairobi (1980).

Government of Kenya, *Farm Management Handbook*, Ministry of Agriculture, Nairobi (1985).

Government of Kenya, *Sessional Paper No. 1 of 1986 on Economic Management for Renewed Growth*, Government Printer, Nairobi (1986a).

Government of Kenya, *Food Policy Formulation and Implementation in Kenya*, paper prepared for the seminar by IFPRI and Ministry of Agriculture in Nairobi, 5 February 1986 (1986b).

Government of Kenya, *Economic Survey*, Government Printer, Nairobi (1986c).

Heyer, J. et al, *Agricultural Development in Kenya: An Economic Assessment*, Oxford University Press, Nairobi (1976).

Kabando, R. M., *Relevance of Structural Organisation of the Sugar Industry*, a paper presented at a seminar on *Incentives for increased Agricultural Production*, in Kericho, Kenya, 1985 (1985).

Kaplinsky, R., *Sugar Processing: the Development of a Third World Technology*, Intermediate Technology Publications, London (1983).

Kenya Sugar Authority, *Policy Guidelines for the Development of Sugar Industries* (1986).

Killick, T. (ed.), *Papers on the Kenya Economy; Performance Problems and Policies*, Heinemann Educational Books Ltd., Nairobi (1981).

Leys, C., *Underdevelopment in Kenya: The Political Economy of Neo-colonialism*, Heinemann, London (1975).

Makanda, D. W., *Trade-off Between Sugar Cane and Food Production*, a paper presented at a seminar on *Incentives for Increased Agricultureal Production*, in Kericho, Kenya, November 1985 (1986).

Makanda, D. W., *Nutrition for Rural Development*, a paper presented at a seminar on nutrition in Kakamega, Kenya, 20-26 April 1986 (1986).

Ochoro, W. E. O., *Some Social Costs of Sugar Production in Kenya*, a paper presented at a seminar on *Incentives for Increased Agricultural Production*, in Kericho, Kenya, November 1985 (1985).

Odada, J. E. O., *The Incentives for Increased Agricultural Production; A Case Study of Kenya's Sugar Industry*, Friedrich Ebert Foundation, Nairobi (1986).

Oniang'o, C. M. P., *The Social Impact of the Mumias Sugar Scheme*, Kenyatta University College, Nairobi (1985).

Swynnerton, R. J. M., *A Plan to Intensify the Development of African Agriculture in Kenya*, Government Printer, Nairobi (1954).

The Daily Nation, *How Farmers Can Be Useful*, 30 December 1986 (1986).

The Economist, *Enslaved by Subsidies*, 10 August 1985 (1985).

Van Zwanenberg, *The Development in Peasant Commodity Production in Kenya, 1920-1940*, in *The Economic History Review*, Second Series, Vol. xxvii, No. 3 (1974).

Ziet, J., and Valdes, A., *Agricultural Production in OECD Countries: Its Costs to Less-Developed Countries*, IFPRI Research Report No. 21 (1980).

12

The Kabras experience: An exploratory socio-economic impact analysis of the West Kenya sugar factory

Lex Lemmens

This paper reflects the findings of a social impact analysis related to the West Kenya Sugar Factory in Kabras, Western Province, Kenya. Use was made of data collected during three months of field work in early 1986. This field work was part of the research project *Technology Assessment for Projects in Developing Economies: Sugar Cane Industry in Western Kenya as a Case Study*, Centre for International Co-operation Activities of the Eindhoven University of Technology (Lemmens, 1987).

An effort is made to use a technology assessment analysis for developing economies to formulate policies with respect to industrialization. The sugar cane industry in the Kakamega district, Western Province, Kenya, was the location of the case study. The main aim of the technology assessment instrument is to include as many impacts as possible in the weighing and subsequent assessment of different policy options.

Socio-economic impacts at the macro and micro level are looked at. Because of the structure of the study, with emphasis on actual field work, it is possible to present comprehensive and recent data on the socio-economic impacts of the West Kenya Sugar Factory in Kabras. In addition it is possible to compare the impacts of the open pan sulphitation factory of West Kenya Sugar Company (WKS) with a large-scale vacuum pan factory, the Mumias Sugar Company (MSC).

Based on general literature, in this paper the socio-economic processes that could be at work in the areas concerned are identified. Interviews with key informants are used to place the resulting framework of analysis in the setting of the areas concerned. Thereafter, a detailed analysis of the socio-economic processes is given, based on a review of more specific literature and on a survey conducted among the farmers of the area.

The analysis leads to conclusions with respect to the different impacts for the farmers in the medium-(WKS) and large-scale (MSC) sugar industries.[1] Although the comparison between the impacts of both industries gives valuable information, definite conclusions are not possible because of the fact that MSC has been operating ten years longer than WKS. The influence of time as an influencing factor is difficult to assess within the limits of this study; therefore at the end the conclusions for the medium-scale industry are reviewed.

IDENTIFICATION OF THE SOCIO-ECONOMIC PROCESSES AT WORK IN THE SUGAR GROWING AREAS OF KAKAMEGA

On the basis of a general scan of the literature on the socio-economic impacts of the introduction of new technologies, a system to analyze the processes at work in the area is devised. In this system two levels of identification are distinguished: the micro and the meso level. At the micro level, the changes for individuals and the changes on the household level, in relation to the introduced technologies, are traced. At the meso level, changes in the direct environment of the technologies concerned are identified. Units of analysis are the factors of production and the persons and households on the micro level. At the meso level, the units of analysis are the socio-economic and physical structures of the environment. The resulting structure for the analysis of the socio-economic processes is given in Table 1.

The review is not comprehensive, and it was not attempted to follow strictly the scientific classification of the socio-economic literature. The review has an heuristic character and leads to the analysis of the most important features.

Table 1: Units of analysis and key words

Levels of analysis	Units of analysis with key words
Micro level	**Changes in the factors of production** ○ Capital ○ Labour ○ Land ○ Skills/knowledge **Changes on the personal and household level** ○ Decision-making process ○ Material changes ○ Family size ○ Education
Meso level	**Changes in the socio-economic structure of the environment** ○ Employment situation ○ Spin-offs ○ Credit facilities **Changes in the physical structure of the environment** ○ Infrastructure ○ Key public institutions

Interviews with key informants in the area

In both the Kabras and the Mumias areas, interviews were held with chiefs, sub-chiefs, farmers and farmers' wives of both sugar growing and non-sugar cane growing families. The interviews had several functions. In the first place, they helped to further identify the processes at work in the study area. Secondly, they provided a start for the analyses of the processes at work, and thirdly, they provided the background for the analyses which follow.[2]

The dynamics of the social system related to the introduction of sugar producing technologies will be covered by reference to the zero option: the situation at the time of the introduction of the technologies. At the micro level, this means a comparison between sugar cane growing and non-sugar cane growing farmers in the area. Although this will cause a bias—because non-sugar cane growing farmers will also be influenced by the establishment of the sugar industries—it is the best societal picture that can be obtained.

ANALYSIS OF THE SOCIO-ECONOMIC PROCESSES AT WORK IN THE SUGAR GROWING AREAS OF KAKAMEGA

The analysis follows the structure presented in Table 1.[3] The analysis of the different units of analysis starts with a more general discussion on basis of the literature. Thereafter, the findings of the literature review are compared with the findings of the survey. The survey was conducted among a sample of households in the areas that can be considered to be under the influence of either the Mumias Sugar Company or the West Kenya Sugar Company. Because of the optimization of transport costs, sugar factories will be placed more or less in the centre of a circle. The circle in which the sugar cane for a certain factory is grown is called a 'zone'. Both the factories and the Kenyan governmental bodies use four concentric circles to sub-divide the sugar zone of each factory. Management and price policies are based on this division into A, B, C and D zones. The radii for the different circles are 10, 16, 24 and 32 km respectively.

The research area is defined as the A, B and C zones of the Mumias sugar factory, and the A and B zones of the West Kenya sugar factory. Part of the C zone of MSC in the north and north-east is omitted

from the survey because the cane growing farmers living there are growing cane mainly for another factory, Nzoia. The research area is subdivided according to the existing sub-locations.

The number of households in a sub-location is taken from the Kenya population census of 1979. The total number of households in the sub-location is 92,906. The sample size was calculated to be 385.

In each sub-location, a number of interviews were conducted, proportional to the number of households. Further sampling was done at random. This resulted in 191 interviews with cane growing farmers and 111 interviews with non-cane growing farmers in the Mumias area. In the Kabras area, these numbers were 35 and 48 respectively.

CHANGES IN THE FACTORS OF PRODUCTION

Capital and labour

The most traditional mode of production for the farmers is subsistence production, in which the crops grown mainly serve the purpose of feeding the family. Some surplus is exchanged with others to provide for those necessities for the household that cannot be produced by the household itself. In this stage, no market system exists. In most parts of Kenya this stage has long passed, and every farmer intentionally produces crops to be sold on the market in order to provide cash income for the non-food needs of the household. The crops produced for this purpose were, in the first instance, the traditionally grown food crops. The intention was first to take care of the food needs of the family, and second to try and grow a surplus of certain crops, often maize and beans, to sell on the local markets. This phase can be characterized as an informal introduction of the subsistence farmers to the market system. The

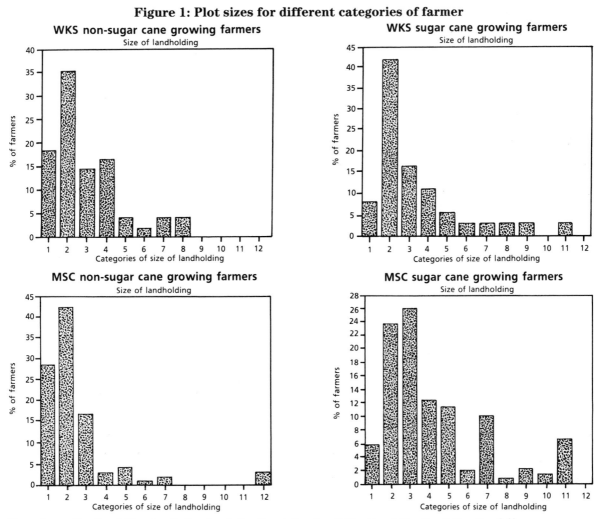

Figure 1: Plot sizes for different categories of farmer

Key: 1 = <1ha, 2 = 1-2ha, 3 = 2-3ha, 4 = 3-4ha, 5 = 4-5ha, 6 = 5-6ha, 7 = 6-7ha, 8 = 7-8ha, 9 = 8-9ha, 10 = 9-10ha, 11 = >10ha, 12 = No answer.

introduction of a cash crop to the subsistence farmers—a crop specifically grown to be sold, and often not even suited to cover food needs directly—marks their formal integration into the market system.

Theoretically, this formal process of integration consists of two phases. In the first phase, the farmer starts with market production by means of cash crops, while maintaining part of his subsistence production. In the second phase, the farmers specialize in the production of cash crops through which they earn enough income to buy what they need on the market.

Tezlaff (1979, pp. 326-327) analyzed this theory for the East African farmers, and concludes that the first phase (in neo-classical and marxist economic theories described as a transition state) appears to be a stable one.

Buch-Hansen (1982a, pp. 4-10) describes the two phases in terms of formal and real repression. The first phase is threatened if the cash crop market collapses. According to Buch-Hansen, it is impossible for the farmers to intensify their production unless this can be achieved through an increase in input of family labour. If the increased labour input cannot be provided by the family, the worsening of the market situation leads to selling the land to the few who, for one reason or another, succeed in entering the second phase. This process squeezes the majority of farmers out of agriculture.

The question is how these processes develop in the case of the sugar technologies considered. In Figure 1, the plot sizes for the different farmers in the sample are given. It is clear that in the Mumias area, small farmers generally are not growing cane whereas big farmers generally are doing so.

The average land holding for the non-cane growers in Mumias is 1.59 ha. For the sugar cane growers, the average land holding is 4.00 ha. In the Kabras area, the difference is less striking. For the non-cane growing and cane growing farmers, the mean plot sizes here are respectively 2.35 and 2.74 ha.

Figure 1 shows that the sugar cane growing farmers in the Mumias area can be divided into small farmers with a land holding of less than 5 hectares and big farmers with over 5 hectares; this division can also be used for the sugar cane growers in the Kabras area. Of the sugar cane farmers, 78 per cent in the Mumias area and 85 per cent in the Kabras area are classified as small farmers. Thus, more small farmers are involved in meeting the needs of the small-scale cane processing factory.

The degree to which the growing of food crops has been replaced by the growing of sugar cane is an indication of the integration of the sugar cane growing farmers in the market system. The part of the land allocated to sugar is given in Table 2.

Table 2: Percentage of land allocated to sugar cane[a]

Cane land	WKS all farmers	WKS small farmers	WKS bigger farmers	MSC all farmers	MSC small farmers	MSC bigger farmers
‹10%	15.6	0.7	12.2	2.7	17.9	20.0
10-20%	34.4	2.7	4.9	3.2	28.6	60.0
20-30%	18.8	11.6	26.8	15.1	21.4	0.0
30-40%	12.5	15.1	14.6	15.1	14.3	0.0
40-50%	12.5	19.2	12.2	17.7	10.7	20.0
50-60%	0.0	27.4	17.1	25.3	0.0	0.0
60-70%	3.1	9.6	4.9	8.6	3.6	0.0
70-80%	0.0	5.5	2.4	4.8	0.0	0.0
80-90%	3.1	6.8	4.9	6.4	3.6	0.0
›90%	0.0	1.4	0.0	1.1	0.0	0.0
Total	100.0	100.0	100.0	100.0	100.0	100.0

a. For two farmers in the case of MSC and for three farmers in the case of WKS it was not possible to calculate the percentage of land under cane because of missing data.

The Mumias farmers are, with an average of 45.9 per cent of land under sugar cane, clearly more involved in cash crop growing than their fellow farmers in the Kabras area, where on average 24.9 per cent of the land is under cane. The smaller farmers in both cases have allocated a relatively large part of their land to sugar cane. The mean percentages under cane for the small and big farmers in the Mumias area are 48.4 and 36.7 per cent, and in the Kabras area 28.2 and 19.9 per cent respectively. The percentage of land under food crops for the different farmers is compared in Table 3 and summarized in Figure 20.

It is obvious that the cane growing farmers have given up part of their food crop production, which can be interpreted as a move out of subsistence production into the market system. However, this shift is small. Compared with the farmers from the Mumias area, the farmers from the Kabras area all rely

Figure 2: Land used by different categories of farmer to grow food crops

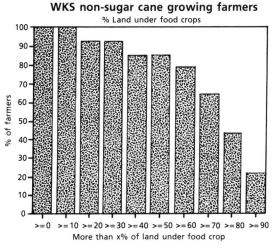

WKS non-sugar cane growing farmers

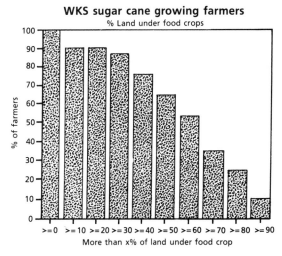

WKS sugar cane growing farmers

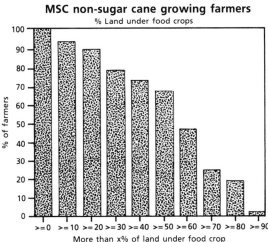

MSC non-sugar cane growing farmers

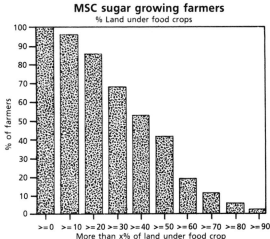

MSC sugar growing farmers

Table 3: Comparison of the percentage of land under food crops for different farmers

	WKS cane growing farmers	WKS non-cane growing farmers	MSC cane growing farmers	MSC non-cane growing farmers	
30% of the farmers have more than	70%	80%	50%	60%	of their land under food crops
60% of the farmers have more than	50%	70%	30%	50%	of their land under food crops
90% of the farmers have more than	20%	30%	10%	20%	of their land under food crops

more on their food crops, and the sugar cane growing farmers from the Kabras area appear to be in the same position with respect to the market system as the non-cane growing farmers in the Mumias area.

A conclusion with respect to the shift from food crop production to cash crop production for smaller and bigger sugar cane growing farmers is not possible because of the relatively small number of bigger non-cane growing farmers serving as a reference. The hypothesis, therefore, is that there is little difference between the big and small sugar cane growing farmers with respect to their involvement in the market system.

It is difficult to confirm or deny the theoretical instability of the first development phase, mentioned earlier, where the farmers enter the market system without totally abandoning subsistence production.

Table 4: Reactions of sugar cane growing farmers to different statements concerning the growing of sugar cane (%)

Statement:	Agree	Disagree	No answer
Mumias sugar cane growing farmers:			
The sugar factory needs my cane	97.9	0.5	1.6
The sugar factory pays a high price for my sugar cane	7.9	86.8	5.3
Because I have a sugar factory nearby I can make enough money from farming	42.6	52.1	5.3
Only when the factory makes a good profit I can make a good profit on my sugar cane	51.1	44.2	4.7
I could make a higher profit on another cash crop than sugar cane	25.3	73.2	1.6
Kabras sugar cane growing farmers:			
The sugar factory needs my cane	96.9	3.1	
The sugar factory pays a high price for my sugar cane	34.4	56.3	9.4
Because I have a sugar factory nearby I can make enough money from farming	71.0	29.0	
Only when the factory makes a good profit I can make a good profit on my sugar cane	65.6	31.3	3.1
I could make a higher profit on another cash crop than sugar cane	45.2	54.8	

For a more definite assessment, at least a second reference point in time would be necessary. The interviews do not point to such a development in the Mumias area, but in the Kabras area there are some indications that farmers are withdrawing from sugar cane production. The attitudes of the sugar cane growing farmers towards the cash crop is reflected in Table 4, where their opinions about some statements regarding sugar cane as a cash crop are recorded.

The Mumias farmers are more dissatisfied with the returns from sugar cane than the farmers in the Kabras area, where there is a general awareness of the mutual dependency of factory and farmers. This awareness is much less pronounced in the Mumias case. The Mumias farmers do, however, recognize their dependency on sugar cane as the most profitable cash crop, whereas almost half of the sugar cane growing farmers in the Kabras area see possibilities for more profitable cash crops. The profitability of different cash crops as indicated by the different farmers is given in Table 5.

Sugar cane farmers in the Mumias area mention sugar cane as the most profitable crop. Coffee is the only crop that is in some competition with sugar cane. Maize and beans are named as reasonably profitable crops, but only in second place. Although half of the sugar cane growing farmers in the Kabras area indicated (Table 4) that sugar cane is not the most profitable cash crop, the answers recorded in Table 5 show that they cannot really think of a competing cash crop. Maize as a profitable cash crop comes clearly in second place. Table 5 also provides information about the non-sugar cane growing farmers and specific cash crops. Both the farmers in the Mumias and Kabras areas consider maize to be the most profitable cash crop. In the Mumias area, sugar cane is, however, quite often mentioned as the most profitable cash crop, and part of the non-cane growing farmers would like to change their crop growing pattern in favour of the cash crop sugar cane. In the Kabras area, this is certainly not the case.

Sugar cane farmers in both areas have entered the first phase of integration into the market system. The Mumias farmers are more intensively involved in market production, but still rely heavily on subsistence production. For these farmers, there is evidence that this phase is a stable one and that they are not entering the next phase where a specialization in cash crop production allows them to rely on cash income for their food needs. In the Kabras area, the process of integration into the market system has not yet stabilized.

Dissatisfaction with sugar cane production could make the farmers in the Kabras area decide to abandon sugar cane cultivation. Because of the lack of alternative cash crops, this would lead to a return to subsistence production. But, as yet, there is no evidence that the economics of the market production systems squeezes the majority of farmers out of agriculture, as predicted by Buch-Hansen.[4]

Table 6 presents a review of the sources of income of the different farmer categories. The data in Table 6 only indicate whether or not the sources mentioned contribute to income. They do not provide information on the magnitude of the contribution. It can again be concluded that the vast majority of farmers not growing cane have no alternative income from a cash crop. Farmers in the Kabras area more often obtain an income from selling the surplus of food crops, including maize and beans, that are partly grown as a cash crop. It is striking that in both areas this source of income is more often mentioned

Table 5: Crops mentioned by the farmers as being most profitable (%)

Crop	Cane growing farmers		Non-cane growing farmers	
	Most profitable	Second most profitable	Most profitable	Second most profitable
MSC farmers:				
Sugar cane	61.8	7.3	19.8	3.6
Coffee	12.0	3.1	4.5	0.0
Beans	7.9	13.6	19.8	22.5
Maize	6.8	17.8	28.8	13.5
Groundnuts	6.3	4.2	7.2	6.3
Tomatoes	1.6	0.5	0.0	0.9
Cotton	1.0	4.2	0.0	0.0
Tea	0.5	2.1	0.0	1.8
Cassava	0.0	0.5	1.8	1.8
Sorghum	0.0	0.0	5.4	3.6
Others/no answer	2.1	46.6	12.6	45.9
Total	100.0	100.0	100.0	100.0
WKS farmers:				
Sugar cane	71.4	5.7	2.1	2.1
Maize	8.6	48.6	54.2	4.2
Groundnuts	5.7	2.9	4.2	2.1
Beans	2.9	5.7	6.3	27.1
Coffee	0.0	0.0	2.1	8.3
Tea	0.0	0.0	10.4	0.0
Others/no answer	11.4	37.1	20.8	56.3
Total	100.0	100.0	100.0	100.0

Table 6: Sources of income for the different categories of farmer (%)

Source of income		MSC cane growing farmers	MSC non-cane growing farmers	WKS cane growing farmers	WKS non-cane growing farmers
Cash crop:	Sugar cane	100.0	0.0	100.0	0.0
	Coffee	1.0	0.0	2.9	12.5
	Tea	0.0	0.0	2.9	10.4
	Others[a]	1.1	0.0	0.0	0.0
Surplus food crops[b]		41.3	37.4	65.7	64.6
Wage labour:	Men	47.6	32.4	37.1	37.5
	Wives	9.4	4.5	2.9	6.3
	Children	41.9	36.0	40.0	35.4
Business		34.0	22.5	25.0	27.1

a. Others include other cash crops grown in the area like cotton, tobacco and rice.
b. Maize and beans which are grown partly as cash crops are included in this category.

for the sugar growing farmers than for the non-sugar cane growing farmers. Wage labour from family members as sources of income are comparable for the four categories, but are slightly higher for the sugar cane growing families. Mumias cane farmers more often get additional incomes from business than the other farmers.

An analysis of the smaller and bigger sugar cane farmers shows that the selling of food crops is just as often a source of income for the latter as for the former: 45 per cent compared to 41 per cent. Business is more often an additional source of income for the smaller farmers than for the bigger farmers: 37 per cent compared to 12 per cent.

The income level of a household is difficult to establish because of the various sources of income, and because of the practical reason that questions related to income are considered to be indiscreet. Consquently, the resulting answers are unreliable.

An alternative way of obtaining information on this subject is to ask for expenditures. The assumption thereby is that the household spends all money that is coming in. In Figure 3, the expenditures on a weekly base are presented. A limitation lies in the fact that the figures only refer to day-to-day expenditures, and the incidental larger expenditures on school fees and the like are not included. The figures show that the expenditure patterns for the sugar cane growing farmers have shifted slightly to the higher expenditure categories. Table 7, presenting the expenditures on a quintiel scale, shows more clearly the small differences in daily expenditures between the different groups of farmers. The only marked difference is between the Mumias sugar cane and non-sugar cane farmers: the sugar cane farmers spend more.

Also included in the table are the smaller and bigger cane growing farmers of the Mumias area. The daily expenditures of the bigger farmers are significantly higher. The daily expenditures of the smaller sugar cane farmers are very much the same as for the non-sugar cane growing farmers.

Figure 3: Expenditures for different categories of farmers on a weekly basis

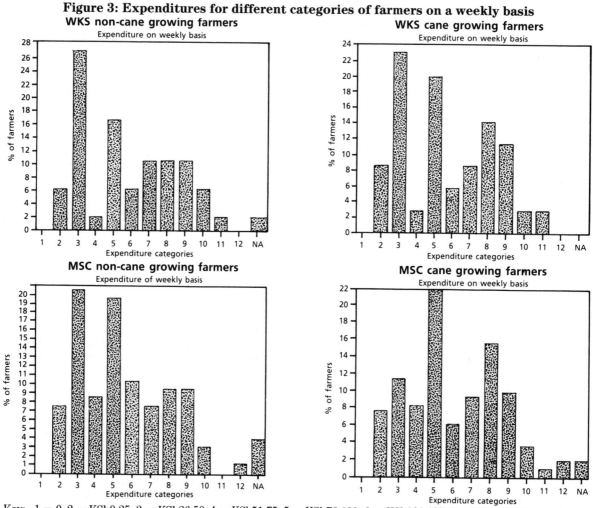

Key: 1 = 0, 2 = KSh0-25, 3 = KSh26-50, 4 = KSh51-75, 5 = KSh76-100, 6 = KSh101-125, 7 = KSh126-150, 8 = KSh151-200, 9 = KSh201-300, 10 = KSh301-400, 11 = KSh401-500, 12 = More than KSh500, NA = No answer

Of the sugar cane farmers in the Mumias area 66.1 per cent hired labour for agricultural practices compared to 34.9 per cent of the non- sugar cane growing farmers. In the Kabras area, the figures are 52.9 per cent and 47.9 per cent respectively for sugar cane growing and non- sugar cane growing farmers. The sugar cane growing farmers in the Mumias area make significantly more use of hired labour than the other farmers. For the bigger farmers the percentage that uses hired labour is 80.5 per cent compared to 62.4 per cent for the smaller farmers. In the Kabras area, a relatively high percentage of farmers uses wage labour. Here, the difference between the two groups of farmers is quite small. In Table 8, the reasons are given why different farmers do not hire labour.

Table 7: Comparison of the expenditure by different groups of farmers (KSh)

	MSC cane growing farmers	MSC smaller cane growing farmers	MSC bigger cane growing farmers	MSC non-cane growing farmers	WKS cane growing farmers	WKS non-cane growing farmers
20% spends more than	151	151	201	151	151	151
40% spends more than	126	101	151	101	126	126
60% spends more than	76	76	101	76	76	76
80% spends more than	51	51	51	26	26	26
100% spends more than	0	0	0	0	0	0

Table 8: Reasons mentioned by farmers why no labour was hired (%)

Reasons why no labour was hired	MSC cane growing	MSC non-cane growing	WKS cane growing	WKS non-cane growing
There was no need to do so	22.5	7.4	12.5	4.0
Family labour was sufficient	37.5	41.2	81.3	56.0
There was no money to hire them	46.9	50.0	6.3	36.0
Labour is hard to get	1.6	1.5	-	4.0

In the Mumias area, the reason why no labour was hired is that there was no money to do so. In the Kabras area, satisfaction with the family labour available is the major reason for not hiring any labour. This is particularly the case for the cane growing farmers. The non-cane growing farmers would hire more labour if they could afford it. In all cases, the availability of labour hardly appears to be a problem.

Some differences emerge between smaller and bigger farmers. The latter use more wage labour, and their expenditures on day-to-day expenditures are slightly higher. These bigger farmers reinvest the profits from agriculture more often in some sort of business, while the smaller farmers seem to rely more on the income from their land. A household from the non-cane growing group is still living very close to subsistence production. Incomes from surplus food production are occurring frequently, but are by no means general. The same is true for income from wage labour — farmers in this group rely mainly on family labour. For an unidentified reason, the farmers from this group are less satisfied with the family labour available than the sugar cane growing farmers. The hypothesis is that this group of non-cane growing farmers is marginalized in socio-economic terms, and that the chances for these farmers to be squeezed out of agriculture are much larger than for the smaller cane growing farmers.

In the Kabras area, the differences between the two groups of farmers with respect to the features looked at are very small. The sugar cane growing farmers have still all the characteristics of the non-cane growing farmers. There is only a tendency to use more wage labour.

Between the two areas, there is a marked difference where the selling of surplus food crops is concerned. In the Kabras area, this is significantly more often a source of income both for cane growing and non-cane growing farmers.

With respect to the other features, the two farmer groups in the Kabras area are comparable with the non-cane growing farmers in the Mumias area, with one important difference. Cash crop growing for sugar farmers and other farmers in the Kabras area is more often a source of income than for households in the Mumias area.

Land

Before 1940 there were no personal land rights. Family groups claimed rights to the land they occupied, but the boundaries were not precisely defined. One of the major reasons for the communal land ownership was the necessity of joining hands in cultivating the land. Therefore, the introduction of ox-ploughs could indeed, as suggested by Barclay (1977, p. 118), have been one of the major reasons for the individualizing of land tenure. Another important reason was the increasing pressure on the land. Land as such was not yet scarce, but those parts that were fertile and easy to work were increasingly in demand. At first, claims on land and the inevitable disputes were dealt with and settled by the local authorities on a rather ad hoc basis. Formal adjudication and the issuing of title deeds started in 1958, but made slow progress.

The planning of a sugar factory in the Mumias area gave land a new economic value, either because of the possibility of using it for cash crop growing or because of the emergence of a market for land. This speeded up land adjudication in this area, and even before the construction of the factory the process was more or less completed. From that time onwards, there was a market for land. Mulaa (1981, p. 95) reports a five-fold increase of transactions between 1970 and 1975 in the early years of the introduction of the sugar cane cultivation. After 1975, the number of transactions decreased to an average of about 150 a year. The total number of 1,503 transactions from 1970 until 1978 include only 3,158 hectares, which is 1.8 per cent of the total area under sugar cane.

When the sugar cane factory in Kabras was established in 1981, the process of land adjudication had already ended. Details on the land transactions are not available, but the general idea is that the trade in land has also been relatively insignificant in Kabras.

Unless the land was fallow before, the use of land for sugar cane competes with other uses, and in the first place with subsistence production. As was pointed out earlier, subsistence production in Kenya does not only involve the production of food but also a surplus production that can be marketed in order to provide money to purchase non-food items necessary for the sustenance of the family. If sugar cane replaces the food crop production, the question arises as to whether buying food on the market from the cash money earned secures the nutrition of the family better than subsistence production. If a cash crop replaces the cash generating side of the subsistence production, the question also arises as to whether the gross margin from sugar cane exceeds the gross margin from the crops cultivated before, or other crops that could be used for the same purpose.

These issues are only part of the problems involved in land use. From Odhiambo (1978), some impression is gained about the land use of outgrowers in the case of MSC. The degree of diversification on the sugar farm decreases when both the larger and smaller farmers tend to specialize in growing cane, but a significant part of the land is still allocated to subsistence crops. Land allocation for grazing is minimal, and whatever cattle are held, particularly among the smaller farmers, are grazed on common pastures.

Mwandihi (1985) looked at the different food crops grown and the cattle held, and found that there was a significant decrease in maize, sorghum and cassava cultivation before and after the introduction of sugar cane, with differences in average output of 30 to 40 per cent. The livestock held decreased by an average of 30 per cent. Mwandihi also looked into the land distribution patterns, and found no significant differences in the average plot size before and after the introduction of sugar cane. His conclusion is that the decline in the food crop production should be explained in terms of change in the crop mix at the farm level. Several authors (Odada, 1981; Buch-Hansen, 1982b; Mulaa, 1981) have reported part of Mwandihi's findings before. The conclusion that a shortage of food crops in the Mumias area occurs because of the use of the land for sugar cane growing is, however, attacked by Amunga (1985), who calculates that more than 50 per cent of the land must be available for other use than the growing of cane. Even allowing for some omissions in Amunga's reasoning, particularly when he does not account for unsuitable land, there is evidence that the land is being under-utilized.

Another explanation for the shortage of food crops could be the shortage of labour when most of the labour is used for cash cropping. Kongstad (1980a, pp. 31-160) mentions the shift in agricultural tasks of women when changing from food to cash crops as a major cause for the reduction of food crop production.

From an aerial survey[5] conducted in 1983, it is possible to gauge the areas of influence of the three major factories in the area (see Figure 4). Jaggery factories are found everywhere, and no special areas of influence can be allocated. For the Mumias area, it is clear that the whole area within the B-circle should be considered as a specific cane area. The northern part of the C-zone belongs to the area of influence of the Nzoia factory. In the east, the border of the area under MSC influence can be drawn at 18.2 kilometres from the centre. There the area of influence of WKS starts. This area is not circular.

The average percentage of land allocated to various agricultural purposes is given in Table 9. Because the averages in Table 9 are in each case calculated separately, only a horizontal comparison can be

Figure 4: Area under sugar cane

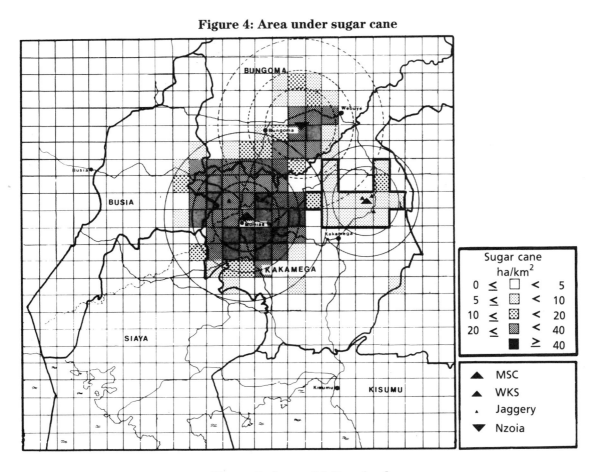

Figure 5: Area of fallow land

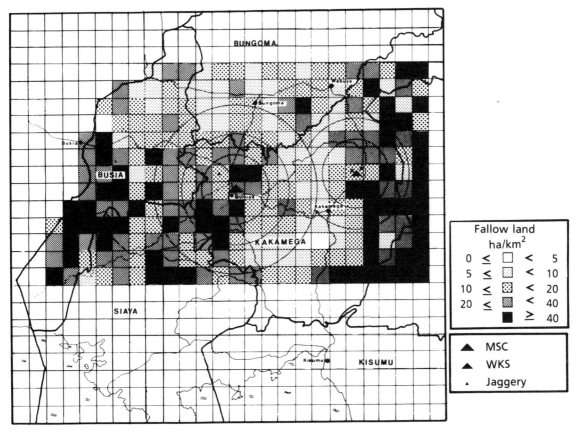

made. Sugar cane growing farmers have less fallow land than the non-cane growing farmers. Bad soils and rocky land are the reasons mentioned most often for leaving the land fallow, except for the WKS sugar cane growing farmers where the lack of money to cultivate the land is more often mentioned. For the other farmers, lack of money is the second reason why land is left fallow. In the Mumias area, for both groups of farmers, a third important reason is a rest period for the land in order to recover its fertility.

The survey also provided information on the distribution of fallow land in Western Province (see Figure 5). It can be seen that large parts of the sugar zone have a lower percentage of fallow land than the surrounding areas, but that comparable areas with low percentages of fallow land can be found also outside the cane areas. Growing of sugar cane is therefore only one of the reasons for the decrease of fallow land. In the north and north-west, other cash crops such as tobacco and cotton can be found. In the south, the very dense population probably causes a maximum use of land. In the south-west and east respectively, bad soils and forests and mountains increase the percentage of land that is fallow.

Table 9: Land allocated to various agricultural purposes (%)

Agricultural purpose	MSC cane growing farmers	MSC non-cane growing farmers	WKS cane growing farmers	WKS non-cane growing farmers
Sugar cane	45.9	0.0	24.9	0.0
Food crops	41.6	56.7	61.0	71.2
Fallow land	7.8	13.2	6.4	14.2
Grazing land	10.3	12.4	19.5	16.1

Table 9 also shows that in comparison with the non-cane growing farmers from the same area, the Mumias sugar cane growing farmers have given up a bigger part of the food crop production. The Mumias sugar cane growing farmers have considerably less land under food crops than their fellow farmers in the Kabras area. The cane growing farmers in the Kabras area have more land allocated to grazing than the sugar cane growing farmers in Mumias; they even have more grazing land than the non-cane growing farmers in the Kabras area. In the Mumias area, the non-cane growing farmers have more grazing land. From the cane growing and non-cane growing farmers in the Mumias area, 20.3 per cent and 18.8 per cent respectively practice zero grazing. For the farmers in the Kabras area, these figures are 38.7 and 21.9 per cent. The cane growing farmers in the Kabras area appear to be more involved in keeping cattle than the non-cane growing farmers.

The crops that are most often grown by the different farmers are listed in Table 10. In the Mumias area, all crops are more often grown by the non-cane growing farmers except potatoes, groundnuts,

Table 10: Crops that are most often grown by the different farmers (%)

Crop	MSC cane growing farmers	MSC non-cane growing farmers	WKS cane growing farmers	WKS non-cane growing farmers
Sugar cane	100.0	0.0	100.0	0.0
Maize	87.4	97.2	97.1	100.0
Beans	57.4	67.0	85.7	93.8
Cassava	44.7	52.3	54.3	43.8
Potatoes	27.4	22.0	60.0	52.1
Millet	25.8	32.1	11.4	20.8
Groundnuts	25.3	21.1	14.3	18.8
Vegetables	20.0	22.9	65.7	68.8
Bananas	18.4	22.0	57.1	60.4
Sorghum	15.3	18.3	14.3	14.6
Fruits	11.1	3.7	5.7	4.2
Peas	9.5	0.9	2.9	2.1

fruits, peas and of course sugar cane. The differences are of an order that allow no conclusions. In the Kabras area, sugar cane growing farmers more often grow cassava, potatoes, fruits, peas than the

116

non-cane growing farmers in the area. This means that sugar cane growing farmers in the Kabras areas rely for their staple crops more often on cassava and potatoes, whereas the non-cane growing farmers rely more on such traditional food crops as millet and beans. Cassava as a staple crop seems to play a very important role for all the farmers in the area. In importance it is only passed by maize and beans, which are most often grown together, and in the case of the WKS cane growing farmers by potatoes. Cassava has replaced traditional food crops like sorghum and millet. In the case of the sugar cane growing farmers, this change is much more apparent.

The benefits from the different crops depend in the first place on the extent to which this benefit serves its purpose: cash crops earn cash and food crops meet the nutritional demands. By attaching the market value to the food crops, following the idea that food crops in the end prevent cash money expenditures, the benefits from the different crops are to some extent comparable.[6]

The gross margins for the different crops are calculated for each farmer growing the crop on the basis of data collected in the field. Often part of the data needed for calculating the gross margins was missing. This was particularly the case for the sugar cane growing farmers in Mumias, where 88 per cent of the farmers did not know what was charged by the factory for the different services like ploughing, provision of fertilizers and seed cane. Therefore, in this case, the field data could not be used to calculate gross margins. The results of the gross margin calculations are presented in Table 11.

The gross margin for sugar cane in the Kabras area is much lower than the 9,187 KSh for smallholders using casual labour and 12,632 KSh for smallholders using family labour, reported by the UK Overseas Development Administration in 1986. The differences occur because the yields reported in the field work were lower, and the net factory price reported was significantly lower. The figures found in the field study appear to be more realistic. The gross margin for the sugar cane farmers in Mumias can be compared with data from the Mumias factory. In 1984, the ex-factory payments were KSh 135,270,399.00 for 16,049.00 hectares of outgrowers land harvested, equivalent to KSh 8,429 per hectare of sugar cane. To arrive at the gross margin, the costs made by the farmers have to be deducted. These are costs for hired labour for planting, gap filling and weeding. From survey data, these costs are calculated to be KSh 3,394 per hectare (Odada, 1985, p. 22). The gross margin is therefore KSh 5,035 per hectare, which is comparable with the figure in Table 11.

Apart from bananas, sugar cane gives by far the best returns. However, bananas are no alternative for sugar cane because of the lack of an extensive market able to absorb quantities of bananas equivalent to the quantities of cane grown. The returns to farmers related from selling cane to the smaller sugar

Table 11: Mean gross margins per hectare for different crops grown in the Kakamega district (KSh)

Crop	Mean gross margin per hectare
Bananas	12,496
Vegetables	4,301
Maize/millet	3,975
Sorghum	3,400
Potatoes	3,373
Groundnuts	3,114
Maize/beans	2,941
Maize/cassava	2,835
Maize/groundnuts	2,583
Maize	1,630
Cassava	1,269
Millet	1,151
Beans	686
Sugar cane	
Kabras area	7,516
Mumias area	4,709

technologies are higher than for the farmers related to the large-scale sugar factory. The difference is caused by the deductions made by the large-scale factory for agricultural services rendered.

The surplus in gross margin in the Kabras area is at the cost of the cane quality or at the cost of the exploitation of labour. The cane quality could already be less than in Mumias, or could become lower

Figure 6: Potential for various crops

118

Pineapple potential

Very good
Good
Fair
Marginal poor

▲ MSC
▲ WKS
▴ Jaggery

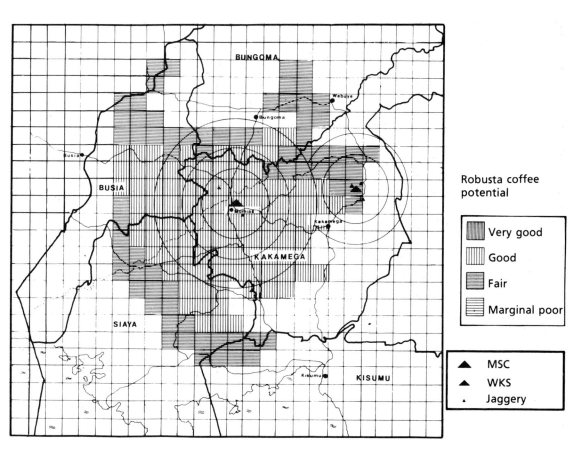

Robusta coffee
potential

Very good
Good
Fair
Marginal poor

▲ MSC
▲ WKS
▴ Jaggery

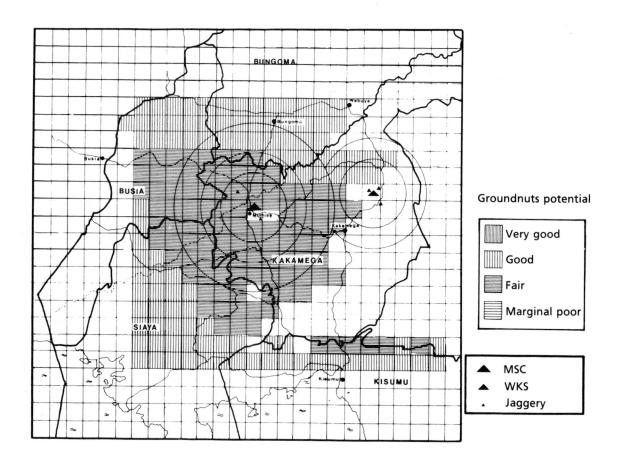

Groundnuts potential

Very good

Good

Fair

Marginal poor

▲ MSC

▲ WKS

▲ Jaggery

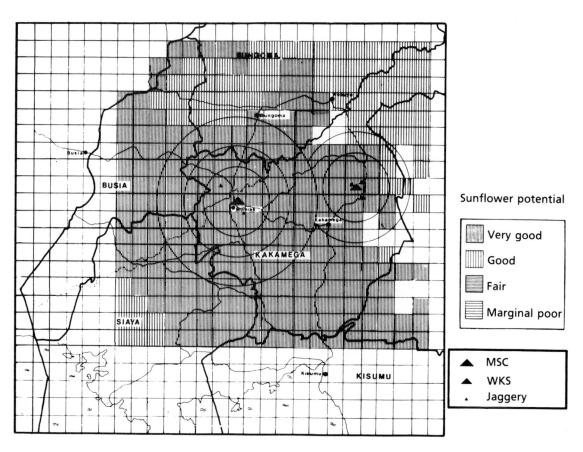

Sunflower potential

Very good

Good

Fair

Marginal poor

▲ MSC

▲ WKS

▲ Jaggery

120

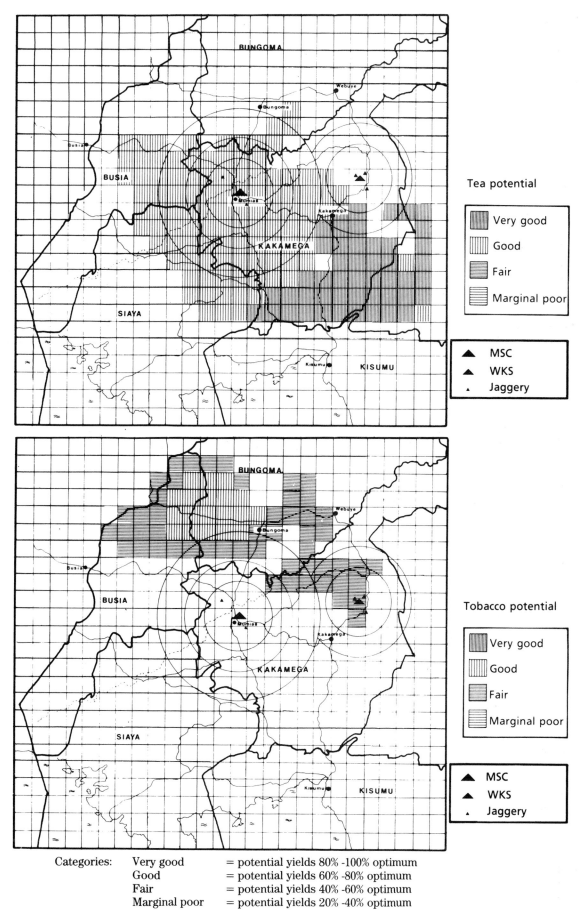

Tea potential

Very good

Good

Fair

Marginal poor

▲ MSC

▲ WKS

▴ Jaggery

Tobacco potential

Very good

Good

Fair

Marginal poor

▲ MSC

▲ WKS

▴ Jaggery

Categories: Very good = potential yields 80% -100% optimum
 Good = potential yields 60% -80% optimum
 Fair = potential yields 40% -60% optimum
 Marginal poor = potential yields 20% -40% optimum

because of the deterioration of the soil owing to the monoculture of cane. In this case, the higher gross margin of the Kabras area is at the cost of the West Kenya Sugar factory. Male casual labour in the Kabras area is paid an average of KSh 9.5 per six hours of work. The average in the Mumias area is KSh 16.6. For female labour, the average payment is KSh 9.5 and KSh 10.9 respectively in the Kabras and Mumias areas. If these differences are the reason for the higher gross margin in the Kabras area, this advantage is at the expense of the labourers in this area.

The major reason for the difference in gross margin should, however, be found in the different inputs of casual labour and family labour by the Mumias and Kabras sugar growing farmers. From the Mumias sugar cane farmers, 56 per cent used casual labour. The average number of labour days hired per hectare under sugar cane in the previous year was 161.5. From the Kabras farmers, only 17 per cent reported using casual labour in cane. The average number of labour days per hectare was, with 30.4 days, much lower. This is in spite of the multitude of agricultural jobs that the Kabras farmers have to do themselves in the sugar cane.

An in-depth analysis of the use of family labour in sugar cane cultivation would be necessary to assess the economic appreciation of family labour before definite statements about the higher revenues in the Kabras area can be made. It is clear, however, that the use of more family labour gives the sugar cane growing farmers in the Kabras area a higher gross margin than the sugar cane growers in the Mumias area.

Of course, all these gross margins are average figures and they do not exclude the possibility that some of the farmers have very low gross margins or even lose on the growing of sugar cane. The Mumias Sugar Company analysed this issue. In the period from January 1984 until September 1985, 497 farmers, or 2.5 per cent, had a negative balance after the factory deducted the costs from the revenues of the cane delivered by these farmers (Amunga, 1985, p. 24). On basis of one figure no conclusions can be drawn. Further monitoring, also in the Kabras area, would be necessary, but the figure indicates that the growing of cane does not frequently lead to losses. Maize inter-cropped with millet or beans and sorghum seems to be the most competitive traditional crop mix. Groundnuts could be an alternative if a market could be developed for large quantities. This is only possible if they are used for industrial production. Alternatives for sugar cane can therefore only be provided by a new cash crop.

The aerial survey in 1983 was combined with an analysis of potential land uses (see Figure 6). It concluded that Arabica coffee, groundnuts and tobacco are not very promising as a substitute for sugar cane in both the Mumias and the Kabras areas. Robusta coffee and tea have good potentials in the Mumias area. Cotton, pineapple and tea have good potentials in some parts of the Kabras area in particular. Sunflower is the only crop that can compete with sugar in the entire area.

Table 12: Gross margins per hectare for different crops (KSh)

Crop	Gross margin per hectare
Sugar	4,709
Sunflower	947
Tea	55,089
Maize and beans	3,910

Source: Odada, 1985.

Gross margins under the prevailing conditions for all the possible cash crops for the research area are not known. Odada (1985) presents gross margins for some of the crops (see Table 12). From this table it is clear that tea is, in economic terms, an alternative for sugar cane. Sunflower is certainly not. But even if gross margins from these crops are higher than for sugar cane, substitution is only theoretical. In practice, the introduction of another cash crop would make it necessary either to set up an infrastructure for these new crops or to provide for a transport system able to bring the crops to the areas that have the necessary infrastructure. The production of some crops (notably tea) is governed by licence. Kenya is already overfulfilling its international quota. The purpose of earning cash appears therefore, at least for the time being, best served by growing sugar cane.

The question of whether growing sugar cane serves the purpose of feeding the family better than the growing of food crops will be dealt with later. From Table 9 it is clear that part of the food crop production is given up for the production of sugar cane. Table 10 shows, however, that a variety of food crops is still grown besides sugar cane. This variety in cropping pattern is also confirmed by the data of the 1983 survey shown in Figure 7.

122

Figure 7: Local crop diversity index

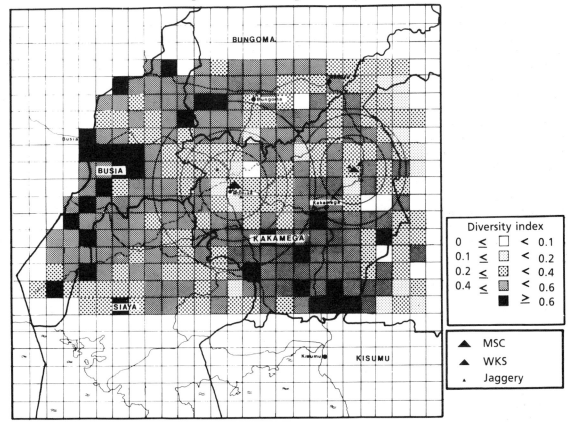

Note:

The local crop diversity index is calculated using the formula:

Diversity index = $1 - (P_i)$

Where P_i is the proportion of each individual crop in the area surveyed.

The conclusion is that land is still used for growing food crops with the purpose of feeding the family. For the cane growing farmers in Kabras, labour is probably not a limiting factor in growing food crops. For the other three groups, labour could be a limiting factor because a considerable number of farmers could have used more labour if they had money to hire it. In the Mumias area 28.9 per cent and in the Kabras area 22.8 per cent of the answers indicate that women are responsible for the cash crops. That implies that there could indeed be a shift from the food to the cash crops in the households of the cane growing farmers.

Skills/knowledge

The introduction of cash cropping in an area should increase the access of farmers to technological innovations in agriculture. Bergmann (1979, p.110) mentions the following characteristics for progress in agriculture:

○ in the biological-technical field: sowing-seed, breeding cattle, fertilizers, pesticides and monoculture
○ in the mechanical-technical field: mechanical and motorized traction power and other machinery and, in general, the use of fossil energy to cultivate the land
○ in the sociological field: extension services, co-operations and other forms of organization and training institutes

Cukor (1974) describes the development that preceeds the one sketched by Bergmann. According to Cukor, the great agricultural revolution in Europe consisted mainly of the introduction of careful weeding and, at a later stage, a high level of fertilization. Still later, the improvement consisted of more intensive utilization of land and a better performance of traditional work such as ploughing, sowing, harvesting and threshing. In Table 13, different indicators related to skills and knowledge in agriculture are given.

In the Mumias area, the sugar cane growing farmers have a small lead in all three fields mentioned before. The 100 per cent use of fertilizer gives some bias because the fertilizer is part of the deal with the sugar factory and is to be used for the sugar cane. This same bias is found with respect to tractor hire.

Most farmers do not recognize the use of a tractor in their cane fields as hiring. Correcting this figure by only counting the number of times a tractor is hired for other crops than sugar cane gives a figure of 14.6 per cent. This is still much higher than the use of tractors by the non-sugar cane growers. The use of ox-ploughs has not been affected by the more frequent use of tractors. The fact that sugar cane requires a better soil tillage has apparently led to a more extensive use of ox-ploughs and tractors in the other crops as well. The small lead in the sociological field is not significant. In fact, development in this field has not started yet for both farmer groups.

In the Kabras area, it is striking that it is the non-sugar cane growing farmers who use fertilizers, certified seeds and pesticides more often. In the biological-technical field, these farmers seem to have a small lead. This is somewhat unexpected because it means that the cultivation of traditional crops leads to more skill than the involvement in sugar cane production connected to the medium- and small-scale sugar technologies. It also reflects a necessity for extension services by WKS. In the mechanical-technical field the sugar cane growing farmers in turn have a small lead, probably for the same reason as mentioned for the Mumias cane farmers. The sugar cane growing farmers in Kabras practice zero grazing significantly more often. This may be considered a more effective use of land and a better use of manure (see Table 8), and thus a step forward in agricultural development.

Table 13: Indicators of skills and knowledge in agriculture (%)

Indicators	MSC cane growing farmers	MSC non-cane growing farmers	WKS cane growing farmers	WKS non-cane growing farmers
Using manure	61.1	63.3	88.6	77.1
Using fertilizer	100.0	20.0	45.7	52.1
Using certified seeds	88.4	81.8	88.2	91.7
Using pesticides	12.6	8.2	8.6	16.7
Owning an ox-plough	26.8	12.8	54.3	43.8
Hiring an ox-plough	52.1	50.5	75.0	69.7
Owning a tractor	2.1	0.0	2.9	0.0
Hiring a tractor	19.5	5.5	17.6	4.2
Practicing zero grazing	20.3	18.8	38.7	22.0
Attending agricultural training programmes	8.6	3.6	8.6	12.5
Member of an agricultural organization	2.1	1.8	5.7	6.3

CHANGES AT THE PERSONAL AND HOUSEHOLD LEVEL

The decision-making process

When describing land as a production factor, an indication was already given of the changes that occurred in one of the basic units of society: the family. Developments in agriculture and pressure on the land put an end to the communal possession and cultivation of land. The scarcity of fertile soils and the possibility of cultivating the land with fewer hands, eg. by using an ox-plough, changed the ideology of the kinship from a community spirit to a more individualistic spirit in which the nuclear family or household became the basis of society. The process of individualization was speeded up by the introduction of the cash crop, particularly because the introduction of the cash crop led to the adjudication of land, which definitely ended the use of common land for crop cultivation. In the Mumias area, even common grazing is disappearing at an increasing rate.

Production takes place on the farms of the individual families, although often more families connected through lines of patrilineality live in one place: the extended family. Such an extended family lives on an individual farm surrounded by shambas, the land where the food crops are cultivated, and most often adjacent to the fields where the cash crops or the staple crops, like maize and beans, are grown.

The individualization of agriculture in Western Kenya has not led to a village pattern of settlement as known in the rural areas of Europe, but is characterized by scattered dwellings. The local people, however, mostly refer to them as villages. Kongstad (1980b, pp. 20-24) predicted a change in the economic 'raison d'etre' of the family, owing to the introduction of the cash crop. Family production would no longer be directed at satisfying the subsistence needs of the family, but at satisfying the needs of capital for surplus value. When analyzing the economic institution, it became clear that this process has not yet made much progress and that few farmers have really entered the capitalist mode of production.

Nevertheless, some of the developments described by Kongstad are certainly there. Communal work as a general practice has almost completely vanished. The family is relying on its own members, and hiring of labour is becoming more and more common. Women seem to have found a way to continue the tradition of communal work on their land by forming womens' groups that work in turn on the land of each member. Sometimes a very low payment of one or two Shillings for half a day of work is involved in this exchange of labour. The process of individualization is developing parallel to a continuing process of differentiation between the different families. An often-formulated hypothesis is that such a process of differentiation can also be found within the household, where cash crop production is considered men's business and food crop production is left to women.

Staudt (1984, p. 16) and Pala (1975) mention a more or less strict division between the fields of decision making for men and women. Men decide about the allocation of land and labour. They are responsible for the cash crop production. The women are responsible for the agricultural subsistence production and selling the surplus of products on the market. There is also a differentiation in responsibility for expenditures. The women are responsible for the food expenditures, and the men for the investment expenditures such as school-fees, house improvements and agricultural inputs. In tables 14a and 14b, the answers are recorded of the respondents in the sample on questions about decision making and responsibilities within the household.

The figures between brackets indicate the answers given by the female respondents on the questions related to the say of women. In case of the cane growing farmers of the Mumias area, one cannot speak of a strict division in decisions and responsibilities. In about one-third of the households, the decisions

Table 14a: Decision-making and responsibilities in the MSC farming households (%)

	House-hold head	Women	House-hold head & women	With relatives	Others/ no answer
MSC sugar cane growing farmers:					
Decisions about:					
Food crops grown	28.2	23.9 (27.5)	45.2	1.6	1.1
Cash crops grown	49.2	9.0 (11.1)	37.6	2.1	2.1
Land allocated to food crops	42.2	17.1 (18.8)	38.5	0.5	0.5
Food crops sold	37.1	21.9 (25.4)	37.1	0.7	3.3
Hire of labourers	42.6	17.9 (14.5)	35.2	1.9	2.4
Who is responsible for:					
The food crops	25.7	36.9 (36.7)	35.8	1.6	0.0
The cash crops	54.3	10.1 (8.8)	31.9	2.7	1.1
MSC non-sugar cane growing farmers:					
Decisions about:					
Food crops grown	41.8	32.7 (34.6)	24.5	0.9	0.0
Cash crops grown	47.3	24.2 (19.0)	27.5	0.0	1.1
Land allocated to food crops	54.2	25.2 (21.6)	19.6	0.0	0.9
Food crops sold	43.3	30.0 (23.1)	24.4	1.1	1.1
Hire of labourers	46.2	24.4 (22.2)	20.5	7.7	1.3
Who is responsible for:					
The food crops	36.1	46.3 (43.1)	17.6	0.0	0.0
The cash crops	49.5	28.9 (29.5)	20.6	1.0	0.0

125

Table 14b: Decision-taking and responsibilities in the WKS farming households (%)

	House-hold head	Women	House-hold head & women	With relatives	Others/ no answer
WKS sugar cane growing farmers:					
Decisions about:					
Food crops grown	45.7	11.4 (19.0)	37.1	5.7	0.0
Cash crops grown	48.6	11.4 (19.0)	34.3	5.7	0.0
Land allocated to food crops	51.4	8.6 (14.3)	37.1	2.9	0.0
Food crops sold	45.7	11.4 (19.0)	37.1	5.7	0.0
Hire of labourers	40.6	25.0 (36.8)	18.8	3.1	12.5
Who is responsible for:					
The food crops	42.9	28.6 (33.3)	25.7	2.9	0.0
The cash crops	48.6	22.9 (23.8)	25.7	2.9	0.0
WKS non-sugar cane growing farmers					
Decisions about:					
Food crops grown	33.3	11.1 (8.3)	51.1	2.2	2.2
Cash crops grown	35.6	8.9 (8.3)	51.1	2.2	2.2
Land allocated to food crops	33.3	8.9 (8.3)	53.3	2.2	2.2
Food crops sold	37.2	9.3 (18.2)	51.2	0.0	2.3
Hire of labourers	34.2	28.9 (44.4)	13.2	2.6	21.1
Who is responsible for:					
The food crops	28.9	26.7 (20.8)	40.0	2.2	2.2
The cash crops	33.3	22.2 (16.7)	40.0	2.2	2.2

are taken by both the household head and the wife, and they together are responsible both for the food and cash crops. For the other two-thirds, it is clear that the men are responsible for the cash crops. They are, however, also quite frequently, even according to the answers of the female respondents, responsible for the food crops. Certainly where it comes to allocating land to the food crops, men have more say than women.

For the non-cane farmers in the Mumias area, there is a more strict division between the responsibilities of men and women according to the description of Staudt and Pala. But also here, both according to the male and female respondents, responsibilities lie more often with the household head, but can be shifting, also in the case of cash crops, to the women. In the Kabras area, the shared responsibilities for both cash and food crops can be found too, particularly with the non-cane growers of which about 50 per cent claim mutual responsibility. Only for the hire of labourers is there a marked deviation, where the women claim that they are responsible. Also in the Kabras area, women can be responsible for the cash crops and men have responsibilities for the food crops.

In both areas, women also indicate that the decision about which part of the food crops are to be sold is not theirs alone. If the general idea is accepted that traditionally the responsibilities between men and women were strictly separated, the conclusion must be that the decision taking and responsibility patterns seem to have shifted from an individual to a mutual concern. This shift can be observed in all farmer groups, but is stronger in the Mumias cane growers and the Kabras non-cane growers.

In Tables 15a and 15b the responsibilities for expenditures are given. Only women were questioned on this item because of possible bias by the men.

Table 15a shows that in the Mumias area the responsibilities for all items mentioned shifted towards the men. It is the man who receives the income from the sugar cane, and apparently he has assumed responsibility for most expenditures. This shift cannot (yet) be noticed in the Kabras area. The emphasis with respect to the expenditure of women is on food, and emphasis with respect to the expenditures of the men on school fees, house repairs and the luxury items. The responsibility for agricultural inputs is still very much with the women, particularly for the Mumias non-cane growing and the Kabras cane

growing households. Again there is a remarkable difference, indicating that the mere fact of growing cane is not responsible for the observed shift in decision taking and responsibilities. The hypothesis is that the shifts are more dependent on the income level of the household. An in-depth analysis would be necessary to reach a more definite conclusion.

Material changes

The possible change in the nutrition status of the household as a result of the shift from food crop to cash crop production has already been mentioned. This negative effect could be offset by the increased buying power as a result of cash income from growing cane or from wage labour related to the sugar industry. In the Third Rural Child Nutrition Survey conducted by UNICEF in 1982, Siaya, Kisii, Kakamega, South Nyanza and Busia are mentioned as the districts that have a high incidence of malnutrition. The growing of sugar cane is suspected to be one of the reasons for this malnutrition (Hitchings, 1982; IFPRI, 1983).

Table 15a: Responsibilities for expenditures as indicated by the women in the MSC sample (%)

Items	Household head	Wives	Household head & wives	Others/ no answer
MSC sugar cane growing farmers:				
Food	55.5	20.0	21.8	2.7
Clothes	62.7	16.4	18.2	2.7
School fees	64.4	13.9	17.8	4.0
Furniture	69.4	17.6	8.3	4.6
House repair	73.4	17.4	5.5	3.6
Doctor	57.9	19.6	18.7	3.8
Seeds	51.9	34.9	10.4	2.8
Tractor	63.6	18.2	6.1	12.1
Ox-plough	66.7	17.5	11.1	4.8
Radio	75.0	14.7	1.5	8.9
Bicycle	84.7	11.9	1.7	1.7
Labourers	54.8	22.6	19.0	3.6
MSC non-sugar cane growing farmers:				
Food	45.3	40.6	12.5	2.6
Clothes	49.2	25.4	12.7	12.7
School fees	66.7	16.7	5.6	11.1
Furniture	66.7	19.0	4.8	9.5
House repair	68.3	19.0	1.6	11.1
Doctor	50.0	30.0	11.7	8.3
Seeds	36.7	48.3	11.7	3.4
Tractor	38.5	34.6	11.5	15.3
Ox-plough	61.0	26.8	7.3	4.8
Radio	57.5	32.5	2.5	7.5
Bicycle	60.0	25.0	2.5	12.5
Labourers	57.5	22.5	12.5	7.5

There are no systematic data on the nutritional situation in the Mumias and Kabras area. At the Public Health Department of the Kakamega District Office, the following sub-locations are mentioned as problem areas with respect to the nutritional situation: in the Mumias area the sub-locations Mumias, Khalaba and Mayoni in North Wanga and Indangalasia in South Wanga, and in the Kabras area the locations Isukha, Butsotso and North and South Kabras. An official of this department does not connect these nutritional problems with the growing of sugar cane, arguing that the malnutrition in these areas was already there before sugar cane was introduced (Washika, 1986). Lack of knowledge about the food crops that contribute to a sustaining diet is mentioned as another reason for the bad nutritional situation.

Ample attention is already given to the mix of food crops and cash crops for the farmers in the two areas. It is shown in Table 16 that in both areas the cane growing farmers, compared to the non-cane growing farmers in the same area, have given up a relatively small part (10 to 20 per cent) of their land

Table 15b: Responsibilities for expenditures as indicated by the women in the WKS sample (%)

Items	Household head	Wives	Household-head & wives	Others/ no answer
WKS sugar cane growing farmers:				
Food	56.3	25.0	18.7	0.0
Clothes	68.8	18.8	12.4	0.0
School fees	75.0	18.8	6.2	0.0
Furniture	75.0	18.8	6.2	0.0
House repair	75.0	18.8	6.2	0.0
Doctor	50.0	31.3	18.7	0.0
Seeds	56.3	37.5	6.2	0.0
Tractor	40.0	10.0	0.0	50.0
Ox-plough	41.7	33.3	8.3	16.7
Radio	69.2	7.7	0.0	23.1
Bicycle	76.9	7.7	0.0	15.4
Labourers	60.0	26.7	6.6	6.7
WKS non-sugar growing farmers:				
Food	40.0	28.0	28.0	4.0
Clothes	48.0	20.0	28.0	4.0
School fees	68.0	16.0	4.0	12.0
Furniture	76.0	16.0	4.0	4.0
House repair	76.0	20.0	4.0	0.0
Doctor	60.0	24.0	12.0	4.0
Seeds	64.0	24.0	8.0	4.0
Tractor	22.2	11.1	5.6	61.1
Ox-plough	68.2	18.2	4.5	9.1
Radio	56.5	13.0	8.7	21.8
Bicycle	52.4	9.5	9.5	28.6
Labourers	60.9	17.4	13.0	8.7

originally allocated to food crops for sugar cane. In the Kabras area, cane growing farmers tend to grow less millet and beans and more cassava and potatoes, which may further worsen the nutritional situation of their households. Table 16 gives the impression that cane growing farmers do not rely more significantly on bought food than the non-cane growing farmers in the same area.

There is, however, a marked difference in the fact that the farmers of the MSC area have to buy less food, probably because they generally own more land. Consequently, there is no firm evidence that the nutritional status of the cane growing households is worse or better than that of the non-cane growing households. Apart from the expenditure on food items, the cash earned from sugar cane can be used for several other items improving the general well-being of the farmers.

The 1983 aerial survey shows that the number of mabati-roofs (corrugated iron) in the sugar cane areas is neither high nor low compared to the surrounding areas, excluding the urbanized area of

Table 16: Food bought by the farmers (%)

Part of food bought	MSC cane growing farmers	MSC non-cane growing farmers	WKS cane growing farmers	WKS non-cane growing farmers
All of the food bought	0.5	0.0	2.9	0.0
Most of the food bought	12.0	17.1	28.6	37.5
Half of the food bought	12.0	10.8	8.6	2.1
Some of the food bought	18.9	16.2	25.7	29.2
No food bought	56.5	55.9	34.3	31.3
Total	100.0	100.0	100.0	100.0

Kakamega township. In Table 17, the distribution of permanent roofs among the different farmer groups is given. Because this single indicator is not very reliable, some other indicators for the status of well-being are added.

Table 17: Indicators of general well-being (%)

Indicators	MSC cane growing farmers	MSC non-cane growing farmers	WKS cane growing farmers	WKS non-cane growing farmers
Presence of:				
permanent walls	22.0	10.8	5.7	20.8
permanent roof	63.9	42.3	17.1	25.4
one room	18.8	27.9	28.6	27.1
two rooms	34.6	30.6	40.0	31.3
more than two rooms	46.6	41.5	31.4	41.6
table(s)	86.3	88.8	100.0	100.0
chairs	90.1	92.8	100.0	100.0
bicycle	50.3	31.5	48.6	35.4
radio	55.5	36.9	37.1	58.3
watch/clock	32.5	11.7	28.6	43.8

The data from the table give the impression that in the Mumias area the housing conditions of the cane growing farmers are significantly better, and also with respect to the luxury items these farmers appear to be better-off. In the Kabras area the situation is just the opposite.

This is the third time that the non-cane growing farmers in the Kabras area resemble the cane growers in the Mumias area. This resemblance was noticed in the decision taking and responsibility pattern, the decreasing involvement of the women in the food crops, and now in the general well-being. Tentatively, the following complex of hypotheses can be formulated:

○ The general well-being of the household depends both on the income of the family and on the degree of shared responsibility within the family.
○ In the early phase of the introduction of a cash crop, the differentiation between the responsibilities of the household head and the woman is reinforced, but later these responsibilities are shared between them.

Education

The impact of the sugar industries on education can be direct and indirect. The direct impact consists of education of the people that are needed in the sugar industry. In the large-scale industry, this training can be undertaken both externally or internally and consists of some form of general education or training or 'on the job' training. In the medium- and small-scale industry only the last form of training can be found, oriented towards a specific job. The indirect impact is that more children can take part in formal education because parents have more cash income. Of the 8,754 jobs provided by the MSC factory, 10.3 per cent require educated labour and 52.7 per cent require skilled labour. The skills are learned on the job, and the greater part of these skills is only relevant in the context of sugar factories. The other 37 per cent of the jobs consist of monotonous and simple manual work. In the OPS factory, 14 per cent of the jobs require educated labour, 7 per cent skilled labour, and 79 per cent of the jobs just concern simple manual work. In absolute figures, the educational impact of the large-scale factory is thus greater than that of the medium- and small-scale industries. The overall impact of the large-scale industries is still better, although the medium-scale factory provides more jobs that require educated labour.

The indirect impact of the sugar technologies should result in a higher school enrolment. The data in Table 18 show that this is certainly true for the large-scale industry.

The table shows that the difference in school enrolment is getting smaller for the younger members of the family. There is also a marked difference in the number of children that received secondary education.

For the Kabras area the data show that the general school enrolment is also very high, but is not much higher for the children from sugar cane growing households. The data further give the impression that more children of the non-cane growing farmers are attending secondary school. On the basis of

Table 18: Educational level of the children (%)

Education	MSC cane growing farmers	MSC non-cane growing farmers	WKS cane growing farmers	WKS non-cane growing farmers
Children older than 20 years:				
None	11.5	14.6	12.5	12.2
Standard 1-3	5.3	4.7	8.8	2.2
Standard 4-5	6.6	6.4	13.8	5.6
Standard 6-7	18.5	21.1	28.8	28.9
Form I-II	8.8	11.1	11.3	11.1
Form III-IV	33.8	28.1	25.0	36.7
Form V-VI	10.8	5.3	0.0	2.2
Higher than form VI	4.0	1.8	0.0	0.0
No answer	0.7	7.0	0.0	1.1
Total	100.0	100.1	100.0	100.0
School enrolment	87.8	78.5	87.5	86.7
Secondary education	57.4	46.3	36.3	50.0
Children between 15 and 20 years:				
None	1.5	10.1	0.0	2.1
Standard 1-3	3.1	8.7	3.2	2.1
Standard 4-5	12.8	11.6	22.6	6.3
Standard 6-7	32.1	42.0	61.3	54.2
Form I-II	10.7	14.5	12.9	16.7
Form III-IV	35.7	11.6	0.0	18.8
Form V-VI	4.1	1.5	0.0	0.0
Higher than form VI	0.0	0.0	0.0	0.0
No answer	0.0	0.0	0.0	0.0
Total	100.0	100.0	100.0	100.0
School enrolment	98.5	89.9	100.0	97.9
Secondary education	50.5	27.6	12.9	35.4
Children between 10 and 15 years:				
None	2.0	18.1	3.1	6.0
Standard 1-3	20.5	30.1	50.0	26.0
Standard 4-5	36.6	28.9	40.6	32.0
Standard 6-7	33.2	20.5	6.3	36.0
Form I-II	6.3	0.0	0.0	0.0
Form III-IV	1.5	2.4	0.0	0.0
Form V-VI	0.0	0.0	0.0	0.0
Higher than form VI	0.0	0.0	0.0	0.0
No answer	0.0	0.0	0.0	0.0
Total	100.1	100.0	100.0	100.0
School enrolment	98.1	81.9	96.9	94.0
Secondary education	7.8	2.4	0.0	0.0

these figures, however, no firm conclusions can be drawn. The education of the children is not oriented towards agricultural jobs. The parental expectations with respect to children are not in that direction either, as can be seen from Table 19.

Table 19: Most frequently-mentioned jobs wanted for the children (%)

Kind of job	MSC cane growing farmers	MSC non-cane growing farmers	WKS cane growing farmers	WKS non-cane growing farmers
Teacher	21	21	25	5
Doctor	13	12	6	11
Mechanic	13	13	10	3
Nurse	9	5	6	7
Clerk	7	5	4	7
Farmer	5	4	4	5
Carpenter	3	5	1	0

CHANGES IN THE SOCIO-ECONOMIC STRUCTURE OF THE ENVIRONMENT

The employment situation

The employment situation in the sugar cane growing areas is affected by the labour needed in the factories and the labour needed for crop production. Employment in the sugar industry can counteract the rural-urban migration. The impression is that farmers involved in growing sugar cane increasingly use wage labour for the agricultural jobs. The salary for this wage labour is, according to Kongstad (1980a, p. 78), very low and often even less than the minimum salary required for subsistence of a single male. This gives the impression that the farmers are exploiting the labour force, but one should bear in mind that this situation is created by the factory owners who are deliberately not entering into a direct capital wage relationship with the farmers (Buch-Hansen, 1982b). Although employment should be seen as a benefit, it may be bought at the cost of open unemployment as is the case in the Mumias area.

All sugar cane factories directly and indirectly provide wage and casual labour jobs for the people in the area. The small-scale jaggery factory is most labour intensive, with 9.2 labourers per 1,000 tonnes of cane milled. The medium-scale WKS factory is second with 5.7 labourers, and the MSC factory has 0.3 labourers per 1,000 tonnes of cane milled. When looking at the entire process of producing sugar, including the agricultural part for which the factory is reponsible but excluding the part for which the farmers are responsible, the figures are 12.5, 7.0 and 6.1 labourers per 1,000 tonnes of cane milled for the small-, the medium- and the large-scale industries respectively. However, these are only relative figures. In absolute figures, the numbers of labourers involved are 15, 173 and 8,754 labourers respectively. In the Mumias factory, 63 per cent of the jobs require educated or skilled labour. In the jaggery factory 40 per cent and in the West Kenya Sugar Factory only 14 per cent of the jobs require educated or skilled labour. The non-skilled labour demand in the sugar factories is almost entirely covered by casual labourers. In the area, employment is particularly important for the increasing number of school leavers looking for wage labour jobs. The Mumias sugar factory offers a considerable number of jobs, matching this development. The quality of the jobs offered by the West Kenya Sugar Company cannot match this development. The impact of the jaggery factories in this field is small and relatively unimportant.

Casual jobs offer no certainty and are no real solution for people that are or want to become dependent for their income on wage labour. The casual jobs in the sugar cane industries do provide chances for the farmers to add to the cash income of their family. This impact is enhanced by the casual jobs offered by the farmers who need the labour for the cultivation of their sugar cane crops, or who, because of their income from sugar cane, can afford to hire labour for other crops. Of the Mumias sugar cane farmers 66.1 per cent hired labour, against 33.9 per cent of the non-sugar cane farmers. In the Kabras area, the percentages for the different groups of farmers are 52.9 and 47.1 per cent respectively. The average salary paid for this casual labour is very low, but in both areas it is generally higher in cane cultivation than for other crops (Table 20).

As agreed upon with the Kenyan Union of Sugar Plantation Workers (Memorandum of Agreement,

Table 20: Payments for six hours of casual labour by farmers (KSh)

Practices	Sex of labourers	MSC cane growing farmers	MSC non-cane growing farmers	WKS cane growing farmers	WKS non-cane growing farmers
General	Female	10.9	10.1	9.5	7.2
	Male	16.6	10.6	9.5	7.8
Weeding	Female	11.1	10.0	9.8	7.0
	Male	16.6	10.7	9.9	—
Ploughing	Female	-	—	—	—
	Male	19.8	—	—	—
Planting	Female	10.2	9.0	8.0	7.3
	Male	11.0	—	8.5	—

1985) in 1985, the minimum payment for manual agricultural jobs at Mumias was 4.02 KSh per hour. In view of this, it can be said that the farmers in the area exploit their workers.

Spin-offs

The sugar industry contributes to the circulation of money and the generation of profits at various levels. The industries are also expected to attract different industries with backward and forward linkages with the sugar producing industries and business of all kinds.

The investor in the Mumias project having the closest ties with the area is the Kenyan Government. The standpoint of the Kenyan Government is (Barclay, 1974, p. 2) that by participating with 6 million Kenyan pounds, it has invested enough in the area. In the light of other priorities, it has no intention of investing further in the area. Other investors are not really involved. Apart from some involvement of local workshops and transporters, there are few linkages with industries in the Kakamega area.

The medium- and small-scale sugar industries have mainly emerged from the Asian commercial community. Inputs have to a certain extent been based on local materials and technological knowledge, and the profits from these industrial activities have been used to expand and diversify the industrial and business activities, although not in the immediate surroundings of these industries. Of the total turnover of the sugar industries, a considerable part remains in the area as an income for the farmers and as wages for the permanent and casual labourers. Apart from the expenditures in the direct sphere, this money can lead to further development of the area.

With respect to the possible spin-offs, the general expectation is that the commercialization of agriculture leads to the establishment of a rural *bourgeoisie*, from which in the end a class of industrial entrepreneurs emerges (Kongstad, 1980b, pp. 103-104). In the area of the large-scale sugar industry, the first steps in this direction can already be seen. Amunga (1985, p. 28) mentions a considerable increase in matatus (taxis), posho mills and local markets. According to Kongstad (1980a, pp. 118-136), the sugar cane has led to an increase in women traders from farms in the surrounding areas, marketing different food crops. The increasing money circulation in the area has led to larger stores where commodities like hand tools, fertilizer, seeds, lamps, charcoal-burners, clothing, beer, pottery, etc., are sold. Only part of the increase of business activities originated from the local farmers. Many activities are attracted from outside the area, and are linked to members of the Kenyan Asian community or to members of the Kikuyu tribe who are already more involved in business activities than the Abaluyias. Of the sugar cane farmers in the Mumias area, 34.0 per cent are involved in some kind of business, 4.7 per cent in two businesses and 0.5 per cent in three. Of the non-sugar cane farmers in this area, 22.5 per cent are involved in one business and 0.9 per cent in two. In the Kabras area, 34.4 per cent of the cane growing farmers are involved in one type of business and 5.7 per cent in two. For the non-sugar cane growing farmers in this area, these figures are 27.1 per cent and 4.2 per cent respectively. The kind of business activities is recorded in Table 21. The results of an inventory of business activities around WKS are shown in Figure 8.

It is clear that a so called middle class emerges from the sugar cane growing farmers in the Mumias area. Not only are they more involved in business and more often involved in a second business, but also the character of their business activities is changing from traditional areas, such as trading food, to trading cloth, running retail shops, bars/hotels, posho mills and even workshops. The emergence of a class of industrial entrepreneurs is not yet visible.

In the Kabras area this development is not yet manifest, but for these long-term developments the time since the establishment of the OPS factory is probably too short. Besides the commercialization

Table 21: Type of business activities performed by the farmers and the workers at the Mumias factory

Type of business	MSC cane growing farmers	MSC cane growing farmers	WKS cane growing farmers	WKS cane growing farmers	Workers at the Mumias factory
Retail shops	21	5	1	1	10
Market trading of food	17	12	7	7	7
Bar/hotel/canteen	6	0	1	1	2
Posho mill	6	0	0	0	1
Sewing/knitting	5	1	2	4	3
Market trading of clothes	5	1	0	0	3
Workshop	4	0	0	0	2
Matatu	3	1	0	0	0
Timber	1	2	0	0	0
Others (all mentioned once)	6	3	3	1	8

of agriculture, which is thought to be the prerequisite for such a development, is only in its infancy. The fact that about 55 per cent of the sugar cane farmers in the sample would like to invest in farming and 27 per cent in business, indicates that similar developments could be at hand.

Credit facilities

One of the major disadvantages of sugar cane as a cash crop is the long interval between planting and harvesting. Farmers have to wait a long time before they receive a cash income. There are almost no possibilities for the farmers to bridge these long intervals by taking out a loan. If a farmer secures a loan, it is most often granted directly or indirectly by the factory to buy farm inputs. The cane harvest serves as security, and the interest and loan are deducted from the payment on cane. This leaves the farmer with very few possibilities of investing in farm inputs for the other crops or for non-agricultural activities.

There is always the possibility of a bank loan, but then the farmer has to offer his land for security. As Staudt (1984, p. 17) maintains, for women it is even more difficult to obtain loans because they have no security at all to offer.

Of the cane farmers in the Mumias area, 60.2 per cent felt the need for a loan. Of the non-sugar cane growing farmers in that area, this was the case with 71.2 per cent. In the Kabras area all respondents felt they needed a loan. The items for which this loan is wanted are presented in Table 22.

Table 22: Items for which a loan is required (%)

Item	MSC cane growing farmers	MSC non-cane growing farmers	WKS cane growing farmers	WKS non-cane growing farmers
Business	39.3	34.7	26.6	8.3
Farm inputs	22.4	32.1	54.7	73.6
Land	15.3	18.3	6.3	9.7
School fees	9.8	8.7	4.7	2.8
Cattle	6.6	3.5	4.7	0.0
Car	2.2	0.0	0.0	1.4
House improvements	1.6	0.9	0.0	1.4
Household purchases	1.1	0.9	0.0	2.8
Luxury items	1.1	0.0	0.0	0.0
Tractor	0.6	0.9	3.1	0.0
Total	100.0	100.0	100.0	100.0

The items mentioned by the cane and non-cane growing farmers in the Mumias area are similar. The non-cane farmers put more emphasis on land and farm inputs, which shows their desire to further

133

Figure 8: Inventory of business activities in the WKS area[a]

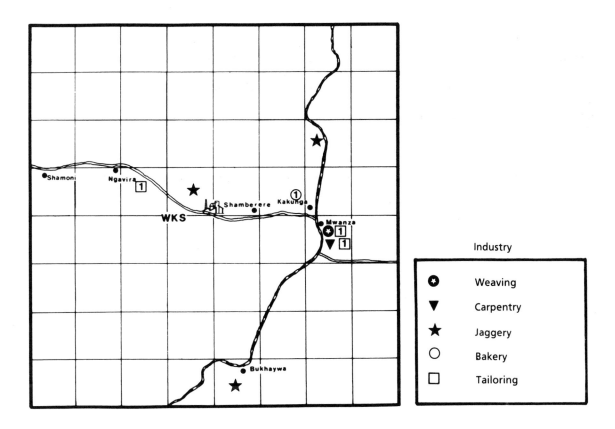

a. For practical reasons the area was restricted to 8km².

commercialize agriculture. The cane farmers put some emphasis on business activities, which matches their role of emerging middle class.

The latter is much more striking in the case of the cane growing farmers in the Kabras area. The frequently-mentioned need for loans for agricultural inputs shows that the farmers want to invest in farming, and are at the brink of the commercialization of agriculture. In the Kabras area the emphasis on commercial agriculture is more pronounced. In the Mumias area, this is the case with respect to business investments.

The number of farmers that indeed received a loan is very small. Less than 6 per cent of each farmer group had received a loan. Seven of the thirteen loans were used to buy land, two to pay for school fees, and one was used for investment in business (three farmers were unwilling to give information on this item). One of the loans was issued by the Mumias sugar factory, five loans were arranged with a commercial bank and four loans with a farmers' co-operative (not a sugar co-operative). From the other farmers, only 6.6 per cent ever tried to obtain a loan. The reasons mentioned why they did not get a loan were the lack of adequate security and the fear of losing the only security they had: land.

The initiative of the OPS factory to provide advance payments on the cane to be delivered (Patel) can therefore stimulate the development of the farmers in the area. Whether this service of the medium-scale factory, extended to commit farmers from the A-zone to the factory and to establish some kind of contractual relation with these farmers, will be sufficient is questionable. Also, the large-scale factory is considering initiating some sort of credit system where the farmers can get an advance on their revenues from the sugar cane [Glasford, 1986]. These 'loans' should be issued as a 'payment' for the weeding by the farmer in his own cane field. For the factory this is advantageous with respect to cane yields.

Migration

Three different forms of migration are considered: migration within the area, migration into the area and migration out of the area. Clearing of factory sites and agricultural land, for example for a nucleus estate, can cause migration within and out of the area. Such migration should be considered as one of the prices to pay for the establishment of a sugar industry. Migration into the sugar areas can be caused by the demand for labour that is not available in the area itself. A second reason for migration is the pull that virtually every technology requiring a large labour force will have on job-seekers from practically everywhere.

Cukor (1974, p. 42) points out that a growth in agricultural productivity, whilst leaving the traditional technologies unchanged, can only be achieved by a growing agricultural labour force. In the case of sugar cultivation in the Mumias area, only part of the practices are kept unchanged, but these are the most labour consuming ones like weeding and cane cutting. The labour necessary for these operations could be provided by influx from elsewhere. Such an influx can be considered as a process that slows down the migration towards the urban areas (Buch-Hansen, 1982b), and is as such a positive impact. Odada (1981) holds a different view, and states that every demographic change of this kind should be seen as a cost for the area.

Table 23: Process of 'Kenyanization' in the large- and medium-scale factories

Mumias Sugar Company		West Kenya Sugar Company	
Year	Number of ex-pats	Year	Number of ex-pats
1	50	1	12
2	34	2	8
3	32	3	6
4	27	4	5
5	32	5	4
6	25		
7	24		
8	19		
9	18		
.	.		
.	.		
14	4		

136

As mentioned before, the establishment of the Mumias factory and its nucleus estate caused a displacement of some 56 farmer households. In the Kabras area the displacement was almost negligible. Most displacements caused only migration within the areas. Barclay (1974) found that only 5 per cent of the displaced farmers migrated to other areas. Although the personal problems for the displaced farmers must be considered as a cost related to the introduction of sugar technologies, the impact on the socio-economic structure has been minimal.

Part of the labour influx is not from Kenya. This, usually specialized, labour is mainly needed during the installation of the factories, workshops, laboratories and the like, and for the management and training during the initial years. Gradually these so-called expatriates can be replaced by Kenyans. In Table 23, the process of 'Kenyanization' of the large- and medium-scale factories is given.

In both factories, it appears that the remaining expatriates are very difficult to replace. The positions they occupy are all in the field of management. The shortage of local management in Kenya is a well-known problem that can only be solved over a long period of time. It shows, however, that the technologies considered are not adapted to the local conditions in the field of management.

Odada (1985, pp. 46-49) carried out a survey using a representative sample of non-managerial employees of the Mumias factory. He reports that 83 per cent of them come from Western Province, and 75 per cent from the Kakamega district. It can be concluded that the influx in the area has been limited and that the people of the Kakamega district have benefited most from the jobs offered at the factory. The number of people from outside the area is, however, large enough to cause the social problems reported in some of the interviews. In the Kabras area the origin of the factory workers could not be properly traced, but according to the factory manager (Patel, 1986), apart from a few expatriates, all workers originate from the immediate vicinity of the factory. The permanent jobs offered by the factories have counteracted the migration from the area. The same is true for casual work offered by the factories. The number of permanent jobs and the amount of casual work is too small, particularly in the Kabras area, to halt the migration.

CHANGES IN THE PHYSICAL STRUCTURE OF THE ENVIRONMENT

Infrastructural facilities and key public institutions

The introduction of a new technology almost always includes the construction of new infrastructural facilities, or the extension or improvement of the existing ones. The large-scale sugar industry has definitely contributed to the improvement of the infrastructure and the key public institutions in Mumias. In Table 24, the improvements as recorded by the Mumias Sugar Company (Amunga, 1985, p. 28) are given.

Table 24: Development before and after the introduction of the Mumias sugar scheme

Item	Before year	Quantitative indication	After year	Quantitative indication
Roads: Main roads	1968	117.1 km	1984	518.1 km
Access roads	1968	83.3 km	1984	216.9 km
Bridges: Culvert	1968	—	1984	410
Other	1968	6	1984	7
Matatus	1972	5	1984	79
Local markets	1972	95	1984	126
Permanent houses	1972	20	1984	6,759
Health centres	1972	12	1984	19
Education/training centres	1972	141	1984	270
Electricity	1968	—	1984	37,070 MW/yr
Drinking water—MSC pump	1968	—	1984	21,000 l/hr

Most improvements are primarily geared to the needs of the industry, and they are not necessarily the improvements the people in the area want. Obiero (1980, p. 229) recorded, from a sample of 370 outgrower farmers, that 94.6 per cent were satisfied with the roads in the area and 81.1 per cent with the schools. There is, however, also a general dissatisfaction with respect to such facilities as piped water (84.3 per cent), electricity (97.0 per cent) and medical services (76.2 per cent).

The influence of a relatively small factory on the infrastructure and the key public institutions cannot be compared with the influence of the large-scale industry. The medium-scale industry simply tries to fit into the existing infrastructure as well as possible. In Table 25, a review is given of the existing infrastructure and the accessibility of some key public institutions by recording the average distance to these institutions.

Table 25: Mean distances to some key public institutions (km)

Mean distance to:	Farmers in the MSC sugar cane area	Farmers in the WKS sugar cane area
A market place	2.2	1.8
An improved water source	2.2	0.8
A post office	6.4	4.1
Credit facilities	9.1	7.4
A telephone	8.1	6.0
A bus/matatu stand	1.9	1.8
A family planning institution	5.7	6.2
A health centre	4.7	6.3
A hospital	9.1	16.2
A primary school	2.1	1.0
A secondary school	4.3	3.1

Compared with the Mumias area, the infrastructure in the Kabras area is not bad; only access to health institutions is worse. This, however, can hardly be influenced by such a small industry. In the interviews the improvement of roads is emphasized. These improvements were brought about by the people themselves in the first place, but they were boosted by the arrival of the medium-scale sugar factory. The same is true for the large number of schools built in the area (see Figure 9). The construction of these schools was mainly supported by so-called Harambee funds. The income from sugar cane has considerably contributed to these funds.

Figure 9: Inventory of schools in the WKS area

Schools

☐ Primary school

◯ Secondary school

▼ Rural development educational centre

CONCLUSIONS

The analysis does not allow definite conclusions about the socio-economic impacts of the West Kenya sugar factory as such. The sample taken was meant to analyze the differences in development of farmers involved in a large-scale sugar industry and a medium-scale sugar industry. For separate conclusions with respect to the farmers involved in the West Kenya Sugar Company, the sample of 35 sugar cane growing farmers was too small. The analysis, however, gives an indication of the processes in the area where the factory is situated and an indication of some important impacts resulting — or, indeed, not resulting — from the establishment of the OPS factory and the introduction of the cash crop sugar cane.

Because of the introduction of the sugar cane in the area, a class of farmers has emerged that entered into commercial agriculture. Contrary to the Mumias Sugar scheme, which discriminates between smaller and bigger farmers, in the Kabras area all farmers took part equally in this development. The shift to the market system is small compared to the Mumias farmers, who on average have about half of their land allocated to the cash crop. The Kabras farmers still rely to a great extent on their own food production. The move towards commercial agriculture is, however, not definite, and a fall back to subsistence agriculture is possible. Such a fall back would definitely occur if the sugar factory closed down. Worsening of the terms of trade or a growing dissatisfaction with the factory because of underpayment and real or supposed exploitation and bribery could cause a withdrawal of at least those farmers that have no formal or informal ties with the factory. These are the farmers that cannot rely on getting a delivery permit from the factory when the cane has to be harvested. There is no real alternative cash crop in the area, which leaves little choice for the farmers if they want to earn cash income from agriculture.

The households in the area all rely on several sources of income. Sugar cane is definitely an extra source of income because there are very few other opportunities to get income from agriculture, apart from selling the surplus of food crops.

The extra source of income for the sugar cane farmers does not seem to be reflected in a different or more affluent expenditure pattern. A slight majority of the cane growing farmers rely to some extent on hired labour. But the use of hired labour does not significantly differ from the use of hired labour of the non-cane growing farmers. The growing of sugar cane requires more than the fallow land available. About ten per cent of the land that was allocated before to food crops is now used for the cultivation of the cash crop. Sugar cane growing farmers have less fallow land than the non-cane growing farmers. The sugar cane farmer still grows a variety of food crops. Compared with the other farmers, he more often grows cassava and potatoes and less of the traditional food crops such as millet and beans. The reason for this could be that cassava multiplies easily, grows fast and requires much less attention and work. It is also tasty and filling. Unfortunately, its nutritional value is very low and compares unfavourably with millet and sorghum.

The gross margin per hectare that can be obtained from sugar cane is much higher than from any other crop that is presently grown in the area. Of the cash crops that could be grown in the area, cotton and pineapple could possibly give a comparable or higher return and only tea will certainly give a higher return. But the necessary infrastructure is not available for any of these crops, and therefore they cannot be considered as a feasible alternative for the farmers.

The growing of sugar cane could introduce new skills and knowledge related to agriculture to the farmers, and it could improve the accessibility of agricultural innovations. This indeed occurs in the mechanical-technical field, where the use of tractors and a more intensive use of ox-ploughs leads to better soil tillage, not only for sugar cane but also for maize. The more intensive use of land has apparently also led to the introduction of zero grazing. In the biological-technical field, such as the use of fertilizers, certified seeds and pesticides, sugar cane farmers seem to lag behind compared to the non-cane growing farmers. On the other hand, there seems to have been little socio-economic development of either farmer group.

Although a connection between sugar cane growing and malnutrition cannot be made, it is quite possible that in an area with malnutrition problems the re-allocation of land from food crops to cash crops will not improve the nutritional situation. The shift from millet and beans to cassava and potatoes in the case of the sugar cane growing farmers indicates a negative change in the diet to more filling but less nourishing food.

The general well-being of sugar cane growing farmers seems not to be much improved compared to the non-cane growing farmers. The increased income from growing a cash crop seems to lead, for the time being, to an increase in the number of children per family. School enrolment for the children is very high, reaching one hundred per cent for the younger children. This situation is, however, the same for the non-cane growing farmers, and there is some evidence that children from these families more often attend a higher form of education. The schooling of the children is not oriented towards agricultural

139

jobs. The aim of the farmers is not to make more productive farmers out of their children, but to stimulate the children to get a well-paid wage labour job which will improve the status of the family. Not many jobs of that kind are available in the area, and an investment in education is merely a waste of resources and leads to an increasing rural-urban migration.

Compared to the traditional division of responsibilities and the traditional decision making processes, there appears to be a shift from the individual to the mutual within all the households in the sample. In the group of the cane growing farmers, the emphasis in matters of responsibilities and decision making tends to be slightly more on the household heads. This could indicate a retardation in the shift to mutual responsibilities, or a counteracting of this process because of the presence of a cash crop in these households. Remarkable in this context is the tendency for women in sugar cane growing households often to be mentioned as the ones responsible for agricultural expenditures like seed costs, hire of an ox-plough and hire of labourers. This indicates, to some extent, that the individual responsibility of these women for agriculture is still more pronounced by the fact that the household is involved in sugar cane cultivation.

The employment situation in the sugar cane growing area of the West Kenya sugar factory is improved by the establishment of the factory, especially because of its very labour intensive production method. This improvement should not, however, be over-estimated. The majority of jobs offered by the factory are simple and monotonous and do not require any skill or education. The labour excess in the area conversely consists of people who finished their primary or secondary education, and school drop-outs with one or two years of secondary education. The factory, by offering unskilled labour positions, does provide an extra source of income for a considerable number of households. Indirectly, the factory provides an additional number of casual labour jobs in the cultivation of sugar cane.

Although the involvement in business activities of the sugar cane households is still only marginally larger than that of the non-cane growing households, it is clear that if a petty bourgeoisie and later a rural class of industrial entrepreneurs are to emerge, the sugar cane growing households are the most likely basis for such a development. Credit facilities, leading to investments in agriculture or business, are a necessary precondition for further development, especially in the case of sugar cane growing with its lump sum payments. Some credit facilities, such as an advance payment on the cane delivered, are given by the OPS factory. This is certainly a positive development, but in view of the specific purpose of this service it is not yet clear whether these facilities will really contribute to an improvement of the economic infrastructure needed for the necessary investments at the household level.

Infrastructure exists for the most part independently of the factory, although the factory and its returns for the area did induce some road improvements and the building of some schools.

The general conclusion has to be that the establishment of the OPS factory has induced some developments in the area, which in the long run could lead to an improvement of the socio-economic status of the rural households in particular and the area in general. The impacts on landless and unemployed are small, since the factory provides mainly casual labour. This labour is for some farmer households in the area a very essential addition to the income.

The development is, however, less connected to the factory itself than to the introduction of the cash crop sugar cane, and the subsequent commercialization of agriculture which is a prerequisite for the emergence of a business class and later of an industrial class in the society. The magnitude and the pace of the development are therefore more dependent on what happens in the agricultural part than in the processing part of the sugar producing technology. The viability and the success of the processing side (the factory) is, however, a primary necessity. This success on the processing side depends on the continuous supply of cane, which in turn depends on the willingness of the farmers to grow cane. This willingness is seriously jeopardized by the discrepancy between the expectations of the farmers and the structure of their relations with the small-scale sugar factory. A further threat lies in the fact that the way in which sugar cane is now cultivated could in the near future lead to diminishing yields. This again calls for attention to the agricultural part of the sugar production. A third threat for the cane cultivation is a possible shortage of food crops as a result of sugar cane growing; a shortage that is not totally absorbed by an increasing buying power through the profits on cane cultivation. Therefore attention to food crop production seems to be just as necessary. In spite of all these threats, the farmers will probably stay with sugar cane because they have no other alternative form of cash-yielding production.

From the point of view of the sugar factory, this is a fortunate situation. For the farmers it means a dependency on one crop, and the threat of being thrown back into subsistence production if for some reason the factory decides to close down.

One of the positive points of the OPS industry until now is that it offers opportunites for development for both the marginal farmers and the larger farmers, ensuring the possible improvement of the socio-economic situation in all strata of the society. The sugar cane industry has only indirect impacts on women as a separate group. Decision-making and responsibilities in the household seem to develop differently in cane growing households. In comparison with the traditional situation the workload for

the women seems to increase, but on the other hand their independence from their husbands seems to be preserved. More in-depth research is necessary before conclusions about the impact of the sugar cane industry on women can be drawn.

Notes

1. Editor's note: throughout this paper, Lemmens classifies WKS as medium-scale and jaggeries as small-scale. In other papers, WKS is referred to as small-scale, medium-scale being used in connection with small VP factories (Lemmens also refers to WKS as small-scale in the summary of his paper, to be found in Section I of this publication).
2. In order to provide the reader with a flavour of the situation, a few of the interviews from the Kabras area have been included in Appendix 3.
3. Analysis of the family size is excluded because of lack of relevant data.
4. Although Mulaa (1980, p. 97) reports a sharp increase in land transactions in the early 1970s, the number of transactions stabilized towards the end of that decade to about 150 per annum. Mwandihi (1985, p. 55) reports no significant change in size of land holdings for his sample of farmers from the Mumias area.
5. More details on these aerial surveys can be obtained from Lemmens, 1987.
6. A major problem arises in this approach, since it assumes a well-functioning marketing system which allows farmers to buy crops at the same price at which the foregone output is valued. The existence of middlemen, the influence of seasonal shortages, and other 'distortions' on price are therefore excluded from the analysis.

REFERENCES

Ackerman, W., *Cultural Values and Social Choice of Technology*, International Social Science Journal, Vol. xxxiii, No. 3 (1981).

Agata, Z., *South Nyanza Sugar Co. Outgrowers Scheme*, paper presented at the seminar: *Incentives for Increased Agricultural Production*, Kericho (18-21 November, 1985).

Alloys Ongere, *Effectiveness of the Kenya Sugar Authority in Controlling the Prices in the Sugar Industry*, paper presented at the seminar: *Incentives for Increased Agricultural Production*, Kericho (18-21 November, 1985).

Amunga, M., *Background Paper for a Workshop on Kenya's Sugar Industry*, paper presented at the seminar: *Incentives for Increased Agricultural Production*, Kericho (18-21 November, 1985).

Barclay, A. H., *Aspects of Social and Economical Change Relating to the Mumias Sugar Project*, paper presented at the Department of Sociology, University of Nairobi (December, 1974).

Barclay Jr, A. H., *The Mumias Sugar Project: A Study of Rural Development in Western Kenya* (PhD thesis), Columbia University (1977).

Bardhan, K., and Bardhan, P., *The Green Revolution and Socio-Economic Tensions: The Case of India*, International Social Science Journal, Vol. xxv, No. 3 (1973).

Barnes, C., *Differentiation by Sex Among Small-Scale Farming Households in Kenya*, Rural Africana, 15/16 (1983).

Bergmann, Th., *Der Beitrag des Agrarsectors zum Entwicklungsprozess, Agrarreform in der Dritten Welt*, Eisenhans, H. (ed.), Campusverlag, Frankfurt (1979).

Bernard, C., *Les Approches du Chemage Deguise dans l'Agriculture des Pays Sous-Developpes*, Mondes en Developpement, No. 26 (1979).

Buch-Hansen, M., and Kieler, J., *The Development of Capitalism and the Transformation of the Peasantry; Case Studies of Agro-Industrial Production in Rural Areas of Kenya*, Socio-economic Analysis and Computer Science, Research Report, No. 28, Institute of Geography, Roskilde University Centre, Roskilde (1982a).

Buch-Hansen, M., and Marcussen, H. S., *Contact Farming and the Peasantry: Cases from Western Kenya*, Review of African Political Economy, 23 (1982b).

Cukor, G., *Strategies for Industrialization in Developing Countries*, St. Martins' Press, New York (1974).

Henley, J. S., *Employment Relationships and Economic Development, The Kenyan experience*, Journal of Modern African Studies, 11, No. 4 (1973).

Hitchings, J., *Agricultural Determinants of Nutritional Status Among Kenyan Children with Model of Anthropometric and Growth Indicators*, Doctoral Dissertation, Stanford, Palo Alto (1982).

Hopcraft, P. N., *Human Resources and Technical Skills in Agricultural Development*, Doctoral Dissertation, Stanford University (June, 1974).

International Food Policy Research Institute, *Cash-cropping: Its Effects on Income and Nutritional Status of Semi-Subsistence Farm Households — the case of Kenya and Gambia*, Research Proposal, IFPRI, Washington DC (December, 1984).

Juma, R., *1985 Workshop on Kenya's Sugar Industry*, paper presented at the seminar: *Incentives for Increased Agricultural Production*, Kericho (18-21 November, 1985).

Kabando, R. M., *Relevance of Structural Organization of the Sugar Industry*, paper presented at the seminar: *Incentives for Increased Agricultural Production*, Kericho (18-21 November, 1985).

Kenya Sugar Authority, *Sugar Development Policy Guidelines 1981-1990*, Report for the World Bank (1980).

Kongstad, P., *Kenya: Industrial Growth or Industrial Development? in Industrialization and Income Distribution in Africa*, Rweyemamu, J. F. (ed.), Codesria (1980).

Kongstad, P., and Memsted, M., *Family, Labour and Trade in Western Kenya*, Centre for Development Research, Kopenhagen, Uppsala (1980).

Koninklijk Instituut voor de Tropen, Kenya, 's-Gravenhage (1978).

Kuhn, J., and Stoffregen, H., *How to Measure Efficiency of Agricultural Co-operatives in Developing Countries: Case Study Kenya*, Food and Agricultural Organization of the United Nations, Rome (1975).

Lemmens, A. M. C., *Technology Assessment for Developing Projects*, Internal Report, Eindhoven University of Technology, Eindhoven (1985).

Lemmens, A. M. C., *Technology Assessment for Projects in Developing Economies: Sugar Cane Industry in Western Kenya as a Case Study*, PhD Thesis, Eindhoven University of Technology (1987).

Lewis, W. A., *Is Economic Development Desirable?, in Economic Development: Challenge and Promise*, Spiegelglas, S., and Welsh, C. J. (eds.), Prentice Hall Inc., New Jersey (1970).

Makanda, D. W., and Awiti, L. M., *Trade-Off Between Sugar Cane and Food Production*, paper presented at the seminar: *Incentives for Increased Agricultural Production*, Kericho (18-21 November, 1985).

Manandu, M., *The Role of Government and Farmers' Organizations in the Sugar Industry*, paper presented at the seminar: *Incentives for Increased Agricultural Production*, Kericho (18-21 November, 1985).

Mulaa, J. K., *The Politics of a Changing Society, Mumias*, MA Thesis, University of Nairobi (1980).

Mulaa, J. K., *The Politics of a Changing Society: Mumias*, Review of African Political Economy, 20 (1981).

Multinational Corporations in World Development, United Nations, New York, 1973 (ST/ECA/190).

Mumias Sugar Scheme: Final feasibility report, Volume II, Main Report (July, 1970).

Mwandihi, L. A., *Rural Industrialization and the Food Problem*, MSc Thesis, University of Nairobi (June, 1985).

Obiero, J. C. A., *The Western Kenya Sugar Industry, with Specific Reference to Nyanza and Western Provinces*, MA Thesis, University of Nairobi (1980).

Ochoro, E. E. O., *Some Social Costs of Sugar Production in Kenya*, paper presented at the seminar: *Incentives for Increased Agricultural Production*, Kericho (18-21 November, 1985).

Odada, J. E. O., *The Role of the Sugar Industry in the Kenyan Economy: A Case Study of the Lake Victoria Basin*, in *Natural Resources and the Development of the Lake Victoria Basin of Kenya*, Okidi, C. O. (ed.), Institute of Development Studies, University of Nairobi, Occasional Papers No. 34 (1979).

Odada, J. E. O., Ochoro, W. E. O., Oucho J. O., and Awuondo, C. O., *Socio-Economic and Demographic Impacts of Rural Industrialization: A Case Study of the Sony Sugar Scheme in Kenya*, Research Proposal, University of Nairobi (April, 1981).

Odada, J. E. O., *Possible Incentives for Increased Sugar Cane Production in Kenya*, paper presented at the seminar: *Incentives for Increased Agricultural Production*, Kericho (18-21 November, 1985).

Odhiambo, M. O., *The Structure and Performance of Kenya's Sugar Industry* MSc Thesis, University of Nairobi (1978).

Oyugi, H. N., *Rationalization of the Sugar Industry*, paper presented at the seminar: *Incentives for Increased Agricultural Production*, Kericho (18-21 November, 1985).

Pala, A. O., *The Role of African Women in Rural Development: Research Priorities, Journal of East Africa Research and Development*, 5, No. 2 (1975).

Robertson, A., *Introduction: Technological Innovations and their Social Impacts, International Social Science Journal*, Vol. xxxiii, No. 3 (1981).

Sciavo-Campo, S., *Perspectives of Economic Development*, Houghton Mifflin Company, Boston (1970).

Staudt, K., *Agricultural Policy Implementations, A Case Study from Western Kenya*, University of Leiden, July (1984).

Technology and Cultural Values (a series of articles), in *International Science Journal*, Vol. xxxiii, No. 3 (1981).

Tetzlaff, R., *Die Durchkapitalisierung der Landwirtschaft in Sudan und ihre Auswirkung auf den Traditionellen Sector*, in *Agrarreform in der Dritten Welt*, Eisenhans, H. (ed.), Campusverlag, Frankfurt (1979). UK Overseas Development Administration, *B2 Sugar Processing Kenya* (1986).

Washika, E., Public Health Office, Kakamega District Office, Interview (16 April, 1986).

142

13

West Kenya Sugar Company Ltd.

Bhikhu Patel

West Kenya Sugar Company Ltd. (the Company) is a small-scale rural development — an open pan mini-sugar factory of 200 tonnes per day crushing capacity. It was established in 1981 under the guidance and encouragement of the New Projects Committee and the Provincial Agricultural Board. The factory uses an open pan (OPS) technology which is labour intensive and encourages the growth of rural agro-industries in line with the Government's Rural Development Policy and the focus on District Development Plans.

COMPANY OBJECTIVES

○ To run profitably
○ To create a source of cash income for farmers
○ To create rural wage-earning employment
○ To transfer open pan technology to suit Kenyan environments
○ To contribute towards national self-sufficiency in sugar

SUGAR CANE SUPPLY AND OUTGROWER FARMERS

The scheme is unique in the Kenyan context because the Company does not have any nucleus sugar cane estate of its own. Since the beginning, it has been the Company's policy that all cane supply should come from small outgrower farmers close to the factory. Currently the Company draws cane from 780 farmers situated within a 16 km radius of the factory with an average cane holding of 3 acres on an average land holding of 6 acres.

The Company runs a successful interest-free advance system, and has set up a KSh 300,000 rotating fund whereby needy farmers with 14 months-old cane qualify for a KSh 1,000 advance which is refunded after four to six months on delivery of the mature sugar cane.

This scheme was set up to assist farmers to:

○ achieve higher yields by cutting mature cane
○ meet cash flow problems

and thus to ensure a regular and adequate supply of cane to the factory.

Farmers are paid regularly on a two-weekly basis. The Company pays an average KSh 1.6 million per month to farmers and workers.

With a positive attitude to the farmers by the factory, adequate education and co-operation, the current pricing policy makes it attractive for the small-scale farmer to grow sugar cane; thus there is a more than adequate supply of cane around the factory.

WORKFORCE TRAINING AND EMPLOYMENT POTENTIAL

Transfer of open pan technology is taking place, and Kenyans at all levels are being trained with the

assistance of local and expatriate technicians. Well over 98 per cent of staff are drawn from the area around the factory, and the majority of the factory workers are also farmers.

Table 1: Labour requirements

	Low season	High season
Direct — regular	180	180
— casuals	20	20
Indirect	90	130
Total factory-related	290	330
Farming activity	200	300
TOTAL EMPLOYMENT	490	630

The workers predominantly receive on-the-job training, supplemented by some outside courses organized by the Federation of Kenya Employees and other institutions. The Company also plans to set up family planning and maternal child care programmes with assistance from the US Aid Programme, and it will hold a First Aid course for 20 workers in conjunction with St John's ambulance.

FACTORY DEVELOPMENT

The open pan sugar processing system has its origins in India where it traditionally operates for 4 to 5 months a year during the dry season to accomodate bagasse drying. In India, sugar cane is harvested at about 12 months maturity.

However, in Kenya the climate allows sugar cane to be planted throughout the year. It is harvested at between 18 and 22 months maturity. Thus, by organization of sequential planting dates, cane can be available to the factory throughout the year. To create regular employment and also to transfer the open pan sugar technology to the Kenyan environment, the Company had to make substantial investment. To date, this investment exceeds KSh 28 million.

The additional investment is mainly in improvements to bagasse drying, bagasse storage, cane storage, juice boiling, generators, workshop equipment, and other factory and service-related infrastructure.

TECHNOLOGY DEVELOPMENT

In collaboration with the Intermediate Technology Development Group, we have undertaken:

○ the installation of shell furnaces to burn wet bagasse, and we continue to experiment to make them self-sufficient in bagasse
○ the installation of an expeller, on an experimental basis, to increase juice extraction and further reduce the scale of OPS
○ to try, at government level, to establish a favourable policy for OPS mini-sugar plants

POLICY

We have had a great deal of moral encouragement and support from various government and private well-wishers, for which we are most grateful. However, to put OPS sugar plants on a firm footing and encourage more private entrepreneurs to start OPS, a favourable policy at government level is requested in order to:

○ allow small-scale producers to sell sugar directly to wholesalers/retailers
○ reduce/abolish excise duty of KSh 1,000 per tonne

We firmly believe that with a clear-cut policy to establish a favourable rate of return, many private investors would venture into this particular industry.

144

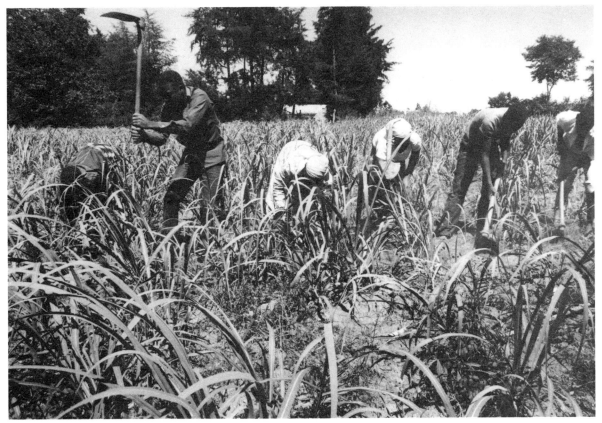

Small farming family which supplies cane to West Kenya Sugar.

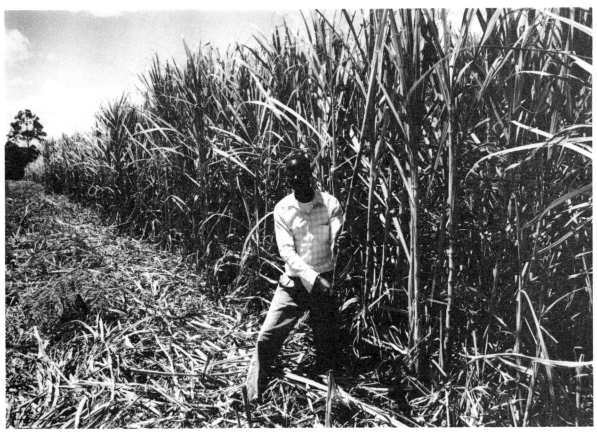

Mature sugar cane.

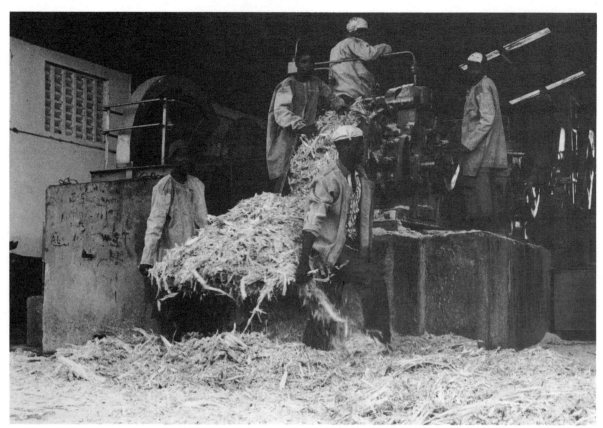

Small-scale sugar processing technology creates significant numbers of jobs.

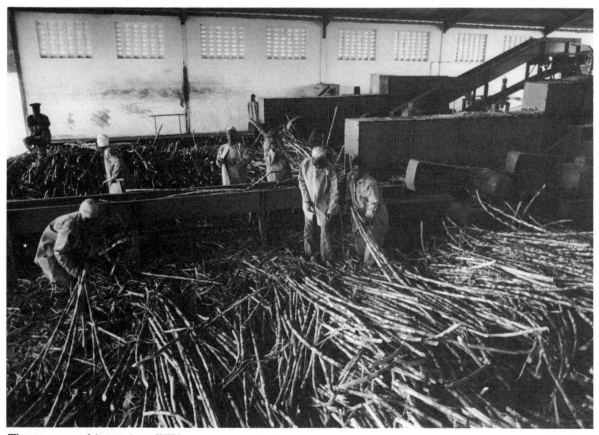

The cane crushing unit at WKS.

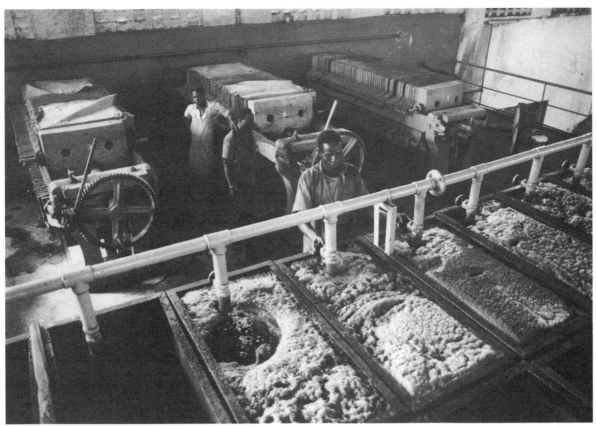

The factory's juice settling and filtration plant.

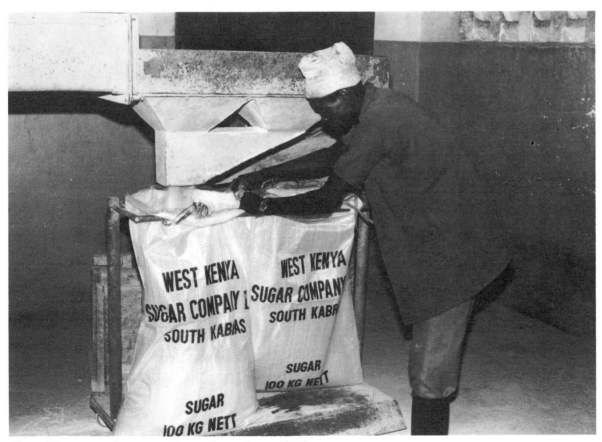

Up to 15 tonnes of sugar are bagged per day at WKS.

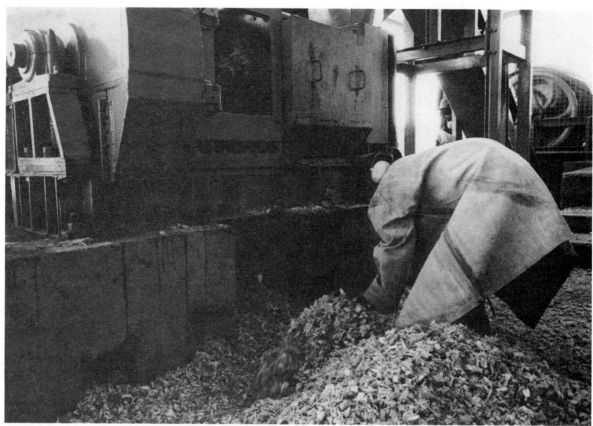

The experimental cane expeller in operation.

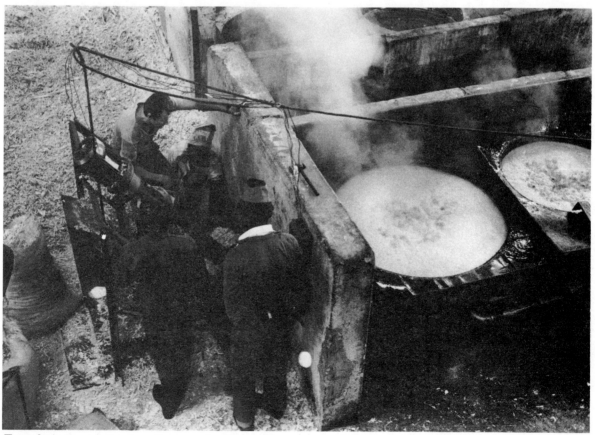

Tests being carried out on furnace development.

148

SECTION F

POLICY IMPLICATIONS

14

The sugar industry in developing countries: Import substitution, government policy and scale of production[1]

Haleem Lone

The majority of developing countries have historically been sugar importers. Sugar production in these countries was established to reduce dependence on imports, as part of a broader process of import substituting industrialization (ISI). The problems experienced in attaining the goal of national self-sufficiency arise from the basic socio-economic and political structures of developing countries. ISI represented one form of industrial development intimately connected with and reflecting these basic socio-economic relations.

The argument developed in this paper is that there are problems inherent in the type of industry associated with ISI, in the form in which it was pursued, which make national self-sufficiency difficult. The crisis in the international economy since the mid-1970s, and in the world sugar market in particular, has accentuated these inherent problems and has important ramifications for the future of the industry, but is not itself the root cause of the difficulties facing the industry in developing countries. These difficulties can only be adequately understood by an examination of the nature of ISI in the sugar industry. Through an examination of these problems, it is argued that while different forms of industry and technology seem to be better suited to the conditions prevailing in developing countries, they cannot be seen to offer a solution to the problem of import dependence. The reasons for this are the conflicting requirements of different forms of industry, and more fundamental structural factors which are specified in the paper. The implication of this is that although a different type of technology is no panacea for the present difficulties faced by the sugar industry, an understanding of the constraints inherent in the ISI strategy is necessary for the reformulation of government policy which has been made imperative by the crisis facing the industry internationally.

After a brief description of the changes in the world sugar market, Part One of the paper is devoted to the nature of ISI in general. Part Two examines the form ISI took in the sugar industry and establishes that government policy is directed predominantly at resolving the inherent difficulties experienced by vacuum pan (VP) mills. Specifically, cane production and marketing policy is seen to be geared to coping with what we postulate to be unavoidable problems in cane supply. Similarly, in sugar pricing and marketing arrangements government policy is seen as flowing from the requirements of large-scale vacuum pan milling.

Part Three presents two country case studies of India and Kenya to illustrate the development of the sugar industry in radically different environments. The Indian case provides a rich source for examining the conditions of competition and co-existence of different types of production. The Kenyan experience, by contrast, reveals the fundamental problems of the industry more directly, since there has not been any significant competition between vacuum pan and other forms of production. We argue that underlying these two apparently contrasting environments lie similar, deep-seated problems endemic to cane sugar production in developing countries.

Part Four concludes the paper and brings together our general argument about ISI and the country studies to summarize the nature of the obstacles to restructuring the sugar industry. The more general implications for ISI as a whole are also considered briefly.

PART ONE: IMPORT SUBSTITUTING INDUSTRIALIZATION

The world market

In the eighteenth century sugar was the most important commodity in international trade, exports coming mostly from the Caribbean and Central America, which remains, to this day, the most significant

exporting region in the world. While sugar industries were established in more countries in the nineteenth century, the most important developments were the rise of sugar consumption in South America, Africa and Asia, and the subsequent establishment of import substituting industries in the majority of developing countries in the twentieth century.[2] After the World War II, and especially during the 1970s, there were major expansions in many developing countries.[3]

The world market in sugar has long been recognized as one of the more unstable commodity markets, with a well-defined 'sugar cycle' of six to eight years of low prices being punctuated with one or two years of high prices. This high degree of volatility presents special problems to those sugar producing countries whose industry is geared primarily to exports, and explains why it is that about one-third of the international trade in sugar is conducted under special arrangements. While such trade agreements undoubtedly cushion the participants from the worst effects of price fluctuations, they do not do so completely. It is, however, those exporting countries without such trade agreements that are worst affected by world market volatility. To understand the problems encountered in the sugar industries of developing countries in the 1980s, however, we need to keep in mind the structural change that has occurred in the world market.

Three factors have combined to produce a structural crisis of over-capacity. First there are the increases in developing countries' production, noted above. Second, there has been a significant increase in European beet sugar production. Third, and perhaps most significantly, the development of alternatives like high fructose corn syrup has added to a structural, rather than a merely cyclical, crisis. Indeed, analysis of world production capacity and consumption reveals that total installed capacity in 1985 was about 103-104 million tonnes, a figure which consumption was not expected to reach until 1988 (Viton, 1985, p. 31).

Further evidence of the structural nature of the crisis is revealed in the trend in world free market prices. While 1987 prices have recovered somewhat to about US $200/tonne, the 1985 low of US $90/tonne represented 'in real terms probably the lowest price ever fetched and a third as much as it costs the best producers to produce it' (*Economist*, 10 August, 1985; Viton, 1985, p. 23).[4] A 1982 study found that recurrent costs of US $250-400/tonne were the minimum incurred in different producing countries, while another review of international costs of production concluded that a minimum price of US $300 a tonne was necessary to maintain production at current levels (Viton, 1981). Experts predict, in fact, that prices will rise sharply soon, but warn that the switch to alternatives would be stimulated further by this very same price rise.

It is, however, a fact that most developing countries with sugar industries are committed, for a variety of reasons, to maintaining a domestic sugar industry. Prior to the changes specified above in the world sugar market, these countries could hope continuously to increase domestic production with a view to eventually finding export markets in an erratic but expanding world market. At present, however, the prospects of permanently saturated markets mean that production plans have to be limited in horizon to supplying the domestic market, to the exclusion of planning for exports. This altered market environment — a virtual collapse in world sugar markets — has serious implications for the particular strategy of ISI hitherto pursued by most developing countries.

ISI represented a distinct stage in the development of the world economy, when manufacturing production on a significant scale came to be located in developing countries. ISI began earlier in Latin America and Asia. It was only after 1945 that ISI as a general process became a major feature of the world economy. There were three groups which were involved in ISI, namely foreign capital, local capital and host governments. In different countries and in different industrial sectors, one or other of these groups took the leading role in ISI. Even where the main agency was the government or local capital, however, the role of foreign capital remained crucial due to the financial and technological dependence of the former on the latter. The essential characteristics of the type of industry associated with ISI were thus basically similar. There are three general aspects of ISI which were crucial in determining the type of industry that was established.

First, the wave of nationalism and independence that followed World War II explains the emergence of ISI as a general phenomenon. For many industrialised countries which previously had secure markets in the colonial era, the post colonial order posed threats to their traditionally captive markets. For these countries ISI was a strategy to hold on to their traditional markets — with the important change that instead of exporting manufactures to developing countries, they could now invest in manufacturing plants behind tariff walls. In the competition between different companies for the privilege of such protected investments, contacts between the old colonial power and the new ruling elites were obviously of great importance. What is important, however, is that the whole pattern of ISI clearly represented an alliance between new ruling elites in developing countries and different segments of foreign capital. The development in the 1970s of joint ventures between foreign capital and host governments further strengthened and institutionalized these ties. This political aspect of ISI had very specific consequences for the type of industry that was set up, as we shall see below.

Secondly, it follows from the above that ISI investment was not motivated primarily by the cost-effectiveness or profitability of the manufacturing process itself. Indeed the unprofitability of much of this investment was implicitly recognized, for, on top of tariff protection, a whole range of concessions, exemptions and other forms of inducement to invest were granted to foreign or local firms. This relative inefficiency of ISI was related primarily to the large-scale, capital intensive nature of the technology employed which, given the small size of many developing country markets, meant sub-optimal capacity utilization and loss of the full scale economies that could potentially be realized (Merhav, 1969).

Thirdly, underlying both of the above features was a factor of the utmost importance in defining the pattern of industrial development that took place. This factor was the peripheral relationship of the indigenous entrepreneurial class to the process of ISI. To understand the full significance of this, we need to look closely at ISI from both a technological and a social perspective.

ISI was geared to supplying the demand from a relatively small elite for goods that had previously been produced in the developed countries. These products were typical of those produced by modern industry in developed societies: they embodied superfluous 'luxury' elements, rather than being designed purely to satisfy 'basic needs'. The production of these goods necessitated an accompanying technology which was capital intensive and geared to production for mass markets. Thus, where foreign companies were centrally involved in ISI they imported their own techology, and where the host government assumed direct ownership of the industry it, too, relied on foreign expertise and technology. Even where a local elite was involved in ISI, it was not, typically, independent of foreign companies in terms of financial resources and/or technological capability. Rather, its basis for participation in ISI was more its place in and control over the state, rather than its entrepreneurial dynamism. It is for this reason that such elites have been termed 'bureaucratic', and it is due to their dependence on foreign companies that they are termed 'auxilliary'.

Thus, whether it was foreign companies, a local elite or the host government that was the main agent of ISI, the key to the pattern of industrial development was the exclusion of an indigenous entrepreneurial class. This was itself due to the weak development in most countries of such a class in the colonial period, and its marginalization in the process of decolonialization. Even where, as in the case of India, a more developed entrepreneurial class existed, its exclusion from the process of decolonization and ISI was critical in shaping the course of industrial development.

This exclusion was due essentially to socio-economic and political factors, and was generally not related to question of technical efficiency. In most branches of industry, modern sector products had locally-produced equivalents — the difference between the two being related to the quality and/or 'luxury' elements of modern sector production. Under a different political regime, even if the pattern of demand had not radically been altered, the production of local goods as near equivalents or subsitities for previously imported commodities could have been centered on the development and upgrading of indigenous industry and technology. That this did not take place in ISI is the important point, and, as we have made clear, this was due more to socio- economic and political — rather than strictly technical — questions of efficiency.

The effect was to promote a 'statist' or 'bureaucratic' market environment, and one where government policy was suspicious of, and hostile to, the development of enterprise outside its control. This was due to the vested interests of members of government in the ISI pattern, the conflicting requirements of ISI and industry outside its orbit, and the general bureaucratization of the economy to which governments had become wedded.[5]

Having established the framework of ISI and the broad parameters of its pattern of industrial development, we need now to examine the specific requirements and forms of organization of such industry before we can analyse the form it took in the sugar industry.

ISI and the organization of production and marketing

The type of industry that was more or less implanted in developing countries carried with it its own forms of organization and its own specific requirements. Its underlying principle of organization has recently been characterized as that of 'mass production': the production of standardized goods for mass markets by special purpose machines (see, for example, Piore and Sable, 1984). The crucial features of this system of production are that it is capital intensive, large-scale, and relies on continuity of production and access to stable mass markets that are expanding. This form of production developed in Europe and the USA from the eighteenth century, but it was only in the post-1945 era that the social and institutional arrangements necessary for its continued expansion were perfected. The stablization of mass markets could only be ensured by the intervention of the government in the economy in a variety of ways, and by the tripartite management of the economy by government, big business and trade unions. A 'regulatory framework' which ensured mass markets stability thus evolved.[6] The necessity to create and sustain demand arose from the inbuilt expansionary dynamic within this sytem of production itself: the 'mass

153

production' system is thus 'supply driven', rather than being one which responds to changes in market demand.

The international recession which set in after 1975 was due to growing instability in product markets. The failure of markets to return to their previous stability represents a failure of the regulatory systems, and has thrown the system of mass production into difficulties. Certain industrial sectors in some of the developed economies have radically altered their form of production to one which is more flexible and capable of responding to the rapid shifts in market demand that have been taking place. This 'flexible specialization' (Piore and Sabel, 1984) — the production of specialized products by all-purpose machines — essentially seeks to avoid investment in large-scale plants which can produce standardized commodities.

The relevance of this to ISI is obvious. As we saw earlier, ISI established itself in the post-1945 era when the international economy was taking off for a sustained 'boom'. The demand for commodities in both world and domestic markets was expanding, and abundant capital was available for investment in modern industry. Conditions pertaining to the stability and prospects for commodity markets were thus favourable. Most developing countries introduced relatively high wage legislation for a small section of workers for the purpose of providing a continuous, reliable and efficient labour force for modern industry.

The requirements of large-scale production units thus guided government policy, and a tightly controlled economic environment was the result. The functioning of factor markets, as well as factor prices, were regulated by government, as were final product prices and distribution. These were in addition, it should be remembered, to import tariffs and control over plants through licensing. Government control over marketing tended to be particulary frequent, and in the case of foodstuffs and other essential items, nationalization of trade was not uncommon. Nation-wide marketing networks, often owned by parastatals, were the instruments whereby the marketing requirements of large-scale production, as well as control over marketing by local elites, was achieved.

The world-wide recession and instability post-1970 has altered the factors which made for a favourable environment for ISI between 1945 and 1975. The collapse in world markets has been accompanied by retarded growth of home markets in most less developed countries (LDCs), especially in Africa.[7]

Furthermore, the debt crisis of the 1980s has meant that there is less public capital available for investment in large-scale plants, as well as for investment in the infrastructure and services which such units require. These factors contribute to the crisis of ISI in general and make imperative a re-evaluation of the nature and limitations of ISI, with a view to articulating different possibilities of development. We turn thus to examine the sugar industry, to illustrate our contention that the conditions necessary for continuously expanding production along the ISI model are increasingly difficult to fulfil in developing countries.

PART TWO: THE SUGAR INDUSTRY AND IMPORT SUBSTITUTION

The very wide diversity in the size of the sugar cane processing industry in LDCs is remarkable, as Table 1 shows. Total capacity ranges from 3,200 tcd in Sri Lanka to 610,000 tcd in Cuba. Another point to note is the difference in average mill capacity, from 1,131 tcd (Japan) to 9,250 tcd (Zimbabwe). The size of vacuum pan mills is a function of several factors — the date of installation, the predominance of plantations or smallholders in cane supply, length of crushing season, the source of finance, and the existence of a private entrepreneurial sector. Thus despite a relatively long season (which tends to reduce mill size), the fact that Africa's sugar industry was established after 1945, that plantations provide most of the cane, and that much of the finance came from external donors in the absence of a well developed indigenous entrepreneurial cadre all help to explain why Africa has a significantly higher average mill capacity than Asia or Latin America. Asian and Latin American countries have older industries with smaller, older mills still in operation. However, within Asia, for example, the disparity in average Indian and Thai mill capacity is related to the predominance of smallholder cane growers in India, and to large farm cane production and a very short crushing season (3 months) in Thailand (see Table 3).

As an import substituting industry in most of these countries, vacuum pan milling catered to what was initially a small, but rapidly growing, urban market for white sugar. Preceding and co-existing with this was the traditional form of non-centrifugal sugar which is produced in almost every developing country.[8] Non-centrifugal sugar contributes a significant proportion of world production, and, while its importance varies from country to country,[9] its inclusion in any analysis of the development of the industry as a whole is crucial as it illustrates important structural factors.

154

Table 1: Milling capacity data for selected countries (tcd)

Country	Number of mills	Total capacity	Average capacity per mill[a]	Capacity range
CENTRAL AND SOUTH AMERICA				
Argentina	24	133,300	5,796	700-19,000
Bolivia	6	25,000	4,167	1,500- 6,000
Colombia	13	54,600	4,200	400- 8,500
Costa Rica	22	30,920	1,406	300- 4,000
Cuba	154	610,000	3,903	690-14,000
Dominican Republic	16	67,500	4,500	500-18,000
Honduras	8	18,700	2,671	1,500- 5,000
Jamaica	9	24,960	2,773	1,200- 6,500
Mexico	69	304,650	4,415	500-20,000
Peru	12	35,950	2,996	300- 8,000
ASIA				
Bangladesh	16	17,450	1,163	1,000- 2,000
China	359	204,756	2,327	1,000- 6,000
India	323	401,766	1,813	450- 6,500
Indonesia	66	144,710	2,193	900- 4,800
Japan	22	24,890	1,131	360- 2,900
Philippines	41	188,126	4,588	470-10,800
Sri Lanka	2	3,200	1,600	1,200- 2,000
Taiwan	25	65,700	2,628	1,300- 4,000
Thailand	43	316,754	7,366	800-18,000
AFRICA				
Egypt	7	64,500	9,214	4,500-12,000
Ethiopia	3	8,000	2,667	1,400- 5,000
Ivory Coast	4	14,500	3,625	3,500- 4,000
Kenya	7	16,700	2,783	1,000- 7,200
Malawi	2	8,300	4,150	3,300- 5,000
Mauritius	20	59,110	2,956	1,350- 6,600
Mozambique	6	22,280	3,713	2,400- 4,320
South Africa	16	103,720	6,483	1,680-14,400
Swaziland	3	20,200	6,733	6,000- 7,200
Tanzania	5	11,575	2,315	2,000- 2,500
Zambia	1	6,000	6,000	—
Zimbabwe	2	18,500	9,250	8,500-10,000

a. The average capacity does not always tally with the number of mills and total capacity, since the capacity of some of the mills included in the total number of mills was not available.

Sources: Lichts, *International Sugar Economic Yearbook and Directory,* 1986; Tame, 1986; Blume, 1985.

At the time that vacuum pan milling was established in most developing countries, it was considered the only viable and efficient technological basis for a national sugar industry. The traditional sector was not considered as an actual or potential supplier of white sugar. The reasons for this were generally social and political rather than technical. It is true that the traditional product is, with notable exceptions in India and Colombia, not substitutable for refined white sugar. In most cases, 'jaggery', 'panela' or 'gur' is made in open pans with no separation of non-sugars. Typically it does not keep well, and therefore is unsuitable for nationwide consumption. However, the crucial point is that the production of white sugar was based on the imported vacuum pan technology rather than on a programme of upgrading and developing the indigenous technology. It is significant that even in Colombia and India, where indigenous milling had progressed to the production of a centrifugal white sugar substitutable for vacuum pan sugar, the technology chosen for ISI was the imported vacuum pan. The resultant structure of the sugar

155

industry was thus marked by a basic dichotomy between the traditional sector and an implanted vacuum pan sector, with government policy being oriented to the requirements of the latter.

As shown elsewhere in this volume, vacuum pan milling has a superior sugar:cane extraction ratio to any other kind of milling, including the improved open pan sulphitation (OPS). However, to achieve low cost competitive production, vacuum pan mills need, above all, continuity of production and high capacity utilization to reap economies of scale. Due to its potential technical efficiency, the high cost of necessary inputs poses fewer problems than does interrupted production, and this is in contrast to less capital intensive forms of production. In the latter, discontinuity of operations involves much lower costs since capital outlay in fixed equipment is very low by comparison. Furthermore, being less efficient in the sugar:cane conversion ratio, a higher cane price imposes big increases in production costs. To the extent that government policies are geared to reducing costs of production, different sets of policy packages will be appropriate to the two different types of technology. This is true in almost every aspect of the industry, from cane supply to sugar marketing and pricing. We turn, therefore, to examine the organizational structure of large-scale VP industry, and the government policies which were developed to support these industries.

Sub-optimal capacity utilization of large-scale mills, arising mainly out of interrupted cane supply, is a recurrent problem in developing countries. Although it is possible to achieve high capacity utilization rates, we would suggest that consistent under-utilization is the norm and is, in fact, to be expected, for reasons we specify below. There is, unfortunately, no systematic study of the actual rates of capacity utilization in large-scale vacuum pan mills in developing countries over, say, the last twenty years. Such a study would, we postulate, reveal an endemic problem of under-utilization. This conclusion is warranted by the persistent recurrence of such problems in a wide range of developing countries. Kenya, Tanzania, the Ivory Coast and Ghana have experienced severe problems.[10] Sri Lanka and Indonesia also report persistent under-utilization, while, in the western hemisphere, mills in Honduras, Bolivia, Jamaica and Peru provide many examples of the same phenomenon.[11]

The specificity of cane sugar production as an agro-processing industry resides in the fact that the two distinct parts of the production process — cane growing and milling — need a high degree of co-ordination. Cane quality deteriorates rapidly after being cut, with significant sucrose losses. Historically, the earliest Caribbean sugar plantations combined growing and milling in one integrated enterprise. Technological improvements in the millng operation after the late nineteenth century, however, led to an increase of scale and the amount of fixed capital required, thus putting it beyond the reach of some plantation owners. Mills to process the cane were thus set up independently, often leading to a separation of the agricultural and manufacturing parts of the full production process. Three distinct organizational forms have emerged over the years:

Total integration: Mill-owned plantations supply the full cane requirements of the mill. Examples of this form can be found mostly in African countries, eg. Zambia, Zimbabwe, Malawi, Swaziland, Ethiopia, Sudan and Mauritius.

Partial integration: Mill-owned plantations supply a portion of the cane requirements, the balance being supplied by contracted 'outgrowers'. Brazil, Argentina, Columbia, Dominican Republic, Honduras in the Americas, and Kenya in Africa have such forms of organization.

Total separation: This is most common in Asia. India, Pakistan, Thailand, Philippines and Indonesia, for example, have no 'miller-planter' enterprises. Mexico, similarly, has no plantations. South and South East Asia are, in fact, the regions where smallholder cane cultivation as part of a mixed crop rotation system is longest established. Mills, therefore, have to secure their cane supply from either a multitude of smallholdings (as in India and Indonesia) or from a mixed group of large and small independent farms (such as those in the Philippines and Thailand).

From a purely technical point of view 'a large enterprise combining agricultural and processing activities ... seems to be conducive to high efficiency', and this is because 'sugar cane is a perennial grass, so it cannot be integrated satisfactorily into a rotation system and as a result, commercial farming of sugar cane is normally carried out as monoculture' (Blume, 1985, pp. 39-40).

As we saw above, however, plantations do not predominate totally in cane supply. While it is difficult to be precise about the relative contributions of outgrowers and plantations in world cane supply, there is little doubt that the proportion supplied by smallholders has increased since 1945. This is itself part of a broader post-war process whereby smallholders participated in the growing of many cash crops, including tea, coffee, pyrethrum and others, for the first time. This trend resulted from strong internal pressures from farmers and politicans for greater domestic participation in cash crop production. Foreign companies were often sympathetic to this trend because '... direct ownership of land ties up large amounts of capital, exposes the owner to the risks endemic in agricultural production, requires control of a large (often unionized) labour force, and runs the risk of nationalization. On the other hand

supervised smallholding production throws much of the risk onto the farmers, and is a cheaper way to obtain the labour of an entire household' (Odada et al, 1986, p. 109).

What form of organization predominates in each country is thus the result of specific historical and socio-economic factors. Tables 2 and 3 present approximate data about origins of cane supply for selected countries.

The purely logistical requirements of large-scale milling in themselves pose a considerable constraint on continuously high capacity utilization. The necessity of having the right quantity of cane harvested, transported, unloaded and milled at the right time requires a high level of managerial expertise. Such a range of skilled professionals is in short supply in developing countries. Furthermore, given poor infrastructure, the technical problems can only be expected to multiply. In addition, the problems of nation-wide marketing systems in developing countries can hold up production; thus cane supply is not the only area where logistical problems can cause low capacity utilization.

Table 2: Importance of smallholders in cane supply

Country	% of Cane production
CENTRAL AMERICA AND THE CARIBBEAN	
Costa Rica	most
Dominican Republic	23
El Salvador	65
Haiti	50
Honduras	30
Jamaica	40
Mexico	most
SOUTH AMERICA	
Argentina	45
Bolivia	90
Brazil	54
Colombia	60
Ecuador	10
Paraguay	95
Peru	20
Venezuela	70
AFRICA	
Egypt	most
Kenya	most
Mauritius	42
South Africa	30
ASIA	
Bangladesh	most
India	most
Indonesia	most
Pakistan	most
Nepal	most
Thailand	70

Source: Chilvers and Foster, 1981.

There is, however, another, deeper problem in ensuring an adequate cane supply, which relates to the type of agricultural production. There are problems in both plantation and smallholder cane supply. Cane plantations, of course, have been associated with slavery in the Caribbean, and still are renowned for the poverty and oppressive labour conditions found in many developing countries (see, for example, Coote, 1987). The interruptions to cane supply from plantations seem to have their source primarily in labour problems — either in cane harvesting, loading, transporting or unloading at the mill. It is, in fact, a remarkable feature of cane plantations that 'only where harvesting sugar cane has been completely

157

mechanized, as in Hawaii, do the large planters or miller-planters no longer have to depend on migratory labour'.[12] Thus, for reasons that are shared by other plantation crop production, cane plantations often seem able to operate viably only when associated with labour conditions and wages which generate labour unrest and problems in cane supply.

Table 3: Distribution of cane area by farm size

Country	Farm size (ha)	% of total cane area occupied
India	‹2	30
	2-5	34
	5-10	21
Pakistan	3-5	23
	5-10	31
Philippines	10-25	17
	25-100	37
	100	28
Thailand	10-50	31.25
	50	62.5

Source: Asian Productivity Organization (APO), 1980, pp. 33-50.

Where cane comes predominantly from outgrowers, and especially smallholders, the factors making a continuously adequate cane supply difficult to obtain are varied and complex. As part of a mixed farming system of numerous smallholding households, cane production is determined primarily by the reproductive and cash needs of the household. Smallholding households are constantly making difficult choices between subsistence food production and cash crops, as well as between different cash crops. The relative market prices for food crops, as well as those obtainable for different cash crops, all enter into the calculation of such households in their decision making. An important feature of developing economies is that often the markets for foodstuffs can be imperfect and regionally segmented, with the result that even with favourable cash crop prices, farmers may be disadvantaged by lack of access to essential foodstuffs if they switch to cash crop production. The consequence of all this is to reduce the mills' ability to regulate effectively the cane supply from a smallholding mixed farming system.

Thus given a commitment to an ISI strategy which favours the utilization of large-scale VP technology, and given the inherent difficulties in providing adequate cane supplies (under both smallholder and plantation systems), government policy has generally been geared to creating conditions which minimize the effects of those factors which cause low mill capacity utilization. It is instructive to examine the major elements of this government intervention.

Cane pricing and procurement

Two main policy instruments are used by governments to ensure cane supply to large mills. First is the enforcement of a contract between mill and farmer, and the delineation of mill zones binding farmers to supply cane to a particular mill. Second is the pricing of cane relative to other crops. This is obviously of the greatest importance in influencing cane supply, and needs careful attention.

By controlling one or all of either the cane, ex-factory or the consumer sugar price, the revenue of cane growers and factories is determined. Abstracting from the numerous different detailed methods, we can distinguish two fundamental systems of cane pricing:

Direct: A price for cane is set by the government. This can either be a fixed price (as in Kenya) or a minimum price allowing upward movement (as in India). In turn, this price can either be per tonne of cane, irrespective of quality, or for the percentage of sucrose contained in the cane.

Indirect: The cane grower gets a fixed percentage of the realised value of the sugar extracted from the cane. The return to the grower is thus determined by the sugar price obtained on the world market for exported sugar and on the domestic market for locally consumed sugar.

The use of any one of these methods does not by itself reveal which particular group's interests are being served. The fixing of a minimum cane price by weight — irrespective of quality, as in Thailand and India

for example — clearly subjects the miller to two risks: that of how much (or little) sucrose the cane contains and how high (or low) the sugar price obtained eventually will be. However, in both Thailand and India the government has been subsidizing the mills heavily, thus protecting them from low sugar prices and, in effect, subsidizing cane production.

Where cane price is linked to cane quality, the miller's risk is reduced to sugar price fluctuation. There is a distinction between payment based upon the total sucrose content (pol % cane), which is determined independently of the manufacturing process, and the percentage of the pol content of the cane that is recoverable commercially. This latter involves taking account not only of pol % cane, but also of the fibre % cane and the degree of purity of the juice: available pol rather than total pol. The amount of sugar that is recoverable commercially, it is important to note, is dependent on the manufacturing process. This varies not only between old and new, small and large VP mills, but also between VP and OPS mills. We noted above that cane and sugar pricing is subject to careful calculation to allow millers an adequate profit;[13] while at one level the available pol method simply gives greater technical accuracy to these calculations, it nonetheless also makes clear that the basis for these calculations is VP technology and, more particularly, its rate of extraction of sugar from cane.

The indirect method means that cane price is based on the resultant yield of commercial sugar per tonne of cane, which insulates the factories to a large extent from a profit squeeze. This does not protect growers from milling inefficiency, and the risk for the miller is minimized here. This method is likely, of course, to result in cane price differentials from factory to factory, but by equating the selling price of sugar, this variation can be directly related to cane quality and factory efficiency. An OPS factory, with a lower sugar recovery rate, would thus pay less per tonne of cane than a VP mill. In practice the growers' revenue can be safeguarded from the worst effects of sugar price fluctuation and milling inefficiency by the state, as it is in Mexico where growers are guaranteed a minimum yield of 8.3 per cent and a maximum sucrose loss of 2.64 per cent. Actual recovery by the mills is lower, thereby requiring a government subsidy.

The distribution of the returns from sugar sales revenue between farmers, millers, traders and government trading parastatals is related to the influence the different groups wield in each country. In Kenya, where the industry is owned mostly by government, it appears to be the farmers who are successful in maintaining or increasing their share of total revenue. In India the demands of the large mill owners contrast with those of large cane growers, and there is constant conflict about the fixing of minimum cane prices by state governments. In Thailand, similarly, there is conflict between independent large farmers and mill owners. We saw above, however, that there is also a partial coincidence of interests between farmers and large-scale mills in that the latter, with their high sugar cane conversion rates and their need for continued supplies of cane on a large scale, are less troubled than smaller mills by high cane prices. It is not possible thus to make any generalization about the distribution of proceeds between farmers, millers and traders. What is reflected in the cane pricing and marketing policies discussed above is the absence — as we would expect from our earlier analysis of ISI—of a small mill owning group in the determination of government policy.

Sugar pricing

In many African countries, and also in others like the Dominican Republic and Indonesia, the government owns or controls a large part of the milling sector. This direct involvement in maintaining the milling industry is only the more obvious manifestation of the commitment by governments in the majority of developing countries to their sugar industries. In cases like Mexico, Pakistan, Thailand and India — to name a few — there is very clear subsidization of milling when the sugar price set or received does not cover milling costs at specific cane prices. In other cases, too, as we shall see, there are indirect and/or hidden subsidies involved.

For our purpose, though, the setting of the ex-factory price is itself of interest as it relates to milling units of different types and sizes. Recognition that smaller and/or older units often have higher unit costs of production has meant that different concessions are sometimes made for them in respect of taxes, levies, quotas, etc. Equally, new VP units are often allowed concessions to enable them to meet recurrent costs when the ex-factory price does not allow them to do so. Such measures (both of which are employed in India) are designed to allow a single producer price to be paid to each factory, though they have different cost structures. Thus, in summary, it can be seen that the determination of sugar and cane prices serves two major functions. First, the level at which cane and sugar prices are set, in conjunction with the range of taxes, levies, subsidies and concessions, is geared to maintaining a range of labour-saving processing units in operation. Second, the price regime is generally targeted to ensure a reliable supply of cane to maintain full capacity utilization in these large-scale VP mills.

Sugar marketing

We saw in Part One how nationwide distribution networks, often under government control, were part and parcel of the political economy of ISI. In more concrete terms, the objectives of such marketing arrangements are defined as arising out of 'a bias against supposed exploitative middlemen, the desire to procure low cost food supplies for urban constituents, the necessity to reduce imports, and to raise tax revenue' (Tame, 1986, p. 1). Indeed in the majority of developing countries, the government exercises a monopoly in the domestic and external trade in sugar. The level to which government monopoly extends in the domestic trade varies. In Kenya, Sudan and Uganda, for example, government parastatals have a monopoly in purchasing from mills and in distribution to wholesalers. By contrast, in Cameroon, Malawi and Swaziland private companies purchase from mills and distribute to traders (Tame, 1986, Table 3, p. 5). In Asia, the government intervenes in the domestic trade in China, India, Japan, Nepal, Pakistan, Philippines and Thailand, and fixes price in all of these countries except Japan and Thailand. In Nepal, Pakistan and Philippines, the government exercises a monopoly in domestic trading (APO, 1980, p. 71, Table 22).

Such marketing arrangements involve heavy costs, and additional levies on the ex-factory price raise the price to the consumer. These costs are increased by the difficulties specific to developing countries, such as poor infrastructure, segmented markets and foreign exchange shortages.

The consequences are found in the high margins between ex-factory and retail prices. In Indonesia in 1977, for example, the retail price was 150 per cent of the ex-factory price — Rs 200/kg and Rs 134/kg respectively. The breakdown of the retail price in 1975 was as follows: production cost 70.5 per cent, marketing cost 6.0 per cent, and government taxes 23.5 per cent (APO, 1980, p.101). In the Philippines in 1977, the retail price was 125 per cent of the ex-factory price. In Sudan in 1981/2, the official producer price was 44 per cent of the official retail price for Khartoum, while the actual producer price was only 31 per cent of retail price. Government taxes represented a full 44 per cent, and excise duty and deductions by parastatals another 27 per cent (Tame, 1985, p. 42, Figure 4).

In conclusion to this part, let us note that in the delineation of mill zones and the enforcement of contracts between mill and farmers, the marketing of cane is also brought, more or less effectively in different countries, under control.[14] Both input and output markets are thus tightly controlled in ISI and this, in addition to the imposition of government taxes and levies, can, as we saw, have very different effects on different types of milling units. The country studies that follow illustrate this.

PART THREE: CASE STUDIES

The existence of a well-developed indigenous sugar industry preceeding the phase of ISI, and the co-existence since then in India of VP, OPS, khandsari and gur production, makes it a particularly illuminating case study. The relationship between the different sectors, the nature and effect of government policy on each, and the underlying difference in the relationship of VP milling and khandsari and OPS production to agricultural production, can be fruitfully analyzed. The Kenyan case, by contrast, reveals more directly the inherent problems of large-scale sugar milling vis-a-vis agriculture. This is because the traditional non-centrifugal production — jaggery — is not substitutable for VP sugar. There is therefore no significant traditional sugar milling which competes with the large mills. In both cases, the exclusion from political decision making at the national level of an entrepreneurial group representing small-scale mills is crucial; in the Indian case despite its existence and economic dynamism, and in the Kenyan case due to its weaker development.

India

India is unique in that it has 'not one but three or at least two sugar industries' (Viton, 1980), and it is not only one of the biggest five centrifugal sugar producers but has the biggest non-centrifugal sugar sector. Gur is the traditional Indian sweetening agent and is widely consumed. It is a non-centrifugal product and not substitutable for refined white sugar. Khandsari, by contrast, is a centrifugal sugar. Its quality varies greatly, but at its best it is substitutable for VP sugar and can fetch an equivalent price. OPS was pioneered in India in the post-war era. It differs from khandsari production in that it involves sulphitation. OPS produces a consistently high quality white sugar, substitutable for VP sugar. Alongside 2,000-3,000 OPS units are 397 VP mills. Only about one-third of the cane crop goes to the VP mills while about 55 per cent is used by gur and khandsari producers, about 10 per cent by OPS units, and the rest is used for seed and chewing. While other countries like Colombia and Pakistan also have significant non-centrifugal sectors, India is unique in having such a large and vigorous khandsari sector which is

highly competitive in relation to the VP mill sector. The view is commonly held that it is not only economic factors like cheap cane and labour but, more importantly, 'institutional' factors which explain the resilience of the khandsari and OPS sectors, and, therefore, that wherever the OPS and conventional technology units co-exist it appears that the OPS units require special conditions and a degree of protection to survive. More specifically, it is argued that OPS units survive only because 'technical and economical forces are modified and thwarted in India by government regulations' (Viton, 1980). Other commentators hold the contrary view that OPS is a viable technology needing no government protection. Given, however, that OPS technology has to date not made a significant impact outside of India, it is particularly important to be clear on the factors which explain the success of OPS units in India. A clear understanding of the factors will shed light on the nature of the problems for OPS technology in other developing countries, as well as on the scope for their potential resolution.

Table 4 gives production data for selected years:

Table 4: Indian production and trade statistics

Year	Production (mill. tonnes)	% variation over previous year	Gur & khandsari production (mill. tonnes)	Net trade
1950/51	1.134	—	—	—
1960/61	3.028	+23.4	—	—
1970/71	3.740	-12.2	—	—
1978/79	5.841	- 9.6	7.60	0.71e
1979/80	3.858	-33.4	7.55	0.13i
1980/81	5.148	+33.2	8.55	0.13i
1981/82	8.437	+63.9	8.04	0.50e
1982/83	8.230	- 2.5	8.55	0.78e
1983/84	5.917	-28.1	9.93	0.08i
1984/85	6.143	+ 3.8	—	1.74i
1985/86	7.625	+14.2	—	1.86i
1986/87	8.700[a]	+14.0	—	—

a. Estimate.

Sources: Government of India, *State Bank of India Monthly Review*, 1986; Lichts, *International Sugar Economic Yearbook and Directory*, 1986; *Czarnikow Sugar Review*, April, 1987.

The data show periodic cycles of under and over-production — two years of higher production are followed by two years of lower production, which are again followed by a period of two to three years of increasing production and so on. These fluctuations, which are also reflected in cane acreage and production data, represent the greatest problem of the industry.

The median size of the VP mills in India is 1,250 tcd, and although the minimum economic size has now been increased to 1,500 tcd and although 3,000 tcd factories have been recently licensed, this small average size is related to the fact that cane is grown on a multitude of very small farms, with the attendant diseconomies of cane collection from an extended area. The fundamental problem for the VP mills is, as we would expect from our review in Part One, that of inadequate cane supply which forces mills to have shorter crushing seasons and to operate at well below full capacity. The problem is not only fluctuation in the cane crop but, additionally, the ability of gur and khandsari units to pay a higher cane price and thus attract cane away from the mills. This ability to pay a higher cane price goes against the accepted notion that that a lower extraction rate means a lower cane price. The commonly advanced explanation for this — as being due to the system of minimum cane price legislation and levy sugar pricing, to which VP mills are subject and from which khandsari units are exempt — is, as we shall see below, not adequate. To appreciate this, however, we need to look briefly at the history of the sugar industry.

The development of a vigorous khandsari sector in the nineteenth century meant that by the 1930s, when tariff protection was granted to the VP mill sector and the process of import substitution started, there were some 200-250 khandsari units. Apart from access to cheap and unorganized labour, their strength resided in their success in engineering 'a situation in which the supply of (cane) was assured, irrespective of price fluctuation and the pull of external demand' (Commander, 1985, pp. 508-509). Farmers' indebtedness to the small owners was the means for achieving this, and it is estimated that in

the 1930s as much as 90 per cent of cane supply in North India was under the secure control of khandsari mill owners (Commander, 1985, p. 509).

The establishment and development of the VP mill sector in these conditions necessitated a whole range of government controls which are, ironically, now said to cause the VP mills to be at a relative disadvantage. The central elements of this system of state control are minimum wage and cane price legislation, and the system of levy sugar in which a proportion of the VP mill output has to be supplied to the government at a set price below the free market price. Each one of the regulations is, in fact, necessary for the very existence of the VP mill sector. Let us consider first the minimum cane and price legislation.

One of the widely recognized requirements of capital intensive technology is continuity of production, and in the post-war era minimum wage legislation was passed in many developing countries to ensure a small and stable labour force. By contrast the rest of the economy, including the informal sector, is a low wage one beyond the reach of such wage legislation. In the Indian sugar industry, then, the higher wages paid by VP mills are both necessary for the industry and also, in being common to most import substituting industry everywhere, essentially constitutive of capital intensive industry.

Minimum cane prices are similarly necessary to try to ensure a continuous cane supply. OPS and khandsari units, with much lower capital outlay, can close down in years of low prices, and the prices such units pay for cane thus fluctuate wildly. The modern sector, by contrast, needs continuity, and price fluctuations have to be limited if they are not to lead to cane shortages in some years.

These controls, arising out of the technological imperatives of large-scale milling, also work to ensure the primary aim of import substitution as we defined it earlier in terms of meeting national consumption requirements. The system of levy sugar is obviously designed for this purpose. It is equally essential, however, in protecting the VP sector for, although the mills complain about levy sugar and its price, experience shows that in guaranteeing a minimum level of demand at a fixed price the industry is protected from a collapse of sugar prices. A commentator wrote in 1986 that with decontrol 'the price might crash in the open market, resulting in financial losses to the sugar factories' (Lichts, *International Sugar Economic Yearbook and Directory*, 1986, p. 25). With production in many years well below the installed capacity (in 1986 of 7.5 million tonnes), the threat of price collapse is a very real one. The system of levy sugar is designed to minimise this. It is true that the levy price brings the composite price paid for VP sugar down to below khandsari price in most years, as Table 5 shows:

Table 5: Mean khandsari and composite VP prices, 1972-1978 (Rs/tonne)

Year	Khandsari price	VP composite price[a]
1972/73	286.5	226.3
1973/74	318	244.8
1974/75	344	340
1975/76	338	291.4
1976/77	317	280.3
1977/78	234.5	259.6

a. The values are based on the arithmetic means of the range of prices given in APO (1980); the composite price is the weighted average of the arithmetic means of the free and levy prices.

Sources: APO, 1980; Government of India, *State Bank of India Monthly Review*, 1986.

However, on the basis of the 1978 decontrol and price collapse, it is likely that the market price would be lower still in most years without the government support price. Government controls and policies are in fact necessary for the existence of the majority of VP units.

Let us turn now to the ability of OPS and khandsari units to pay a higher cane price. First, the general point that the relative inefficiency of OPS in its cane-sugar conversion does not in itself make it an inefficient technique since capital utilization is also an important component of efficiency. Secondly, the explanation for the competitiveness in general of OPS units — in terms of factors which tend to counteract the lower sugar extraction factor — includes low capital costs as well as low cane transportation and low sugar storage and distribution costs.[15] Since the evidence from North India is that OPS units do not suffer significant disadvantages in the actual unit costs of production anyway,[16] it is no surprise that the factors listed above give them a competitive edge which allows them to pay higher cane prices Any increase in the recovery rate or length of crushing season, or reduction in cane price, obviously reduces the unit costs further.

162

We need, finally, to keep in mind the various concessions, exemptions and subsidies given to VP mills. The levy:free sugar ratio is down to 55:45 at present, and the levy retail price has been raised to Rs 4.80/kg. The minimum cane price for the 1986/7 season was fixed at Rs 17 per quintal. These were measures long called for by the mills. New mills are allowed special free sale quotas and even exemption from levy sales in some cases, while a differential price policy of giving an additional levy price for smaller and older units was also adopted. In addition, soft capital loans and credit for cane purchases (which are also heavily subsidised by provincial governments) are also provided.[17] Holding charges on buffer stocks and the interest on loans are reimbursed by the government. Yet despite these subsidies to VP mills, a review in 1986, noting that costs for new installations 'may prove to be too prohibitive', calls for 'some fresh incentive schemes ... to make new factories and expansion projects viable'. In fact almost two-thirds of the VP units in the industry are in serious financial trouble, with almost 70 per cent of factories in Uttar Pradesh more than 40 years old (Government of India, *State Bank of India Monthly Review*, 1986, pp. 204-205, 316, 198 and 253 respectively).

Concluding remarks: Despite the elaborate complexity of government controls, the cane and sugar industry is, to a large extent, free of government control; only the 30 per cent or so of the cane which the large-scale sector uses is subject to minimum cane price legislation, and, at present, 55 per cent of the VP sugar has its price fixed by government. The uniqueness of the Indian environment lies precisely in this. Due to the strength of the previously established khandsari sector and the nature of a multitude of smallholding cane growers, the VP mills have not been able, by economic or bureaucratic means, to monopolize the supply of cane. There is a tax on cane which applies both to VP and OPS mills, but this is not high enough to undermine OPS production. Being cane intensive the price of cane is particularly important for OPS units, and their continued access to low and high priced cane at times of low (and high) prices is critical to their viability.

Similarly, in marketing, gur and khandsari producers are free to dispose of their product without government intervention. The lower rate of excise duty (or duty per centrifuge)[18] and the absence of any transportation/storage marketing levies to recover costs incurred by the national distribution system (which is necessary for the large-scale mills) are also important.

The inability of government and VP mills to effectively subordinate the agricultural and non-VP mill sectors to the requirements of import-substitution is reflected in the continuing difficulties of VP milling and the consequent necessity to import sugar, despite being one of the world's largest producers. This inability is itself due to unique historical and social factors, but the resultant freedom of small units from government control is, as we have seen, the key factor which allows khandsari and OPS units to continue to flourish.

Kenya

The sugar industry of Kenya is currently in a state of crisis. The industry was established largely in the 1960s, and underwent a period of rapid expansion up to the 1980s so that domestic requirements were met and exports began. In the 1980s, however, production has stagnated and imports have become necessary.

Government involvement in the expansion has been significant. Apart from two privately owned mills which were established before 1945, the five mills set up from the 1960s onwards are all government

Table 6: Factory capacities and output reductions, 1981-5

Factory	Capacity	Production	
		1981	1985
	tcd	('000 tonnes)	
Miwani	1,200	31.0	11.0
Chemelil	2,235	51.4	51.8
Muhoroni	1,800	36.6	38.0
Mumias	7,000	168.0	182.0
Nzoia	2,000	44.0	29.7
SONY	2,000	29.6	16.7
Ramisi	1,530	8.3	10.8
Total		368.9	336.2

Source: Factory reports.

owned, with government investment by 1980 amounting to some KSh 2.1 billion (US $290mill.) at historic costs (Makanda). The government fixes cane and sugar prices, as well as the costs to be debited to farmers by the mills, and has a trading monopoly. The extensive role of government is reflected in the involvement of no less than five ministries and organizations in the sugar industry. Up to 1980, Kenya recorded an impressive increase in sugar production, but since then problems have multiplied and massive illegal sugar imports in 1987 have exacerbated the situation to the point that the eventuality of 'the closure of sugar mills coupled with non-payments of delivered sugar...(forcing) cane growers to put away their hoes...is no longer the figment of imagination' (*Financial Review*, 7 September, 1987).

This exogenous shock for the industry of sugar imports hides more deep-seated problems, however, which Table 6 reveals. While four of the plants had maintained or slightly increased their production, the other three had had significant reductions in output between 1981 and 1984. By 1987, in fact, all plants except Mumias were reported to be operating at under 50 per cent capacity (Lichts, 1987).

Cane production: About 80 per cent of Kenya's cane was grown by outgrowers in 1984, as Table 7 shows. By far the biggest proportion comes from small farmers.[19] The overall level of cane production only recovered its 1980 peak in 1984. To try and reverse this decline in cane production (and hence in milling capacity utilization), cane prices were raised in 1987 to KSh 341/tonne. But, as our discussion in Part Two would lead us to expect, the factors responsible for falling cane production are complex, and it is unlikely that this price support alone will enable mill capacity utilization rates to be raised significantly.

Table 7: Cane production by type of farmer ('000 tonnes)

Type of farmer	1980	1984
Nucleus estate	925.0 (23.3%)	729.2 (20.2%)
Large farms	556.0 (14.0%)	599.9 (16.6%)
Small farms	1,772.3 (44.6%)	1,718.8 (47.6%)
Co-operatives	310.7 (7.8%)	218.8 (6.1%)
Settlement schemes	408.3 (10.3%)	344.8 (9.6%)
Total	3,972.3	3,611.5

Source: Odada et al, 1986.

Cane pricing: There is disagreement between commentators about the relative and absolute returns to farmers between cane and other crops. Odada et al (1986), for example, write that 'not only are the average net returns to sugar cane farmers low in relation to other crop enterprises, but a large number of farmers still end up with negative incomes after complete crop cycles lasting five years'.[20]

While the 1985 margins for sugar cane are greater in absolute terms than those for 1981-1984, they are still uncompetitive with maize/beans in some schemes and well below tea in all schemes.[21] We interpret the further significance of this below.

Returns to cane farmers are held to suffer from two sets of factors. Firstly, the high cost of inputs and services provided by the sugar companies. Cane transportation costs represent more than 33 per cent of the value of cane, and cane production and marketing costs are said to amount to 72.8 per cent of the value of cane, leaving the farmer only 27.2 per cent. Furthermore, large deductions by intermediaries between mill and consumer (for which see further below) mean that the farmer gets 10.8 per cent of the value of the retail price of sugar and 15.5 per cent of the ex-factory price (Odada, 1986, p. 65).

This view about the causes of under-capacity utilization in the mills is challenged by other commentators, who hold that a major problem in the Kenyan sugar industry is too high a cane price. While the cane price has risen from KSh 133/tonne in 1977 to KSh 300/tonne in 1986, Tribe calculates that the index of cane price, (ie. cane price deflated by the input price index) is actually lower in 1987 than it was in 1977.[22]

The farmers' share of gross revenue is said to have increased from 45 per cent in 1977 to 54 per cent in 1985. As we have seen, though, deductions from the cane price for inputs significantly affect farmers' margins, and it is net revenue that is of importance to the grower. It appears, then, that while the farmer may not have benefited from the cane price increases as much as it might appear, the mills, nonetheless, have had to pay a price for cane which in the context of controls on final sugar prices has critically affected their margins.

These contrasting views about the causes of low capacity utilization in Kenyan VP mills are illustrative of the inherent difficulties of large-scale milling in developing countries that we specified in Part One

of this paper. The problems with cane supply are, however, not related only to cane pricing. First of all, as we have seen, it is the net return to farmers that is the important variable and this is affected by company deductions. Related to this is dissatisfaction among farmers with the sugar companies — small farmers dealing with a large company are in a vulnerable position. Secondly, however, as Lemmens points out in his paper, cane is often the only cash crop alternative in the sugar belt in Kenya. The cane price relative to other cash crops is thus not often relevant. This relates, however, to a third point: cane returns are spread out over four to five years, while maize/beans yield an immediate return.

Finally, and most importantly, is a feature characteristic of developing countries. The markets for food crops in Kenya are not fully developed and integrated. They are severely segmented regionally, and, in this context, farmers who come to depend on buying their food requirements can find themselves acutely disadvantaged periodically. Evidence has been presented elsewhere in this book about the decline of food production in the sugar belt. Such regional specialization, appropriate and even desirable, perhaps does, in effect, leave cane farmers vulnerable to food shortages. It is for this reason that disappointment with the 'money illusion' of cane is prevalent among small cane farmers.[23]

Marketing: As stated before, the government has a monopoly in the purchasing of sugar from the mills and its distribution, through the Kenya National Trading Corporation (KNTC), to wholesalers. Apart from wholesalers' and retailers' margins, additions to the ex-factory sugar price include government excise duty of KSh 1,000/tonne, the charge levied by the Ministry of Commerce and the KNTC margin. By 1986, excise tax and Ministry of Commerce charges represented 19.5 per cent of retail price, while distributors costs and margins had gone up from 11 per cent in 1976 to 24 per cent of ex-factory price.

In part, this increasing share of the surplus arising in production is appropriated by parastatals in various forms of 'rent-seeking' behaviour. Many commentators observe that this process is intrinsic to ISI. Clearly, such additions to the ex-factory price impose an additional cost on the consumer. This is especially true of rural consumers who, under a different production and marketing structure, could benefit from more immediate access to district-level suppliers. As we specified in Part One, such costs are unavoidable in the particular process of ISI that has taken place so far.

By providing transportation and other infrastructure,[24] government effectively provides a subsidy to VP mills. The excise tax on sugar production, therefore, can be seen as related to this. The imposition of such taxes, levies and parastatal charges in any small-scale plants which do not require such extensive infrastructure and distribution systems, however, has less justification. In effect, it imposes a penalty on such units.

Concluding remarks: From our discussion of divergent views about cane pricing and the causes of the present crisis of the sugar industry, it will be clear that cane supply is not just a function of the relative prices of crops. Our analysis revealed varied causes, deeply rooted in the social structure, which create problems in cane supply. This represents a serious problem for capital intensive technology, and implies that a different technology, more flexible in its response to market environment, may have a role to play in the sugar industry.

The OPS plants in Kenya do not have access to cheaper cane. This means that the continuous increase in cane prices has a particularly damaging effect on their costs of production. At the marketing end, too, they are subject to the KNTC levy, the exemption from which is held to be necessary for their viability. All in all, these factors represent the intent and the ability — so far — of the government to bring this non-VP sector under its control.

The reasons for this lie in the absence of a well-developed traditional industry in Kenya, such as there is in India. Its consequences are that OPS units have to operate in a market which is highly controlled, and in which the natural access of small units of production to cheaper inputs and proximate markets is foreclosed. Government policy thus manages to achieve two unhappy effects. On the one hand, it restrains the growth of OPS milling due to its tight control over the industry. On the other hand, its inability to satisfactorily subordinate smallholding mixed agriculture to the requirements of large-scale milling results in fluctuations in cane supply which are the main cause of the slump in sugar production that has taken place in the 1980s.

In conclusion to our case studies, let us note that they complement each other and support our hypothesis of inherent constraints to large-scale industrial development in LDCs. In the Indian case, the problems of the vacuum pan sector surface as problems posed by competition from OPS and khandsari production, but in reality they reflect the difficulties of maintaining full capacity utilization of large-scale factories. Our analysis of the Kenyan sugar industry supports this thesis by revealing that even in the absence of such competition, more fundamental constraints to large-scale production operate. Despite the radically different nature of their economies, then, the two basic factors of the exclusion from ISI of an independent entrepreneurial class and the prevalence of smallholding agriculture lead to persistent difficulties in the successful expansion of the sugar industry.

PART FOUR: CONCLUSIONS

Our central point, it will be remembered, is that the establishment of large-scale vacuum pan milling as part of a wider process of import-substitution arose primarily out of socio-economic and political factors rather than out of its efficiency in strict technical and/or economic terms. This both reflected the political and/or economic weakness of an indigenous entrepreneurial class, as well as causing the further suppression of indigenously-based industry. The problems facing the sugar industry — of erratic cane supply, capital wasteage through low capacity utilization, low mill profitability, and continued, if irregular, import dependence — implicitly suggest that alternative forms of small-scale production have a role to play in the restructuring of the industry. This is so primarily because, as we saw in Part Two, the uncertainties of cane supply in developing countries with smallholding agriculture means that large-scale mass production technology is intrinsically unsuitable. Although it is possible to ensure adequate cane supply in some circumstances, the articulation of smallholder mixed farming and large-scale cane processing is on the whole fundamentally problematic.

Small-scale OPS processing is, by contrast, inherently suited to mixed farming economy. It economizes not only on transportation of cane and marketing of sugar, but more importantly it represents a different relationship between agriculture and industry. Here, OPS production responds to milling profitability levels and the availability of cane supplies from an existing mixed farming system without directly establishing control over this farming system.[25] In sharp contrast, large-scale processing requires the reorganisation and subordination of agricultural practice to the requirements of the milling unit. The inability of mills to effectively achieve this only reinforces the conflict-ridden nature of this relationship.

Thus the main determinants of the structure of the industry have been essentially political. Although the technical and economic efficiency of alternative forms of milling, like khandsari and OPS, are important in themselves, the future shape of the industry is essentially a political issue. It is important to keep this in mind in assessing the implications of our analysis. The problems specific to large-scale sugar milling, as examined in Part Two, arise out of the general characteristics of large-scale ISI in LDCs. The typical nature of LDC factor and product markets means that in different regions and in different industrial sectors, large-scale ISI may often be an inappropriate strategy. The general commitment by LDC governments to the pattern of large-scale ISI may therefore need to be reconsidered. However, as we have seen, the constraints to industrialization in LDCs lie deep in their social structures. Consequently, policy reform of the kind that may be necessary may itself require political changes of a fundamental character.

In considering the possibilities of such a change in government policy in any specific country, two issues are central. Firstly, it is not immediately evident how the conflicting requirements of the large-and the small-scale sectors can be resolved. The ISI sector requires tight market control while the OPS sector does not. The Indian example is one of small-scale production remaining outside the orbit of government control, due to the strength and establishment of the khandsari sector, rather than government policy actually encouraging the co-existence of the two types of production. Rather the government confronts an existing small-scale sector, and this is reflected in the system of regional variations and partial control. This provides a potential policy model to resolve the conflicting requirements of the two sectors, but it is beyond our scope here to consider the form such a policy might take.

The second issue is the political one. It relates to where the impetus for such policy changes can originate in the context of the absence of a strong entrepreneurial class in control of small industry. As we saw in Part One, the interests of ruling elites are intricately tied up with established large-scale import substituting industry. It follows from this that the possibilities of inducing policy changes are weakest where ISI is further developed and where the ruling elite is directly involved in it. Conversely, in those countries where the ruling elite does not have such direct interests in maintaining ISI, or where ISI is itself not so entrenched and developed, the possibilities of policy change are greater. There is, however, a relative difference between countries in the nature of the obstacles preventing effective policy reform. These obstacles lie essentially in the political realm, and, as stated above, fundamental political changes may well be a prerequisite before an alternative industrialization policy can be implemented.

Notes

1. I would like to thank Ben Yates of Booker Agriculture for providing me with valuable material and for taking time out to discuss the issues with me. Ian McChesney of ITDG also provided me with useful material. Gerry Hagelberg, Mel Jones and Raphael Kaplinsky all read an earlier draft of this paper and their comments have been extremely useful. My thanks also to Irene Williams, Colette Nurse and Carrie Brooks for helping with the production of this paper, and to Marilyn Cross at the International Sugar Organization (ISO) Library for her generous help.

2. Hagelberg (1977, p. 894) reports sugar production in over 100 countries. Cane sugar plants, about 1,500 in total, are mostly in developing countries, while most of the 1,000 beet sugar plants are in developed areas.

3. Thailand's production increased fourfold from 0.5 million tonnes to 2 million tonnes; India's erratic expansion was from 3.7 million tonnes to 7.1 million tonnes; Brazil's output rose by 75 per cent between 1970 and 1977 to 8.8 million tonnes. Production increased steadily in a host of other countries as well. Total world production increased from 72.9 million tonnes in 1970 to 88.9 million tonnes in 1979, and is estimated at 102.1 million tonnes for the 1986/7 season (Czarnikow Sugar Review, May, 1987).

4. One source estimates 'an underlying decline in the real price of sugar' of 40 per cent between 1950 and 1979 (Chilvers and Foster, 1981, p. 7).

5. This has been extensively documented and analysed in relation to the informal sector in a wide range of countries. The International Labour Organization (ILO) report on Kenya (1972) was seminal in bringing this to light.

6. See Perez, 1983, and Lipietz, 1987, for discussion of this.

7. This is due to falling revenues as export incomes from commodities drop, and as deflationary structural adjustment policies reduce real incomes in developing countries.

8. See Blume, 1985, for a listing of 25 names in different languages, signifying both the wide incidence of its production as well as the localized and fragmented nature of its markets.

9. India, Pakistan, Columbia and China have the biggest non-centrifugal sectors. Total world production is about 13 per cent of centrifugal sugar production and takes about 20 per cent of total cane production.

10. In Tanzania, average capacity utilization is reported at 40 per cent; in Ghana, Hagelberg (1979) reported the figure to be 50 per cent; for Kenya see Part Three of this paper.

11. See ISO, 1982, for the prevalence of the problem in diverse areas.

12. Blume, 1985, p 187; some examples are: Haitian migrants in the Dominican Republic, Burundi migrants in Kenya and Indian migrants in Fiji before the break up of plantations.

13. Except where a deliberate policy of favouring consumption over production (as in Colombia) is implemented, and in mills subsidized by governments, as in Pakistan and Mexico.

14. See Part Three for the case studies for analysis of this issue. Thailand is the only example, to the best of my knowledge, where farmers are free to sell their cane to whichever mill they please.

15. The fact that VP mills pay for cane in three instalments over 15-18 months, while OPS mills pay fully in cash on supply, is obviously another reason that farmers prefer to deal with OPS mills.

16. Kaplinsky (1984, pp. 53-62) found that with the recent improvements in OPS technology, unit costs of production were less than those of VP plants in Northern India.

17. The co-operative milling sector, which accounts for about 50 per cent of total sugar production, is heavily subsidized. With equity capital from rich growers forming only 10 per cent, the rest is from state governments. Losses are thus subsidized through state finance, while farmers take their profits in higher cane prices (Chithela, 1985).

18. In some states there is, in addition, an ad valorem tax on khandsari production.

19. Odada (1986) does not define small farm size, presumably employing the size definition used by the Kenya Central Bureau of Statistics of less than 20 ha.

20. See Odada, 1986, p. 24: the evidence for negative returns to some farmers is on p. 62, Table 3.14.

21. See Odada, 1986, p. 60: during 1981-4 gross margins per ha ranged from 58.5 per cent (Miwani) to 43.4 per cent (Nzoia) of the gross value of the crop. Sugar Knowledge International Ltd. (1984) says the figure is as high as 90 per cent.

22. See Tribe, 1987, Table 11, which shows erratic movements in this deflated cane price index.

23. Both Lemmens and Makanda make this point.

24. And also by using historical equipment costs to calculate depreciation — see Kaplinsky, 1984.

25. While specific khandsari owners in India managed to bind growers to them through indebtedness, as we saw earlier, this did not fundamentally alter the pattern of farming. Rather, it was control of cane supply relative to other mills which was assured. With large-scale milling, the enforcement of contracts lasting several years, together with the sheer quantity of cane milled, has typically meant the subversion of the cropping pattern of entire districts.

REFERENCES

Allen, G., The Development of the Mumias Sugar Company, Kenya, Oxford Agrarian Studies, Vol. xii (1983).

Alpine, R., and Duguid, F., Economic Viability in African Conditions of the Small-Scale Open Pan Sugar Technology, mimeo (uncirculated).

Asian Productivity Organization, Sugar Cane Production and the Sugar Industries in Asia, Tokyo (1978).

Asian Productivity Organization, Sugar Cane Production in Asia, Tokyo (1980).

Baron, C. G., Sugar Processing Technologies in India, in Bhalla, A. S., Technology and Employment in Industry, ILO, Geneva (1985).

Blume, H., Geography of Sugar Cane: Environmental, Structural and Economical Aspects of Cane Sugar Production, Verlag Dr. Albert Barten, Berlin (1985).

Buch-Hansen, M., Agro-Industrial Production and Socio-Economic Development, Roskilde University Centre, Denmark (1980).

Burley, T. M.,

Sugar in the Arab World, in World Sugar Journal Directory (1984).

Chilvers, Lloyd, and Foster, Robin, The International Sugar Market: Prospects for the 1980s, Economist Intelligence

Unit (1981).

Chithela, I., *Origins of the Co-operative Sugar Industry in Maharashtra, in Economic and Political Weekly*, Vol. 20, No. 14 (April, 1985).

Commander, S., *Proto-Industrial Production as a Barrier to Industrialisation*, in *Economic and Political Weekly*, Vol. 20, No. 12 (March, 1985).

Commonwealth Secretariat, *The Challenge to Cane Sugar in the 1980s*, (1983).

Coote, B., *The Hunger Crop: Poverty in the Sugar Industry*, Oxfam (1987).

Economic and Political Weekly, *Sugar Crisis: Who Bears the Burden* (July 5, 1980).

Forsyth, D., *Appropriate Technology in Sugar Manufacturing*, in *World Development*, Vol. 5, No. 3 (1977).

Government of India, *Co-operative Sugar Directory and Yearbook* (1980).

Government of India, *Indian Sugar*, Vol. 31, No. 5 (1981), and Vol. 36, No. 6 (1986).

Government of India, *State Bank of India Monthly Review* (April, May and June, 1986).

Graham, E., and Floering, I., *The Modern Plantation in the Third World*, Croom Helm (1984).

Hagelberg, G., *Appropriate Technology in Sugar Manufacturing — A Rebuttal*, in *World Development*, Vol. 7, 8/9 (1979).

Hewson, K., *Capital in the Thai Countryside: the Sugar Industry, in Journal of Contemporary Asia*, Vol. 16, No. 1 (1986).

Hobhouse, H., *Seeds of Change* Sidgwick and Jackson (1985).

International Labour Organization, *Employment, Incomes and Equality in Kenya*, Geneva (1972).

International Sugar Council, *The World Sugar Economy Structure and Policies*, Vol. 1: *National Sugar Economies and Policies* (1963).

International Sugar Organization, *Annual Report* (1978-1985).

International Sugar Organization, *Yearbook* (1979-1985).

International Sugar Organization, *National Sugar Economies and Policies*, Vols. 1-4 (1982-3), and Vols. 1-10 (1976-1984).

Kaplinsky, R., *Sugar Processing: The Development of a Third World Technology*, ITDG Publications (1984).

Kenya Sugar Authority, *Policy Guidelines for the Development of the Sugar Industries* (1981).

Lichts, F. O., *International Sugar Economic Yearbook and Directory* (1983-1986).

Lichts, F. O., *International Sugar Report* (1976-1987), various.

Lichts, F. O., *New Processing Capacities in the World Sweetener Industry*, Part Two: *Sucrose* (1983).

Merhav, M., *Technological Dependence, Monopoly and Growth*, Pergamon Press (1969).

Messineo, J., *Thailand's Proverbial Sugar Problems*, in Sugar Y Azucar, (October, 1981).

Odada, J. E. O. (ed.), *Incentives for Increased Agricultural Production: A Case Study of Kenya's Sugar Industry*, Friedrich Ebert Foundation, Nairobi (1986).

Pineda-Ofrineo, R., *The Philippines Sugar Crisis in an International Setting, International Studies Institute*, Report No. 1, University of the Philippines (1985).

Piore, M., and Sabel, C. F., *The Second Industrial Divide: Possibilities for Prosperity*, Basic Books, New York (1984).

Sugar Knowledge International Ltd., *Kenya Sugar Industry: A Financial Comparison Between the Development Options for Sugar Factories in Western Kenya* (1984).

Tame, J., *The Efficiency of Sugar Marketing Systems in Sub-Saharan Africa*, Reading University (1986).

Tribe, M. A., *Choice of Technology for Agro-Industrial Projects, in Nigerian Journal of Rural Development and Co-operative Studies* (1986).

Tribe, M. A., *Sugar in Kenya and in the International Economy*, originally produced as part of the Open University's Third World Studies Summer School's *Mumias Activity Notes* (July, 1986).

Tribe, M. A., *Sugar in Kenya and in the International Economy*, unpublished (1987).

Tribe, M. A., and Alpine, R., *Economies of Scale in Cane Sugar Manufacturing in Less Developed Countries*, David Livingstone Institute of Development Studies, Discussion Paper No. 2, University of Strathclyde (1982).

Viton, A., *Prospects in Asia*, in Lichts, F. O., *International Sugar Report*, Vol. 119, No. 1 (1987).

Viton, A., *Sugar in India: Retrospect and Prospects*, in Lichts, F. O., International Sugar Report, Vol. 112, No. 22 (1980).

Viton, A., *Prices and Production*, in Lichts, F. O., *International Sugar Report*, Vol. 113, No. 10 (1981).

Viton, A., *The World Sugar Economy, 1990*, in Lichts, F. O., *International Sugar Economic Yearbook and Directory* (1985).

15

Policy and performance of the sugar industry in Kenya[1]

D. P. Nyongesa and J. I. Mbuthia

BACKGROUND

Practically all commercial sugar is derived from either sugar cane or sugar beet. Nevertheless, sugar cane remains the most important source of sugar supply in the world. Non-sucrose sweeteners such as high fructose corn syrup (HFCS), aspartame, dextrose, etc. are important substitutes, especially in developed countries, but so far pose no threat to Kenya's sugar production. Though the usage of these non-sucrose sweeteners may increase as the country becomes more industrialized, cane sugar is destined to continue to be the most important sweetener in Kenya for a long time to come.

Until early 1960s, the only significant development in the sugar industry was the establishment by private entrepreneurs of Miwani sugar factory in Nyanza and Ramisi sugar factory at the Coast in 1924 and 1927 respectively. Since Independence, five large-scale sugar factories have been established at Chemelil and Muhoroni in the Nyanza sugar belt, Mumias and Nzoia in the western sugar belt and South Nyanza Sugar Company at Awendo. The Government of Kenya and its state corporations own the controlling share capital of the five sugar companies. Apart from these factories, there are currently two small-scale open pan plants operating at West Kenya, near Kakamega, and at Yala in Nyanza province.

This paper attempts to outline the salient features of the government's policy on sugar and the performance of the sugar industry in Kenya. The probable outlook for the sugar industry is briefly analyzed.

SUGAR POLICY

The overall agricultural sector policy aims at increased food supply, growth in agricultural employment, expansion of agricultural exports, resource conservation, and poverty alleviation. Within this overall sector policy, the major objectives of Kenya's food policy are stated (Government of Kenya, 1981) to include:

○ maintaining a position of broad self-sufficiency in the main food-stuffs, in order to enable the nation to be fed without using scarce foreign exchange on food imports
○ achieving a calculated degree of security of food supply for each area of the country
○ ensuring that these foodstuffs are distributed in such a manner that every member of the population has a nutritionally adequate diet

Sugar is an important food item in the diet of the average Kenyan household. It accounts for a good part of total food expenditure of the average household, and more money is spent on it than any other single food items except for maize-meal, meat and milk.

Therefore, the government's objectives in sugar should be seen within the overall agricultural sector policy. Indeed, sugar policy aims at broad self-sufficiency in sugar production with moderate surplus, in good years, for export. The sugar industry has therefore to produce sugar to meet an ever-increasing demand, to provide for a growing population and industrial users. The development of the sugar industry is also seen as a major strategy in generating agricultural employment.

PERFORMANCE OF THE SUGAR INDUSTRY

Import substitution

Kenya has largely been a net importer of sugar. Up to the mid-1960s, there were only two privately owned and operated sugar factories at Miwani and Ramisi, producing about 35,000 tonnes annually. At the time our domestic demand for sugar stood at 105,000 tonnes a year, and therefore the country had to rely on substantial imports to satisfy local requirements for sugar.

In the post-Independence era, the country set itself on implementing the policy of self-sufficiency in sugar production. The strategy adopted to realise this policy goal was the establishment of new sugar factories with majority public ownership. As a result of this policy, five sugar factories were established between 1966 and 1980 — Muhoroni in 1966, Chemelil in 1968, Mumias in 1973, Nzoia in 1978, and South Nyanza (SONY) in 1980. Through these projects, sugar production increased nearly twelve times from 35,333 tonnes in 1964 to 401,239 tonnes in 1980. Production then declined to 308,019 tonnes in 1982, and has since increased to 365,796 tonnes in 1986.

While production has fluctuated over time, consumption of sugar has been steadily increasing, except for 1975 when there was a drop in consumption from 223,661 tonnes in 1974 to 195,294 tonnes in 1975. This decline in consumption came at the time when there was a boom in the world market prices, and Kenya had to increase substantially its consumer price for sugar. Table 1 shows production, consumption, imports and exports of sugar over the period 1964 to 1986. Kenya was able to move from a position of supplying only one-third of domestic requirements for sugar in 1964 to self-sufficiency in 1979, and even generated exportable surpluses during the years 1979 to 1981. The country has since then resorted to importation to meet its ever-increasing domestic demand for sugar. However, Kenya currently produces enough sugar to meet about 95-96 per cent of its domestic requirements.

The deteriorating performance of the industry during the 1980s that led to the country reverting to sugar importation has been mainly owing to inadequate supply of sugar cane which was caused by a combination of factors, including:

○ inadequate arrangements for crop financing
○ drought in 1980/81 and 1984
○ poor research efforts
○ lack of effective and co-ordinated extension services to farmers
○ inappropriate high costs of new investments and financial structures
○ high financial costs to sugar companies resulting from the devaluation of the Kenya Shilling, since some costs necessitate the expenditure of foreign exchange

Socio-economic objectives

Apart from the realization of self-sufficiency in sugar production, the other major considerations in the government's policy on sugar are employment generation, rural development, and revenue generation to meet other government social responsibilities.

Employment: Direct regular wage employment on sugar plantations and in sugar factories has grown from 14,350 in 1975 to 24,398 in 1983, representing an annual growth rate of 7.7 per cent. In addition, the sugar industry provides self-employment to about 65,000 small-scale growers who supply the larger proportion of sugar cane required by the sugar factories. The industry also provides employment to unskilled labour for planting, weeding, fertilizer application, cane harvesting, loading, etc.

Rural development: The national development objectives stress rural development as a strategy that would lead to increased rural production and incomes, increased equity in the distribution of incomes generated, and increased access to services and participation in decision-making at the district level. In this regard, the sugar industry has performed admirably. Where sugar projects have been established, other socio-economic services have sprung up, eg. better housing, schools, health services, postal and telecommunication facilities, sports and recreation facilities. Access roads have also been constructed to facilitate transportation of sugar cane, inputs and other goods in cane growing areas, thereby improving mobility in the rural areas.

Revenue generation: Government levies an excise duty on sugar. The excise revenue raised has increased from about K£5.67 million in 1976 to K£16.81 million in 1984. The only other significant commodities on which Government raised excise revenue were beer and cigarettes. Thus the industry contributes substantially to government revenues.

Table 1: Sugar production, consumption, imports and exports, 1964-1986 (tonnes)

Year	Production	Consumption	Imports	Exports	Production % consumption
1964	35,333	105,126	n.a.	Nil	33.6
1965	29,085	112,261	n.a.	Nil	25.9
1966	36,611	131,822	105,761	Nil	27.8
1967	65,611	131,818	42,893	Nil	49.8
1968	88,415	143,924	58,260	Nil	61.4
1969	134,755	153,401	28,513	Nil	81.3
1970	125,156	162,375	38,672	Nil	77.1
1971	124,073	183,062	72,121	Nil	67.8
1972	92,284	194,612	113,617	Nil	47.4
1973	137,932	217,462	76,016	Nil	63.4
1974	164,308	223,661	81,814	Nil	73.5
1975	159,607	195,294	10,722	Nil	81.7
1976	167,124	197,015	31,815	Nil	84.8
1977	180,410	223,198	33,681	Nil	80.8
1978	236,276	251,186	44,495	Nil	94.1
1979	296,586	253,413	10,983	1,983	117.0
1980	401,239	299,514	1,488	94,674	134.0
1981	368,970	324,054	Nil	69,054	113.9
1982	308,019	328,236	Nil	18,200	93.8
1983	326,329	332,973	Nil	3,880	98.0
1984	372,114	348,678	4,000	4,001	106.7
1985	345,641	365,694	43,000	Nil	94.5
1986	365,796	381,394	142,000	Nil	95.9

Source: Kenya Sugar Authority, Annual Statistical Series.

STRATEGY FOR SUSTAINED SELF-SUFFICIENCY IN SUGAR

Demand for sugar in Kenya will continue to grow, partly as a result of increasing population, and partly due to growth in per capita income. The national growth targets for the period to the year 2000 indicate that population will increase by 3.7 per cent and per capita income by 1.8 per cent (Government of Kenya, 1986). The per capita consumption of sugar has been increasing steadily. It was 15.4 kg in 1977, and increased to 18.0 kg by 1986. This per capita consumption is still low compared to the average world per capita consumption of 20.1 kg in 1974/76 (International Bank for Reconstruction and Development, 1987).

Projections by the Kenya Sugar Authority (KSA) indicate that the per capita consumption could increase to 18.8 kg by 1995. On the basis of projected population, domestic demand for sugar will grow from 381,394 tonnes in 1986 to 455,157 tonnes in 1990, 573,814 tonnes in 1995 and 705,094 tonnes by the year 2000. The implications of these projections are that sugar production will almost have to double during the next thirteen years for the country to remain self-reliant in sugar. In the remaining part of this section, the programmes being designed to ensure sustained self-sufficiency in sugar production are outlined.

Rehabilitation/expansion of existing factories

Several of the existing factories are undergoing rehabilitation and expansion of their capacities. These programmes entail capacity rehabilitation and expansion, and the development of sugar cane fields and basic infrastructure. The major rehabilitation/expansion programmes already approved for implementation cover Muhoroni, Nzoia, SONY and Miwani.

Expansion plans for Chemelil and Ramisi are being finalized, and their implementation will be considered thereafter. No further expansion plans are envisaged for our biggest factory, Mumias, because the project covers a very large area; thus the cost of sugar cane transportation is high.

When these rehabilitation/expansion programmes are completed, the maximum potential production of sugar will increase to 527,000 tonnes per year. This level of production assumes efficient utilization of installed capacity at modernized and improved technology levels. Further factory expansions beyond

the planned capacities would be limited at Chemelil, Muhoroni, and possibly Miwani, owing to lack of available land for cane development. Marginal expansion of the Nzoia and SONY factory capacities would still be a possibility beyond the current planned rehabilitation and expansion programmes.

New sugar projects

Even with the implementation of the rehabilitation and expansion programmes, new projects would need to be considered by the year 2000 to provide additional sugar to meet increasing domestic demand. Several potential areas for large-scale sugar factories have already been identified. A study commissioned by the Ministry of Agriculture in small-scale sugar production concluded that it was economically possible and desirable for Kenya to develop small-scale sugar production as a complementary, rather than an alternative, strategy to the large-scale production programme, but financially unattractive at the current producer prices (Agro-Invest (East Africa) Ltd., 1976).

The consultants found that the small-scale vacuum plants were financially more attractive than the open pan plants. Nevertheless, potential areas for both open pan and vacuum pan plants were identified. Although small-scale sugar plants contribute an insignificant proportion to our total sugar supply, their future viability will be examined in order to determine whether or not they can be expected to complement production from large/medium-sized factories.

Pricing policy

To ensure the viability of the sugar industry, government reviews annually the producer prices for cane and sugar as required under the Agriculture Act (Cap. 318). The following criteria are taken into account in the review of producer prices:

○ net returns to sugar cane farmers should be competitive with other alternative crops
○ the ex-factory price for sugar should be set at a level that will enable an efficiently run factory to earn a given return, currently set at 15 per cent on equity capital

In pursuing this policy, the government has reviewed producer prices and set trade margins annually, as shown in Table 2.

The price paid to sugar cane growers increased at a higher rate, owing to the fact that most of the sugar factories were operating under capacity, and therefore the government's major concern was to give the farmer an incentive to produce more cane.

Sugar research

Our National Sugar Research Station continues to work under budgetary and staff constraints. As a result, very little work on generation of research findings is ongoing. Consequently the industry is starved of new research packages. Since research is the basis of the industry's future, it is hoped that the Sugar Research Station will be reconstituted into a National Sugar Research Foundation to give it a broader outlook and financing. Such a financing requirement would be shared between the government and the sugar industry.

Table 2 (KSh/tonne)

Effective date	Cane price	Ex-factory price	Consumer price
April 1981	150.00	3,075.00	4,850.00
December 1981	170.00	3,600.00	5,750.00
January 1983	227.00	4,290.00	6,300.00
February 1984	250.00	4,773.00	6,900.00
January 1985	270.00	4,986.00	7,200.00
February 1986	300.00	5,263.00	7,550.00
February 1987	341.00	5,830.00	8,151.00

Overall industry management

The management of the industry is co-ordinated by the two Ministries of Agriculture and Commerce. Whereas the Ministry of Agriculture is responsible for production, the Ministry of Commerce is responsible for marketing and distribution. KSA, a parastatal under the Ministry of Agriculture, is

responsible for promoting and fostering the development of the sugar industry. On the other hand, the Kenya National Trading Corporation is an agent of the Ministry of Commerce responsible for distribution of sugar within the country.

In order effectively to co-ordinate and monitor the development of the sugar industry for sustained self-sufficiency, KSA would need to be strengthened and granted enough powers and authority to plan, co-ordinate and monitor the implementation of government-approved projects and programmes.

Notes

1. Views expressed by the authors in this paper do not necessarily represent the views of the organizations for which they work.

REFERENCES

Agro-Invest (East Africa) Ltd., *Small-Scale Sugar Production in Kenya*, 1976.

Government of Kenya, *National Food Policy*, Government Printer, 1981.

Government of Kenya, *Sessional Paper on Economic Management for Renewed Growth*, No. 1, Government Printer, 1986.

International Bank for Reconstruction and Development, *The World Sugar Economy Review and Outlook for Bank Group Lending, 1978.*

16

The future of small-scale sugar processing in Tanzania

W. A. Mlaki

SUGAR SUPPLY AND DEMAND IN TANZANIA

The sugar industry in Tanzania: Production *versus* demand

There are five sugar processing factories in Tanzania. Their total installed capacity is 220,000 tonnes and is distributed as shown in Table 1.

Table 1: Distribution of installed capacity in Tanzania

Company	Installed capacity (tonnes)	Location
Tanganyika Planting Co. Ltd.	64,000	N. East (Kilimanjaro Region)
Kilombero Sugar Co.	76,000	East (Morogoro Region)
Mtibwa Sugar Estate	34,000	East (Morogoro Region)
Kagera Sugar Ltd.	56,000	N. West (Kagera Region)
Total	220,000	

The factories are operating at an average of 46 per cent of their installed capacity, thus producing about 101,000 tonnes annually.

Consumption per capita has decreased over the last few years and has now reached the level of approximately 4 kg per capita from 9 kg in 1978/79 (see Appendix IV).

The demand for sugar in the country has been estimated from two approaches:

According to estimated per capita consumption: It is estimated that the per capita demand is 7 kg, and it may grow to 8 kg in 1990. Under this assumption the estimated demand is 154,000 tonnes (population 22 million), and is projected to reach 200,000 tonnes in 1990 taking the population growth rate of 3.3 per cent. If the per capita consumption of 10 kg is aimed at, as is average now with most African countries, or 15 kg, as is the case in South East Asia, the supply falls very much below demand (see Appendix IV).

According to assessed regional demand: The Sugar Development Corporation undertook a survey of the demand for sugar in the country by region (see Appendix IV). The aggregate demand for sugar is currently estimated to be about 325,623 tonnes.

174

As indicated in the tables, the supply is unevenly distributed among regions. Owing to transportation and distribution problems, there is an acute shortage of sugar supply in rural areas and towns which are distant from Dar es Salaam.

Causes of low supply of sugar in Tanzania

The causes of low supply of sugar in Tanzania are:

○ low production of sugar in the existing factories. The low capacity utilisation is caused by:
○ old and worn out equipment and machinery whose spare parts have to be imported
○ unskilled management for sugar cane estate/factory complex
○ inadequate and expensive transport and distribution system of sugar from factories to consumers
○ lack of foreign exchange for importing sugar

OPTIONS FOR INCREASING THE SUPPLY OF SUGAR

Importation of sugar

This option is not possible now due to scarcity of foreign exchange. Because of the shortage of foreign exchange, less sugar was imported during the last two years. Besides the foreign exchange problems, this option does not solve the problems of transportation and distribution.

Construction of new factories

Investments in new factories will require a high amount of foreign exchange. This option is also difficult to attain at the moment because of the economic problems that will continue for some years.

Rehabilitating the existing factories to near full capacity

According to the Sugar Development Corporation's estimates on supply and demand of sugar in the country, sugar supply would satisfy only 68 per cent of the demand. If it were possible to operate at 100 per cent capacity, there would still be a supply of gap of 105,623 tonnes.

However, to utilize 100 per cent of the capacity requires major rehabilitation of the estates and factories as well as completion of the Kagera project; an exercise estimated to cost a total of about TSh 5,433 million in foreign exchange (over US $75mill.). It is not considered feasible at the moment to carry out such heavy investments.

It has therefore been decided to concentrate efforts on maintaining sugar production at present levels and on preventing further deterioration of facilities, and, where possible, to bring about gradual improvement.

Promotion of alternative sugar processing methods

The manufacture of sugar may generally be divided into five major processes or stages:

○ extraction of juice from sugar cane
○ clarification of the juice
○ evaporation and concentration of the juice into what is called massecuite
○ formation of crystals and separation of these crystals from massecuite to obtain the final product — sugar and a by-product (molasses)
○ drying of the final product

The promotion of alternative sugar producing methods implies in our case the production of sugar in small plants.

Small-scale sugar production involves production of smaller quantities of sugar compared with normal factories, because the equipment used is modified or simplified or some stages may be completely omitted.

Three different types of small-scale sugar production process can be distinguished: mini-plants, jaggery plants (sukari guru) and open pan sulphitation or khandsari plants.

The following are implications in the choice of type of small-scale plants intrinsic of their technology:

Mini-plants: Mini-plants (ie. small vacuum pan plants) are exactly the same as large plants, the only

difference being that they are of smaller capacity. These plants range from 150 to 800 tonnes cane per day, producing between 2,250 and 13,000 tonnes of sugar per annum. The most common size is 250-350 tonnes of cane per day, producing 5,000-9,750 tonnes of sugar a year depending on the production season.

An example of such plants can be found in Zanzibar Mahonda Factory, the Old Mtibwa Factory and the Old Kagera Factory.

Mini-plants are comparatively expensive, since everything is the same as in large factory except for size. The investment cost per tonne of sugar is very high. An average mini-plant of 350 tonnes cane per day, producing about 9,750 tonnes of sugar in 150 days of 24 hours, is estimated to cost US $7.5 million turn key, resulting in investment cost of US $1,420 per tonne of sugar.

Operation and maintenance are the same as in a large factory. It therefore requires the same type of personnel (engineers, technologists, etc). Due to the lower production, utility of experts is very low and cost of experts per tonne of sugar produced would be rather high.

The equipment and process being the same as in large factories, operation and maintenance will rely heavily on imports (equipment, spares and chemicals).

In conclusion, mini-plants under Tanzanian conditions will be adversely affected by exactly the same constraints affecting large factories, namely lack of foreign exchange for operation and inadequate skilled personnel to operate and maintain the plant. To propagate the mini-plant technology would simply mean multiplying existing constraints facing the sugar industry.

Jaggery plants: There are about fifty registered jaggery plants in Tanzania. The following brief model project is for a jaggery mill in Tanzania of a cane crushing capacity of one tonne per hour, based on a 150-day working year, and operating at one shift (8-10 hours).

At this rate of production (giving about 135 tonnes of jaggery per year), a total of approximately 1,200 tonnes of cane are required. It is known that smallholder cane farms yield 40-50 tonnes of cane per hectare, therefore the total area required would be 24-30 hectares. This cultivated area is quite feasible in several parts of the country.

Capacity expenditure is low and usually comprises buildings which can be one closed shed (low-cost, using clay bricks) for housing the diesel engine, cane crushers and juice tank.

There are open sheds for evaporation pan, moulds, storage space and piping. Imported machinery and equipment are cane crushers and diesel.

The popularity of these plants indicates that they are potentially financially viable.

The technological **advantages** of jaggery production include:
○ The technology is simple and involves no more than crushing cane to get out the juice and boiling the juice.
○ Investment is low, depending on the size of the crushers. Jaggery plants do not seem to respond to economies of scale within wide ranges of capacities. Production can be economical from a few hundred kg per day to a few tonnes per day.
○ The equipment involved for production of jaggery is simple and some can be made or assembled in the country, eg. crushers, motors, pans, etc.
○ The skill involved in making jaggery is elementary and is within the capacity of an average peasant.
○ Operation and maintenance of the equipment involved are not complicated, and are within the capability of an average village mechanic.

The **disadvantages** of promoting jaggery technology are:
○ Jaggery plants do not produce crystal sugar but a form of brown fondant. It has a strong taste of molasses and will therefore not be suitable for use as a sweetener in coffee or tea. Only for specific purpose can it be considered as a substitute for sugar. Even in a situation of scarcity it is not seen by the local population as a substitute for sugar. There are no studies available with regard to the demand for jaggery. It seems to be used mostly for local brewing and sometimes as a sweetener in porridge.
○ Juice boiling consumes a lot of fuel. In most areas of Tanzania wood is used as a fuel. The danger connected with jaggery production is therefore a potential deforestation problem akin to that of the tobacco industry.
○ The product requires careful handling to avoid health hazards.

Open pan small sugar plants (khandsari plants): The end product from a khandsari plant is normal white sugar. There is one khandsari plant in operation in Tanzania. It belongs to the Prisons Department. Another khandsari plant is under implementation. It belongs to the District Development Corporation of Kilosa, Morogoro Region.

It is not possible to obtain the data on operational costs of the operating plant because it is not operating on a commercial basis. Because of its ownership the plant does not suffer from what is seen

RODNEY KING
34 ARLINGTON AVE.
LEAMINGTON SPA.
CV32 5UD.

Printed in England © J. SALMON LTD., SEVENOAKS, KENT. TEL: [01732] 452381.

27.1.97

Dear Rodney
A very happy new year
to you ! Thanks for
your Christmas card +
last letter — we will
book in time to make +
deliver a summerhouse
hopefully before Easter —
will ring to make
arrangements with HRRA when not so
washed off our feet !—
best wishes to you & the family, Adele & Andy

Ironbridge, Shropshire
2 - 22 - 06 - 16

Ironbridge

as one of the main disadvantgages of this type of production, ie. the labour intensity of the production process.

The major technological difference between large plants and the khandsari plants are: no sophisticated cane preparation in khandsari plants, fewer mills and rollers in the milling section, a simpler system of clarification, open pans instead of evaporators and vacuum pans at the evaporation and concentration stage. In khandsari plants, expensive items like boilers, turbines and turbo generators are eliminated.

The result is that a khandsari plant consists of simple equipment which is simple to operate.

This has the following **advantages:**

○ The equipment could be fabricated locally — for example at National Engineering Company, Mang'ula Mechanical Machine Tools Manufacture Company — thereby saving on foreign exchange.

○ Investment cost is comparatively low when compared to mini-plants and could be within the country's present and immediate future ability. A khandsari plant of 100-150 tonnes cane per day, which can produce about 1,000-1,500 tonnes of sugar in 150 days of 24 hours, will cost about US $950,000 turn key. The investment cost per tonne is therefore between US $633 and US $950.

○ Operation and maintenance of the plant would not require the high levels of skill needed in large factories because the level of automation is lower.

○ As plant and equipment lend themselves to a possible high degree of local manufacture or fabrication, long-term dependence on imports could be minimised.

The technological **disadvantages** of khandsari plants are:

○ The absence of automation dictates that many operations are done manually. Also, due to the simplicity of the equipment, there are various sugar losses during the process. Overall, in large plants 10 per cent of cane can be expected to be recovered (ie. 10 tonnes of cane = 1 tonne of sugar), while in khandsari plants the overall recovery would be 6-7 per cent. The combination of higher labour requirements and lower sugar yields from cane make the unit cost of producing sugar using khandsari plants higher than in large plants. It is estimated that the unit production cost in khandsari plants is higher than in large plants operating at full capacity by about 42 per cent.

○ In large plants the bagasse is burnt in boilers to provide steam which is used for processing and also for driving turbines and generation of electricity for various mechanical drives, lighting, etc. Large factories are therefore self-supporting in terms of energy/fuel. In khandsari plants the bagasse is used only for boiling. Mechanical drives depend on external sources of energy — either electricity from a generating set or from the national grid.

○ A khandsari plant, though simple to operate when compared to large plants, is nonetheless above the technical skills and managerial capacity available in the rural areas of Tanzania.

17

Incentives for increased cane production: Critical policy considerations for Kenya's sugar industry[1]

Maurice Awiti[2]

During the post-Independence period, production of sugar cane in Kenya grew very rapidly, leading to self-sufficiency by 1979. Self-sufficiency was, however, short-lived, and Kenya started importing sugar again in 1984.

This development posed two important questions: What factors have prevented Kenya from sustaining the self-sufficiency objective? Does the organizational structure of the sugar industry provide sufficient incentives for all parties involved in the industry to achieve this goal? A third question is whether the industry has created significant socio-economic benefits for the country's rural economy.

Incentives for Increased Agricultural Production is the result of an attempt by six researchers to find answers to these and other issues in the industry. This paper provides the highlights of the study and the major recommendations which resulted.

An assessment is made of the production performance of the sugar industry, in terms of it fulfilling its self-sufficiency and foreign exchange savings objectives. Trends in the world market for sugar are surveyed and some economic, technological and institutional developments that potentially pose challenges and opportunities for Kenya's sugar industry are identified.

The progress the country has made to achieve self-sufficiency in sugar requirements has been commendable — over 90 per cent self-sufficiency in every year since 1978, as shown in Table 1. In view of the uncertain world sugar market potential, the basic policy recommendation for Kenya is to gear its efforts towards self-sufficiency rather than towards an aggressive export oriented programme. Further, it is recommended that the price of cane be increased to encourage its cultivation.

Table 1: Self-sufficiency in Kenya's sugar requirements

Year	% self-sufficiency achieved
1978	92.0
1979	116.9
1980	129.4
1981	100.3
1982	101.4
1983	97.6
1984	97.6

The issue of foreign exchange is analyzed. Kenya is a marginal country with respect to world sugar production, not being dominant in either exports or imports. She imports all her large-scale sugar processing plant machinery and spare parts. Hence there is much foreign exchange used in sugar production in Kenya. The study estimates that between 40 and 60 per cent of production costs are foreign exchange costs. Given the relationship between exchange rates, the ex-factory price of sugar in Kenya and world sugar market prices, it is determined that purely on the basis of saving foreign exchange Kenya may have been losing over the last few years. However, given the large fluctuations in both the exchange rate and the world sugar prices, it is probably safer for Kenya to continue pursuing the self-sufficiency objective because she would find it impossible to switch overnight from importing sugar to producing enough for domestic consumption, should the exchange rate for the Kenya Shilling fall or the price of sugar increase.

Furthermore, the development of the sugar industry is in line with the general development objectives of the Government. These objectives include creation of employment opportunities, establishment of labour intensive industries, and development of rural based industries to curb rural-urban migration.

The organizational structure of the sugar industry in Kenya involves various categories of cane farmers, and different ownership and management arrangements for the sugar processing factories. Sugar cane is grown either in nucleus estates (plantations) or by outgrowers. Nucleus estates are owned by the factories, while outgrowers consist of large-scale farmers, small-scale farmers, co-operatives and settlement schemes. Most of the sugar cane comes from outgrowers. Two of the factories are owned and managed by private companies, while the rest have the government as the dominant shareholder.

Full utilization of the sugar industry's rated capacity has not been realized. The existing factories have a combined capacity to produce about 500,000 tonnes of sugar per year, which is considered enough sugar for domestic consumption up to the year 1990. The under-utilization of capacity is due to cane shortage, and this has something to do with the organization, structure and management of the industry.

Major recommendations here include strengthening farmers' organizations (outgrowers' companies and the co-operative unions) in order to improve their performance, and establishing a well co-ordinated and reliable way of financing cane development to supply the factories adequately. There is evidence of duplication of functions in the industry, eg. the distribution of sugar is the responsibility of the Ministry of Commerce and the Kenya National Trading Corporation. Distribution and storage should be left to one efficient, parastatal organization. It is recommended that the Kenya Sugar Authority be vested with more exective powers, autonomy and facilities to enable it to control and co-ordinate the activities of the industry more effectively. The sugar research station at Kibos needs immediate strengthening and reorganization.

A detailed description is presented of the process of sugar cane production (including geo-physical and climatic factors, soil preparation and crop husbandry), sugar milling processes, and pricing and costing at all stages of production and distribution.

The relative profitability of sugar cane production from the farmer's perspective and the extent of the trade-off between sugar cane and food production within the sugar schemes in Western Kenya are analyzed. Several important recommendations are given on how Kenya could attain a reasonable degree of self-sufficiency in sugar production without worsening food availability in the sugar growing regions. Transportation is found to be the biggest cost item and farmers far away from the factory should be discouraged from producing sugar cane.

The issue of sugar cane financing features here again. There is no point in building factories if a continuous flow of cane is not guaranteed. Recommendations to ensure a satisfactory flow of cane include the following: Farmers must be rewarded adequately and on time. Payments must be prompt (thirty days, according to the Outgrowers' Agreement), and the farmer's margin should be comparable with other crops which can be produced in the area. All sugar companies should have a deliberate food production programme for their respective zones. In short, the Government should ensure that sugar cane production is profitable to the farmer and that it does not have a negative impact on the nutrition of the farmer's family. The farmer should be the principal beneficiary in sugar production.

The significance of the industry in the domain of provision of employment opportunities and as a source of income for a sizeable number of the Kenyan labour force and their dependents is illustrated. The role of the industry as a source of revenue to the Government is also examined, as are the various uses of sugar cane by-products, eg. molasses. Some of the negative contributions of the sugar industry are described, eg. the sorry state of the evicted families who had to make room for the creation of nucleus estates, and the unbalanced relationship between the outgrowers and the sugar companies through the Outgrowers' Cane Agreement. It is noted that parts of the Agreement are violated by the companies.

Notes

1. Editors' note: This paper is a summary of the book Incentives for Increased Agricultural Production: A Case Study of Kenya's Sugar Industry by J. E. O. Odada, C. M. Manundu, W. E. O. Ochoro, L. M. Awiti, D. W. Makanda and R. M. Kabando, published by the Friedrich Ebert Foundation, P. O. Box 48143, Nairobi, Kenya. It is neither possible to print the contents in full here, nor to do justice to the issues it raises, in this short summary. Instead, the major areas of debate are identified and significant recommendations noted. It is hoped that readers interested in pursuing the subject will refer to the original text.

2. The views expressed by the author in this paper do not necessarily represent the views of the organization with which the author is associated.

SECTION G

CONCLUSIONS

18

Small-scale cane sugar processing: The way forward

Raphael Kaplinsky

OPEN PAN SULPHITATION TECHNOLOGY: THE STATE OF OUR KNOWLEDGE

Open pan sulphitation (OPS) technology exists, and it does so in large quantity in the Indian sub-continent. A modified form of open pan processing also finds widespread application in Colombia. The reasons for this real-world viability reflect a number of factors, including the following: the peculiarities of different product markets (in Colombia, panela is the main product), the so-called 'biases' in factor prices and state-intervention in India, and the relative factor prices and factor availabilities.[1] Yet the fact that OPS seems to travel well in at least one case — the West Kenya Sugar Company (WKS) — raises the possibility that it has a wider role to play elsewhere in Kenya, as well as in other cane sugar producing countries.

In large part the function of this conference on the viability of small-scale sugar technologies has been to explore this issue, as well as to raise the possibility that other small-scale alternatives — such as diffusion or simple scaled-down vacuum pan (VP) technology — may be worthy of investigation. In reviewing the evidence which was presented and the discussions which ensued, it is helpful to begin with the framework which Jones has set out in the opening contribution. In this he distinguished between the technical, the financial, the economic and the social. After reviewing the evidence within this framework, we will then proceed to discuss the policy implications, both for governments and for non-government organisations (NGOs) such as ITDG.

Technical factors

Open pan sulphitation (OPS) technology operates under the shadow of the dominant VP alternative. For reasons which will be discussed, the VP technology has significant inherent scale economies which are such that when these large plants operate at full capacity, OPS technology will find it very difficult to compete. It is important, therefore, to distinguish between the importance of factors of scale in both OPS and VP, as well as in regard to the relative capacity performance of each of these technologies.

Scale and VP technology: Chemical engineers have come to apply a rule of thumb — the 0.6 rule — to prejudge the capital costs of increasing scale. This assumes that for a doubling of capacity, unit capital costs only increase by around two-thirds.[2] This ratio is the same as that between circumference and volume, and suggests that the volumetric nature of much of sugar processing technology is reflected in capital costs in this proportion. In fact, as both the contributions of Tribe and Bush point out, it is not merely capital costs that decrease with scale, but also some variable costs such as energy.

Working on the basis of these costings, Tribe calculates that the optimum scale for VP processing is between 5,000 tcd and 10,000 tcd. Certainly, in comparison to smaller VP plants — that is, between 1,000 tcd and 2,500 tcd — a well-functioning large VP mill suggests significantly lower unit processing costs; if anything, the extent of cost advantage will be even greater in comparison to the much smaller OPS plants. The issue, then, is what are the implications of a poorly-run VP mill running at less than full capacity?

Tribe's analysis provides a counter-intuitive conclusion, namely that a small VP plant running at the same rate of under-utilization as a large plant suffers a disproportionately large penalty on unit costs. This is precisely because of the scale economies inherent in production technology, since fixed costs are a higher proportion of unit costs for small plants. The logic thus seems to reinforce the optimality of very large-scale processing plants.

Yet, quite clearly, very large scale is not always optimal.[3] There are in fact four sets of circumstances in which it will not pay to utilize VP technology at its optimal large scale. First, the market may not be big enough to justify large-scale production, but is sited with sufficient distance from 'efficient'

large-scale producers that transport costs rule out cheap imports or competitive exports. The second is that the managerial implications inherent in operating large- scale plants are such that the greater the scale, the more likely sub-optimal capacity utilization will result. As Moody-Stuart points out, the logistics can often be very complex—a 20,000 tcd plant will involve delivery by a 10-tonne truck every 45 seconds, round the clock. Unfortunately no data is available which systematically relates scale to capacity utilization, but it need not matter whether this relationship exists one way or the other as a general rule; if a pattern occurs in particular and relatively predictable situations, the import will be the same for policy-makers. For example, if experience suggests that larger plants are relatively more difficult to operate at full-scale in African or irrigated conditions, then the policy implications may be reasonably clear.

A third reason why large-scale VP may not be the most sensible choice relates to the supply of cane. Here it is possible that, under certain conditions, it is more difficult to ensure very large quantities of sugar cane on a regular basis, and this would obviously affect the larger plants disproportionately. A number of possible scenarios come to mind: rain-fed cane production in ecological regions of great variability, unstable pricing regimes which lead farmers to move in and out of alternative crops, land scarcity which induces farmers to limit the amount of cane grown,[4] the increasing degradation of soil, agricultural policy which forces production away from predictable factory estates to peasant-farmer smallholder production, and so on.

Fourthly, and most contentiously, it is possible that the other non-technical factors associated with scale ('non-intrinsic factors' in Tribe) are adverse to large-scale plants. Tribe argues the opposite — he believes, for example, that skilled labour costs also experience scale economies. But the problems are very complex. In some cases, the results may be ambiguous. Consider the case of infrastructure: small plants may be able to utilize existing roads; large plants, as in Western Kenya, may require new roads to be constructed. But these new roads may also generate external economies to other farmers and other crops. So are they a disproportionate cost or an ancillary benefit of scale? Similarly, the costs of outgrower schemes may increase with scale, but, at the same time, improved growing practices have positive spin-offs for other crops. Other types of costs may be less ambiguous. Here the most obvious case is that of transport, since the catchment area for a very large plant (especially if it is government policy that smallholders only devote a fraction of their land to cane) may be enormous and much larger per unit of output than for a series of small plants.[5]

Again we are left with difficulties of generalization. Some of these factors occur across all environments, such as the higher unit cane-transport costs of larger plants. Others occur in particular circumstances; but these may vary. Countries which experience small markets may have extensive land, or new roads may also have to be constructed for smaller plants. So, as Hagelberg points out, whilst large VP plants may in general be the most preferred form of production, there may be a range of circumstances in which the larger the plant, the greater the difficulty of ensuring full capacity production. It is this which gives the scope for small-scale processing technologies.

Small-scale OPS technology: Three variants of small-scale technology present themselves as alternatives. The first of these is a scaled-down VP plant, perhaps avoiding some of the costly mechanization of the past five decades. The idea here would be to reconstruct a 1920s vintage VP plant, perhaps operating at 800 tcd. The problem with this idea is that it merely represents a hunch, a possibility for action. No examples are available for inspection, and the experiment might prove to be a costly failure. In a situation in which the sugar industry was expanding internationally, it might be worthwhile to explore this option; although the probable cost involved is such that only a large trans-national corporation (TNC) could afford the risk. However, as the contribution by Goodwin makes clear, the outlook on the long-term balance between supply and demand, and therefore on prices, is such that there is little prospect of such an initiative.

A second possibility is that of small-scale diffusion, where working examples are in fact in operation. One recent investment in Bangladesh utilizes this technology, but the mechanism of technology transfer utilized—a grant by the Danish government—has led to a 'gold-plated' plant which would show up adversely in cost calculations.[6] Nevertheless, small-scale diffusers are technically viable, are in operation, and are perhaps worthy of pre-feasibility study, although the cost prognoses do not look too attractive.

The third variant of small-scale sugar technology is OPS. Here, as McChesney and Patel show, a number of conclusions are evident. First, a well-functioning plant is operating profitably (despite the unfavourable pricing regime which has led all but one of the larger VP mills to run at a loss) in Kenya. Second, the new shell furnaces operate effectively, allow for wet bagasse burning (which means that the plant can run through the rainy season), and save labour which was previously utilized for drying bagasse. Third, the screw expeller has been shown to increase juice extraction significantly; however, it consumes more energy than crushing mills. Fourth, even the most efficient OPS plants run at an energy deficit which has to be made up by a combination of wood (for the furnaces) and electricity/diesel

motors for the crushing and centrifuging. Fifth, much scope exists for further improvement—in part in the general control of the boiling and crystalizing processes (which would increase sugar recovery), and also with regard to fuel utilization (for example, in feeding the furnace).

Two additional factors arise as problems which are specific to individual countries. The first is that OPS makes heavy demands on specific types of skills (per unit of output), notably in relation to managerial and supervisory staff and with respect to the *kharigars* who control the critical boiling operation. Such skills are much less constrained in India than in other countries, such as Kenya.[7] Secondly, there is not yet much experience on scale economies within OPS.

Certainly these exist in the step from 100 tcd to 200 tcd, but there is no substantial 'feel' for the scale at which these economies are exhausted. In particular, at what scale of output will it make sense for a small-scale OPS plant to upgrade its boiling process into a small-scale vacuum pan, and would the costs of this upgrading be excessive?

Financial factors

The facts are that there are a large number of OPS plants in operation in India (well over 1,000 in Uttar Pradesh alone), that a variant of OPS continues to flourish in Colombia, and that a single modern plant has proved itself viable in Western Kenya. Whilst suggestive of the private profitability of OPS technology, this evidence alone cannot be used to 'prove' the financial attractiveness of OPS in relation to VP. This is because the price and legislative structure encountered by sugar producers is influenced by a series of factors which 'distort prices'—not only in the sense that prices no longer represent 'opportunity costs', but that different types of producers face different prices, different decision criteria, and different legal encumbrances.

Consider, for example, the case of India. There a whole series of regulations constrain sugar production. Some are legal regulations (prices paid to cane farmers, controls on the proportion of sugar sold on the 'free market'), others reflect decision criteria by planners (who for many years confined VP mills to an average size of 1,250 tcd, well below the optimal scale identified in the previous section). Large-scale plants are also more carefully policed with respect to the Factories Act, and also generally have to pay higher wages than OPS factories. Many of these factors tend to inflate the relative costs of the large-scale VP mills, and are believed by some commentators to explain the survival of what they consider to be an inherently unprofitable small-scale technology. However, other factors intervene which throw doubt on this analysis. Most of the large-scale mills either run at a loss (many are owned by state governments or co-operatives), or depreciate on unrealistically low historic costs.[8] At any rate, merely by focusing on declared profits there is no way of understanding either the existence of most VP mills (which run at a loss), the large numbers of OPS mills, or the decline in the number of these OPS plants in recent years.[9]

The Kenyan situation is less complex, with the industry relatively free from the myriad detailed production regulations which govern sugar production in India. However, as Makanda points out, cane prices, processing margins and various tiers of distributor margins are set by the government and continue to limit profitability in milling. In fact, only one VP mill—the Mumias plant—runs at a book profit, although were it to depreciate at replacement rather than historic costs, the level of this profit would be significantly lower. The OPS plant in Western Kenya does, however, also run at a profit; but it is likely that this would be much lower (perhaps even recording a loss) if it paid the same price for labour as the large-scale mills do, or if it paid the various government distributors' margins. (On the other hand, the large-scale VP mills almost certainly obtain capital on more favourable terms, and most do not actually pay the excise tax—which is greater than the distributor's margins—for which they are liable).

Some other form of analysis therefore has to be undertaken to determine whether OPS plants are profitable, and therefore whether they justify investment by private entrepreneurs. Mallorie attempts an ex ante simulation under Kenyan prices, and draws two major conclusions. The first is that given the prices which the government has set for various stages of the sugar cycle, neither OPS nor VP mills are capable of repaying their costs using a 10 per cent discount rate.[10] The second conclusion he draws is that whilst OPS mills are slightly more unprofitable than their VP counterparts, the 'calculations lack sufficient precision to conclude that OPS is a less economic (ie. profitable) system of sugar production'. However, Mallorie's calculations omit three major factors which are likely to improve the relative profitability of OPS. First, for both technologies he calculates production on a full capacity utilization basis (although he does consider them to have different gestation periods); yet we have seen from earlier discussion that it is at least possible—if not probable—that a large-scale mill will have greater difficulty in ensuring cane supplies than a small one, and, moreover, the implications of sub-optimal capacity utilization are likely to be more adverse for the capital intensive VP mills than for the labour intensive OPS factories. Second, Mallorie rules out consideration of what Tribe refers to as 'non-intrinsic scale

factors', and here, once again, it is probable that there exist scale diseconomies, at least in some environments. Third, Mallorie excludes the screw expeller—which significantly increases the sugar recovery from cane (albeit at higher energy costs)—from his calculations.

A definitive conclusion is therefore impossible. No observer doubts that, in theory, an efficiently run large-scale VP plant is a much more attractive investment than either small-scale VP, diffuser or OPS plants. But, on the basis of the profitable existence of the Western Kenya OPS plant (in contrast to the losses of all but one of the VP mills),[11] and with the amendments made to Mallorie's ex ante simulation, it is possible to conclude with reasonable confidence that OPS production in Kenya is no less profitable than most VP production. In India, earlier analysis suggests a similar conclusion (Kaplinsky, 1983). One other factor worthy of noting, as Mlaki points out, is that for small, poor and foreign exchange starved economies, the potential of large-scale VP is only theoretical, since the resources required for investments of this nature (in the hundreds of millions of dollars) are simply beyond the reach of these countries or, indeed, of private investors.

Economic factors

The economic analysis differs from financial analysis in that it attempts to 'correct' market price imperfections and make them more accurately reflect opportunity costs. In the most widely accepted form of analysis—for there are a number of alternative ways of reflecting opportunity costs—it is considered that the ultimate opportunity cost is the world market. In theory, inputs can either be procured locally or from abroad, and outputs can similarly be destined for the local or foreign markets. Whilst a theoretically attractive method of analysis, this use of a foreign exchange *numeraire* bristles with practical difficulties. In many sectors, the conception of 'world prices' is much more difficult than it seems.[12] In the sugar sector—as Goodwin shows—there is no sensible 'world price', since the 'free market' price is merely a residual left after various preferential markets have been served. How then, argues Makanda, can this 'free market' price be utilized in any sensible evaluative technique?

In the face of difficulties of this sort, attempts have been made to measure opportunity costs on a less precise basis. Mallorie feeds shadow prices for labour and foreign exchange into his model (which, as we saw, excludes consideration of the expeller technology and makes no allowance for differential non-intrinsic costs), and values both sugar and maize production at their border prices (representing the opportunity cost of land).[13] Both the VP and the OPS technologies gain from considering these shadow prices, and the measure of their unprofitability falls from KSh 424/tonne to KSh 19/tonne for the VP mills and from KSh 710/tonne to KSh 39/tonne for OPS. Significantly, OPS gains disproportionately from this, and the measure of its unprofitability compared to VP falls from KSh 286/tonne to KSh 20/tonne.

From this narrow perspective, our earlier conclusions on the apparent private viability of OPS are reinforced when opportunity costs are taken into account.[14] The really important issue, however, is whether the economic weighting of non-intrinsic costs is such as to further strengthen the relative position of OPS. Are the market price costs of infrastructure an underestimate of real opportunity costs? If they are, then the relative attractiveness of OPS—in conditions where there are diseconomies of scale with respect to these infrastructural costs—will be further reinforced. Once again, as in the case of financial costs, there can be no general rule here. In some circumstances, which Hagelberg begins to identify, there will clearly be an economic case for OPS. Kenya, if all the loss-making VP plants (the sole exception being the profitable Mumias plant) are any evidence, represents just one of these cases where OPS has such potential.

Social factors

There is a common belief—amongst economists at any rate—that social cost benefit analysis is a suitable technique for determining the social appropriateness of a given technology. This is not the forum in which to examine the validity of this belief. However, not only do we doubt the role to be played by this form of analysis, there are no examples of its systematic application to the measurement of the social impact of sugar technologies. Nevertheless, the fact that there is no acknowledged 'correct' manner of determining an—or 'the'—appropriate technology does not mean that there is no need to consider the social context in which innovation occurs, and the effect which the innovation has in accentuating or diminishing particular areas of social concern. So, a discussion of the social considerations involved in small-scale sugar production is an essential part of the evaluative process before sensible policy guidelines can be generated.

There are, however, a number of difficulties which stand in the way of this. First, we have observed above that the 'specification' of **the** socially appropriate technology is impossible—appropriateness is an inherently relative concept. So it is first necessary to determine the environment which is to be considered, and the group(s) whose interests are to be met, before a judgement on appropriateness can

be made. With respect to this, the area for policy determination which is considered in this set of studies is Western Kenya. It is a high rainfall region, allowing for almost continuous cane supply and crushing. Land scarcity is significant, and, coupled with the high rate of population growth (both in the sub-region and in the country as a whole), growing unemployment and food-deficit agriculture, there is some concern about the present and future competition between agricultural production for direct consumption and that destined for cash markets. The economy at large has a relatively poorly-developed capital goods sector, and shows little capacity to manufacture sugar processing equipment, especially for the large-scale VP mills. Whilst this particular confluence of circumstances is specific to this region, there are clear similarities with other potential sugar producing countries, especially in Africa.

With respect to the specification of interest groups, it has long been ITDG's distinctive policy to focus on the needs of the poorest, especially those in the rural areas. And where there is a trade-off over time between the interests of current and future consumption, it has generally been the case that ITDG tends—**relatively speaking**—to focus on the present, leaving the state to place its emphasis on dynamic issues of reinvestment and linkages. Nevertheless, it has been the experience in many cases that focusing on the interests of the rural (or urban) poor has been associated with more positive externalities (such as a higher rate of surplus generation) and greater linkage effects than has an emphasis on production for the richer elements of society. And whilst none of the papers in this study provide direct evidence on the relative linkage effects of these two types of technology, we know from other studies that the backward linkages to the capital goods sector are greater with the small-scale OPS technology (Kaplinsky, 1983).

A second problem in identifying the socially appropriate sugar processing technology is that of measurement. Some variables are inherently difficult to measure, such as the change in intra-family dynamics which result from a shift from subsistence to cash crop production. Other variables are particularly sensitive—for example, the attempt to determine the pattern of expenditure which results from the receipt of cash income, or the reality of allegations of corruption or cheating which are often levelled against cane purchasing factories (be they large-, medium- or small-scale).

Third, there is the problem of identifying causality. Most often, this takes the form of talking of the 'impact' of a particular technology or factory on a society. But what occurs here is the observance of a correlation between two factors—for example, the establishment of a sugar factory and the growth of a particular pattern of class formation. From this follows the **supposition** that the two are causally related. But in actual fact the two variables may have little to do with each other, and the growth of particular classes may be induced by some other cause, such as the immigration of landless workers into an area because of political turmoil in a neighbouring country, as occurs in the Western Kenyan sugar belt. For this reason, it is necessary to take great care in interpreting the social impact studies on sugar production, in Kenya and elsewhere.

Related to this is a fourth methodological problem which involves the treatment of time in the analysis. In some cases, a comparison between two plants may reveal striking differences between the social context in which two different factories operate. For example, there may be a much greater extension of capitalist social relations in one area, leading to the conclusion that the greater inequalities inherent in a particular large-scale plant are more likely to lead to social division than those involved with a smaller plant. Indeed, some of Lemmens' analysis is suggestive of this sort of conclusion. However, as we shall see with regard to the Western Kenya case, these major differences most probably arise because the large-scale VP plants have been in operation much longer than the small OPS factory, and there has been more time during which social relations could be extended in this manner.

Finally, the analysis of social parameters is compounded by what may be called 'the ripple problem'. This involves the difficulty of determining where to end the investigation of social phenomena. For example, as we shall see, although there is some divergence of views between Makanda (who finds evidence of increased malnutrition) and Lemmens, in neither case is it argued that malnutrition is very widespread. But to end the analysis here with the conclusion that malnutrition is not associated with sugar production may be mistaken, since the really significant incidence of malnutrition is to be found in the case of farmers who have been displaced from the region and are no longer either growing cane or even resident in close proximity.

With these caveats in mind, we can turn to the major conclusions which arise from the analyses of the social context of sugar production in the Kenyan sugar belt. Here, a single major conclusion arises around the broad question of whether Kenya should be engaged in sugar production at all. Briefly, the position is that, as Goodwin points out in his analysis of world sugar markets, the likely long-term 'free market' price of sugar is such that it is difficult to suggest that any new plants should be established to produce sugar; indeed in some cases it may well even be 'logical'—within the peculiar constraints of cost-benefit analysis—to decommission existing plants and turn the land over to other crops where the opportunity costs of production (measured in terms of foreign exchange) are lower. In this case, all sugar production—whether VP or OPS—is inappropriate in a country such as Kenya.

There are a number of objections to drawing this conclusion. As Mallorie's analysis suggests, there is no great difference between the foreign exchange costs of growing sugar or maize.[15] But of much greater significance, Makanda (and to a lesser extent Lemmens) argue that the Western region of Kenya would be severely disadvantaged without sugar. This is because there is no potential for growing other high cash-yielding and profitable agricultural crops. Coffee (which is not viable in the Kabras region where the OPS plant is established, but is viable in other parts of the Western region) and tea are the two most profitable crops, and have allowed for extended development in other regions. This is most clearly the case in Central Province, where high rural incomes have contributed to the growth of rural industry and thus to extended development in the region (Lone, 1987).

However, in both cases production is regulated by international quotas, and the overwhelming bulk of these quotas has already been allocated to other regions of Kenya. Other potential high yielding crops are bananas (where the market is not large enough to provide equivalent gross returns to those of sugar) and pineapples and cotton (where not only is the processing infrastructure not available, but the net farm returns are lower than for sugar). Thus, whatever the logic of sugar production in Kenya as a whole may be, the fact is that unless other regions of the country release some of their quotas on high yielding crop substitutes (which is highly unlikely), then sugar production is of vital importance to the relative welfare of the Western region.

Within this, there is of course the question of whether sugar production should be expanded, and if so, which processing technology should be utilized. The first of these is not easy to determine, partly because it is linked with the question of bringing the existing plants to full capacity utilization; apart from the very large-scale Mumias plant, none of the other western region VP plants operate either profitably or at anything like their designed capacity. Whilst remedying this is clearly a major objective for the Kenya Sugar Authority, no-one seems to be asking the question of whether this task is more or less difficult than introducing one or more new small-scale OPS plants. However, if new capacity is to be installed, we can see from earlier analysis that there is a persuasive case for including one or more OPS plants in this equation. In part this is a question of financial viability, but it also reflects the greater employment-generating capabilities (per unit of output) of the small-scale factory. Moreover, if the primary rationale of sugar production in the Western region of Kenya is to open up disadvantaged areas to cash production, then it may make more sense to establish a new small plant in an under-developed region than to expand an existing plant in a developed region.

If the inter-regional implications of sugar production dominate the analysis of social appropriateness, a subsidiary question concerns the balance of positive and negative factors associated with OPS production. Both Lemmens and Makanda consider these issues, with Lemmens' detailed study of particular assistance in this area. The conclusions which are drawn seem fairly clear. Both large- and small-scale plants seem to be associated with 'beneficial' effects, in that there is more money around, and little evidence of displacement of farmers from land or of malnutrition. Moreover, despite *a priori* concern that the shift from a food to a cash crop would be disadvantageous to women, no such conclusions can be drawn.

But there remain problems. Lemmens argues that much of the cash which is generated is spent on virtually 'worthless' education, but this involves a speculative judgement on the value of education as both a private and social investment. He also is concerned that the dependence of these farmers on a single cash crop makes them extremely vulnerable to a change in relative crop prices, which would drive them back to subsistence without a viable alternative form of cash income. Associated with this is the ecological danger of monocropping. Makanda suggests that there is already evidence of a degradation in the yields in areas with a long history of cane growing, and this remains an important concern.

Nevertheless, at least in the short term, the pattern of social relations associated with sugar production seems not to be adverse. If anything, the situation seems to be even more favourable with the small-scale plants (for example, because land-holding patterns are less unequal), but this may only be a reflection of their relatively recent history. One problem worth noting, however, is that the by-products of cane processing are often used to manufacture alcohol illegally. This is a particular problem for the small-scale factories (and especially the jaggeries), since the proportion of molasses which remains (the feedstock for alcohol) is greater, and because the small-scale plants are more difficult to regulate.

Finally, the assessment of whether sugar production (or particular variants of technology) is appropriate necessarily involves a judgement on the desirability of capitalist development in the rural areas. One of the clearest conclusions emerging from Lemmens' detailed study is that the surplus generated from cane growing is utilized for reinvestment in other profit-yielding enterprises. This provides a strong causal link between the extension of capitalist social relations and sugar production. Here, it is necessary to offset the inherent inequality of capitalism with three factors. First, in the context of viable alternatives in this region, the choice is probably that between dynamic capitalism and static peasant/quasi capitalist production; the choice is thus between higher absolute levels of income and inequality, and greater equality and lower living standards for the majority of the population. Second,

some would argue that the transition to a more socially acceptable form of social organization is contingent upon the prior extension of capitalist social relations. Third, there remains the regional problem. Even if Western Kenya abdicated from sugar production and remained a region of relative social equality, the absence of a high yielding cash crop in the region would make the province significantly less affluent than other regions in Kenya. Inequality would thus be heightened, but at an inter-regional rather than intra-regional level.

Before leaving the discussion of the social parameters of sugar production, it is best to be aware of a number of uncertainties which remain and which influence the analysis. In addition to the problem of time (that is, will the picture change significantly with the passage of the years?), three areas of uncertainty arise. First, does VP production necessarily imply estate or other forms of large-scale farm production? Lone suggests that it does, and the implications of this may be significant. Lemmens provides some evidence that because of the extension services offered by the large-scale plants, their farmers tend to utilize more fertilisers, and this may not only signify that they are generally more progressive but also that this progressiveness may spill over into other crops. But is Lone correct, and is it not possible for the OPS plant to increase the extent of its extension work, and is this in itself also not a function of time? Second, we have almost no data on capacity utilization. Do the large-scale plants (with the exception of Mumias) have long-term problems in this regard, and what are viable gestation periods for new VP plants in this region? And to what extent do these capacity utilisation problems have social points of origin? Do they reflect the particular socio-political environment within the Kenyan sugar belt? Finally, Moody-Stuart, Makanda and Lemmens all point to the quality of the employment which is provided. Most tend towards the view that the large-scale VP factories provide 'better' employment opportunities. But what does this mean? Is it not an imposition of upper-income professional values on rural farmers? Are there opportunity costs to employing highly educated personnel in this sector? These and other aspects of employment creation remain clouded with uncertainty, and are clearly worthy of further investigation.

A BACKGROUND FOR POLICY FORMULATION

Sugar production is a major agricultural activity in the Third World as a whole. In some countries in which ecological factors are particularly favourable it is the major activity, accounting for the largest share of paid employment, the bulk of exports, and the largest sectoral share of investment. Consequently, what happens in the sugar sector is important as a policy concern in itself. But, inevitably, developments in this sector not only have implications for sugar and agricultural policies in specific countries. They inform policy in other sectors, in other countries and in other decision-making fora such as NGOs; in turn, developments in the sugar sector are also informed and affected by events occurring in other sectors, in other countries, and at other times. Therefore, in considering the future policy implications for both small-scale sugar processing technology and ITDG's programme in this area, it is essential to begin by taking account of some of these wider issues which form a backdrop to our central areas of concern.

Intermediate or appropriate technology?

The importance of identifying alternatives to industrially advanced country (IAC) technology for the Third World was identified many years ago by Fritz Schumacher, who then went on to form ITDG. In this, he argued the need for a technology which was in some sense 'intermediate', standing somewhere between the high capital costs per workplace of IAC technology, and the low efficiency of traditional less developed country (LDC) technologies. Yet, valuable as though such an initiative has been, there is a danger that this particular representation of the problem will lead to a mis-specification of alternatives. For not all the optimal choices necessarily are intermediate ones, and indeed, in some crucial areas, the most **appropriate** technology may well consist of a combination of the most traditional and the most technologically advanced sub-sets of technology. The example of micro-hydro—in which the small-scale technology has been made an attractive choice by appending an electronic load-displacing device—is an important case in point here.

Thus, in searching for an appropriate small-scale sugar technology, an eclectic perspective is essential. The viable alternatives may involve an upgrading of traditional technologies (as in the OPS variant), or the introduction of a scaled-down modern variant such as diffusion technology. It may also imply, at some future date (for there is no sign of this happening at the moment), the introduction of a modern ancillary technology; perhaps to regulate the flow of the rab through the various pans in OPS factories. The main point here is that in discussing the type of technology which is best suited to meet social needs

in sugar production, it is important to bear in mind that the quest is for an appropriate alternative which will thus not only be technologically imaginative, but will necessarily also vary between countries and over time.[16] There are no *a priori* reasons for supposing that this will necessitate the use of either the most advanced or the most traditional technology; nor is there any reason why it should not involve a combination of such technologies.

Technological development takes time

Although sugar production has a long history—particularly in relation to cane sugar—the systematic attempt to improve small-scale OPS technology is of relatively recent origin. It was only after the mid-1970s that resources of any significance at all were addressed to meeting the technological problems of this sector, and after the death of M. K. Garg in 1985 much of this pioneering momentum came to an abrupt halt. Indeed, at present most of the technological input is occurring through the initiative of ITDG.

Many of the judgements condemning the non-viability of this small- scale technology fail to take these temporal factors into account, and point to the greater static efficiency of VP technology. Yet as Pearson shows, following the introduction of the first vacuum pans in the 1820s VP technology was itself developed over a period of almost one hundred years. Beet sugar technology also involved many years of effort, and its recovery rate rose from a negligible percentage in 1799 to just over five per cent in 1836 and only to around its present optimum in the first decade of the twentieth century. Moreover, studies of technological development in other sectors show a similar time-span of development (R. M. Bell et al, 1982). The Japanese and the South Koreans took around six decades to develop their textile industries, and the recent Japanese prowess in the automobile sector involved seven decades of production and at least four decades of concerted development (Cusumano, 1984). So the failure of the small-scale sugar technology to reach its full potential in a relatively short span of history should not be taken as an *a priori* judgement of its unsuitability. This needs to involve a much longer time-frame, and a broader canvas of decision-making.

Technological development takes resources

Yet time alone is not adequate. Technologies do not develop by virtue of merely 'being around'; somebody has to make it their business to improve them. This raises the question of the appropriate scale required to make these improvements. At present, annual expenditure by ITDG on its sugar programme is in the region of 75,000. Together with accumulated expenditure at the Appropriate Technology Development Association (ATDA) in India, and with some improvements arising out of the Indian capital goods industry, it is likely that total developmental expenditure has been something rather less than 1mill. For a technology with such wide-ranging social and economic implications, and which is relatively complex by comparison with other appropriate technologies, this represents a paltry commitment of resources.[17] And by comparison with some other industries—such as the automobile sector, where the European and US assemblers alone spent over $120 billion on new technology within a single decade—these miniscule sums are almost laughable, and hardly even qualify as 'developmental expenditure'.

Yet the returns to even this low investment in technical change have not been negligible. The introduction of shell furnaces as a substitute for the traditional bell furnaces and the potential success of the screw expeller juice extracting technology are together likely to increase the recovery rate of OPS plants by about fifteen per cent; that is from just over seven to just over eight per cent under North Indian operating conditions. Arguably, these technological developments have already changed the balance of private profitability in favour of OPS when compared to smaller or inefficiently-run VP mills. And there remains plenty of room for further improvement, not just through the accretion of minor changes on the recovery rate but also with respect to fuel efficiency and even labour productivity.

So, if it is in fact the case that under some operating conditions OPS technology is already more profitable than many VP plants (something we shall discuss in more detail below), and if OPS provides the potential for significant further improvements, why are the larger sugar-oriented TNCs not moving into this sector?

The institutional context of innovation

The fact is that there are few TNCs with significant sugar operations in LDCs. Most of the larger traditional firms such as Tate and Lyle or Booker have diversified out of sugar, or have moved into beet or have concentrated on sugar distribution. In a few isolated cases they have maintained their involvement in the form of management contracts, as in the case of the large and relatively successful Mumias plant in Kenya.

A number of factors have contributed to the TNCs' retreat from direct equity and production. For one, many developing countries have internal political pressures which make it difficult to maintain foreign investment in a sector in which the technological barriers to entry are the TNCs.[18] Another factor underlying the retreat of the TNCs has been the gradual squeeze on processing margins. In many countries, governments have been confronted with conflicting pressures in setting the price structure for sugar — the necessity of keeping the consumer price of a basic foodstuff low in periods of inflation, and the political pressure from the commercial farming lobby for high growers' margins. The consequence has been a generally low rate of return for sugar processing, and a consequent tendency for much of the ownership to be in the public sector; this is not uncommon in basic goods industries which are subject to these scissor-like pricing pressures. And finally, although in theory the quantum of profit from many small factories may be greater than that arising in a single large factory, central management often has great difficulty in appropriating returns which are generated in such a decentralized manner. This is a common problem where there exists a choice of technology between very large- and very small-scale plants, as for example in the baking industry.

Thus, faced with the absence of the major traditional investors and a simultaneous squeeze on margins which pretty well rules out almost all profitable investment, it is perhaps not surprising that the Bookers and Tate and Lyles are not taking up the opportunities offered in the improvement of OPS technologies. Instead the vacuum has largely been filled by NGOs. However worthy the efforts of these organizations, their impacts will always be limited by three factors. In the first place, most have constrained resources and thus find difficulty in funding developmental expenditures which approach 1mill. Second, the process of investment is not an endogenous part of their operations in the same way that it is in capitalist enterprises which search for monopoly profits by developing and introducing new products and processes.[19] And third, few of these NGOs—especially those based abroad—have the political muscle which is required to change the incentive system in favour of a more rational pattern of investment. Again, these are not problems which are confined to the sugar sector; they are to be found repeatedly in many other sectors of appropriate technology activity.

The importance of political will

This leads the discussion to the structure of the political environment which surrounds technological development and innovation. The recent historical experience of both Japan and South Korea shows just how important the role of the state—together with a vibrant entrepreneurial sector—can be in facilitating the pace and structure of industrialization. At the moment, in most LDCs (with the possible exception of China) the dominant political coalition is such that there is little incentive to the development of appropriate technologies. The importance of the political structure can be gauged from comparative experience in both micro-hydro and cement production. In the first case, Chinese technology is inferior to that existing in the West; yet whereas the total number of micro-hydro plants built around the world annually (excluding China) number less than 200, the Chinese build something like 10,000. In the case of cement, Indian cement technology is significantly superior to the Chinese variant; yet whereas mini-cement plants only account for around 2.8 per cent of India's current production (projected to rise to around 10 per cent by 1990), they make up 75 per cent of all of China's production.

In both these sectors, the modern large-scale plants are, of course, much more efficient in technical terms. In addition, were they both to pay the same market price for their inputs, it is possible (but by no means probable) that the larger plants would be more profitable. But the fact is that they don't pay the same prices, partly because the same factors in different situations have different opportunity costs. Moreover, in many rural communities the capital content of these small-scale plants has little opportunity cost since it represents mobilized resources which would otherwise not be available.

So what emerges from these two examples is the importance of government policy. Unless this is such as to reinforce 'socially sensible' decision-taking, then appropriate technologies will have little chance of widespread innovation unless they continue to be subsidized by NGOs, or find a limited but profitable market niche.

POLICY IMPLICATIONS

Based upon these wider issues and on the extended body of technical, financial, economic and social analysis reviewed earlier, it is possible to identify a number of policy implications. These mostly relate to Kenya, since this is where the empirical analysis has generally been undertaken. However, since there are a great many similarities between operating conditions in Kenya and in other developing countries (especially in Africa), the conclusions which are drawn will obviously be of wider relevance. Policy conclusions are not only relevant at the national level, however, and since ITDG and other NGOs have

been—and continue to be—intimately involved in the development and diffusion of small-scale sugar processing technology, there are naturally also lessons for them which can be drawn from the experiences related at this Conference.

Policy implications at the national level

There are a number of different levels at which these policy implications have relevance to a developing economy such as Kenya, and it is useful to separate out the various sets of implications. These are with respect to the question of whether sugar production should occur at all, to the incentive system which governs investment and production in this sector, and to the need for heterogeneous and flexible policies.

Should Kenya have a sugar industry?: The contribution by Nyongesa and Mbuthia shows that the performance of the Kenyan sugar industry in terms of output growth has been very impressive. In the first two decades after Independence, production rose from 35,333 tonnes to 365,796 tonnes, an annual rate of increase of 12.4 per cent. By the standards of most countries this is an impressive record.[20] Yet despite the rapid growth of sugar production, the policy of self-sufficiency was not achieved. Production actually dropped after reaching its high point in 1980 and at the same time consumption continued to expand, so that imports have also grown, reaching an all-time high of 142,000 tonnes in 1986.[21] Moreover, the mere fact of output growth masks the important question of opportunity cost—how much did the whole effort cost, and could these resources have been better used in other sectors?

We cannot, of course, pretend to answer these questions here. Moreover, to some extent the exercise would be merely academic since the fixed investments have already been made, and it is now only the variable costs of production **plus** the costs of rehabilitating the existing large-scale plants (to bring them up to full capacity utilization) which are at issue.

In addition, whatever the 'economic rationality' of rolling-back these sugar investments or of curtailing new ones (perhaps in favour of importing low-cost dumped sugar, or even of making imaginative use of artificial sweeteners), there are pressing political reasons why sugar production should be maintained and probably even marginally expanded. When those regions which now find that sugar is the only crop which provides a lucrative source of cash incomes identify an alternative agricultural or industrial product, then such a radical departure from the past two decades of agricultural policy may make more sense. But until then, the political logic of directing a surplus-yielding cash crop to the Western region will outweigh any narrow economic logic. In terms of economic logic, this is probably best expressed as a mechanism for redistributing income from all Kenya consumers (of whom the majority live in Central and Eastern Provinces) to one of the poorest regions of the country. It must be said, however, that despite the political factors justifying sugar in the poor Western region of the country, there will remain the question of how much sugar should be grown. Clearly there must be some limits to this process of immiserising regional redistribution which, given the scarcity of land and the rapid growth of Kenya's population, will probably have to be below long-run self-sufficiency.

There is another political factor which is likely to have an increasing impact on the sugar industry in Kenya, and this concerns the opportunities which it gives for the development of indigenous entrepreneurship. At the moment the financial, skill and technical barriers to entry are such that few local entrepreneurs see much potential for themselves as owners. A business lobby for the industry is thus absent, and the running has largely been left to the farming community and the sugar industry trade unions. But when indigenous capital formation is more advanced, and when skilled human resources are more widespread, there will undoubtedly be more political pressure for an expansion of the sector. And since many of these barriers are significantly lower for OPS than for VP technology (although there is, as we have seen, some debate on the question of skills), then it is likely that an additional and substantial internal lobby will become evident in favour of the small-scale technology.

The incentive system for investment and production: It is impossible to make market prices reflect opportunity cost, especially social opportunity cost. Thus the price mechanism cannot be utilized as the sole criterion for resource allocation. Nevertheless, there are a number of cases in which the signals which are provided by the market do bias choice in socially inappropriate directions and which are subject to remedial action. In other cases where market prices are imperfect indicators and are difficult to reform, it is important for policy makers to be aware of the distortions which these prices imply.

The first of these categories has a single element which stands out in importance: the valuation of capital. To understand the problem which arises in this regard, it is necessary to consider the pattern of ownership which has arisen in the sugar sector. In combination with a number of other developing countries, much of the Kenyan sugar industry is now owned and/or controlled by the State. There are good reasons for this. The indigenous private sector has been unable to muster the resources required for large-scale sugar production, foreign investment has many undesirable features which has led government to limit its role, and margins have been squeezed in a dual attempt to maintain farm incomes

and to protect low-income consumers from inflation in their purchase of a staple commodity. This state ownership of an inherently unprofitable area of agricultural processing has been associated with a virtual neglect of modern accounting practices, particularly those associated with the valuation of capital at replacement rather than historic costs.[22] Were all choices of technology to be influenced in a similar manner, then there would be no problem. But this is not the case in sugar, since new investments in the small-scale industry all emanate from the private sector. These private entrepreneurs are forced to recover all of their costs on an *ex ante* basis, so that the current practice of the large-scale mills in virtually writing off capital costs is of no use to them. Moreover, the greater capital intensity of the large-scale VP plants means that they are disproportionately favoured by this practice—it is perhaps equivalent to a procedure whereby the labour intensive OPS plants were able to write off all their labour costs. This practice of capital valuation needs to be recognized as influencing the choice of processing techniques in this sector.

The second category of price distortions concerns those which are difficult to reform for structural reasons but which bias technological choice. The most obvious one which comes to mind is that which is utilized in cost-benefit analysis. The supposition here is that every investment has an opportunity cost which can be measured in terms of market prices, specifically those which can be measured in terms of foreign exchange. Thus, it is commonly argued, farmers are faced with the possibility of growing a range of alternative crops and the optimal choice will be determined by the relative market price of each. But the imperfections in market prices often make a nonsense of such calculations. Retailers characteristically take advantage of scarcities by pushing up the cost of purchased foods way in excess of their 'free market prices', and middlemen often buy farm crops in periods of glut at way below the same 'market prices'. On the other hand, because of the organization of the sugar industry, farmers tend to obtain a relatively reliable and consistent value for their cane output. So great care must be taken in policy formulation—especially in the setting of relative prices—before sugar is jettisoned as a crop on the basis of abstract calculations on relative crop profitability.

These examples of the valuation of capital and the calculation of 'free market prices' are merely examples of more general tendencies which are often found to determine government policy towards the sugar industry, in Kenya and elsewhere. At the same time, the tendency to try and 'fix' these distortions through the application of cost-benefit analysis often results in the mechanical application of a textbook formula which runs into particular difficulties in handling the problem of a *numeraire*. Domestic prices are flawed because the market generally does not operate efficiently, and the determination of world prices involved in this methodology is often problematic—seldom more so than in the case of sugar.

The need for a heterogeneous and flexible policy: So where does all this leave small-scale sugar technologies such as OPS? If there is one central message which has come out of the detailed evaluation of sugar processing in Kenya (and, to a lesser extent, India), it is that diversity is the most appropriate policy. Such a policy would have implications at a number of levels.

We have observed that a full capacity VP plant offers the possibility of unbeatable production costs. Yet establishing and running such plants efficiently at full capacity is no easy task. Moreover, either for ecological reasons (a shortage of adequate suitable land) or political reasons (to provide a high-yielding cash crop to a small or new area), such large-scale plants may not be viable. Therefore, sensible policy should involve a combination of small and large plants.

These plants need not necessarily operate as competitive technologies, and here a number of possibilities exist. One is to utilise the OPS strength in crushing (the 'front end') to develop a number of decentralized thick-juice factories.[23] Special-purpose tankers would then transport this juice to a series of large-scale VP plants (which are much stronger at the 'back end' of processing) for conversion into sugar. This would save on unit transport costs (since no bagasse would have to be transported), would utilize the scale economies of large-scale plants where they are really evident (in boiling), and would allow for small pockets of cane to be exploited. Then when the OPS technology improves its boiling process further (perhaps by tackling the fuel-feed problem identified by McChesney), it can also process its own juice; or when cane growing capacity is adequate, then a new VP plant can be established.

Another linked possibility is to specifically design OPS plants which can be relatively easily decommissioned. These factories can be used to establish cane growing in a particular area, and once the volume of acreage is adequate, the OPS plants can be deconstructed to be replaced by a VP plant; the same small-scale equipment can then be transferred to another area so that the procedure can be repeated.

The central theme emerging here is one of both symbiosis between large and small, and flexibility in policy formulation. Lone observes that this philosophy is not unique, and that a transition from a fixation with large-scale and inflexible plants to smaller-scale flexible production is widespread in all of the

industrially advanced countries. The application of these new principles of industrial policy would be advantageous to developing countries.

Policy implications for the NGOs

The involvement of NGOs in the development of OPS technology is not unique to the sugar industry, since in general the major developers of technology—firms in the industrially advanced countries — have little interest in small-scale and appropriate technology. What is rather special about the sugar sector is the relative size of the investments involved, for 'small' is a relative term and what may be small in one sector (as in sugar) may be very large by comparison with another (as in maize milling). For this reason, there have been particular problems for the NGOs involved in the sugar sector which are analogous to those in a few other sectors, such as cement, cans and and glass containers.[24] The NGO currently doing most to promote small-scale sugar technology is ITDG, and it is possible to draw out three areas of policy which arise in the further pursuit of its sugar programme. These are in relation to technological development, the consideration of other forms of small-scale technology, and to the OPS programme in particular.

Further technological development: We have already observed that whilst technological development is characteristically a long-term project, much can be done to speed up the process. In particular, it is necessary not only to have a planned programme involving short-, medium- and long-term goals, but also to be able to back these plans with adequate resources. For a multinational, such a strategic perspective would not only create no great problems but would also be a vital aspect of corporate planning. However, for a resource-constrained NGO which is generally accustomed to much more modestly-sized projects, this may be considerably more problematic.

In developing a technological strategy, it is convenient to distinguish between the 'front end', ie. crushing, and the 'rear end', ie. boiling and crystallizing. At the 'front end', the now conventional line-up of two (or three) three-roll crushers works satisfactorily. The cane expeller, however, simultaneously offers the prospects of improved juice extraction and a reduced scale of operation (50 tcd compared to 100 tcd). Pilot tests of the expeller have encountered teething problems, and further investment would be necessary to produce a commercially viable cane expeller. Yet this technology may offer the key to the upgrading of jaggery plants (many of which operate at 20-40 tcd) to white sugar production.

Problems at the 'rear end' arise in two particular respects. The first concerns the overall control of the boiling and crystallizing sub-processes, where it is likely that attention to detail will provide a series of incremental improvements which over the years will yield a significant improvement in recovery.[25] The second applies specifically to the process whereby the furnaces are fed with bagasse. McChesney observes that the manual feeding of these furnaces appears to be much more problematic in African conditions than in India, and some simple form of mechanized feeding may provide generous returns.

The experience of technical change in other countries has been that scientific institutions and NGOs have proved to be relatively poor carriers of technical change. The capital goods industries—who have a vested interest in technical change—are much better in this respect. The first signs of technologically progressive capital goods firms are beginning to emerge in India, but with the death of M. K. Garg some of the impetus may have been lost. It might therefore pay ITDG to reopen its contacts with these Indian machinery suppliers to ensure that technological changes are rapidly transferred into new plants. The main problem with this strategy is that the incentives governing innovation in the sugar industry are such that few new small-scale plants are being installed, even in India. And until the incentive of possible repeat orders exists, importing capital equipment from India is likely to remain beset by problems of quality and delays.

Other types of small-scale technology: It is clear that whilst OPS is the dominant small-scale sugar processing technology, it is not the only one available. As we have seen, there is also the possibility of reviving an earlier vintage of VP technology as well as utilizing modern diffuser technologies. The issues for ITDG to consider are whether it has been right to back OPS rather than the alternatives, whether it should switch to either of these other small-scale technologies, and whether it can continue to explore more than one small-scale alternative at a time.

On balance, the most sensible choice would probably be to stick with the existing programme. Scaled-down and simplified VP technologies require not only a substantial programme of investment but also resources far in excess of anything ITDG can now muster. Diffuser technology is probably equally costly and is, besides, a relatively capital intensive path to small-scale production. Moreover, for better or worse, ITDG has already concentrated its resources on OPS and it makes sense to capitalize on this past investment.

But this does not mean that additional elements should not be introduced into the programme. For example, although it is clear that the Colombians meet a large proportion of the sucrose needs via open

pan boiling, no attempts have yet been made to explore the efficiency of these plants in comparison to the Indian designs which form the basis for the current OPS plants. In addition to this, some more attention might be paid to the marketing of jaggery as a food; partly because it reaches a different (and poorer) group of consumers, and partly as a way of upgrading these small-scale producers to more efficient granular sugar production. Indeed for OPS plants which produce a mix of sugar and jaggery, the effect would be to increase the profitability of OPS production and redirect supplies of jaggery away from illicit alcohol production.

Implications for the OPS programme: A number of decisions currently faces the OPS programme within ITDG. The first of these is the question of how to handle the existing effective OPS plants, such as that operating in Western Kenya. Should ITDG facilitate the construction of a second OPS plant, and if so, to what extent should it subsidize its operations (for example through free technical assistance)? Should it facilitate the conversion of this factory into a small-scale VP factory; again, with or without subsidies of one sort or another? What additional value would ITDG derive from the additional technical knowledge gained from having a factory as a demonstration unit?

Second, we have seen at various points that the single most important consideration in the expansion of small-scale sugar processing is the policy environment in which it operates. Currently this environment is such that in almost all producing countries, large-scale VP plants are favoured in a range of ways. In Kenya in particular, sugar pricing policy is such that only the single most efficient large-scale plant operates at a profit. The others are subsidized, mainly through an extended deferment of excise duties.

How are decision-makers to be affected? How can ITDG best get its message through to these policy makers? Indeed, is there a case for switching the dissemination effort from Kenya, if the government continues with policies which are not conducive to small-scale sugar production, to another country such as Tanzania where the government appears to be more receptive? So far, influencing government policy has not been an important part of either the sugar programme's activities or of ITDG in general. But perhaps this is now a suitable opportunity to begin exploring these wider policy issues. There are implications here for a different kind of expertise in ITDG—dissemination requires communication and political expertise far removed from the engineering skills necessary to establish, run and improve a sugar plant.

A third policy consideration for the sugar programme within ITDG concerns the manner in which managerial and technical expertise is to be made available to new entrants. Arguably, the methods utilized in the case of Western Kenya—which was pioneering the utilization of efficient small-scale OPS technology in Africa—are too high-cost to be repeated in the future. Sending expensive staff from the UK to Africa makes little sense when expertise already exists locally in the Western Kenya plant; but how, and on what terms, is this expertise to be transferred to new plants? Is it to be on commercial terms, given that there has already been over the years a large sub-commercial input from ITDG? Do provisions exist to govern this process of domestic transfer in the future, and what is to happen if a new plant(s) is established in a neighbouring country?

Fourth, as Jones concludes, one of the major lessons learnt from the social analysis is that whilst there are no obvious negative social consequences arising from the sugar programme in Western Kenya, this does not mean that this region is free from adverse social relations. Therefore, from the point of view of meeting ITDG's wider concerns with social development, perhaps some form of package of technologies should be considered for a particular area. This would approximate to the recognition in the late 1970s that integrated rural development programmes provided important synergies. Thus, at the same time as transferring another OPS plant, food production extension services, nutrition education, and possibly new sanitation technologies, cooking technologies and other important elements of the basket of appropriate technologies could be provided for the same region, all perhaps within the aegis of an ITDG programme. But would this programme be too big for ITDG to manage? Would it still be too small for large donors to fund?

Finally, if and when one or more other OPS plants are established in a particular area, there remains the problem of repair and maintenance. Some form of common facility would be of great importance, perhaps provided as part of an aid package. This could not only meet the direct needs of the small-scale sugar processing sector, but might have much wider application to other rurally-based industries, and in itself be an important element of capital goods provision in such areas.

Notes

1. See Kaplinsky (1983) and the bibliography therein for a discussion of these extensively-debated issues.
2. Of course, great care has to be taken in using and interpreting this rule of thumb. For *reductio ad absurdum*, this would imply that there was no sensible limit to any chemical processing plant. What, in fact, generally occurs is that the initial plant involving an increase in capacity involves large cost over-runs, but, once the unexpected problems have been solved, subsequent generations of investment do realize the anticipated cost-savings.

3. As Lone points out, the disillusion with the mass production paradigm is not confined to parts of the sugar industry. Many industrial sectors are now coming to realize that the inherent uncertainty of factor provision and markets create great risks for large-scale production. There is thus a widespread tendency to both descale production and to make large plants more flexible in their output (Piore and Sabel, 1984; Hoffman and Kaplinsky, 1988). This latter route of increased flexibility is, of course, not really open in sugar production, since the output is by its nature relatively homogeneous.

4. This may be an especially significant problem over time, since plant-policy may be to gradually increase scale whereas demographic pressures suggest an exacerbation of the food/cash-crop conflict.

5. For example, given the Kenyan Government's policy that smallholders devote not more than one-third of their land to cane, a 10,000 tcd plant would have to be fed from 1,800 sq. kilometres.

6. This plant of 300 tcd capacity cost $6.5mill. (1984 prices), and took 20 months to bring to operation after signing of the contract. It employs about 200 people. By comparison, a modern 200 tcd OPS plant would cost about $1mill. (1987 prices). Taking into account the lower sugar recovery of the OPS plant, the capital costs per tonne of sugar production (at full capacity) are about $200 (1984 prices) for the diffuser plant, and $70 (1987 prices) for the OPS plant.

7. On the other hand, these skill barriers could not be overwhelming since the Kenyan OPS plant has managed to achieve high rates of sugar recovery by utilizing locally-trained workers.

8. Given that the VP mills tend to substitute capital (a fixed cost) for labour (a variable cost), depreciation on historic costs is a major biasing factor favouring the 'bottom line' of the VP mills (Kaplinsky, 1983).

9. Between 1975 and 1985, the number of OPS plants in Uttar Pradesh apparently fell from 4,500 to around 1,000.

10. Mallorie compares a 100 tcd OPS plant with a 3,500 tcd VP mill. As can be seen by reference to previous discussion, neither reflects the optimum scale of production for these two technologies.

11. However, the OPS benefits from a remission of the Kenya National Trading Corporation (KNTC) and Ministry of Commerce distributors' margins. The VP plants effectively benefit from an absence of excise duties, since most are significantly behind with their payments on this account.

12. In the classic case, what is the 'price' of a Volkswagen gearbox when it is only produced by VW subsidiaries and traded with other affiliates?

13. Although as Lemmens and Makanda point out, the most realistic alternative to sugar cane is a combination of maize and beans.

14. Although it is important to reiterate our earlier conclusions that at current government-set prices, neither VP nor OPS is able to repay its investment at a 10 per cent discount rate.

15. Although, as both Lemmens and Makanda point out, the most likely alternative to sugar is not maize, but intercropping of maize and beans. Considering both crops makes a substantial difference to the nutritional pattern of output, and will also probably also make a difference to this 'economic' valuation of output.

16. For, as Hagelberg pointedly observed at an earlier stage of the debate on sugar technologies: "Where a product or process not only admits a choice of technologies, but several are actually practised, the thesis that one is universally appropriate must be sceptically examined. Appropriate technology is inherently relative" (Hagelberg, 1979, p. 894).

17. An analogous picture is to be found in the cement sector, where the total resources devoted to technological development were less than $800,000. By comparison with the sums invested in the improvement of the large-scale plants, this is a paltry amount.

18. In the case of Booker, the 1976 nationalization of the sugar industry in Guyana was especially significant in inducing a change in corporate orientation.

19. This is the heart of the so-called Schumpeterian motor of accumulation.

20. Although, after the big push in India in the late 1920s, it took only seven years for sugar production to grow from 63,000 tons to 700,000 tons.

21. Care should be taken in interpreting these figures, though, since some of the sugar 'available' on Kenyan markets inevitably found its way through various channels into surrounding countries.

22. In periods of rapid inflation, there can obviously be significant differences between capital valuation in these two methods.

23. This novel idea was suggested during discussion by Moody-Stuart.

24. On cement see Kaplinsky, 1986, and Sinha, 1985; on glass containers see Kaplinsky and Leppington, 1980, and on cans see Kaplinsky and Pearson, 1981.

25. As Katz (1987) points out, these incremental improvements have historically proved to be the mainspring of technological progress in many sectors in the industrially advanced countries.

REFERENCES

Bell, R. M., Ross-Larsen, B., and Westphal, L. E., *The Costs and Benefits of Infant Industries: A Summary of Firm-Level Research*, mimeo (1982).

Cusumano, M. A., *The Japanese Automobile Industry: Technology and Management at Nissan and Toyota*, Harvard University Press, Cambridge, Mass. (1985).

Hagelberg, G., *Appropriate Technology in Sugar Manufacturing: A Rebuttal, World Development*, Vol. 7, pp. 893-9 (1979).

Hoffman, K., and Kaplinsky, R., *Driving Force: Autos, Components and Global Restructuring*, Westview Press, Boulder, Colorado (1988).

Kaplinsky, R., and Leppington, B., *The Potential for Small-Scale Can-Making in Kenya*, Intermediate Technology

Industrial Services, Rugby (1980).

Kaplinsky, R., and Pearson, E., *Feasibility Report on the Establishment of a Small-Scale Glass Plant in Kenya*, Intermediate Technology Industrial Services, Rugby (1981).

Kaplinsky, R., *Sugar Processing: The Development of a Third World Technology*, Intermediate Technology Publications, London (1983).

Kaplinsky, R., *The Experience of Mini-Cement: What are the Lessons for the AT Movement?*, Appropriate Technology International, Washington (1986).

Katz, J. (ed.), *Technology Generation in Latin American Manufacturing Industries*, Macmillan, London (1987).

Lone, H., DPhil Dissertation, University of Sussex, Brighton (1987).

Piore, M. J., and Sabel, C. F., *The Second Industrial Divide: Possibilities for Prosperity*, Basic Books, New York (1984).

Priestley, M., Institute of Development Studies, mimeo, Brighton (1988).

Sinha, S., *A Technology for the Intermediate Entrepreneur: The Place of Mini-Cement in the Indian Economy*, Economic Development Associates, Lucknow (1985).

APPENDICES

Table 1: World sugar summary ('000 tonnes, raw value)

	1987/88	1986/87	1985/86	1984/85	1983/84	1982/83	1981/82	1980/81
Production (crop year)	101,210	193,642	999,461	101,117	96,189	101,335	100,249	87,974
Consumption (calendar year)	105,469	103,945	1,009,323	98,437	96,474	93,825	92,942	78,463
Estimated loss in trade	500	500	500	500	500	500	500	500
Apparent stock adjustment	-4,759	-803	-1,971	-2,180	-785	7,010	6,807	-1,989

Estimates as at 1st October 1987

	1987/88	1986/87	1985/86	1984/85	1983/84	1982/83	1981/82	1980/81
End August stock[a]	30,351	35,110	35,913	37,884	35,704	36,489	29,479	22,672
Stock as % consumption	28.78	33.78	35.58	38.49	37.01	38.89	31.72	25.34

a: These indicated stocks are the result of combining Czarnikow estimates of production, consumption and unrecorded disappearance all carried forward from Licht's stock at 01.09.77.

Source: C. Czarnikow Ltd.

Table 2: World consumption report ('000 tonnes, raw value)

Country	Forecasts		Final Figs.	1986	1985	1984	1983	1982	1981	1980
	1988	1987								
AFRICA										
Algeria	655	646	85	637	600	650	620	600	580	550
Angola	105	105	85	105	100	105	110	90	110	110
Benin	5	5	84	6	6	8	5	7	7	7
Botswana	42	40	85	39	37	36	36	31	32	37
Burkina Faso	45	42	85	40	35	31	31	32	30	27
Burundi	10	9	85	9	7	7	6	9	6	5
Cameroon	83	80	83	76	72	68	60	60	62	56
Cape Verde Islands	9	8	84	8	8	9	8	6	6	5
Central African Republic	2	2	84	2	2	2	2	2	2	2
Chad	39	37	84	34	32	30	28	25	20	14
Comoros	3	3	84	3	3	3	3	2	3	3
Congo	22	21	84	20	19	18	18	17	15	12
Djibouti	9	9	84	9	9	8	8	8	8	8
Egypt	1,800	1,750	84	1,700	1,650	1,600	1,550	1,450	1,342	1,121
Ethiopia	179	175	85	171	144	177	170	151	147	161
Gabon	14	13	84	12	11	13	9	9	8	7
Gambia	48	45	84	42	38	40	30	25	19	18
Ghana	56	48	84	41	33	30	10	15	50	50
Guinea	39	37	84	35	33	30	30	25	25	25
Guinea Bissau	4	4	84	4	4	4	3	3	3	2
Ivory Coast	146	138	84	129	121	119	102	92	92	80
Kenya	484	463	86	462	418	375	357	351	353	328
Liberia	10	10	84	10	9	10	10	6	7	7
Libya	160	155	85	150	145	140	130	125	100	120
Malagasy	78	79	85	81	84	72	80	88	96	100
Malawi	74	70	86	73	62	53	48	52	49	43
Mali	46	45	83	44	43	42	40	40	40	35
Mauritania	47	45	83	43	41	39	35	40	32	28
Mauritius	40	40	86	40	39	40	39	38	41	39
Morocco	771	750	86	723	707	681	702	620	640	664
Mozambique	87	86	84	86	85	90	74	89	112	136
Niger	8	8	84	8	8	10	5	6	7	7
Nigeria	650	620	83	595	563	550	900	950	900	750
Rwanda	6	6	84	6	5	8	4	4	2	2
Senegal	73	74	84	75	75	71	80	75	92	75
Sierra Leone	9	10	83	11	12	13	13	14	15	20

Country										
Somalia	81	79	84	77	75	80	70	70	61	55
South Africa	1,407	1,392	86	1,381	1,368	1,334	1,340	1,330	1,303	1,291
Sudan	491	476	83	460	445	430	410	380	395	385
Swaziland	24	23	86	24	22	22	21	22	22	21
Tanzania	129	127	84	126	125	122	120	115	111	120
Togo	46	43	84	40	37	35	25	28	25	22
Tunisia	221	214	85	207	212	180	190	180	170	150
Uganda	42	39	84	36	32	35	20	20	20	15
Zaire	76	75	84	74	73	75	70	75	70	67
Zambia	135	130	85	125	113	118	111	101	116	111
Zimbabwe	253	245	86	238	225	223	212	191	174	154
Subtotal	8,715	8,521		8,317	7,987	7,836	7,945	7,668	7,532	7,045
ASIA										
Afghanisatn	141	133	83	125	117	109	109	90	76	75
Bangladesh	261	249	84	238	226	185	225	195	180	170
Brunei	6	6	84	6	6	6	6	5	6	6
Burma	87	84	83	81	78	75	75	65	65	65
China	7,250	7,000	83	6,650	6,200	5,750	5,500	5,000	4,300	4,000
China (Taiwan)	543	528	86	533	476	472	477	445	440	455
Hong Kong	124	120	83	117	114	110	100	100	100	90
India	10,000	9,750	85	8,875	8,974	8,237	7,183	6,707	5,393	5,042
Indonesia	2,223	2,150	86	2,123	1,950	1,875	1,856	1,830	1,800	1,550
Iran	1,400	1,350	83	1,350	1,364	1,352	1,327	1,249	1,301	1,455
Iraq	700	675	83	650	650	626	550	600	600	550
Israel	254	247	83	240	232	225	220	210	200	195
Japan	2,703	2,733	86	2,738	2,891	2,747	2,783	2,923	2,747	2,982
Jordan	163	155	83	148	141	133	128	125	110	89
Kampuchea	6	6	84	6	6	5	5	5	6	6
Korea (North)	117	117	83	116	116	116	120	120	110	100
Korea (South)	775	750	85	718	570	523	470	418	379	447
Kuwait	89	85	83	82	78	75	70	70	65	60
Laos	7	7	84	7	7	6	6	6	6	6
Lebanon	57	59	84	62	65	60	50	70	80	85
Macao	3	3	84	3	3	3	3	3	3	3
Malaysia	641	620	84	600	579	583	515	500	495	489
Maldives	7	6	84	6	6	5	6	6	5	5
Mongolia	50	49	84	47	45	40	40	40	40	39
Nepal	31	30	84	29	27	35	20	20	25	18
Pakistan	2,000	1,950	84	1,800	1,453	1,300	1,200	1,100	950	781

Country	1980	1981	1982	1983	1984	1985	1986	Final Figs.	Forecasts 1988	1987
Persian Gulf	115	120	135	125	125	132	134	84	139	137
Philippines	1,209	1,134	1,066	1,206	1,281	1,340	1,180	86	1,250	1,200
Saudi Arabia	325	400	425	400	375	330	340	84	360	350
Singapore	120	143	115	125	125	136	140	84	148	144
Sri Lanka	205	220	240	260	300	305	323	84	359	341
Syria	345	345	421	367	415	437	460	82	506	483
Thailand	632	642	604	660	701	721	744	86	795	769
Vietnam	225	225	250	300	350	375	425	84	500	475
Yemen (North)	85	100	100	120	129	137	145	83	161	153
Yemen (South)	42	44	46	48	55	55	58	84	63	60
Subtotal	22,066	22,855	25,304	26,665	28,509	30,342	31,299		33,919	32,974
EUROPE										
Albania	42	45	45	47	48	50	52	84	55	53
Austria	384	352	394	354	360	348	357	86	359	359
Bulgaria	425	440	400	437	442	449	455	82	467	461
Cyprus	19	19	22	18	21	23	23	84	25	24
Czechoslovakia	705	730	740	730	763	776	790	83	816	803
EEC	11,998	11,840	12,165	11,934	12,037	12,070	12,137	85	12,190	12,110
Finland	225	188	200	209	203	202	209	86	215	212
French territory (European)	8	8	8	9	10	10	10	84	10	10
Germany (East)	756	785	835	805	778	807	814	85	821	817
Gibraltar	1	1	1	1	1	1	1	84	1	1
Hungary	541	530	559	471	485	518	513	86	493	497
Iceland	12	12	12	12	13	13	14	84	15	14
Malta	14	10	10	14	15	17	14	85	14	14
Norway	174	190	140	162	167	175	170	86	180	177
Poland	1,534	1,345	1,724	1,871	2,012	1,690	1,750	85	1,800	1,750
Romania	600	610	600	605	609	618	610	83	620	615
Sweden	364	367	365	382	382	386	383	86	396	392
Switzerland	270	287	301	287	287	287	297	86	295	293
Turkey	1,097	1,119	1,332	1,335	1,429	1,443	1,496	84	1,600	1,548
USSR	12,815	12,950	13,062	13,092	13,177	13,250	13,900	83	14,250	14,250
Yugoslavia	858	850	836	798	890	914	939	83	988	963
Subtotal	32,842	32,678	33,751	33,573	34,129	34,047	34,889		35,610	35,363

NORTH AMERICAN CARIBBEAN

Bahamas	8	8	84	8	8	7	7	9	9	8
Barbados	14	14	86	14	14	14	16	15	16	16
Belize	6	6	86	6	6	7	6	7	8	7
Bermuda	2	2	84	2	2	2	2	2	2	2
Canada	1,006	1,010	85	1,013	1,050	1,072	1,010	940	941	1,014
Costa Rica	163	159	84	156	152	150	140	139	138	139
Cuba	730	725	86	762	887	728	678	649	552	530
Dominican Republic	335	318	86	295	304	258	239	212	206	209
El Salvador	178	173	86	176	159	159	154	153	142	155
Guatemala	299	292	84	284	276	265	243	262	256	256
Haiti	58	58	84	58	58	53	60	60	60	62
Honduras	123	121	85	118	120	114	97	106	119	111
Jamaica	88	90	84	92	94	95	95	92	100	117
Mexico	3,628	3,572	86	3,451	3,548	3,343	3,241	3,514	3,261	3,152
Netherlands Antilles	8	8	84	8	8	9	8	8	7	7
Nicaragua	179	171	84	164	157	154	139	134	123	126
Panama	90	87	85	84	79	76	80	78	74	70
St Kitts	2	2	85	2	2	2	2	2	2	2
Trinidad	70	68	83	66	64	62	64	55	59	60
USA	7,250	7,200	86	7,085	7,290	7,738	8,074	8,310	8,958	9,330
Other Central American	22	21	84	21	21	17	20	20	23	21
Subtotal	14,259	14,105		13,865	14,299	14,325	14,375	14,767	15,056	15,394

SOUTH AMERICA

Argentina	1,032	1,029	85	1,025	1,074	1,003	957	954	1,022	1,037
Bolivia	211	206	84	201	196	195	172	185	168	171
Nrazil	6,900	7,050	85	6,750	6,080	6,201	5,909	6,097	5,872	6,264
Chile	421	418	85	416	402	402	391	400	425	430
Colombia	1,142	1,116	86	1,101	1,044	983	1,013	1,010	1,041	992
Ecuador	298	303	84	308	313	319	321	329	312	300
Guyana	36	36	86	35	31	37	42	37	37	34
Paraguay	93	90	82	87	84	80	78	75	71	70
Peru	800	775	84	735	675	620	577	597	593	585
Surinam	16	16	84	15	15	15	14	14	14	12
Uruguay	108	107	82	106	105	104	93	99	100	102
Venezuela	781	766	83	752	737	722	706	631	669	704
Subtotal	11,838	11,912		11,531	10,756	10,681	10,273	10,428	10,324	10,701

Country	Forecasts 1988	1987	Final Figs.	1986	1985	1984	1983	1982	1981	1980
OCEANIA										
Australia	825	820	86	818	764	750	760	783	793	783
Fiji	37	36	86	35	36	36	37	40	35	33
New Zealand	171	169	84	167	165	165	157	161	155	159
Papua New Guinea	31	30	85	30	27	28	27	27	30	28
Western Samoa	3	3	84	3	3	3	3	3	3	3
Other Oceania	13	12	84	11	11	12	10	10	12	12
Subtotal	1,080	1,070		1,064	1,006	994	994	1,024	1,028	1,018
WORLD TOTAL	105,469	103,945		100,965	98,437	96,474	93,825	92,942	89,463	89,066

Source: C. Czarnikow Ltd.

Table 3: World production estimates — cane, includes amendments up to 01.10.87.
('000 tonnes, raw value)

Country	1987/88	1986/87	1985/86	1984/85	1983/84	1982/83	1981/82	1980/81
Spain (see also beet)	15	16	16	10	9	17	18	15
Argentina	1,037	1,124	1,186	1,545	1,624	1,623	1,624	1,716
Barbados	90	85	113	101	98	86	88	97
Belize	90	88	99	109	108	121	113	104
Bolivia	200	200	175	198	197	228	260	262
Brazil	8,500	8,470	8,268	9,332	9,576	9,314	8,393	8,547
Colombia	1,300	1,325	1,272	1,367	1,177	1,340	1,318	1,212
Costa Rica	200	206	218	234	240	200	182	190
Cuba	7,750	7,300	7,347	8,101	8,331	7,174	8,279	7,542
Dominican Republic	875	850	798	1,040	1,197	1,160	1,217	1,046
Ecuador	300	285	273	328	220	253	322	368
El Salvador	285	260	285	283	259	247	185	180
French West Indies	75	80	78	65	50	64	78	66
Guatemala	600	615	580	550	515	555	551	448
Guyana	250	245	261	258	256	265	305	320
Haiti	10	39	43	50	50	55	55	47
Hawaii	945	945	935	919	963	947	892	951
Honduras	220	215	220	235	226	214	221	212
Jamaica	200	210	192	209	188	202	198	204
Mexico	4,100	4,100	4,050	3,490	3,242	3,078	2,842	2,518
Nicaragua	250	240	245	240	249	257	237	202
Panama	150	125	139	160	176	206	239	185
Paraguay	75	70	80	85	80	75	77	89
Peru	700	575	610	757	605	452	622	492
Puerto Rico	78	90	90	99	88	91	103	139
St Kitts	25	30	29	27	31	29	37	33
Trinidad	95	86	92	83	67	79	79	93
USA Mainland	2,130	2,050	1,833	1,765	1,711	1,887	1,619	1,547
Uruguay (cane)	55	55	55	50	60	50	50	37
Venezuela	550	565	590	496	423	377	382	303
Other Americas	6	6	7	6	7	6	6	7
TOTAL AMERICAS	31,141	30,534	30,165	32,182	32,014	30,653	30,574	29,157

Country	1980/81	1981/82	1982/83	1983/84	1984/85	1985/86	1986/87	1987/88
Angola	27	32	28	25	23	25	30	30
Egypt (cane)	658	730	758	715	814	868	905	870
Ethiopia	165	160	192	202	196	200	185	200
Ivory Coast	135	166	187	125	121	143	155	155
Kenya	430	399	335	353	404	375	398	400
Malagasy	116	112	87	102	78	99	100	100
Malawi	156	177	183	187	160	154	168	160
Mauritius	504	610	729	640	610	684	748	711
Morocco (cane)	35	60	55	80	76	77	75	80
Mozambique	170	178	126	75	38	30	35	35
Nigeria	46	47	55	58	70	40	45	50
Reunion	242	266	272	236	261	242	260	250
South Africa	1,737	2,218	2,304	1,480	2,551	2,280	2,245	2,350
Sudan	234	275	375	455	542	491	540	575
Swaziland	328	368	402	408	425	396	537	460
Tanzania	122	122	114	143	110	105	120	125
Zaire	52	51	57	56	66	66	75	75
Zambia	111	102	117	132	141	143	150	140
Zimbabwe	358	391	405	433	433	456	513	470
Other Africa	243	264	280	283	328	355	343	351
TOTAL AFRICA	5,869	6,728	7,061	6,188	7,477	7,229	7,627	7,587
Bangladesh	155	215	190	160	95	89	197	180
China (see also beet)	2,565	2,975	3,370	2,830	3,730	4,634	4,825	4,750
China (Taiwan)	768	771	658	661	706	575	507	625
India	5,589	9,165	8,946	6,401	6,677	7,625	9,250	8,600
Indonesia	1,359	1,359	1,769	1,790	1,856	1,875	2,150	2,000
Iran (cane)	139	151	202	205	200	240	200	200
Japan (see also beet)	240	236	255	296	283	298	257	260
Malaysia	65	60	45	75	82	85	87	85
Pakistan	906	1,375	1,180	1,225	1,430	1,198	1,365	1,400
Philippines	2,395	2,530	2,533	2,418	1,771	1,571	1,340	1,300
Thailand	1,641	2,930	2,265	2,349	2,572	2,586	2,664	2,600
Vietnam	115	125	258	310	350	415	410	425
Other Asia	93	102	92	110	110	107	129	129
TOTAL ASIA	16,030	21,994	21,763	18,830	19,862	21,298	23,381	22,554

Australia	3,500	3,438	3,439	3,624	3,254	3,634	3,527	3,419
Fiji	373	519	354	497	286	506	489	411
Other Oceania	5	10	10	37	37	11	489	411
TOTAL OCEANIA	3,880	3,967	3,803	4,158	3,577	4,151	4,016	3,830
TOTAL CANE	65,177	65,525	62,511	63,689	60,618	63,645	63,330	54,901
WORLD BEET & CANE	101,210	103,642	99,461	101,117	96,189	101,335	100,249	87,974

Source: C. Czarnikow Ltd.

Table 4: World production estimates - beet, includes amendments up to 01.10.87.
('000 tonnes, raw value)

Country	1987/88	1986/87	1985/86	1984/85	1983/84	1982/83	1981/82	1980/81
Belgium	815	1,017	1,025	912	850	1,201	1,133	856
Denmark	375	542	576	595	376	584	522	464
France	3,800	3,734	4,297	4,303	3,870	4,833	5,576	4,253
Germany (West)	2,880	3,468	3,429	3,147	2,725	3,591	3,690	2,982
Greece	190	312	345	237	323	322	351	189
Irish Republic	225	202	189	241	214	242	182	160
Italy	1,750	1,868	1,352	1,297	1,352	1,282	2,226	1,932
Netherlands	1,035	1,325	975	1,014	807	1,228	1,135	951
Portugal	5	4	9	9	9	9	9	9
Spain (see also cane)	1,100	1,093	965	1,158	1,339	1,226	1,095	965
UK	1,200	1,438	1,316	1,440	1,157	1,542	1,187	1,202
EEC (beet)	13,375	15,003	14,478	14,453	13,022	16,060	17,106	13,963
Albania	40	37	40	40	35	35	40	40
Austria	375	307	468	464	385	612	486	456
Bulgaria	150	165	70	145	110	150	145	155
Czechoslovakia	800	850	935	844	750	885	750	810
Finland	110	120	103	129	155	116	99	125
Germany (East)	675	725	805	776	680	813	740	600
Hungary	500	475	533	544	518	537	605	480
Poland	1,875	1,890	1,809	1,880	2,140	2,010	1,870	1,130
Romania	570	625	600	605	450	550	550	555
Sweden	275	387	345	398	298	389	370	333
Switzerland	120	129	139	131	124	120	135	105
Turkey	1,650	1,450	1,398	1,654	1,770	1,860	1,518	944
USSR	8,000	8,750	8,250	8,550	8,750	7,400	6,100	7,150
Yugoslavia	950	850	1,010	980	772	708	871	729
EUROPE TOTAL	29.465	31,763	30,983	31,593	29,959	32,245	31,385	27,575
Other Beet								
Canada	115	122	55	113	110	126	140	105
Chile	450	455	483	350	360	230	136	267
China (see also cane)	850	900	983	955	1,020	815	720	695
Iran (see also cane)	500	475	545	490	515	565	439	512

Japan (see also cane)	685	685	624	647	510	667	537	582
Morocco (see cane)	350	330	303	352	370	335	300	317
USA (see also cane)	3,325	3,098	2,719	2,633	2,449	2,483	3,074	2,857
Uruguay (see cane)	30	30	35	25	30	45	50	42
Other beet	263	249	220	268	248	179	138	121
TOTAL BEET	36,033	38,117	36,950	37,428	35,571	37,690	36,919	33,073

Source: C. Czarnikow Ltd.

APPENDIX II

Edward Mallorie

FINANCIAL APPRAISAL

Table 1: Physical parameters

Products (S=sugar, (M=molasses, J=jaggery)	S,M	S,M	S,M	S,J	J
Capacity	3,600	450	100	100	45
Season length (days)	250	250	240	240	160
Operate[a] (days/yr)	220	231	234	234	160
Capacity utilization[b] (%)	90	90	90	90	90
Cane milled (t/yr)	712,356	93,387	21,023	21,023	6,480
Rendement (sugar)	11	11.2	8	5.5	
Molasses yield (%)	4	4	4.2		
Jaggery yield (%)				6.7	9
Output: sugar	78,359	10,459	1,682	1,156	0
(t) molasses	28,494	3,735	883	0	0
jaggery	0	0	0	1,409	583

a. Operating days per year is average, weighted by discount rate, of season length over 20 years allowing for the following build-up (%) to full production:

	VP	MVP	OPS1	OPS2	JAG
Year: 1	40	50	75	75	100
2	60	75	100	100	100
3	80	100	100	100	100
4+	100	100	100	100	100

b. Capacity utilization is utilization per day of operation, and excludes planned shut downs or restricted cane supplies.

Table 2: Price assumptions, financial prices (KSh/t unless other unit shown)

	VP	MVP	OPS1	OPS2	JAG
Cane at mill gate	341	341	341	341	170
Chemicals/tonne cane	4.21	4.21	10.62	10.62	
Bags/tonne cane	10.29	10.47	7.48	11.41	7.65
Fuel: furnace oil	2,282	2,282			
diesel (KSh/1)	5.69	5.69			
IDO (KSh/1)			4.13	4.13	4.13
firewood			250	250	250
Sugar, ex-mill	5,830	5,830	6,459	6,459	
Molasses	200	200	670		
Jaggery				3,571	4,286

Table 3: Sugar price structure, 1987 (KSh/t)

	VP price	OPS price
Retail price	8,150	8,150
Retail margin	568	568
Wholesale price	7,582	7,582
Wholesale margin	122.50	122.50
KNTC selling price	7,459.50	7,459.50
KNTC margin	123	
Ramisi margin	13	
MoC distribution	493.50	
Excise duty	1,000	1,000
Ex-mill price	5,830	6,459.50

Table 4: Input requirements (KSh unless other unit shown)

		VP	MVP	OPS1	OPS2	JAG
FUEL REQUIREMENTS (per day)						
Operation:						
furnace oil (t)		1	0.25			
IDO (1)				760	760	192
Shutdown:						
diesel (1)		157	96			
IDO (1)				21	21	
Total fuel cost pa.		631,382	204,972	744,599	744,599	126,874
MAINTENANCE						
As % equipment cost		2	2	7	7	10
LABOUR REQUIREMENT AND COST (financial prices)						
				Number of staff employed		
PERMANENT (salary/month)						
General manager	23,000	1	1	0	0	0
Manager	11,500	6	0	1	1	0
Department head	6,900	21	4	0	0	0
Foreman	4,600	0	0	0	0	0
Skilled	3,450	62	15	4	4	1
Trained	1,150	114	41	5	5	4
Instructed	850	260	72	0	0	0
Unskilled	475	229	68	5	5	1
Allowances:	plus 30%					
SHIFT WORKERS (wage/day)						
Supervisors	45			12	12	6
Shift workers	21.85			146	146	36
Total labour cost pa.		14,222,130	3,790,800	1,341,541	1,381,536	132,990

Table 5: Capital investment, financial prices (KSh '000)[a]

	VP	MVP	OPS1	OPS2	JAG
Furnaces			1,595	1,595	440
Mill equipment	722,477	199,571	4,631	3,254	317
Gensets, engines			1,189	1,189	220
Mill civils, etc.	288,991	39,914	3,173	2,679	363
Staff houses	196,000	32,667	100	100	0
Site works	28,899	3,991	317	268	0
Access roads: 180 km	11,000				
Mill vehicles	10,925	1,456	288	288	144
Factory site	100	100	27	27	27
Construction interest	251,678	27,770	566	470	38
Pre-operating costs	29,428	3,735	363	355	22
TOTAL	1,539,499	309,205	12,250	10,224	1,571

a. Depreciation (life years) is taken to be as follows:

	VP/MVP	OPS	JAG
Furnaces	0	5	3
Mill equipment	20	10	10
Gensets, engines		4	20
Mill civils, etc.	20	20	10
Staff houses	20	20	10
Site works	20	20	10
Access roads: 180 km	20	20	10
Mill vehicles	4	4	4
Construction interest	20	20	20

Table 6: Capital and operating costs, annual basis, financial prices[a] (KSh '000)

	VP	MVP	OPS1	OPS2	JAG
CAPITAL					
Furnaces			421	421	177
Mill equipment	84,862	23,442	754	530	52
Gensets, engines			375	375	26
Mill civils etc.	33,945	4,688	373	315	59
Staff houses	23,022	3,837	12	12	0
Site works	3,394	469	37	31	0
Access roads: 180km	1,292	0	0	0	0
Mill vehicles	3,447	459	91	91	45
Factory site	10	10	3	3	3
Construction interest and pre-operating costs	33,019	3,701	109	97	7
Total capital	182,991	36,606	2,174	1,874	369
OPERATING					
Cane at mill gate	242,913	31,845	7,169	7,169	1,102
Chemicals and bags	10,328	1,371	380	463	50
Fuel	631	205	745	745	127
Maintenance	14,450	3,991	407	311	54
Labour	14,222	3,791	1,342	1,382	133
Management assistance	20,000	5,000	0	0	0
Vehicles and misc.	10,185	2,159	431	435	81
Total operating	312,729	48,362	10,474	10,504	1,546
TOTAL COSTS	495,720	84,968	12,648	12,377	1,915
REVENUE					
Sugar	456,834	60,978	10,863	7,468	0
Molasses	5,699	747	592	0	0
Jaggery	0	0	0	5,030	2,500
TOTAL REVENUE	462,533	61,725	11,455	12,498	2,500
NET MARGIN	-33,187	-23,243	-1,193	121	585

a. The interest rate is assumed to be 10%.

Table 7: Financial and economic prices (KSh unless other unit shown)

	Financial prices			Conversion	Economic prices		
	Maize	OPS cane	VP cane	factor	Maize	OPS cane	VP cane
Ploughing	840	840	840	1	840	840	840
Other mechanical cultivation			1,400	1	0	0	1,400
Seed	237.5	2,728	2,728	1	237.5	2,728	2,728
Seed transport			568	1	0	0	568
Fertiliser: kg/ha							
N	50	85	85				
P	80	106	212				
cost/ha:							
N (@ KSh/kg 11.18)	559	950	950	1	559	950	950
P (@ KSh/kg 11.3)	904	1,198	2,396	1	904	1,198	2,396
Chemicals	68		500	1.05	71.4	0	525
Labour: person/days							
cultivate	121	310	245		121	310	245
harvest		112	60			112	60
KSh/day: cultivate	7.5	9.5	15		7.5	7.5	7.5
harvest		15	25			7.5	7.5
KSh/ha : cultivate	908	2,945	3,675		908	2,325	1,838
harvest	0	1,679	1,508		0	839	452
Harvest machinery			6,902	1			6,902
Crop transport:							
KSh/tonne		63	71	1		63	71
KSh/ha		13,545	20,590			13,545	20,590
Total costs	3,516	23,885	42,057		3,519	22,425	39,189
Yield/ha: tonnes	3.6	215	290		3.6	215	290
Price/tonne	2,089	341	341	Import parity	3,404		
Income/ha	7,520	73,315	98,890		12,255		
Gross margin.	4,004	49,430	56,833		8,735		
OPPORTUNITY COST OF SUGAR CANE							
Crop cycle: months	9	56	58		9	56	58
Costs/ha/yr		5,118	8,701			4,805	8,108
Land rent/ha/yr[a]		4,004	4,004			8,735	8,735
Total		9,123	12,706			13,541	16,843
Yield/ha/yr: tonnes		46	60			46	60
Total cost/tonne		198	212			294	281

a. Land rent = maize gross margin.

Sources: CSP, 1986; Mallorie, 1984.

Table 8

	Export US cents/lb		Import US cents/lb	
SUGAR	High	Low	High	Low
'World price' (raw sugar fob Carribean)	17.1	10	17.1	10
Adjust to mill white grade	0.9	0.6	0.9	0.6
Ocean freight and insurance			1.3	1.3
Total	18	10.6	19.3	11.9
= US $/tonne	397	234	425	262
	KSh/tonne	KSh/tonne	KSh/tonne	KSh/tonne
FOB/CIF @ SER: $ = KSh 19.63	7,791	4,588	8,353	5,150
Wharfage, insurance etc.	- 112	- 112	90	75
Inland transport	- 450	- 450		
Export quality bags	- 111	- 111		
Total	7,118	3,915	8,443	5,225
MAIZE	$/tonne		$/tonne	
'World price' (fob US Gulf)	131		131	
Ocean freight and insurance			20	
Bags			20	
Total	131		171	
	KSh/tonne		KSh/tonne	
FOB/CIF @ SER: $ =Sh.19.63	2,572		3,357	
Wharfage, insurance	- 47		47	
Inland transport, drying	- 434			
Bags	- 159			
Total	1,932		3,404	
MOLASSES	$/tonne			
FOB US $ in Mombasa	60			
	KSh/tonne			
FOB/CIF @ SER: $ = KSh 19.63	1,178			
Inland transport	- 450			
Wharfage, insurance	- 47			
Total	681			

Source: Mallorie, 1984.

217

Table 9: Physical parameters

	VP	MVP	OPS1	OPS2	JAG
Products (S=sugar, M=molasses, J=jaggery)	S,M	S,M	S,M	S,J	J
Capacity (tcd)	3,600	450	100	100	45
Season length (days)	250	250	240	240	160
Operate[a] (days/yr)	220	231	234	234	160
Capacity utilisation[b] (%)	90	90	90	90	90
Cane milled (t/yr)	712,356	93,387	21,023	21,023	6,480
Rendement (sugar)	11	11.2	8	5.5	
Molasses yield (%)	4	4	4.2		
Jaggery yield (%)				6.7	9
Output: sugar	78,359	10,459	1,682	1,156	0
(t) molasses	28,494	3,735	883	0	0
jaggery	0	0	0	1,409	583

a. See financial appraisal, Table 1.

Table 10: Price assumptions, economic prices (KSh/t unless other unit shown)

	VP	MVP	OPS1	OPS2	JAG
Cane at mill gate	281	281	294	294	294
Chemicals/tonne cane	4.21	4.21	10.62	10.62	
Bags per tonne cane	10.29	10.47	7.48	11.41	7.65
Fuel: furnace oil	2,453	2,453			
diesel (KSh/l)	4.75	4.75			
IDO (KSh/l)			4.75	4.75	4.75
firewood			250	250	250
Sugar (ex-mill)	5,225	5,225	5,854	5,854	
Molasses	681	681	670		
Jaggery				3,571	4,286

Table 11: Input requirements (KSh unless other unit shown)

		VP	MVP	OPS1	OPS2	JAG
FUEL REQUIREMENTS (per day)						
Operation:						
furnace oil (t)		1	0.25			
IDO (1)				760	760	192
Shutdown:						
diesel (1)		157	96			
IDO (1)				21	21	
Total fuel cost pa.		647,581	202,702	856,289	856,289	145,905
MAINTENANCE						
As % equipment cost		2	2	7	7	10
LABOUR REQUIREMENT AND COST (economic prices)						
		Number of staff employed				
PERMANENT (salary/mnth)						
General manager	23,000	1	1	0	0	0
Manager	11,500	6	0	1	1	0
Department head	6,900	21	4	0	0	0
Foreman	4,600	0	0	0	0	0
Skilled	3,450	62	15	4	4	1
Trained	1,150	114	41	5	5	4
Instructed	467.5	260	72	0	0	0
Unskilled	261.25	229	68	5	5	1
Allowances:	plus 30%					
SHIFT WORKERS	(wage/day)					
Supervisors	45			12	12	6
Shift workers	12.02			146	146	36
Total labour cost pa.		11,907,110	3,134,430	1,009,245	1,033,848	129,656

Table 12: Capital investment, economic prices (KSh '000)[a]

	VP	MVP	OPS1	OPS2	JAG
Furnaces			1,595	1,595	440
Mill equipment	687,599	189,937	4,348	2,998	317
Gensets, engines			1,037	1,037	220
Mill civils etc.	275,040	37,987	3,108	2,618	363
Staff houses	196,000	32,667	100	100	0
Site works	27,504	3,799	311	262	0
Access roads: 180km	11,000				
Mill vehicles	10,925	1,456	288	288	144
Factory site	100	100	27	27	27
Construction interest	241,634	26,595	541	446	38
Pre-operating costs	27,735	3,496	298	286	22
TOTAL	1,477,536	296,036	11,652	9,657	1,571

a. Depreciation — see financial appraisal, Table 5.

Table 13: Capital and operating costs, annual basis, economic prices[a] (KSh '000)

	VP	MVP	OPS1	OPS2	JAG
CAPITAL					
Furnaces			421	421	177
Mill equipment	80,765	22,310	708	488	52
Gensets, engines			327	327	26
Mill civils etc.	32,306	4,462	365	307	59
Staff houses	23,022	3,837	12	12	0
Site works	3,231	446	37	31	0
Access roads: 180km	1,292	0	0	0	0
Mill vehicles	3,447	459	91	91	45
Factory site	10	10	3	3	3
Construction interest and pre-operating costs	31,640	3,534	98	86	7
Total capital	175,712	35,059	2,061	1,765	369
OPERATING					
Cane at mill gate	199,974	26,216	6,179	6,179	1,905
Chemicals and bags	10,328	1,371	380	463	50
Fuel	648	203	856	856	146
Maintenance	13,752	3,799	377	282	54
Labour	11,907	3,134	1,009	1,034	130
Management assistance	20,000	5,000	0	0	0
Vehicles and misc.	9,811	2,052	400	401	83
Total operating	266,419	41,775	9,202	9,216	2,367
TOTAL COSTS	442,131	76,834	11,263	10,981	2,735
REVENUE					
Sugar	409,458	54,654	9,846	6,769	0
Molasses	19,402	2,544	592	0	0
Jaggery	0	0	0	5,030	2,500
TOTAL REVENUE	428,860	57,198	10,438	11,799	2,500
NET MARGIN	-13,270	-19,636	-825	818	-236

a. Interest rate as in financial appraisal, Table 6.

Table 14: Cost per tonne of sugar, economic prices (KSh)

	VP	MVP	OPS1
CAPITAL	2,242	3,352	1,225
OPERATING			
Cane at mill gate	2,552	2,506	3,674
Chemicals and bags	132	131	226
Fuel	8	19	509
Maintenance and misc.	301	559	462
Labour	152	300	600
Management assistance	255	478	0
Total operating	3,400	3,994	5,471
TOTAL COSTS	5,642	7,346	6,696
REVENUE			
Sugar	5,225	5,225	5,854
Molasses	248	243	352
TOTAL REVENUE	5,473	5,469	6,206
NET MARGIN	-169	-1,877	-490

Table 15: Estimated cost of capital equipment

	FOB	CIF	DUTY	CLEARANCE	TOTAL
OPS FACTORY (KSh '000) add:		117%	30%	15%	
6 roll mill & motors	940.68	1,100.60	330.18	165.09	1,595.87
Weighbridge	201.20	235.40	70.62	35.31	341.33
Gensets	700.91	820.07	246.02	123.01	1,189.09
For 1 — 3 sugars					
Other imported equipment	770.46	901.44	270.43	135.22	1,307.09
Local fabrication	1,386.71				1,386.71
For 1st sugar only					
Other imported equipment	436.00	510.12	153.04	76.52	739.67
Local fabrication	576.76				576.76
Total 1-3 sugars					5,820.09
Total 1st sugar					4,442.72

	sq. m	KSh/sq. m	TOTAL		
Civils 1-3 sugars	2,000	1,150	2,300		
Civils 1st sugars	1,750	1,150	2,013		
Installation 1-3 sugar			873		
Installation 1st sugar			666		
Total 1-3 sugars			3,173		
Total 1st sugars			2,679		

	FOB	CIF	DUTY	CLEARANCE	TOTAL
VP AND MVP MILLS (KSh mill.) add:		108%	30%	15%	
VP Equipment	461.35	498.26	149.48	74.74	722.48
MVP Equipment	127.44	137.64	41.29	20.65	199.57

APPENDIX III

Lex Lemmens

INTERVIEWS WITH KEY INFORMANTS AND REPRESENTATIVES OF DIFFERENT SUB-GROUPS IN THE RESEARCH AREA OF KABRAS[1]

Sub-chiefs

The first sign of sugar cane in the area was to be seen in 1947, but only in the late sixties did most farmers realize the importance of sugar cane. In 1969 the first farmer to own a jaggery factory emerged. After the start of his factory more farmers started growing sugar cane. A real boom in sugar cane growing came after the start of the Kabras factory in 1981.

The reasons why farmers started to grow sugar cane were generally to improve their lives both socially and economically. They wanted to build schools, earn money for the necessary school fees and improve the communication network. The farmers considered sugar cane a good crop to integrate with their crop rotating programme or to fill up the fallow parts of their land. The money that could be earned they wanted to use for buying graded cattle.

Positive impacts of the sugar cane industry are that the farmers now get more money than they were getting before from growing maize. Farming has been improved as the farmers were encouraged to use their land properly. Many families have improved their social and economic situation. A lot of people have been employed as a result of the coming of the sugar industry. Most people have built good houses. They have improved their clothing and many farmers have bought cattle for the production of milk. More people than before were able to start a business. To enable easy transport of sugar cane, more 'all weather' roads have been constructed. After the introduction of the sugar cane in this area, more schools were built with the help of Harambee funds. Most of that money came from sugar cane farmers. Also the Shamberere Polytechnic was started.

The sugar industry in Kabras also had some negative impacts. Food production has decreased and malnutrition has affected most of the families involved. The increasing area under sugar cane provides a hiding place for wild animals that are harmful to the farmers, their crops and their dairy cattle. The farmers are now encountering many problems in dealing with the sugar industry.

The problems of the farmers with the sugar factory concentrate on the issue of getting a permit. The managers give permits to certain individuals instead of just giving a permit to any farmer whose sugar cane is ready to be cut. Permits are not given in time when the cane is mature, thus leaving the farmers with a delay in the harvesting of the cane. When a farmer, after a long struggle, gets a permit he cuts all his cane. The factory then sends only two tractors to collect the cane leaving the rest of the cane rotting in the field.

The jaggery factories also cause problems, mainly because they do not use a weighbridge to measure the amount of cane delivered by the farmers.

Sugar cane growing farmers

First male farmer: I was born in 1936 here at Chesero. At home we were six boys and two girls. My father had two wives but the first wife was barren. My father cultivated the land and looked after the cattle. We, the boys, also did this work for some time before we went to school. The girls used to help my mother in the household work until they got married. My father had a negative attitude towards the girls and as such he never sent them to school. We had six acres of land. We mainly grew maize as the source of our food. However, we also grew millet, simsim, cassava and potatoes but on a much smaller scale. When we went to school my father could call in relatives to work on the

farm and the girls were the ones that had the responsibility for the cattle. At that time there were not many serious problems. The most serious problem was that my barren stepmother was very hostile towards us and our mother.

My own household consists of one wife and four children, three boys and one girl. They are still small and not yet working. I just depend on my land for a living. I have one and a half acres of land. I mainly grow maize near the stream where the soil is fertile. I have half an acre of my land under sugar cane. I also grow some vegetables and potatoes. The work on the land is done just by me and my wife.

Most problems I experience are economic. There is not enough money to educate, feed and dress the family and care for their health. When West Keny Sugar Factory came, in the year 1981, we were very happy because we had heard how the people of Mumias were benefiting from the sugar cane growing. We were expecting to get money from growing cane and prosper very quickly. We thought that problems with the school fees could now be solved; that we could build good houses and improve our standards of living. But in my opinion life before the coming of the sugar factory was better than it is at present. Our expectations with respect to the sugar factory are not fulfilled. All that we got was disillusionment and up to now our expectations have remained dreams.

There is hardly any positive impact from cane growing because the input is greater than the outcome. We farmers really do not gain anything. Maybe the only positive impact that I can mention is the fact that the factory can advance a farmer KSh 1,000 if he is having problems and if his cane is over 16 months old. I actually cannot see any change brought about by cane farming. Life has not improved. In fact only the land available for food crops has been reduced.

I am thinking of stopping sugar cane growing if another cash crop is introduced. If only the Mumias Sugar Company would extend its outgrowers farms up to this area, we might be able to benefit. There was a time that we could get permits to transport our sugar cane to the Nzoia factory and we were very well paid then.

As for food crops I will continue to grow maize, vegetables and any other crop that will be available.

Second male farmer: I was born here in the Bushu sub-location in the year 1939. My father had three wives and several children, but most of them died when they were still young. Currently we are four boys and two girls. My father had a very big herd of cattle and also owned a large piece of land. Both the boys and the girls used to work on the farm in the mornings. After that, the boys could go to look after the cattle while the girls could help their mother in the household work.

At home we mainly grew maize and some millet and finger millet on a small scale. We had a form of co-operative with our neighbours and we worked in turn on each member's land. In those days there were hardly any problems. People were very sociable and used to see each other as brothers. If there were any problems it must have been those of daily life that were hardly noticeable.

Currently I have two wives and twelve children. I myself am working as a carpenter, my wives are unemployed. I have eight acres of land of which two are under sugar cane. I grow a lot of maize for my own consumption and I even have a surplus that is sold on the market. Then still two acres are left for grazing. The work on the farm is all done by myself. My children also give a hand during their holidays.

The West Kenya Sugar Factory was introduced in 1981. The reaction of the people on the coming of the factory was different. Some were enthusiastic because they knew of the benefits of cane growing. Others were very much against it because it meant that some people were forced to migrate.

After all I think that life before the coming of the factory was better. The introduction of sugar cane growing has led to so many problems. We farmers do all the work on the farm: we prepare the land, have to look for the seed cane ourselves, do the planting and all the weeding. The factory does not provide fertilizer and so the cane does not grow well.

If another cash crop will be introduced I will try it if I can be sure that it will not pose the problems that sugar cane growing has done. But now I think I still have to grow more sugar cane, as I understand that there is another sugar factory under construction at Kambalamba near Chimanget at the junction at Malava. If this is true, there might be a competition for cane resulting in higher prices.

First female farmer: I was born in the Chesero sub-location, South Kabras, in the year 1942. My father was a guard, my mother was a farmer. I had four brothers and two sisters. The household owned sixteen acres of land on which food crops such as millet, cassava, potatoes, maize, peas and beans were planted. We also owned a lot of cattle. Cultivation of the land was done by both men and women. My father owned an ox-plough and used it to prepare the soil for planting. The whole family would then go out to plant. Weeding was done with hoes by the father, the mother and the daughters. The boys had to look after the cows. There were so many members of the family available that no labourers were hired to work on the farm. The soil was not very good, so the yield in most cases was very poor. This forced us to be very economical in our way of eating in order to ensure that the food could carry us up to the next season's yield.

I got married in Bushu sub-location. I am widowed now and therefore act as the household head. I have five sons and three daughters. From the seven acres of land, I have three acres under sugar cane. A piece of two acres is under maize and beans which are also planted as a cash crop. For food crops I plant bananas, potatoes, yams,

vegetables and cassava. I do not keep any cattle. My sons are all working; they have salaried jobs, so I have to rely on hired labour to work on my farm. I hire a tractor for ploughing the sugar fields. An ox-plough is used for the maize and beans field. A group of women is hired to do the weeding with hoes.

The West Kenya Sugar Factory began in 1981. At that time the chiefs and sub-chiefs announced the coming of the factory to the people, and the farmers were invited to grow sugar cane and sell it to the factory. I was not interested in the cane then. My husband had a well-paid job as a driver and the children were small and did not need education yet.

Later, when I lost my husband, I started to grow cane. The sugar cane helped me in educating the children and helped them to a salaried job. Now I do not need the money any longer and the sugar cane is taking too much of my time. Therefore I have decided to do my last cane harvest this year and then only grow maize and beans as a cash crop.

Second female farmer: I was born in 1920 in the Bushu sub-location. My father had only one wife. I had five brothers and one sister. I cannot remember how much land we had, but it must have been more than twenty acres. Besides, in those days people had no specific land allocated to them. One was allowed to move freely and cultivate anywhere one would like to. People were only bound by the tribe or the clan they belonged to. We did not plant any cash crop.

As food crops we cultivated millet, cassava, sorghum, potatoes, simsim and vegetables. We also had many cows. Cultivation of the land was done with the help of women from the village. They did the ploughing, the planting, the weeding and the harvesting. Men's work was only slashing and clearing of the land in preparation for ploughing. Children, both girls and boys, were to take the cattle out for grazing. My mother brewed beer which was given to the women as a token of thanks for the help offered.

At that time there was plenty of food and my mother had no problems in feeding the family. Problems could arise from natural calamities such as drought or destruction of the crops by pests. The most common pests were locusts. When they came the only food crops which could survive were potatoes and cassava. When locusts were expected the chiefs advised the people to grow a lot of these crops.

I am married in the same sub-location were I was born. I am the only wife of my husband. We have six children, one girl and five boys. We have fifteen acres of land. Sugar cane takes nine acres, two acres are under maize which we intercrop with beans. On one acre we intercrop bananas with vegetables and two acres are used for grazing. The rest is fallow because of stones. I work on the farm together with the five boys while my husband is looking after the cattle. We hire labourers to work in the sugar cane plantation. We have had our own ox-plough for ploughing since 1943.

I encounter problems with feeding the household. My sons are all married and we use our land all together, but the food produced is not enough to feed the whole family.

At the time the sugar factory came into the area the chiefs and sub-chiefs called to farmers to plant sugar cane and sell it to the factory. The interested farmers were instructed how to prepare the land and how to plant the cane. Everyone was so excited about it because they were promised a lot of income from the cane. All of us were then planning to educate our children and even to build a better house. The high expectations have, however, faded as time went by. Less food is produced because very little land is reserved for food crops. People get a lot of money but are forced to buy the food they need. This is unlike the old days, before cane was introduced. As a result the money from the sugar cane is not serving the purposes expected.

Some people have not even been able to put up a better house, while others still cannot take their children to school. Only those who have been able to divide the land properly amongst the different crops have been able to build good houses and educate their children.

The tasks for us women have been drastically reduced. These days men help in the ploughing, weeding and they even do the harvest. In some houses, however, the women are treated like slaves. They must do only what the husbands tell them to do. Such treatment was very rare in the old days. Most men take all the money for themselves and yet expect the women to feed the household.

As time goes on people should withdraw from sugar cane growing and only grow maize and beans as a cash crop. After all, these can be used as food crops as well. Potatoes, bananas, millet, sorghum and vegetables should be planted as food crops. If a son marries, he should get a portion of land as soon as possible. That should reduce the food problem encountered by the very large households.

Educating children is good, but the Government should create jobs for them as soon as they leave school. It really discourages parents when, after paying so much in fees, they end up with a jobless child who maybe has done its best in school.

Third female farmer: I was born in 1927 in Sulungai, a sub-location of North Kabras. My father had only one wife. Ten children were born by my mother, of which six died. The four remaining are two girls and two boys. My parents were in business and my father owned ten acres of land.

The two boys grew up into farming and the two girls got married. Our land was not divided amongst the family members. On the land food crops were grown including millet, sorghum, cassava, simsim, nuts and peas. No crop

was planted as a cash crop. Each food crop was planted in plenty. The surplus was exchanged for meat or other things we needed. All the work on the farm was done with hoes. The amount of labour needed was therefore very large. Assistance was given by fellow villagers. Such labourers were not paid with money. My mother would brew some beer and then call neighbours to come and work on the farm, after which they would assemble at home and drink the beer. There was no problem in feeding the family because it was a small family and there was plenty of food.

This nice situation changed when I got married to a family of four wives, myself being the second wife. In total there are nineteen children. I gave birth to twelve children, but six of them died. The whole family depends on farming as the only source of income. My husband has only eight acres of land equally divided amongst the family members, which means two acres for each wife. On my piece of land I plant food crops like maize, beans, vegetables, yams, bananas and vegetables. I have planted half an acre of sugar cane as a cash crop. I do all the cultivation myself with the help of my children, except for the cultivation of sugar cane where I hire labour for the planting, the weeding and the harvesting. I pay seven Shillings per worker per day.

It is very difficult to feed my family because the food grown is not enough. Maize that was harvested last year, for instance, only lasted up to February this year.

The half an acre of cane is sold to the West Kenya Sugar factory. At the start of the factory, chiefs and sub-chiefs announced that people should plant sugar cane and that it was going to bring them a lot of money. Everybody became very enthusiastic. The people were advised to buy the plant canes by themselves from the Mumias area. This was done and very soon cane was planted everywhere. By 1981 cane was being delivered to the factory by the farmers. Payments were done on cane delivery. Though cane growing required too much labour input, these payments stimulated the farmers to work even harder and plant more cane. The people even thought that the factory would supply the farmers with white sugar. Parents even encouraged their children to be employed as factory workers, in the hope that free white sugar would be supplied to them.

The planting of sugar cane has raised the living standard of most people. Some have managed to educate their children, while others have bought more land or built better houses.

It also had some negative impacts on the people. As a result of planting sugar cane, less land has been left for food crops and therefore hunger often strikes the people. Some people have even decided to quit planting the cane and instead use the land for food crops. The results of this change have been very discouraging because the soil was found to have lost all its nutrients and is no longer productive. Maybe after all maize and beans is a better cash crop.

I hope that the government will provide employment for my children. I also hope that children can be born freely and birth control is abandoned. People should get back to the traditional way of life. Also a change is needed in that women seem to be doing all the donkey work while men sit back. Men should carry out more duties such as cultivation, cattle keeping, provision of food and many others.

Non-sugar cane growing farmers

Male farmer: I was born in Chesero in 1936. My father had three wives, all of them being sisters. I cannot really remember the number of children but most of them died when they were still young. Ten children are still alive, six boys and four girls. My father was principally a farmer. He used to plant maize in plenty because he earned his living by selling the surplus. He also had many cattle. At home the boys had to help on the farm. My father loved his daughters so much that they only had to help my mother with her daily household work.

We had a very big piece of land of which I cannot remember the acreage. We principally grew maize as our staple food but we also grew beans, potatoes, millet, vegetables and cassava, though on a small scale. Normally the sons and my father did the work. When there was too much work our neighbours and relatives would come to give us a hand. The problems we then encountered were just the usual hardships in every day life. Maybe there were quarrels in our polygamous house, but that is normal and unavoidable. I think I would be wrong if I do not cite the diseases that killed most of my brothers and sisters, otherwise there were no problems.

Currently I am married to two wives and I have ten children. All my children are still at school. I know some elementary mechanics but I depend on my land for my living. I principally grow maize which has a ready market in Kakamega. During the dry season I really get a lot of money from maize, especially from the Wanga people in Mumias. Most of the time I use hired labour to work on the land. There are so many refugees from Uganda who offer cheap labour. Occasionally, when the children are at home for holidays, they give a hand.

I am not in sugar cane growing because when the crop was introduced I was still in a land dispute with my neighbour. When I won the case I really had hopes of planting sugar cane, but when I heard from my friends that they were not gaining much from cane I decided to continue with maize farming which I think pays very well. In my opinion people in this area who plant maize are better off than those who went into cane farming. I would very much welcome coffee or tobacco growing if they would be introduced in the area. If Mumias Sugar Company would extend its plots up to these sides I will be very willing to grow sugar cane. Otherwise I will continue growing maize as I have done until now.

Note

1. The reproduction of a limited number of interviews has the inherent danger that details are taken out of their context in the analyses and take on their own life. It is therefore emphasized that all information recorded in the interviews is based on the opinion of individuals. Conclusions cannot be drawn on basis of these interviews; they should be the result of a careful analysis of the features mentioned in the interviews. The interviews are presented as they were recorded by the various Kenyan research assistants. In order not to effect their authentic character, corrections with respect to the

Appendix IV

W. A. Mlaki

Table 1: Production and consumption of sugar in Tanzania

Year	Production[a] (tonnes)	Imports[b] (tonnes)	Exports[a] tonnes	Total available (tonnes)	Population (million)	Consumption per capita (kg)
1975/76	94,600	11,000	29,315	76,285	16.1	4.7
1976/77	99,200	19,400	11,775	106,825	16.6	6.4
1977/78	91,174	22,550	10,940	102,784	17.1	6.0
1978/79	122,808	22,000	13,950	158,758	17.7	9.0
1979/80	121,236	27,800	19,903	129,133	18.3	7.1
1980/81	114,231	5,000	-	119,231	18.9	6.3
1981/82	115,465	-	9,974	105,491	19.5	5.4
1982/83	98,065	-	10,300	87,765	20.1	4.4
1983/84	131,269	2,000	11,028	122,241	20.8	5.9
1984/85	106,164	2,524	10,786	97,902	21.5	4.6
1985/86	100,339	2,878	10,090	92,308	22.2	4.2

Sources:
a. Sugar Development Corporation.
b. *World Development Report,* 1986.

Table 2: Supply vs demand in 1985 and demand/production for 1990 and 2000 by region

Region	Supply, 1985	Demand, 1985	Demand, 1990	Demand, 2000
Dar es Salaam and coast	37,900	28,600	42,600	81,500
Morogoro	3,700	6,600	8,700	12,600
Dodoma	3,700	7,600	9,700	14,000
Tabora	2,800	6,200	8,600	13,100
Kigoma	1,900	4,900	6,300	8,900
Shinyanga	3,700	10,600	13,900	20,300
Mwanza	4,600	11,300	14,700	21,600
Mara	1,900	8,600	10,300	13,400
Kagera	2,800	8,100	10,700	16,000
Iringa	2,800	7,000	8,800	12,400
Mbeya	2,800	7,500	9,700	14,600
Ruvuma	1,900	4,400	5,800	8,800
Mtwara	1,900	4,600	5,700	7,600
Tanga	5,625	8,300	10,200	14,800
Kilimanjaro	4,600	8,000	10,000	13,800
Arusha	4,600	8,900	12,200	18,300
Singida	1,900	4,700	5,900	9,500
Lindi	1,900	3,900	4,800	6,100
Rukwa	1,900	3,800	5,300	8,700

Source: *Tanzania National Food Strategy,* Ministry of Agriculture and Livestock Development, 1984.

Table 3: Estimated regional demand for sugar[a]

Region	Population base, 1978	Rate	Estimated population, 1985 (tonnes)	Estimated sugar demand, 1985
Arusha	928,478	3.9	1,213,610	16,991
Kilimanjaro	902,394	3.0	1,109,827	15,827
Morogoro	930,190	2.9	1,147,256	16,061
Coast	516,949	1.7	581,690	8,143
Mtwara	771,726	2.0	886,468	12,410
Mwanza	1,443,418	2.9	1,763,192	24,684
Mbeya	1,080,241	3.3	1,745,714	24,439
Mara	723,295	2.6	742,100	10,389
Kigoma	648,950	2.9	792,715	
Tanga	1,038,592	2.7	1,251,518	17,521
Dodoma	971,421	2.9	1,187,238	16,621
Dar es Salaam	851,522	8.2	1,478,378	44,351
Lindi	527,902	2.1	610,563	8,548
Ruvuma	564,113	3.3	708,054	9,912
Iringa	992,001	2.7	1,111,987	15,567
Singida	614,030	2.7	739,914	10,358
Tabora	818,049	4.5	1,113,248	15,585
Rukwa	451,897	4.6	619,070	8,666
Shinyanga	1,323,482	3.6	1,439,074	20,147
Kagera	1,009,379	4.0	1,328,271	18,595
Total			21,569,887	325,623

a. Per capita sugar demand = 14 kg (except for Dar es Salaam = 30 kg).

Source: Sugar Development Corporation.

GLOSSARY

A short list of technical terms is given here. Most of them are more closely defined in the various technical papers.

Bagasse The crushed cane stalks remaining once the juice has been extracted.

Brix The percentage of solid material (sugars and non-sugars) in a sugar solution.

Extraction The process of crushing the cane to remove the juice. Also a crude measure of milling efficiency defined as tonnes of juice per tonne of cane.

Imbibition The technique of adding water to the cane between crushing operations in order to extract more sugar.

Inversion The breakdown of sucrose into simpler sugars which occurs particularly at high temperatures and in acidic conditions and reduces sucrose recovery.

Jaggery Brown sugar lumps produced by boiling whole juice or molasses until it solidifies. Also known as gur or panela.

Khandsari A traditional non-centrifugal Indian crystal sugar.

Massecuite Sugar syrup which has been concentrated to a point where the sugar will crystallize.

Milling efficiency The efficiency with which sucrose is extracted from sugar cane during crushing.

Molasses The liquor remaining after sugar has been crystallized from a massecuite.

Multiple effect The evaporators used in the VP process which re-use the steam produced to perform further evaporations.

OPS Open Pan Sulphitation: A process for producing white sugar using relatively simple technology (see papers for further details).

Overall recovery See rendement.

Plantation white An unrefined white sugar, usually off-white in colour which is the end product of the basic VP process. It may be sold for direct consumption or be further refined.

Pol The percentage of pure sucrose in a solution or in a solid product.

Purity The sucrose content of a solution divided by the total dissolved solids content. (Pol divided by brix.)

Refined sugar Sugar which, after production, has gone through further treatment, usually to improve its colour and purity.

Rendement The percentage of sucrose in the cane that is finally recovered from the process. (Overall recovery is a slightly higher figure that allows for non-sucrose in the product.)

tcd Abbreviation for tonnes of cane per day.

VP Vacuum Pan: The large-scale process for the production of white sugar (see papers for further details).